James
Guerrucci

DRAWING
The Creative Process

SEYMOUR SIMMONS III

is currently a research fellow
at the Carpenter Center for Visual Studies, Harvard University,
and is an exhibiting artist, designer, and illustrator

MARC S. A. WINER

is currently a research fellow
at the Carpenter Center for Visual Studies, Harvard University,
and has had seven one-man shows during the past five years

DRAWING

SEYMOUR SIMMONS III / MARC S. A. WINER

The Creative Process

PRENTICE-HALL, INC. A SPECTRUM BOOK Englewood Cliffs, New Jersey 07632

Library of Congress Cataloging in Publication Data

SIMMONS, SEYMOUR.
 Drawing: the creative process.

 (A Spectrum Book)
 Bibliography: p.
 Includes index.
 1. Drawing—Technique. 2. Drawing—Themes, motives.
3. Artists' materials. I. Winer, Marc S. A., joint
author. II. Title.
NC730.S44 1977 741.2 77-4982
ISBN 0–13-219378-7
ISBN 0–13-219360-4 pbk.

Cover illustration:
FRANCESCO VANNI (Italian, 1565–1610)
Head of Man with Closed Eyes (black and red chalk), 14⅜ x 9⅞"
Courtesy of The Metropolitan Museum of Art. Gift of Cornelius Vanderbilt, 1880

Drawing: The Creative Process, by Seymour Simmons III and Marc S. A. Winer
© 1977 by Prentice-Hall, Inc., Englewood Cliffs, New Jersey 07632

A SPECTRUM BOOK

10 9 8 7 6 5 4 3 2 1

Printed in the United States of America

Prentice-Hall International, Inc., *London*
Prentice-Hall of Australia Pty., Ltd., *Sydney*
Prentice-Hall of Canada, Ltd., *Toronto*
Prentice-Hall of India Private Limited, *New Delhi*
Prentice-Hall of Japan, Inc., *Tokyo*
Prentice-Hall of Southeast Asia Pte., Ltd., *Singapore*
Whitehall Books Limited, *Wellington, New Zealand*

To Martine
s.s.

To my parents, for their love and continual support
m.w.

With special thanks to Linda Melamed
for her sensitive and intelligent editing;

to Will Reimann
for his always helpful criticism and desire to share his knowledge of drawing;

to the staff of the Fogg Art Museum and
the Carpenter Center for Visual Studies, Harvard University;

and to our many friends

Contents

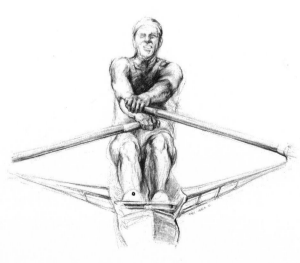

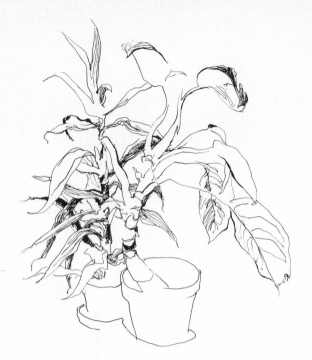

CHAPTER ONE
Basic techniques and materials 16

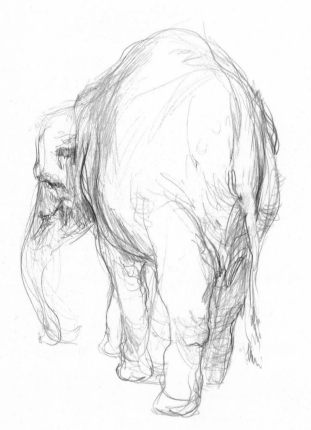

CHAPTER TWO
The elements of drawing *36*

CHAPTER THREE

Still life *54*

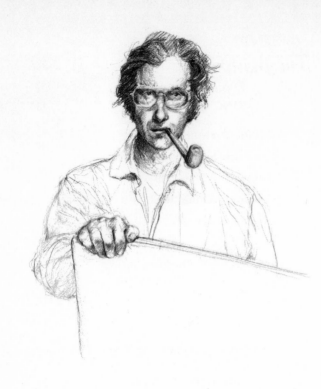

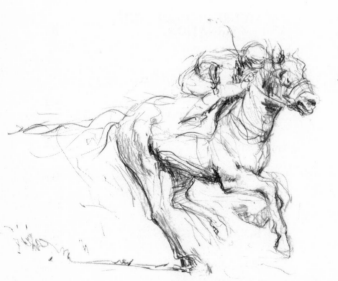

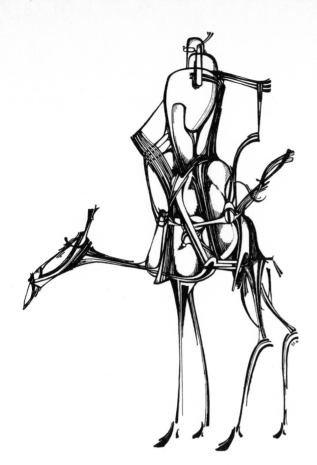

DRAWING
The Creative Process

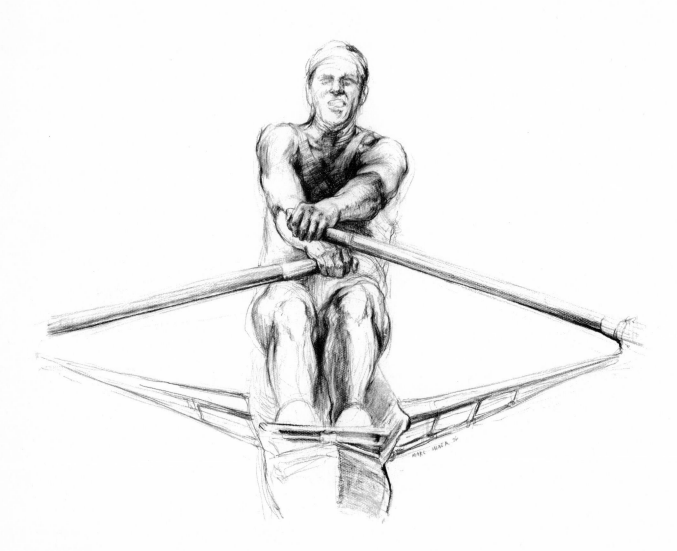

WHY DO WE DRAW? The first impulse might come from a desire to make a picture, to express ourselves, or to relax. However, as we learn we may recognize that drawing offers a much greater reward than these. By encouraging us to develop fully our visual awareness, it enriches our lives and puts us more in touch with the world around us.

The type of "seeing" required for drawing is different from the "seeing" that we use normally. It is not necessarily the perception that identifies objects or helps us to read a book or a map. Rather, it is closer to the true perceptions of the eye without the interpretive actions of the brain. This is the more objective sight that recognizes forms and **values*** for their own sake without referring to an object.

There are three aspects to "seeing" as it applies to the act of drawing: first, the ability to judge accurately shapes, relationships, and proportions; second, the visualizing activity that allows us to recognize and organize drawing potential in a subject; and third, the

*Words in boldface type are defined in the Glossary.

2

INTRODUCTION

Why do we draw?

ability to read and interpret the marks of the drawing itself.

At the beginning, the major hurdle is learning to see clearly and objectively. Many drawing students protest when told they are not "seeing well," but first drawings are rarely accurate. After someone points out a discrepancy, the response is usually, "How come I didn't see that before?"

Often a mature, highly intelligent adult will draw like a six-year-old. This is generally because the person has not done any drawing since that age and is maintaining the same drawing habits developed in childhood. A child develops a symbol to stand for an object: a box with a circle on top and four lines coming out at odd angles represents a person. As perceptions evolve, the symbols are gradually replaced by more naturalistic depictions. If, however, the developmental process is halted somewhere along the way, abilities remain frozen. Improvement can come only through breaking old schematic habits and learning to examine a subject freshly and objectively (see Figure 0.1).

The second aspect of seeing—the visual-

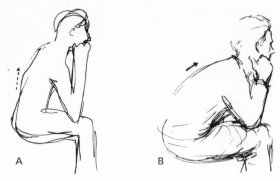

Figure 0.1
Students often think they are seeing accurately but end with something like "A," not being aware of the relationship and real spaces shown in "B."

izing skills that enable you to recognize potential for a drawing—also develops with time and experience. It is this ability, for example, that allows us to organize large, complex landscapes into patterns of lines, form, and value or to see an abstract design in a natural or man-made structure. Potential subject matter is everywhere, but we can only recognize it if we know what to look for. A beginner often searches in vain for "inspiration"; an experienced artist can envision a drawing in the most ordinary of objects.

Once you find a subject you want to draw and start to work, you begin to use the third type of seeing—the ability to read the marks of the drawing itself. This perception is employed in two ways. First, it enables you to recognize whether the marks accurately represent the subject being drawn; second, it lets you see the image that is developing objectively and without preconceptions so you can respond to its strong and weak points, rearranging and balancing the **elements** as necessary.

No matter what the original stimuli, it is the way the image is presented that gives it meaning and artistic value. Any drawing, even a "realistic" one, must be well designed and arranged to have lasting interest and to convey its message thoroughly. You must be able to "see" and build an image that has both variety and unity if your drawing is not to look like a bunch of random forms.

For the sake of clarity, we have broken down the types of seeing into three artificial categories. In practice, all three types occur at once, often unconsciously or spontaneously. It may be necessary at the beginning, however, to develop one aspect at a time, then bring them together once basic principles are understood. Remember that learning to draw means acquiring the skill of seeing more effectively, and this learning process will take some effort.

Winter Landscape, by Rembrandt van Rijn, (see Figure 0.2), is an excellent illustration of all the issues presented above. It is apparent that Rembrandt saw his landscape with a direct and receptive eye and recognized the drawing potential within it. His organization and transformation of the stimuli were products of years of "seeing" experience.

This tiny landscape (a little over six

Figure 0.2
REMBRANDT VAN RIJN (Dutch, 1606–1669)
Winter Landscape (quill-and-reed pen and bistre wash), 68 x 160 mm.
(2 5/8 x 6 5/16")

Courtesy of the Fogg Art Museum, Harvard University. Bequest of Charles Alexander Loeser

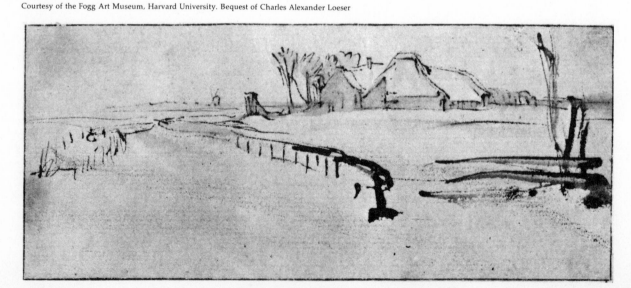

inches long) is, in fact, a consummate example of *all* the drawing elements. The marks themselves are abstract and take their form and meaning only in relation to each other. The front of the fence is pure Oriental **calligraphy,** a crisp and handsome **abstract** design, yet its placement in the frame identifies it by relating it to the haywain on the left and the farmhouse in the background. The trees and building barely exist even as scribbles, yet they form the middle ground with their marks and help the viewer to identify the rest of the forms. Rembrandt has **edited** out everything extraneous; each element is made to work as **abstract** pattern, **spatial indicator,** and tonal shape, as well as standing for the "real" object. Throughout this small space, Rembrandt's ability to see how his marks were **counterpointing** one another allowed him the freedom to leave most of the paper white.

In its spontaneity and economy, this drawing invites us to participate in the process of creation. There is a real sense of the swift movement of the pen and brush, which allows us to reconstruct the making of the drawing.

This quality of immediacy and accessibility, demonstrated in the Rembrandt drawing, is perhaps the most attractive and important aspect of drawing. By picking up so simple an instrument as a pencil or pen, we can record our responses to things seen, as well as to feelings, thoughts, and fantasies. And, depending on the directness of our response, we can allow a viewer to share our creative thought.

DIFFERENT MODES OF SEEING AND DRAWING

Under the general heading of drawing, we find a multitude of images that serve a variety of functions. In the following pages we will discuss several of the major categories: Descriptive Drawing, Ornament and Illustration, Drawing as Social Commentary, Drawing as a Means to Clarify or Crystalize an Idea (preparatory drawings for painting, sculpture, architecture, and invention), and Drawing as a Means of Self-expression.

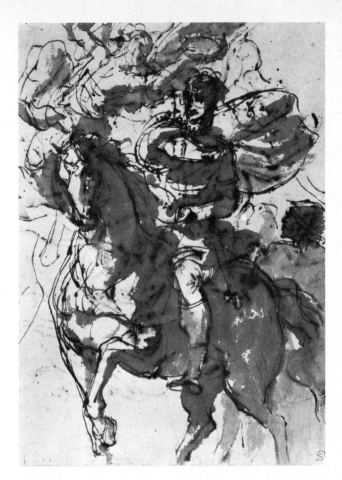

Figure 0.3
VENETIAN SCHOOL (Italian, 17th century)
A Triumphant General Crowned by a Flying Figure
(quill pen and bistre wash)

Courtesy of the Fogg Art Museum, Harvard University. Bequest of Meta and Paul J. Sachs

These categories are not always clearly distinguishable from one another. For example, the Rembrandt landscape described earlier was clearly a descriptive drawing, yet at the same time, it is an excellent example of self-expression. In the freedom and spontaneity of line, it is obvious that the drawing was done for the artist's pleasure, to celebrate seeing and to revel in the movement of hand over paper.

Descriptive Drawing

The next three drawings (Figures 0.3, 0.4, and 0.5) date from roughly the same period as the Rembrandt landscape, but each demonstrates a very different response and goal. The work of each artist, to some degree, represents a historical position. But drawings are as different as the people who create them, even as they are influenced by time and culture.

The magic of the Rembrandt landscape

rests in its economy and simplicity; in the Venetian equestrian study (Figure 0.3), the power derives from a swirling energy that amplifies the drama. In both drawings, the artists have transformed the images in personal, emotional ways, through the use of tone and line. In their brevity, these drawings engage us in a way that more finished forms of art might not. We can participate in the creation by bringing our own meanings and feelings to the sketchy notations.

The cathedral at Utrecht in Figure 0.4, done in the same century as the Rembrandt and the Venetian equestrian study, uses the same simple tools of drawing to create a stately and ordered image. Instead of the calligraphic grace of the Rembrandt, this drawing presents a linear balance with fewer dramatic effects. Although Saenredam is concerned with accuracy, he chooses to stress specific elements in his composition (such as the strong horizontal halfway up on the left) and play them against less defined, light areas to better represent his conception. This kind of editing is very different from a photographic acceptance of all detail.

Accurate drawing of man-made structures need not record only hard facts, as is well illustrated in Brueghel's castle scene (Figure 0.5). This study, although most probably representational in its proportions and details, conveys a sense of stillness and mystery. The **stippled** surfaces of the walls seem to be made from the same substance as the heavy air that surrounds them. Here, in two drawings of buildings (Figures 0.4 and 0.5) made about one hundred years apart, we find two unique responses to a similar subject. In effect, Saenredam and Brueghel were "seeing" in two very different ways.

Ornamentation and Illustration

The twentieth century has brought with it monumental changes in the drawn image, as it has in every form of art. New styles and techniques, along with the unusual subject matter now familiar to the contemporary eye, may make the four drawings we have just discussed seem ancient. In fact, they are relatively recent in the history of art. The first

Figure 0.4
JANSZ PIETER SAENREDAM (Dutch, 17th century)
The Nave and Side Aisles of the Cathedral at Utrecht
Courtesy of the Museum of Fine Arts, Boston

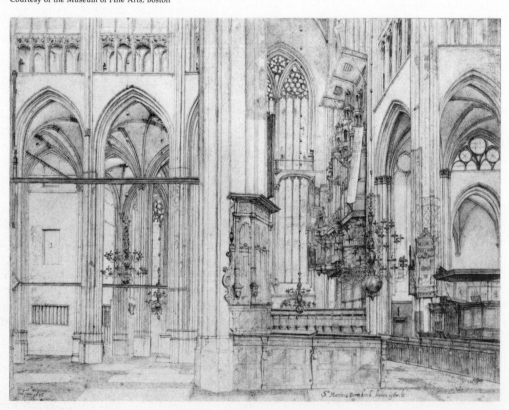

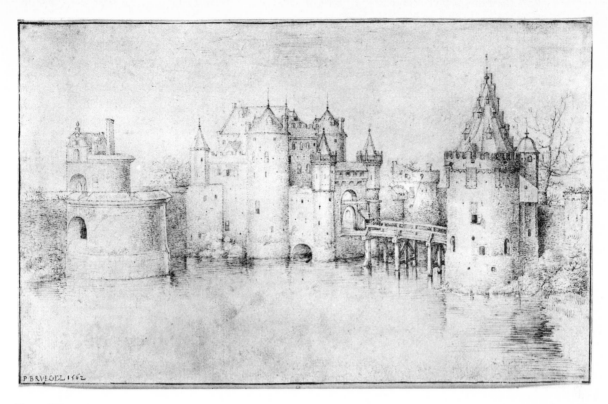

Figure 0.5
PIETER BRUEGHEL THE ELDER (Flemish, 1525–1569)
Castle with Moat and Bridges (pen and bistre)
Courtesy of the Museum of Fine Arts, Boston, Gift of Horace L. Mayer

known drawings, found in the caves of southern France and Spain, date from about 15,000 B.C. They were representations of animals, believed to be religious or magical symbols. Later, drawings of geometric patterns and abstracted symbols were applied to **neolithic** pottery and crafts for decorative purposes.

In the history of civilization, design, ornamentation, and functional form have developed simultaneously. The Greek vase (Figure 0.6) is a fine example of all three. Here a curving, linear image complements the shape of the vase, while enlivening its surface with strong, contrasting lights and darks. The figure of the monster conveys a legend or mythological episode, adding illustration to pure ornamentation.

The second example of ornamentation (Figure 0.7) decorates a page of a manuscript rather than a functional implement. It is a stylized design composed (in part) of Arabic script. The imposing quality of the bird indicates that the artist had considerable experience observing real birds before creating this filigreelike abstraction.

As in Figure 0.6, this Persian image illustrates as well as decorates. The peacock empha-

Figure 0.6
GREEK (Attic Period)
Heracles and Triton (vase—hydria, black-figure)
Courtesy of the Museum of Fine Arts, Boston. Gift of Horace L. Mayer

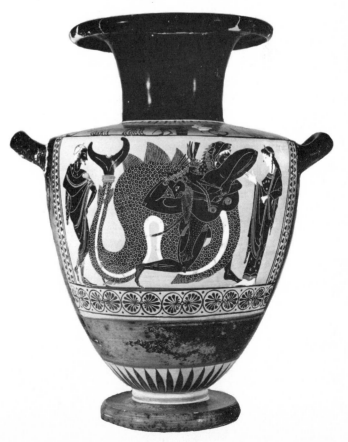

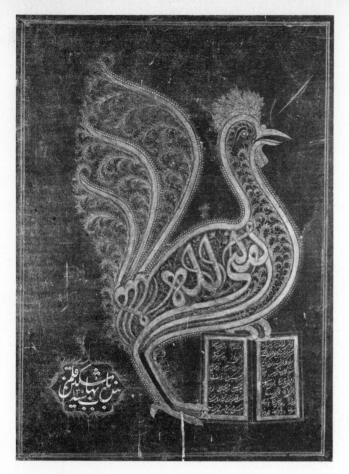

Figure 0.7
PERSIAN (1888)
Cock of Calligraphy, saying "He is God" (manuscript)

Courtesy of the Fogg Art Museum, Harvard University.
Gift of John Goelet

sizes, in a symbolic way, the passages of the text it presents.

The drawing that depicts Ali Baba, by Beardsley (Figure 0.8), uses both forms of ornamentation discussed above and, like them, is an illustration as well as decoration. The style of the Beardsley work duplicates the line qualities and value contrasts of the Greek vase, at the same time suggesting the jewel-like motifs of the Persian bird. As in the bird study, lettering is an essential aspect of the overall composition. In the Beardsley, the geometric stiffness of the words complements the sumptuous black lines of the figure. As the frontispiece for *Ali Baba and the Forty Thieves,* the drawing tells its own story, relating important information about a leading actor. As we read, Beardsley's opulent characterization will remain with us. This will be the figure we visualize as the story unfolds.

The nineteenth-century view of Boston in Figure 0.9 is surrounded by an ornamental border into which individual depictions of buildings are woven. Although the framework

of plants crawling up a trellis may appear old-fashioned to contemporary eyes, the device was an interesting solution to the problem of showing a distant scene and close-ups within the same border.

In Figure 0.10, on the other hand, the crisp, linear statement of the carriage, coupled with the script underneath, has a more contemporary feel in its starkness. It offers little in the way of personal statement, its intentions being entirely informational. Although we can enjoy the decorative aspect of this drawing today, it was originally meant as pure illustration. This is the nineteenth-century equivalent of the advertising art we see in today's magazines.

Drawing as Social Commentary

In many of the examples mentioned so far—the Beardsley, the Persian bird, the Greek vase, and the dog cart—the drawn image has served to complement written or verbal information. Pictures often stay in our minds after words fade. For this reason, drawings are

Figure 0.8
AUBREY BEARDSLEY (British, 1872–1898)
Cover Design for The Forty Thieves (pen, black and white ink, brush, and black chalk)

Courtesy of the Fogg Art Museum, Harvard University. Bequest of Grenville L. Winthrop

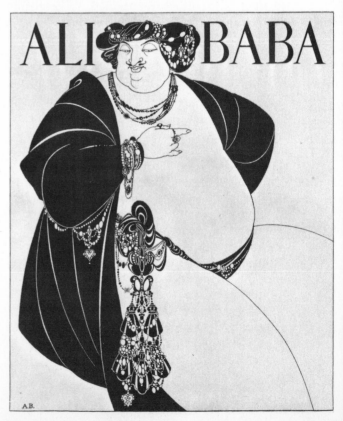

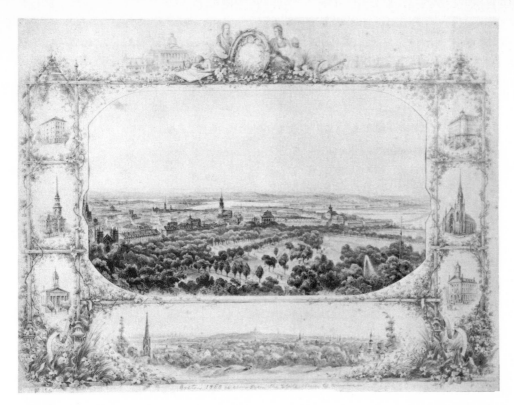

Figure 0.9
HERMANN JULIUS KUMMER (American, 1817–1869)
Boston 1858 as Seen from the State House (pencil and
watercolor)

Courtesy of the Museum of Fine Arts, Boston.
Bequest of Charles Hitchcock Tyler

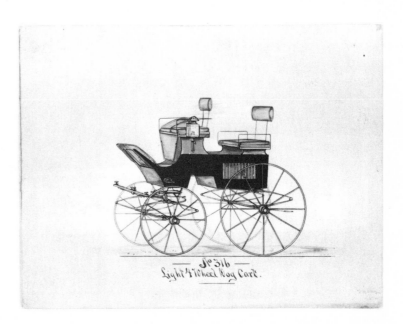

Figure 0.10
STEINBECK (American, 19th century)
*Carriage Drawing for Brewster, No. 316:
Light 4-Wheel Dogcart*

Courtesy of the Museum of Fine Arts, Boston.
M. and M. Karolik Collection

used as a means of communication, not only
in illustration and advertisement, but in social
commentary as well.

Drawing can communicate messages
about people in a succinct and penetrating
way. Unlike a photograph, which records more
detail, drawing can focus directly on the es-

sential and can make its point through inter-
pretation, distortion, or exaggeration.

There is no need to wade through a col-
lection of descriptive words to get to the
meaning of the commentary by Rowlandson
(Figure 0.11). This packed and loathsome
crowd could not have been portrayed by a

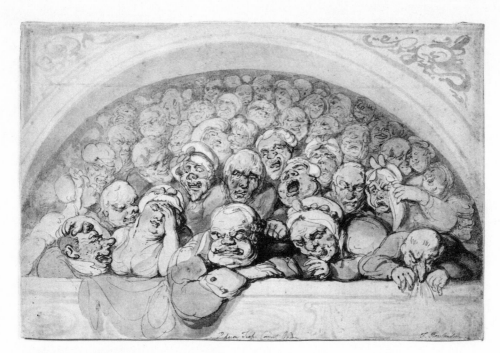

Figure 0.11
THOMAS ROWLANDSON (British, 1756–1827)
Pigeon Trap, Covent Garden (pen and brush)

Courtesy of the Museum of Fine Arts, Boston. Gift of John T. Spaulding

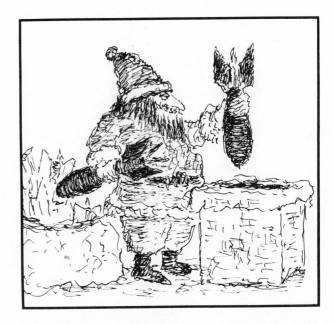

Figure 0.12
EDWARD KOREN (American, 20th century)
Santa (pen and ink over graphite on white paper),
280 x 353 mm. (11 x 15 7/8")

Courtesy of the Fogg Art Museum, Harvard University.
Anonymous gift

camera, since both arrangement and expressions have been exaggerated by the artist for his own editorial purposes.

Rowlandson and the Frenchman Daumier are among the founders of a tradition that has evolved into the editorial cartoon. An example of Daumier's satire is shown in Chapter 7 (Figure 7.27). There, in a swirl of gestural lines, two sordid faces emerge from the surface of the paper. We are not invited to share in the song and are discomfited by their strange expressions.

Edward Koren, on the other hand, is most happy to share his joke with us (Figure 0.12). This cartoon is in a much lighter vein, yet it still packs some punch, as the benign, smiling Santa prepares to drop a rather substantial bomb down a chimney. As in the pre-

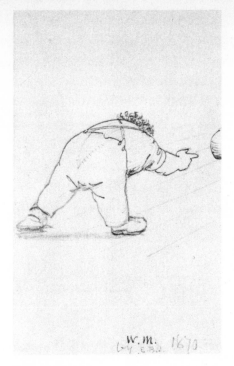

Figure 0.13
SIR EDWARD BURNE-JONES (British, 1833–1898)
Caricature of William Morris Playing Skittles (graphite)

Courtesy of the Fogg Art Museum, Harvard University

vious two examples, the drawing style helps to convey the message. The scribbles that coalesce into Santa—the way he stands, smiles, and grips the bombs—can not be separated from the idea.

Burne-Jones demonstrates another form of social commentary in a gentle and playful caricature of his friend William Morris (Figure 0.13). Although we see him from the rear, we are given a fine sense of the man through body type, movement, clothing, and that bit of curly hair visible over the broad back.

Drawing as Clarification

Drawing, through its brevity and immediacy, can also be a means of crystallizing thought; as we move our hand over the paper, ideas only vaguely guessed at begin to develop substance. In this instance, drawing becomes part of a thought process which can evolve into an invention, a building, a sculpture, or a painting, as well as a more finished drawing.

Figure 0.14 demonstrates an early stage of the creative process that eventually materialized as the finished sculpture (Figure 0.15). In this sketchbook entry, an idea was given form; inspiration became quick notations on paper. But even as lines were applied, the image began to change and evolve from that first conceived. In effect, the clarification that oc-

Figure 0.14
DIMITRI HADZI (American, 20th century)
Drawing, for Samurai (pen and ink on gray-blue paper)

Courtesy of the Fogg Art Museum, Harvard University.
Purchase, Alpheus Hyatt Fund

Figure 0.15
DIMITRI HADZI (American, 20th century)
Samurai (sculpture in bronze), H: 10″ W: 11 3/4″

Courtesy of the Fogg Art Museum, Harvard University.
Gift of Mrs. Max Wasserman, in honor of Agnes Mongan

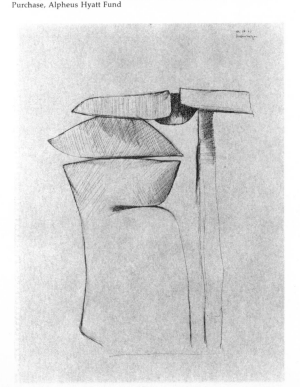

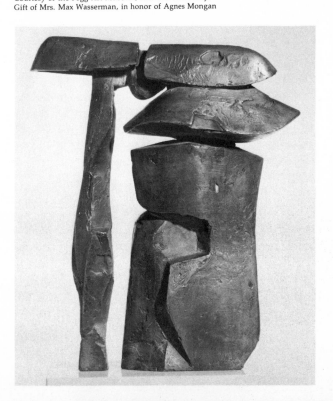

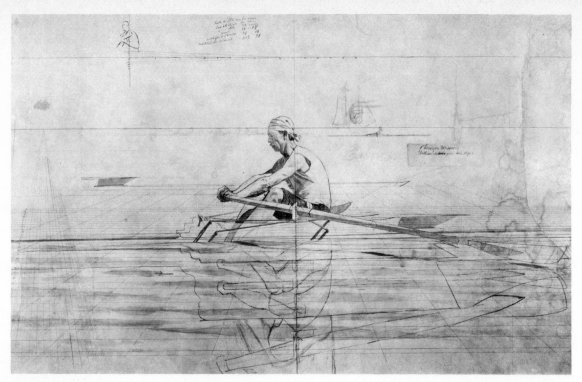

Figure 0.16
THOMAS EAKINS (American, 1844–1916)
*Perspective Drawing for John Biglen, In a
Single Scull* (pencil)

Courtesy of the Museum of Fine Arts, Boston. Gift of
Cornelius V. Whitney

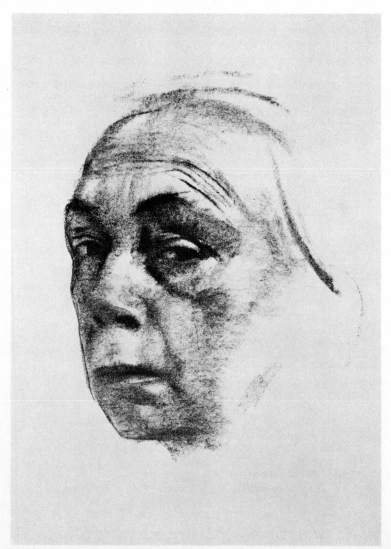

Figure 0.17
KATHE KOLLWITZ (German, 1867–1945)
Self Portrait (lithograph), H: 250 x 225 cm.

Courtesy of the Fogg Art Museum, Harvard University

curs while drawing is every bit as important as the initial vision in the creative process.

In Figure 0.16, Eakins has prepared an elaborate structural drawing of a sculler, indicating lines of perspective that will set the surface and reflective pattern of the water in the finished painting. Even though this careful drawing does not have the investigative quality of the Hadzi, it, too, was probably something of a revelation to the artist. For no matter how completely we visualize an image, its actual appearance may take a surprising form.

Drawing as Expression

Every drawing, no matter what the mode or level of competence, expresses something of the maker—emotions, imagination, perceptions, as well as sense of design. The problem occurs, however, when beginners want a certain type and level of imagery that may be beyond their capabilities. They want to "express themselves" in a specific way, only to become frustrated when their drawings do not meet their expectations. "That wasn't what I meant at all!" is a common complaint.

To truly control the expressive aspect of your drawing requires a fairly high level of competence, where technical issues are no longer the foremost problem and attention can be concentrated on direct communication. Each master drawing discussed in this introduction displays this level of competence and speaks of the nature and intention of the artist.

The force and directness of the self-portrait by Kathe Kollwitz (Figure 0.17) could have been accomplished only after years of drawing.* The artist has orchestrated all the drawing elements to serve and intensify her goal—a statement about herself as a person and as an artist. Her graphic vocabulary is extensive; rich black shapes are balanced by subtle and varied line qualities. The face seems to project out from the page surface

*The "Self-Portrait" by Kathe Kollwitz (Figure 0.17) and the "Head of Menace" by Paul Klee (Figure 0.18) are actually prints (lithograph and etching), rather than drawings. They have been included in this chapter since they were initially drawn (on litho stone and etching plate) before reproduction. Prints such as these will be used occasionally throughout the book.

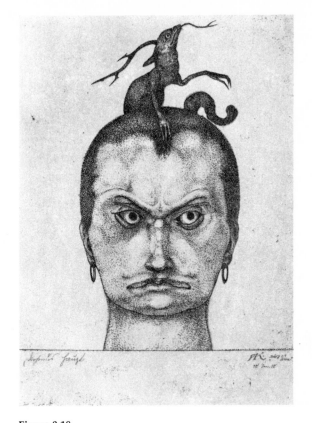

Figure 0.18
PAUL KLEE (German, 20th century)
Head of Menace (etching, print)

Courtesy of the Busch-Reisinger Museum, Harvard University.
Anonymous gift

like a **bas-relief,** yet our first reaction is not to the technique but to the suggested experience, maturity, and depth of the individual being portrayed.

The self-portrait in Figure 0.17 depended on penetrating realism for its impact. The early Klee in Figure 0.18 relies on distortion and the combination of weird elements. The way in which facial features are "pushed" just beyond realism requires a firm knowledge of *actual* features. The success of this distortion is demonstrated by the strange lizard, which really seems to belong on the man's head. Where Kollwitz stressed the three-dimensional existence of her face, Klee's head develops suddenly and uncomfortably from a flat (neck) line. Yet, as an expression of mental torment, it is as affecting as the Kollwitz self-portrait.

In the Reimann drawing (Figure 0.19), we find an empathetic, concrete expression of the weight and stance of the rhinoceros. Previous experience in studying animals and in making many drawings is evident in the un-

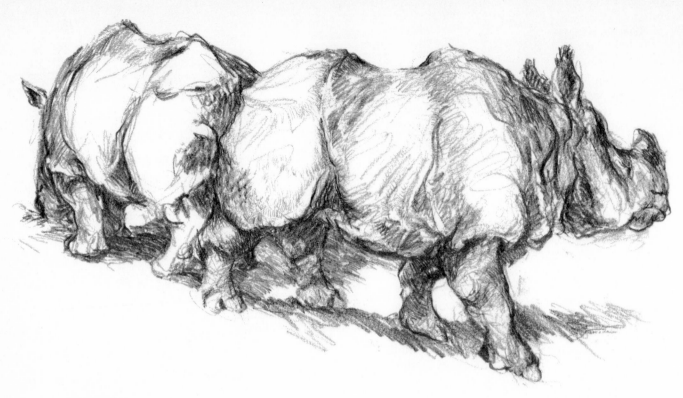

Figure 0.19
WILLIAM P. REIMANN (American, 20th century)
Two Rhinos (pencil)

Courtesy of the artist

Figure 0.20
ALEXANDER CALDER (American, 20th century)
The Lion Cage (pen and wash drawing)

Courtesy of the Museum of Fine Arts, Boston. Lee M. Friedman Fund

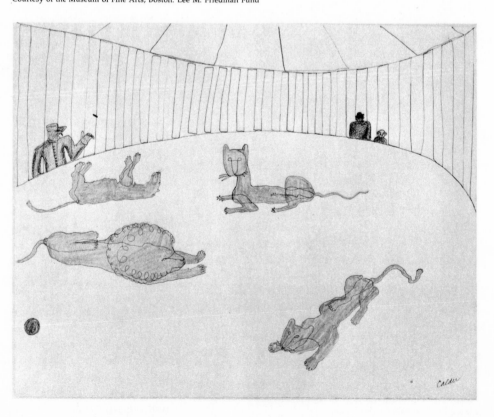

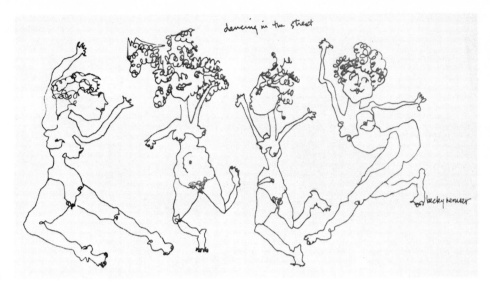

dancing in the street

becky nemser

Figure 0.21

Courtesy of Rebecca Nemser

equivocal yet searching marks. Through the artist's selection of those aspects portrayed as well as those he has intentionally left out, we are given a forceful statement of the dynamic, blocky thrust of these huge beasts.

Drawings do not have to be completely serious to express feelings and intentions. At first glance, the Calder drawing (Figure 0.20) may seem like the work of a child, but we need only look at the evocative handling of the hips in all the animals to dispel this misconception. Calder is obviously having a good time here, but his playful images derive from solid drawing principles.

Although the master drawings presented previously demonstrate the skill and sophistication that comes only with experience, we should not forget that drawing, at any level,

can be fun—as shown in these lighthearted student drawings, Figure 0.21.

It should be apparent through this introduction that there are many ways to draw, that no one way is necessarily better than another. As you learn, keep an open attitude, not only to your environment and to other works of art but to your own drawing as well. Within each image, try to see a potential for development together with the strengths and weaknesses. Do not force yourself to adopt a particular style or approach to drawing; rather, learn to understand yourself and seek out your own directions. Drawing is something you can do all your life. Allow it to change and evolve with you.

DRAWING IS A PROCESS OF MAKING MARKS; yet the nature of these marks and their relationship to one another determine their impact. Lines, dots, even scribbles can be applied with a sensitive hand and eye to create a rich, personal statement.

Whether these marks read as a childish scrawl or an eloquent, convincing image depends to a great extent on the artist's intention and his or her ability to carry out that intention. This ability comes in part from "natural talent" and in part from training. Of the two training is the more vital. If someone

has the interest and desire to learn, the time to practice, and good instruction, it is possible to develop the ability to draw well even though natural talent may not have been evident in the beginning.

Most people can draw in one way or another and can derive genuine pleasure from the action or process; and the process is what drawing is really all about. The final product, even for an experienced artist, should be a secondary concern. Unfortunately, many beginners approach drawing hoping to produce a beautiful or accurate picture and then be-

CHAPTER ONE

Basic techniques and materials

come discouraged when the results do not meet their expectations.

No instructor expects a beginning student to be able to create an accurate image, yet students often demand this of themselves. It seems a part of human nature to have expectations that go far beyond our abilities, particularly in a new endeavor. But beginners should remember that learning to do anything well requires training and experience. This same point applies to students who had stopped drawing after reaching a certain level of proficiency and then find themselves frustrated

when their current efforts are not up to the standards they had come to expect from themselves. The real danger here is that this frustration can impinge on the enjoyment of drawing or cause a student to stop drawing before any more progress can be seen.

Drawing must be looked upon as a learning experience. Success will come only as a result of good instruction and perseverance.

In this book, we offer a course in drawing that will provide information and instruction to direct you in the absence of a qualified teacher. It will also serve as a sourcebook and

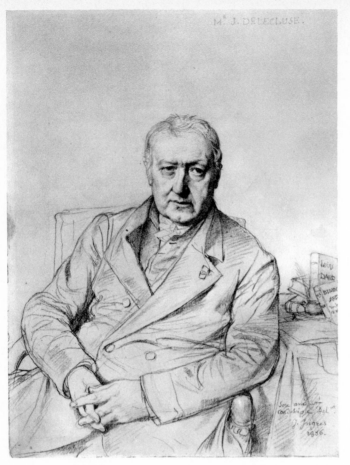

Figure 1.1
J.A.D. INGRES (French, 19th century)
Portrait of M. Etienne-Jean Delecluze (graphite and white chalk), 317 x 247 mm. (12 1/2 x 9 3/4")

Courtesy of the Fogg Art Museum, Harvard University.
Bequest of Grenville L. Winthrop

you should take the exercises in this book as part of your learning process, not as ends in themselves.

WORKING ON YOUR OWN

If you are working on your own, without the aid of a class or instructor, you are responsible for determining your own course of study and also for the more difficult tasks of self-discipline and self-evaluation. It is often hard to make yourself sit down alone to draw. And, at the very least, it is difficult to assess your own progress. Therefore, we recommend that you set wholly obtainable objectives. For example, decide to work 20 or 30 minutes a day, every day, and stick to your decision. In this way, drawing becomes a natural activity and part of your daily routine. This is greatly preferable to saying, "Well, I'll work four hours on Saturday." People just don't draw "four hours on Saturday." They have to build up to that kind of time commitment.

In evaluating your work, it is essential that you learn to be objective. You will certainly make mistakes in the beginning, and your efforts for quite some time may not satisfy you. However, if you work steadily, results will come. Remember that you are involved in a process, and that your work will continue to change and evolve throughout your life. Try to find delight in what you are doing, rather than bemoaning your imagined failures. In this regard, it is essential that you receive support from those around you.

If you are working by yourself, you would probably find it helpful to speak to a professional about your work. Many instructors at local universities or adult education centers would be willing to spend 15 or 20 minutes evaluating your work. Don't accept negative criticism from those around you who are unqualified to judge. Don't apologize or be embarassed by your early attempts. They are exercises only.

As you begin to work, maintain an open and positive attitude. Use lots of energy and lots of paper. *Enjoy the process!* Don't be afraid to make mistakes. They are an essential

supplement for the classroom experience, with explanations and exercises that can be used as an aid to both teachers and students.

We have set up a chronological progression introducing basic information on drawing materials, elements, and techniques. These are then applied to the study of still life, landscape, figure drawing, portraiture, and animal drawing. We will also include sections on perspective, anatomy and composition which may serve as references to help solve many more advanced problems.

Although our inclination is to present a course in drawing geared toward accurate representation, you should not think of drawing solely as the graphic reproduction of nature. Much of the valued art in our museums has only an indirect relationship to photographic reality, and most artists working today, whether in a realistic or abstract manner realize the necessity to express themselves in distinct and personal terms. Consequently,

part of learning. Refer to them and study them along with the good qualities of your work. When you begin again, try not to repeat the errors.

Warm-Up Exercises

Most drawing sessions begin with warm-up exercises designed to make you loose and relaxed, able to respond to and organize visual stimuli. Warm-ups in drawing serve the same purpose as warm-ups in athletics or music; they help to release tension. Although it takes a certain amount of tension to do any type of work, too much only intereferes with your efforts. Athletes and dancers stretch to relax their muscles; musicians produce unpleasant screeches and moans to prepare their instruments, fingers, and lips for a performance. In drawing, the arm and hand are the instruments that must follow the direction of the mind and eye, so a warm-up for an artist will give his or her instrument the flexibility necessary to follow the orders of perception.

If you are working without formal instruction, be sure that you begin with a few of the warm-up exercises described below. Then, as you continue to draw, try to maintain this sense of relaxation. If tension begins to build up, walk around or stretch. Writers, for example, are legendary for pacing up and down between bouts with the typewriter. Trips back and forth to the refrigerator are well integrated into working patterns of most artists (at least those not on a diet).

In doing warm-up exercises, waste plenty of large sheets of inexpensive paper. Charcoal or soft pencils are recommended as a medium because they are relatively easy to control and flexible in their application. Use an easel for drawing if possible; it allows greater freedom of arm movement than a flat table (see the section on easels under Accessories later in this chapter).

Exercise 1

SILENCE
(No drawing)

Turn off your radio or phonograph and sit in complete silence for a few minutes. Make a break in your daily

routine. *The amount of noise we continually endure requires that we turn off our senses just to function. In drawing you will want these senses fresh and receptive. The use of one of our senses can often impinge on the responsiveness of the others. For example, you may have found that closing your eyes at a concert allows you to hear the music more intensely. We don't suggest that you not draw with music on—it is often a rich stimulus and good company—but rather that you allow yourself to concentrate your focus in silence before beginning to work.*

Exercise 2

CIRCLES
(Time: 2–5 minutes; material: charcoal or soft pencil)

Begin by drawing small circles with your hand and wrist, just as if you were writing; then use your whole arm to increase the size of the circles, drawing as if from your shoulder. Then put your back and whole body into it, using as much energy as possible.

Exercise 3

RANDOM MARKS
(Time: 2–5 minutes; material: charcoal or soft pencil)

Simply produce scribbles, nervous lines, or broad sprawling strokes. Don't draw anything. Try to put all your tensions into the marks you are making so that your body can be relaxed and ready to work.

*Exercise 4

STRETCHING AND RELAXING
(No drawing)

Stand on your toes and stretch your arms toward the ceiling. Then slowly relax from the top down the spine, and collapse on the floor. Repeat a number of times.

*Exercise 5

LISTENING TO SIMPLE SOUNDS
(No drawing)

This exercise is begun by shutting the eyes and relaxing. Listen to sounds outside the room, then inside the room . . . nearer yourself . . . inside yourself. If you are in a group, tell each other what you've heard. Listen again for high and low sounds. Discuss. This is broadening both through the concentration it demands and the sharing, which often makes a person realize that he or she has not heard everything.

*Exercises 4–8 are reprinted from *Fragments*, by Professor Lowry Burgess, Massachusetts College of Art. Reprinted by permission of the author and the Education Development Center, Inc., Newton, Mass.

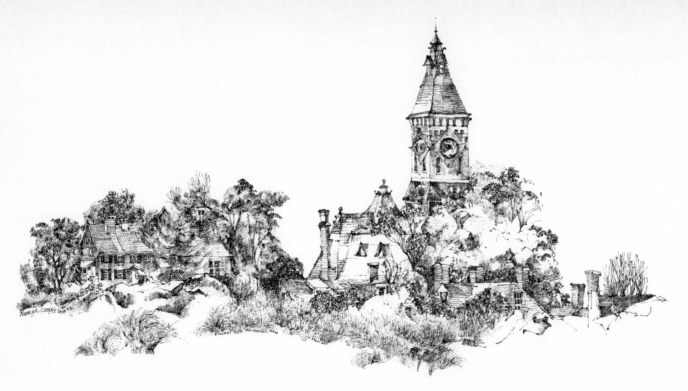

Figure 1.2
NANCY E. COOPER (American, 20th century)
Crocker Park, Marblehead, Mass. (pen and ink)

Courtesy of Mr. and Mrs. Louis Winer, Swampscott, Mass.

*Exercise 6

FROM STILLNESS TO MOVEMENT
(No drawing)

Try to comprehend fully your total posture as you stand or lie still (starting your concentration in the fingers or feet and spreading throughout the body). When this is accomplished, begin to move, trying to sustain the full awareness. See how long you can sustain it.

*Exercise 7

DRAWING WITH EYES CLOSED
(Time: 10–15 minutes; any drawing and painting materials)

Think of something to draw or paint. Close your eyes and draw or paint it. Spend 10 to 15 minutes finishing the picture. Try not to look as you draw. There will be a great deal of tension in this; fear that you will not be able to draw what you are trying to draw. Let the tension mount. You will be surprised at the results.

*Exercise 8

AUTOMATIC DRAWING
(Time: 10 minutes or more; any drawing materials)

Shut your eyes, relax, and begin to draw without trying to draw anything. Find movements that you like, things that you want to do. Do this for at least 10

*Ibid.

minutes; then open your eyes. Show your pictures to others who are present. How does the effect of this drawing compare with your other drawings?

MATERIALS AND MEDIUMS

The choice of drawing materials can be as important for the art student as it is for the professional artist. Many exercises, to be effective, require the use of specific drawing tools, and the success of a developed work may depend on suitable paper and an appropriate medium.

Any medium offers a spectrum of possible effects, but it also imposes limitations. Some materials, such as charcoal or soft pencil, lend themselves to quick sketches or spontaneous drawings. Others, such as pen and ink or hard pencil, require more skill in handling and are often employed for technical drawings or accurate renderings.

It is suggested for most drawing exercises that a beginning or intermediate art student work with materials that encourage relaxation. This is not to say that you should not experiment with more demanding medi-

20

ums, such as pastels, pen and ink, and so on. But the fact remains that such materials present technical problems that may interfere with your primary concerns — enjoying the act of drawing and learning to see accurately and **graphically.** In subsequent chapters, we will recommend materials that are appropriate for particular exercises. For the most part, these will be relatively easy to handle, allowing you to put most of your energy into careful observation. Specific information on these materials and others will be found on the following pages.

The variety of drawing mediums is seemingly endless. Artists might work directly with charcoal or pencil or they may combine materials, blending, rubbing, and erasing. They may experiment with unusual materials, introducing collage or found objects to a drawing; they can produce a regular drawing on an irregular surface like a wall, a pillow, or a sidewalk.

In this section, we intend to discuss only the standard materials with a brief explanation of their uses. You should refer to other sources to learn more specialized techniques, and experiment with different approaches or combinations of mediums on your own. See the bibliography for source books on specific subjects and materials.

Basic materials used in these exercises include:

- Newsprint tablet, 18″ by 24″
- Medium weight multipurpose paper, approx. 14″ by 17″
- Medium weight multipurpose paper, approx. 5″ by 8″
- Medium vine charcoal, #1 or #2
- Soft compressed charcoal, #.00 to #2
- Soft pencil, #2B to #6B
- Kneaded eraser
- Japanese brush
- India ink

Papers

Great drawings have been done on animal skin parchment, on the backs of menus, on lecture notes, and on the walls of caves. Paper is not always the first concern of the artist. However, students would do well to familiarize themselves with the variety of papers that are manufactured expressly for drawing. These come in many styles and qualities and may be chosen according to the requirements of the medium to be used, stylistic preference, or simply on the basis of cost.

Paper is classified according to type and weight. Type may refer to the material that the paper is made of, such as 100 percent rag, or the paper's particular use. Weight refers to the weight of a ream (500 sheets) of standard sized paper. For instance, a ream of watercolor paper may weigh 90 pounds to 300 pounds. The heavier papers are sturdier and more resistant to buckling when water is applied.

Certain types of paper are designed to be used with a wide variety of materials.

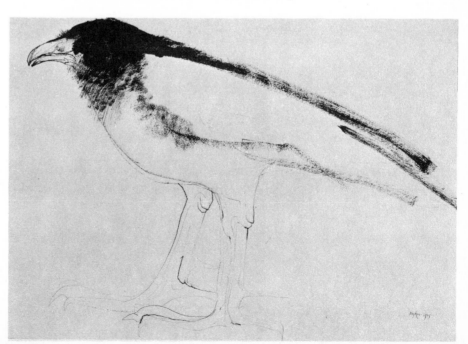

Figure 1.3
LEONARD BASKIN (American, 20th century)
Impulsive Crow (pen and wash with carbon black ink over traces of graphite on white paper). 670 x 1011 mm. (26 1/2 x 40″)

Courtesy of the Fogg Art Museum, Harvard University. Gift of Leonard Baskin

These, which we will call multipurpose paper, range in quality and price from inexpensive newsprint and manila to multiple-ply vellum papers, which may cost more than $1 per sheet. Other papers are manufactured especially for use in a particular medium, for example, pastel or watercolor papers.

MULTIPURPOSE PAPER

Newsprint. The stuff that newspapers are printed on is the most popular paper for beginning and intermediate drawing students because it is inexpensive (between one and four cents per sheet) and relatively receptive to charcoal, soft pencil, conté crayon, or brush and ink. Newsprint should not be used for careful or finished drawings as it yellows quickly, tears easily, and wears down under heavy erasing or hard pencil work. It is good only for exercises and quick sketches.

The use of paper such as newsprint, which is especially made for practice and exercises, may help the timid student to overcome his or her fear of ruining a drawing or wasting paper. Realizing that because of the quality of newsprint any drawing must be considered an exercise, the student may work more instinctively and with more energy, starting drawings over and experimenting with new styles and techniques. In addition, he or she may be encouraged to do the endless gesture sketches and make the many mistakes that are a necessary part of learning.

Newsprint sheets or tablets are available in many different sizes; however, the 18" by 24" is recommended for large, loose drawings. The paper will have either a smooth or rough texture, or "tooth." The rough-toothed paper appears to be heavier and is generally more receptive to drawings done in vine charcoal and pastel, since the crumbly medium will adhere better to a coarser surface. Smooth newsprint is more receptive to compressed charcoal and brush and ink work.* Pencil may be used effectively on either a rough or smooth surface.

Manila paper. This paper, which looks

like oatmeal, is also inexpensive. It is heavier and sturdier than newsprint and works well for drawing exercises and quick sketches.

In addition to newsprint and manila practice papers, most manufacturers produce a wide variety of good quality, multipurpose papers that may be used for finished drawings.

SPECIALTY PAPER

Once you decide to do more extensive work with one medium, it is worth having a paper expressly suited to that medium.

Charcoal and pastel papers. These come in white as well as a rainbow of colors and tints. They offer a grainy, rough, or patterned tooth, which holds the crumbly chalk, charcoal, or pastel more efficiently than a smooth or untextured paper. The tint may serve as a background for sketchy drawings or as an undercolor for more finished works, providing a middle tone to which darks or highlights may be applied.*

There are also velour papers and others that are textured with a very fine coating of sand. These types of papers are often used to make smoothly blended pastel drawings, which may have qualities much like those of an oil painting. Canson, a French-manufactured, 100 percent rag pastel paper, is used by one of the authors and is of superior quality.

Pencil paper. Pencil can be used effectively on almost any type of paper. However, for a finished drawing, it would be best to work on a good quality paper, such as 100 percent rag, which is firmly constructed, even textured, pure in color, and resistant to yellowing.† Other papers that provide an excellent surface for pencil drawings are the more textured, "vellum" and "cold press," or the smooth, shiny "plate finish" and "hot press."

*When using ink or watercolor on newsprint or other relatively lightweight papers, care must be taken to protect the underlying sheets from damage due to seepage.

*Any tinted paper, even 100 percent rag, will fade when exposed to direct sunlight over a period of time.

†Rag paper, unlike most others, is not made from wood pulp, but from cotton rags, which are cut into very small pieces, soaked with a binder, and then lifted in a screen to dry into sheets. The 100 percent rag contains none of the corrosive acids or oils that cause other papers to yellow and become brittle. When matting a valued drawing, only rag mat board should be used to prevent eventual discoloration to both mat and artwork.

Watercolor paper. Most papers used for watercolor are relatively heavy and have sizing on the surface, which allows them to absorb water slowly and evenly. The paper can be purchased in sheets, in loosely bound tablets, or in blocks. The blocks are fixed on all sides so that the paper will not permanently buckle when water is applied. Since good quality watercolor blocks are extremely expensive, the beginner would be well advised to use single sheets and tape them to a drawing board to prevent buckling. Before taping, soak the sheet in a tub for 20 minutes until it has absorbed its fill of water. Then tape the paper with about 1-inch overlap to a drawing board with brown package sealing tape, making sure that all edges are secured. When dry, the paper will be stretched tight (see Fig. 1.4)

There are hundreds of types of watercolor paper, and each responds to paint and water in a different way. The serious student of watercolor should experiment with a variety of papers to understand their unique natures. Watercolor paper may be used with pen and ink, brush and ink, pencil, and mixed media.

Pen-and-ink-paper. Generally, pen and ink drawing requires a smooth-surfaced, medium-weight paper. Many artists prefer a two-ply bristol, either plate or vellum surface, but any multipurpose paper will do. The smooth surface will ensure that the pen point does not snag and that the ink goes on smoothly without undesired spreading.

Brush-and-ink paper. For brush and ink, Japanese or Chinese rice, bamboo, or sumi papers are often used since they absorb ink evenly to allow a minimum of uncontrolled spreading. However, very expressive effects can be achieved by using a dry brush or washes over a **toothier,** less absorbent surface. For this type of work, we recommend a rough-textured watercolor paper or a fairly heavy drawing paper. These will absorb water reasonably well with a minimum of buckling.

Charcoal

Four standard types of charcoal are currently available: vine, compressed charcoal, charcoal pencil, and powdered charcoal. Each has specific uses, merits, and problems.

Figure 1.5
Vine charcoal

Courtesy of Charrette, Cambridge, Mass.

Vine (see Figure 1.5) is the natural charcoal, made from straight beech, bass, or willow twigs, which have been kiln-fired until all the organic material is burned away and only pure carbon remains. Each stick is about 4 inches long and 1/4 inch to 1/2 inch wide. Vine is manufactured in four degrees of hardness, from "very soft" to "hard." The softer forms blend easily and may be used for carefully modeled renderings, but building rich, dark values is difficult. All styles are excellent for quick loose sketches, although it should be noted that hard vine will not adhere to smooth newsprint paper.

Vine charcoal has been used by artists for hundreds of years to do **cartoons** for **frescoes,** preliminary sketches for paintings, portraits, and figure studies. It can be blended easily with finger, paper stomp, or chamois cloth, or quickly erased with chamois or kneaded eraser. This quality of erasability, however, also presents certain problems, since charcoal lines may be eradicated by an accidental swipe of the hand or smudged or smeared through careless handling. To pre-

Figure 1.4
Watercolor paper stretched over a drawing board

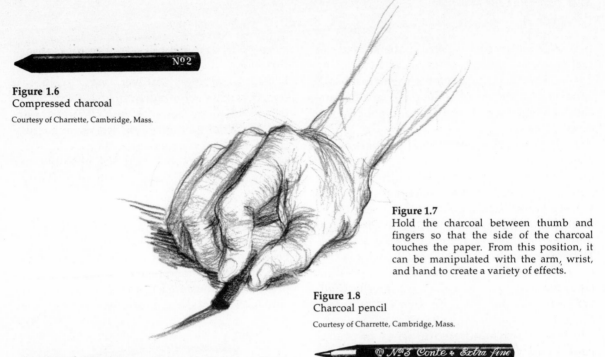

Figure 1.6
Compressed charcoal

Courtesy of Charrette, Cambridge, Mass.

Figure 1.7
Hold the charcoal between thumb and fingers so that the side of the charcoal touches the paper. From this position, it can be manipulated with the arm, wrist, and hand to create a variety of effects.

Figure 1.8
Charcoal pencil

Courtesy of Charrette, Cambridge, Mass.

serve a drawing, it is necessary to spray it repeatedly with fixative.*

Compressed charcoal (see Figure 1.6), made by powdering the vine charcoal and compressing it with a binder, offers a much wider range of values than vine and tends to be somewhat more permanent and resistant to smudges. Sticks are either round, like chalk, or square, and range from #.00, which is very soft and produces a rich, black mark, to #5, which is hard and makes a much lighter line. Compressed charcoal does not blend as easily as vine; however, with skillful handling, the softer forms (#.00 to #2) can produce a variety of lines, textures, and values. Because of these qualities, many instructors recommend compressed charcoal as one of the best materials for beginning and intermediate students. It lends itself to both quick sketches and long studies (see Figure 1.7).

Charcoal pencil (see Figure 1.8) is simply compressed charcoal in pencil form. It is much neater than other types, but it is also limited because only the point can be used for drawing. Pencils are either bound in wood, which can be sharpened with a knife† or

*Fixative alone cannot solve the problem of "offset," in which a charcoal or pastel drawing rubs off on the facing page of a sketchbook. To protect your drawings, either remove them from the sketchbook or place a protective sheet over them after spraying with fixative. (See section on fixative under Accessories in this chapter.)

†Pencil sharpeners often break the tip and wear down charcoal and other soft lead pencils too quickly.

wrapped in paper that can be unwound as the charcoal wears away.

Powdered charcoal can be used for tracing or for shaded backgrounds. It comes in a can and may be sprinkled on the desired area and then spread with chamois or fingers. You may experiment by spreading powdered charcoal over a drawing surface and then erasing into it. In this way, forms are revealed in areas of light against dark, and lines are used only to clarify shapes and add details.

Pencils

There are dozens of types of pencils with as many uses (Figure 1.9). Any pencil can be applied to drawing and each has particular qualities that may influence or reflect an artist's style. Soft graphite, carbon pencil, conté, eb-

Figure 1.9
A variety of pencils

Courtesy of Charrette, Cambridge, Mass.

ony, and lithographic pencils lend themselves well to loose, spontaneous drawing. Hard graphite and mechanical pencils tend to be used for detailed renderings and yield a lighter, finer line than the softer pencils; because of this light, fine line, values must be built up gradually by cross-hatching or other shading techniques.

Standard drawing pencils are listed according to degree of hardness. The softer pencils are referred to as "B" and range from 1B to 6B (the softest). Hard pencils are referred to as "H" and range from 1H to 9H (the hardest). HB, the middle grade pencil, is about as hard as a standard #2 writing pencil.

For most of the exercises in this book, we recommend the use of a soft lead pencil (2B to 4B) due to its responsiveness to the varying pressures that can produce dark or light areas, broad or narrow lines. In addition, soft pencils require less pressure than harder pencils, and thus may be used with less tension.

Because most people have used pencils since childhood, they remain our most familiar drawing tool. But with this familiarity comes an inherent problem. When people are taught to write, they develop habits of holding pen or pencil that are appropriate for writing, not always for drawing. The tensions of the hand and arm that help to provide the fine control necessary for writing are often unnecessary and inhibiting to spontaneous drawing. In most responsive drawing, the muscles of the arm, shoulder, and even the back should be used, leaving the hand relatively relaxed, except when adding fine details. The pencil may be held between the thumb and fingers like charcoal. In this position, it can be manipulated with greater freedom than if it is held the way it is for writing (see Figure 1.10). Although this may feel un-

Figure 1.10
How to hold a pencil. (A) By holding a pencil in this way, the hand can remain relaxed. The whole arm can be used to make the drawing, not just the hand and wrist. (B) This is the position that the pencil is normally held in. It is useful for writing and detailed drawings, which demand precision and control. This position is inhibiting to loose, expressive drawing since only the point is used and the small muscles of the hand must control the drawing action.

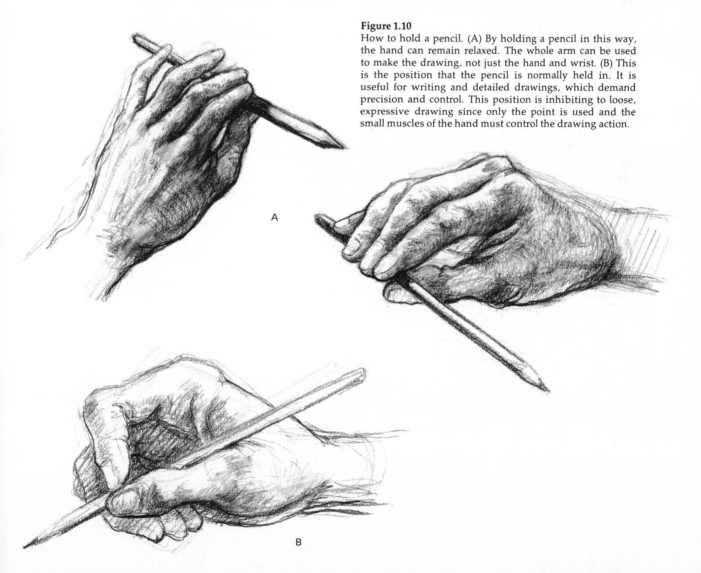

comfortable at first, stay with it. Learning the correct form in any new endeavor, whether holding a tennis racket or learning fingering positions for the piano, is always awkward in the beginning. But it is necessary if competence is to be gained. For fine or controlled drawing, hold the pencil as you would for writing.

CONTÉ CRAYONS AND PENCILS

For centuries, drawings have been done with a reddish chalk called *sanguine.* Today this name is synonymous with *conté crayon,* Conté a Paris being the most popular producer of sanguine (see Figure 1.11). The consistency of conté is at once chalky and waxy. Like charcoal or charcoal pencil, it can be employed for fresh quick sketches or for carefully developed studies. The consistency allows it to adhere to any paper surface; however, with the medium and soft sticks, care must be taken to avoid smudging. This may be accomplished by keeping the side of your hand off the paper or by placing a smooth, thin sheet of white paper under your hand while working on the drawing.

Figure 1.11
Conté crayon

Courtesy of Charrette, Cambridge, Mass.

Conté pencils or sticks come in three degrees of hardness—#1, very hard, #2, medium, #3, soft. The colors range from earth oranges and reds to sanguine (Venetian red) and sepia (deep brown), as well as black and white.

Conté is erasable to a degree and can be used in combination with other materials, such as soft pencil, charcoal, and pen and ink.

LITHOGRAPHIC CRAYONS AND PENCILS

When you shop for art supplies, you will find lithographic crayons and pencils very much in evidence. These are used primarily for drawing on lithographic plates or stones. However, they are suitable for drawing and produce a mark similar to that made by a wax crayon, but far more permanent. Lithographic

crayons come in varying degrees of hardness and can produce a wide range of dark and light values and textural possibilities.

Chalks and Pastels

Chalks and pastels are made from natural pigments that are compressed with a binder into uniformly sized sticks. They may be coarse or fine in texture, hard or soft, oily or dry in consistency. The most common chalks are those used by children, which start out brightly colored but fade quickly because of the impermanence of the pigment.

Pastels are typically high quality, dry chalk with very permanent pigments. They come in an extraordinary assortment of colors and hues, and may be used loosely for sketching or carefully blended to achieve a richness of tone similar to that of an oil painting.*

It should be noted that this careful blending requires considerable skill and color sense, as overworked pastels usually fuse into a morass of grey and brown. Because of this maddening tendency, many artists using pastels today try to keep the colors as fresh as possible by applying them directly with a minimum of blending.† Pastels are often used for portrait, life drawing, and landscape. There are many acceptable brands of pastels on the market today. The standard Grumbacher and Rembrandt pastels are most popular. Grumbacher also makes soft pastels of the finest quality, comparable to those used by artists such as Degas. They sell for about $1 per stick and generally must be specially ordered.

Oil pastels, or *craypas,* are simply oil-based pastels that are slightly softer than dry pastels. They are oilier in consistency and do not blend as completely. Some students prefer them over dry pastels because they crumble less readily and are somewhat neater. However, they are limited in their uses.

*By fixing the pastels and drawing over the work, very **painterly** effects, like **scumbling,** may be achieved. This method of overlapping colors allowed Degas to achieve his glowing layered surfaces.

†If a pastel drawing is to be preserved, it must be matted and placed under glass to protect the colors from smearing.

Pen and Ink

The beginner may be ill at ease working with pen and ink, and the first drawings are often stiff and awkward. If one is at all hesitant about putting lines on paper, the permanent, crisp black mark of the pen can be all the more intimidating. As with watercolor, mistakes cannot be erased, so each line registers in the final image.

You can work expressively and spontaneously in pen and ink, but at first it requires a willingness to experiment, to take chances, and to make mistakes.

Reed-and-quill pens (Figure 1.12) have been used for drawing and writing for hundreds of years. These pens are available today and are sometimes used by artists and calligraphers for the richness and character of their lines.

Steel-point pens, which were introduced in the 1800s, have largely replaced reed-and-quill pens on the popular market. Steel pen points (Figure 1.13) come in hundreds of styles and widths, ranging from 1/60th of an inch to over 1 inch. Fine points are used for drawing, drafting, and map making.

Lettering pens (Figure 1.14) are often wider and have a round, straight, or angular tip. The best pens for drawing are the fine-pointed flexible pens that respond to differing degrees of pressure (see Figure 1.15 for pen-filling tech-

niques). They can produce lines of varying widths for expression, texture, and shadowing. Hunt produces many different pen points for fine line work. Their Crowquill tip, #102, is the most popular for drawing due to this flexibility.

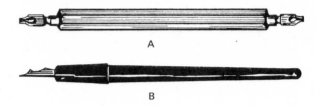

Figure 1.12
Steel-point pens and holders. (a) Lettering pen. (B) Crowquill pen

Courtesy of Charrette, Cambridge, Mass.

Figure 1.13
Hunt fine-line pen points

Courtesy of Charrette, Cambridge, Mass.

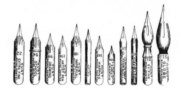

Figure 1.14
Lettering-pen point

Courtesy of Charrette, Cambridge, Mass.

Figure 1.15
To fill a drawing or lettering pen, apply the ink with the stopper rather than dipping the point into the bottle. In this way, you save ink, keep the point clean, and reduce drips caused by overloading the tip.

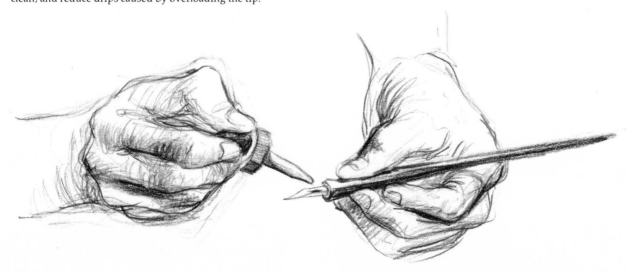

Mechanical pens, as well as felt-tipped pens, have a certain advantage over the common steel-tipped type in that they contain a self-enclosed ink cartridge and do not require constant dipping. As a result, the drawing action remains undisturbed. Also, the problem of accidentally spilled ink from an overloaded pen point or an upset ink bottle is virtually eliminated. Mechanical pens emit a constantly flowing line which cannot vary. It is possible to purchase pen tips that may produce a very fine line or tips that produce a heavy line, but the quality of line cannot be changed by increased or decreased pressure. This lack of variety in line quality severely limits the ability to produce certain types of textures, shadows, and lines. Pelican produces a good quality mechanical pen that is versatile, but it requires some breaking in. Faber-Castel has an excellent pen that can supposedly use any type of ink without clogging. Rapidographs (Figure 1.16), which are the most popular, tend to clog unless cleaned frequently.

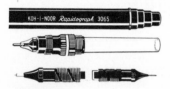

Figure 1.16
Rapidograph mechanical pen

Courtesy of Charrette, Cambridge, Mass.

Felt-tipped marking pens and fountain pens offer a much richer range of line qualities than mechanical pens, but their inks tend to be translucent and are subject to radical fading, unless marked "permanent."

Ballpoint pens are also limited in the quality of lines they can produce. Any of the pens mentioned here may be used effectively in drawing, however, and are certainly more convenient for on-the-spot sketching than the standard steel-point pen and ink bottle.

INKS

Inks available today may be translucent or opaque, and they come in various colors and tints. China and India (Figure 1.17) are the most widely used black inks since they are very opaque, yet fluid enough to spread evenly and easily. Most inks may be used directly or mixed with water to produce graduated wash effects.

Figure 1.17
India ink

Courtesy of Charrette, Cambridge, Mass.

Brush and Ink

Brush and ink can be a very enjoyable and expressive medium for a beginning or advanced student. Although most Oriental brush drawings communicate a tremendously disciplined, yet sensitive control, it is just as possible to work freely with a brush and achieve very exciting results. There are many techniques in brush drawing, which range from the fine Oriental **calligraphic** line to the slash and drip of **abstract expressionism.** Ink can be taken onto the brush directly from the bottle to produce a rich black line, combined with water for a wash, or slightly blotted to produce a dry brush or textured effect. The brush is far more flexible than a pen, so with a certain amount of control nearly any type of line or texture can be produced.

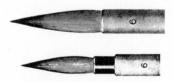

Figure 1.18
Medium-priced Japanese brushes, two styles

Courtesy of Charrette, Cambridge, Mass.

There are many types of brushes available. These range in price and quality from the cheap Japanese brush, which sells for about $1, to the rare horse, leopard, and fox hair brushes from China, which may sell for $30 each. For the beginner, we recommend the inexpensive Japanese bamboo brush with India ink and newsprint paper (see Figure

1.18). Have a container of water and several individual dishes available for diluting the ink to be used in washes. Experiment with the brush to create large and expressive shapes. Then try a smaller watercolor brush for fine lines and textures.

Hold the Japanese brush between thumb and fingers, as you hold a pencil for drawing (see the earlier section on Pencils). Hold the smaller detail brush as you would a pencil for writing so that it may be manipulated with the fingers.

Watercolors

Watercolors can be used like brush and ink, either directly or in a **wash** (Figure 1.19). They work very well in combination with pencil or

Figure 1.19
Watercolor brushes come in many different sizes, styles, and qualities.

Courtesy of Charrette, Cambridge, Mass.

Figure 1.20
Cake-type watercolor box

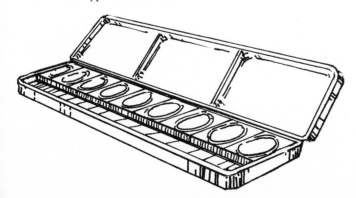

pen drawing to create large **tonal** areas, which may enhance the line, or for tints and shadows within the sketch. Used in this way, watercolor presents an easy introduction to the use of color. Although watercolors come in the more expensive tube form, we recommend a good quality "cake" type for those who are experimenting with the media* (see Figure 1.20).

Finger Paints

Like crayons, these can be a marvelously direct and effective medium. But most of all, they're fun. Finger paint colors are washable and nontoxic. They may be used on special finger painting paper, which has a smooth coating and no texture, or on watercolor paper; either alone or in combination with other materials, such as pencil, crayon, pastel, or ink.

Accessories

Materials other than paper and mediums that are an important part of drawing may be listed as accessories. We mention here only the most essential ones, those that should be a part of any artist's general equipment.

ERASERS

In a truly candid survey of drawing students, the eraser would probably rank with paper as the most essential material for drawing. However, while it does have genuine importance as a tool, the eraser is more often used as a crutch. Students are sometimes too quick to attack an error or rework an unsatisfactory area. Overconcern with correcting particular mistakes may deprive you of sufficient time to develop the rest of the drawing. Also, as a result of too much erasing, the work may be smeared and the paper surface damaged,

*If you are using tube watercolors and the caps are stuck, hold the tube upside down and place the cap (only) in very hot water for about 1 minute. This will expand the plastic and melt some of the solidified paint. The cap should then unscrew easily. This also works for oil paint tubes.

making the drawing impossible to complete.* Make your mistakes, but finish the drawing in spite of them, taking care not to repeat the error in the next attempt.

Although the primary function of an eraser is to eliminate marks, it also may be used to blend or soften pencil lines or shaded areas. There are several types of erasers. Experiment with them just as you would with any other materials. The best for eliminating mistakes are the kneaded, vinyl, and gum erasers.

Kneaded erasers (Figure 1.21) are soft and pliable and absorb graphite or charcoal. As one surface of the eraser becomes saturated, it can be kneaded with the fingers until a clean surface appears. The kneaded eraser also can be shaped to a point for erasing details and for making highlights in a charcoal, pastel, or pencil drawing. The nonabrasive texture will not damage the paper as stiffer erasers sometimes do.

Figure 1.21
Kneaded eraser

Figure 1.22
Art gum eraser

Courtesy of Charrette, Cambridge, Mass.

Art gum (Figure 1.22) is a dry rubber eraser that effectively removes pencil and charcoal. Gum erasers work well on most papers, but will not remove deeply embedded lines. They also tend to leave crumbs. Gum erasers will not smear a surface as readily as an unclean kneaded eraser will; however, you should always check the surface of any eraser before using it.

The more recently developed *vinyl eraser* (Figure 1.23) is excellent for eradicating pencil

lines, at the same time doing a minimum damage to the paper.

Figure 1.23
Vinyl eraser

Courtesy of Charrette, Cambridge, Mass.

Figure 1.24
Pink pearl eraser

Courtesy of Charrette, Cambridge, Mass.

The *pink pearl eraser* (Figure 1.24) is the most effective for blending or softening lines and shaded areas, but it will not erase as thoroughly as the others already mentioned. It is wedge-shaped with sharp edges on either end that may be used to eliminate certain lines without disturbing others. Either the edges or the flat surface may be used for blending or softening. Simply use the eraser lightly, varying pressure according to how much you want to eliminate and how much you want to retain of the charcoal or graphite.

DRAWING BOARDS

Students often make the mistake of trying to use the cardboard backing of a tablet as a support for their paper. However, since these are not sufficiently thick or stiff to hold the paper on an easel, the tablet often falls or bends. Mount your paper on solid or plywood drawing boards, using metal clasps, masking tape, or tacks (Figure 1.25). By using a drawing board, the paper can be held on the lap, propped up against the back of a chair, or put on an easel. The firm, even backing provided by the board gives both support and stability.

Figure 1.25
Tacks, clasps, and clips hold the paper to the drawing board.

Courtesy of Charrette, Cambridge, Mass.

EASELS

Easels are wood or metal stands that hold a drawing pad or paper nearly vertical (Figure 1.26). When the paper is vertical, it is

*In many cases, erasing is not necessary. If your preparatory marks are light, you should be able to refine them by using darker lines. The original light lines, even if they are inaccurate, may reinforce and enrich the final, more distinctive marks.

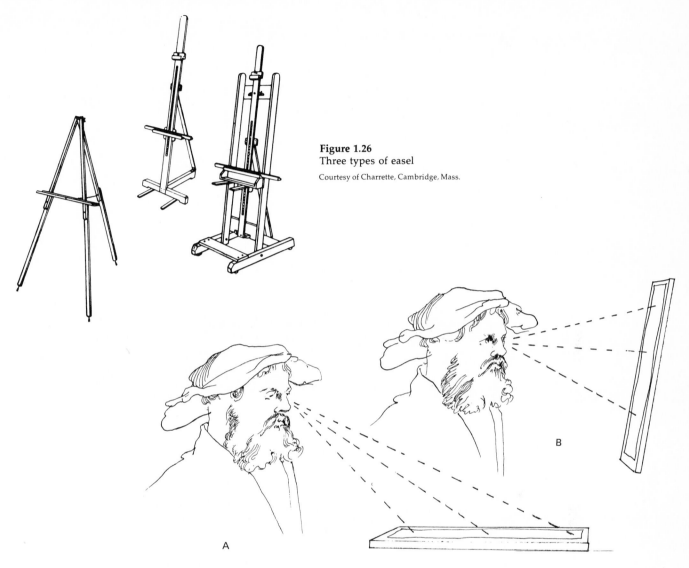

Figure 1.26
Three types of easel
Courtesy of Charrette, Cambridge, Mass.

Figure 1.27
Perspective distortion occurs when drawing paper is held on a horizontal surface. (A) illustrates three different perspectives possible on a horizontal drawing board. (B) shows an equal visual distance at all points of the drawing.

on a parallel plane with the subject matter, so it becomes easy to look back and forth from subject to drawing, and there is less chance for perceptual distortion than if the paper is held flat. In addition, the use of an easel encourages the student to draw from the shoulder, using the whole arm rather than just the hand and wrist. Adjust the easel so that your eye is a little above the middle of the paper, and place the easel so that to look at your subject you need only turn your eyes and not your whole head (see Figure 1.27).

Figure 1.28
Tortillon, or stomp
Courtesy of Charrette, Cambridge, Mass.

STOMPS OR TORTILLONS

Stomps are sticks used for blending pastel, chalk, and charcoal (Figure 1.28). They are made of wrapped paper twisted into the shape of a pencil. The point can be used to control and limit the shape of the blended

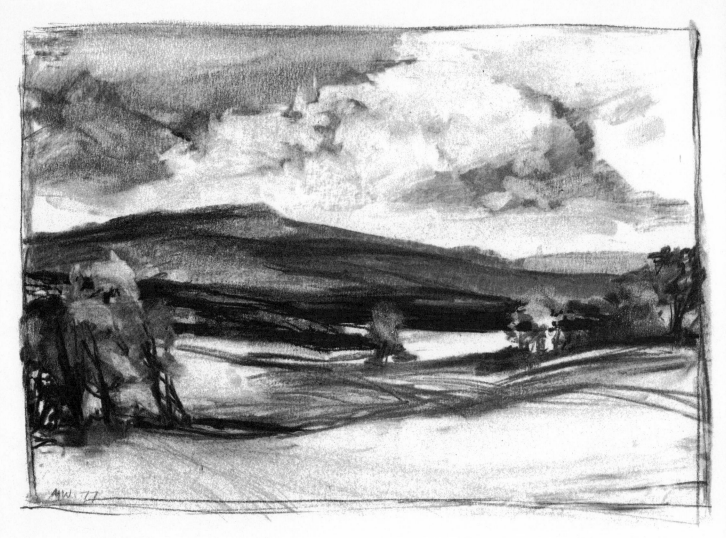

Figure 1.29
Landscape sketch in vine charcoal

areas and to vary the degree of shadow. Although stomps have a lingering bad reputation left over from the nineteenth-century academic practice of laborious rendering, they can be used with freshness and vitality.

CHAMOIS

The same soft pliable leather cloth used to dry your car also can be used to eliminate or blend charcoal or pastel.

FIXATIVE

This is a spray used to bind and protect a drawing done in pencil, charcoal, or pastel, all of which smudge easily. Unless a drawing in these materials is matted (to separate it from the glass) and framed immediately, fixative must be applied as soon as possible.* Fixatives are generally designated as "workable," which can be used and drawn over intermittently in the process of doing a drawing, or "final" or "finished," used when the drawing has been completed.

Although fixative is available in an inexpensive liquid form that is applied with a blower, most people prefer the easier-to-use aerosol spray. Even with the aerosol, however, precautions must be taken. Before spraying,

*Fixative is limited in its effectiveness, so drawings should still be handled with great care to avoid smudges.

check the fixative on another piece of paper to be certain that the spray will come out in a fine mist, rather than in great destructive blobs. Also, use fixative only in a well-ventilated room or outside on a calm day. *Do not use it in a classroom or populated area* since the spray can be harmful.

Hold the can about 1 foot from a vertically mounted drawing, and spray several light coats, allowing 10 to 15 minutes drying time between coats.

The shelf life of an aerosol fixative is about 6 to 12 months. Blair No Odor Spray Fixative seems to work well both as a "workable" and a "finished" fixative.

CLAY

Working with clay can help you to understand three-dimensional form so necessary to a convincing drawing. Use an oil-based clay, such as plasteline, which does not dry out and may be reused.

RULER, TRIANGLE, T-SQUARE, OR COMPASS (FIGURE 1.30)

These are helpful for accurate renderings or perspective drawing, but are naturally inhibiting for more expressive work. Relatively straight lines or well-formed shapes are easy to make despite the common complaint of beginning students, "I can't draw a" We feel that rulers and technical equipment should be employed only in work where precision is essential.

Figure 1.30
T-squares and compass

Courtesy of Charrette, Cambridge, Mass.

MASKING TAPE

Because of its easy availability, masking tape is used for a variety of drawing needs, from holding down paper to matting. If used and removed carefully and immediately, it works well in a first-aid capacity, but masking tape should not be left on a drawing and should never be used in serious matting. It corrodes the paper and itself becomes dried and brittle, often causing drawings to drop from their mats during the summer. Linen tape, a fine quality, noncorrosive tape, should be employed for matting and framing.

MATTING AND FRAMING

The best way to insure the safety of your drawings is to mat them and frame them under glass (see Figure 1.31). To mat the picture,

Figure 1.31
Matted picture with wider bottom margin

use a large piece of white or colored mat board, available at art supply stores. The mat serves to enhance the image while protecting the picture surface by recessing it away from the glass of a frame. The best mat boards are made of 100 percent rag paper. Although more expensive, these will not corrode the drawing over time as a standard wood pulp mat will.

Matting may be purchased precut in standard sizes from an art supply store or cut to order at a gallery or frame shop. Cutting a mat yourself requires the skillful use of a mat knife and very careful measuring. If you choose to cut the mat yourself, this is the procedure to follow:

1. You will need the following materials:

• mat board
• mat knife (Figure 1.32)

• Dexter mat cutter (Figure 1.33) or Exacto mat cutter

 • pencil
 • yardstick
 • metal T-square
 • linen tape
 • cutting surface

Figure 1.32
Mat knife

Courtesy of Charrette, Cambridge, Mass.

Figure 1.33
Dexter mat cutter

Courtesy of Charrette, Cambridge, Mass.

A mat knife is a large-handled metal knife with a sharp, removable blade. It is used by pulling it toward you, following the edge of the ruler or T-square. The Dexter mat cutter is a device shaped and used something like a carpenter's plane. Designed specifically for the purpose, it is much easier to control than the mat knife. In addition, its blade is on a swivel and can be set either vertical or diagonal to give a beveled edge. The mat cutter is pushed rather than pulled along the edge of the T-square. *Note:* Always hold the T-square securely on the mat board as you cut along its edge. Make sure your cut is clean and precise the first time. A damaged edge can not be repaired.

2. Measure the image area you wish to frame. This does not necessarily mean the area of the whole drawing. You can use selective **cropping** to enhance your composition.* If you choose to frame the whole drawing, it may be necessary to leave a little space around the edge of the image to avoid crowding it.

3. Measure a section of mat board large enough to border your image area on all sides. Standard border measurements are 2 1/2 to 3 inches on the top and sides and 3 to 3 1/2 inches on the bottom.† The extra 1/2 inch on the bottom generally helps to balance

*See Chapter Three, Still Life, for discussion of cropping and composition.

†Border sizes may be much larger or smaller, depending on personal preference and compositional requirements.

and support the picture image.* Always use the T-square to measure and cut your perpendicular lines.

4. Measure and cut the window (opening) in your mat. Be sure to make the window slightly smaller than the paper size you are framing (see Figure 1.34).

Figure 1.34
The beveled edge gives a more open and attractive mat.

5. There are two ways of putting the drawing in the mat.

• The first is to attach the drawing paper directly to the back of the cut mat board, making certain that the image is framed properly and using linen tape at the top edge and corners to secure the paper. Another piece of board, the size of the original mat, is then attached to the mat as a protective backing.

• The second, more professional, method is to make a hinge mat. In this method, the drawing is attached to a piece of rag board backing. The cut mat and the backing are then attached together at the top by a hinge made from linen tape (see Figure 1.35).

Figure 1.35
Hinge mat. Note that doubled tape supports the drawing paper.

*Because of our familiarity with gravity, we tend unconsciously to assign imagery a **"visual weight."** By allowing an extra 1/2 inch or 1 inch on the bottom of the mat, we insure that the framed image does not appear to be slipping downward.

6. If you do not intend to frame your picture under glass, place a sheet of clear acetate (a thin transparent plastic) over the picture and mat. The acetate should be .003–.005 inch thick and large enough to fold over the back of the mat. After it is folded, secure the edges and corners with tape. Be careful in folding the acetate since it is often brittle and cracks easily. Use a glue-on hook to hang it to the wall. This, of course, is not the recommended method for protecting valued artwork, but it will serve temporary purposes.

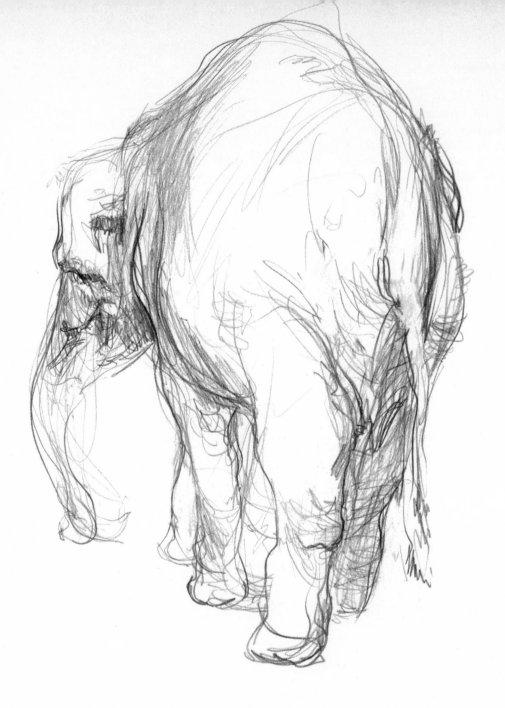

ANY DRAWING, whether it is realistic or abstract, simple or elaborate, is built of six primary elements: line, form, value, space, texture, and color (see Figure 2.1). These elements make up the language and tools of drawing, as well as the components of objective observation. In this chapter, you should become familiar with these elements and learn to apply them to make a drawing. At first you will probably use them in realistic representation. Once you have mastered them, however, they can be applied to make imaginative, abstract, or interpretive drawings and designs.

In this, the really creative aspect of drawing is born.

An artist's application of the drawing elements determines his or her **style.** One artist may choose to concentrate on certain types of line, another may be interested primarily in tones and textures. Each person, by nature, training, and purpose, utilizes the elements in a different way.

Elements are tools, used to shape a drawing. You might begin a drawing with the intention of using only one element and remain with this decision, or, during the course

CHAPTER TWO

The elements of drawing

of work on the drawing, it may become apparent that a new element must be introduced. For instance, a straight contour drawing might suddenly call for the use of some textural indications.

The process of drawing, then, is a growing and changing one, in which demands are constantly made on the artist to improve or develop one area, play down another.

It must be noted that even if an artist chooses to concentrate on the use of one element, all the others will be present in the drawing through suggestion. For purposes of

clarity in this chapter, we will discuss each element separately, but the reader should understand that they are all interrelated.

LINE

Line is the most familiar and versatile convention in drawing. It defines shapes, describes surfaces, and separates one form from another. In addition, different types of lines may suggest

Figure 2.1
WU CHI (Chinese, c. 1268)
Six Persimmons
Reproduced by permission of Ryoko-in, Daitokuji, Kyoto, Japan

The artist, in a meditative state, created this masterpiece, spontaneously incorporating all the drawing elements.

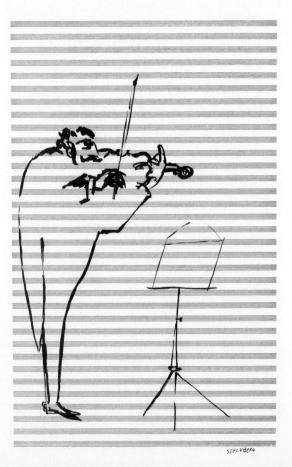

Figure 2.2
SAUL STEINBERG (American, 20th century)
The Violinist (india ink on music paper), 541 x 341 mm (21 5/16 x 13 7/16")
Courtesy of the Fogg Art Museum, Harvard University. Bequest of Grenville L. Winthrop

Steinberg uses the staff lines of the sheet music both as pattern and droll background for his whimsical line drawing.

textures, shadows, or structural qualities on the interior of a form. Every artist seems to have a personal approach to line, and as a result, we find a vast catalog of uses and qualities ranging from the precise edge of architectural perspective to the slashes and scribbles of abstract expressionism (see Figure 2.2).

To familiarize yourself with the function and application of these lines, we will, throughout the book, present exercises calling for the use of different "types" of line, including:

1. Gesture lines, quick scribbles or marks designed to show movement or action by flowing over and through the interior of a form or composition.

2. Lines of construction used to organize and simplify complex forms by reducing them to basic geometric shapes.

3. Contour or outline, which follows the outer edge of a form.

4. Cross contour, which passes over the interior surface of a form, defining its three-dimensional shape through modulation.

In this chapter we will further define and explain the various lines and their uses. Along with those already mentioned, we will also refer to lines used for shading, texture, and expression.

Gestural Line

One of the first functions the beginner must develop is the coordination of the hand and the eye. The use of gestural line stimulates this coordination by allowing the eye and hand to move rapidly, recognizing and defining forms, suggesting movement and action. By the quick, fluid indication of shapes, gesture drawing helps the student to recognize the overall design of the subject matter, and does not allow overinvolvement with superficial details until the basic form and design have been determined. This follows the natural scanning movement of the eye.

Gesture is especially important in figure drawing, and most sessions with a model begin with a series of one-or two-minute gestural sketches. These not only help to "loosen you up," but also to establish a sense of ac-

tion and vitality that should be carried into longer poses.

Gesture also may be used in still life and landscape as an undersketch for a longer drawing, or for the development of a compositional design (Figure 2.3A).

Construction Line

Lines of construction (Figure 2.3B) are used to define objects and subjects in simple geometric terms. They are, in some ways, an extension and refinement of the gesture line in that they organize designs and forms, allowing you to seek out and identify basic shapes before details can be seen. Although gesture is often a scribble, construction lines have to be somewhat more controlled.

We will be using lines of construction throughout this book to enclose complex shapes in simpler geometric ones so that their proportions and design can be seen and drawn more easily. Besides enclosing single objects, construction lines can compose and organize entire still lifes, figures, and landscapes; and then define, in simple terms, the shapes within the whole. Construction lines may simplify forms in terms of two-dimensional shapes (triangles, rectangles, or circles), or three-dimensional shapes (cubes, pyramids, cones, or spheres). In defining three-dimensional shapes, construction lines also may become lines of perspective, which indicate how forms recede into space.

Other types of construction lines that are not strictly geometrical may be used to simplify and explain complicated forms and compositions by uniting apparently separate parts. These are similar to gesture lines in that they follow the movement of the eye from one area to another. In creating a composition, we will use these lines to organize the forms and direct the viewer's eye to different areas of interest. (For more information on this type of line, see Chapter Nine, Composition.)

Contour Line

The contour or outline (Figure 2.3C) follows the edge of a form. Beginners often gravitate toward this line because it is easy to see or

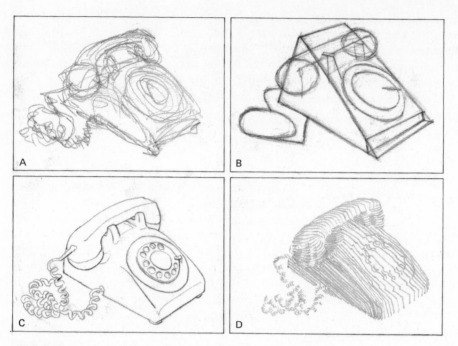

Figure 2.3
Different types of lines describe particular qualities of a telephone. (A) Gesture line. (B) Construction lines. (C) Contour lines. (D) Cross-contour lines.

because they are not aware of other possibilities. However, the effective use of contour is a more advanced problem. Besides following the edge of a form, contour can, by its **quality,** describe structure, surface textures, and value patterns and can establish points of emphasis and interest. Contour lines may be smooth and flowing, short and choppy, dark, light, broad, or narrow. Each type of line serves a different purpose: a gray line may suggest a shadow, a faded line may appear to recede, a black line among lighter ones may serve as a point of emphasis.

Cross Contour Line

Contour lines not only follow the outside edges of shapes, but also may be used around the edges of interior forms. Cross contour (Figure 2.3D) lines are an extension and grouping of these interior lines, which not only follow the edge, but also move across the surface of a form to describe its structure. Many times these lines are placed closely together to make a pattern across the surface

that may be read as texture or shadow. Variations in darkness or breadth of cross contour lines further enhance these effects.

Lines for Shading

Besides the varied contour and cross contour lines, many other lines and line patterns have been developed to create shading effects. One, called *hatching* or parallel line shading, con-

Figure 2.4
Hatched lines

Figure 2.5
Cross-hatched lines form pattern, value, and space.

Figure 2.6
Early Renaissance cross-hatching approach to drapery. This method still forms the foundation for much contemporary pen technique.

sists of closely placed parallel lines running as diagonals, verticals or horizontals across a surface (Figure 2.4). Due to their closeness, they are read as a pattern rather than as separate lines. To describe the change in value from one shadowed area to another, the lines can be varied in density and darkness.

Cross hatching (Figure 2.5), another type of linear shading, is simply the overlapping of parallel lines at different angles. Values are built up by adding layers of these sets of parallels. This technique is especially useful in pen and ink work and in fine line pencil drawing (see Figure 2.6).

Lines used for texture and expression will be discussed later in this chapter under Textures.

Exercise 1

LINES

(Time: 1–15 minutes each; material: soft pencil)

Do several drawings of familiar objects using the different types of lines described in this section. Begin by drawing the object using gestural lines, then construction, contour, and cross contour. Then try shading your contour drawing. (See Figure 2.7.)

Figure 2.7
Examples of line qualities—darkness, width, direction, and speed. These qualities will come to life only when lines are placed in active relationship to one another in a drawing.

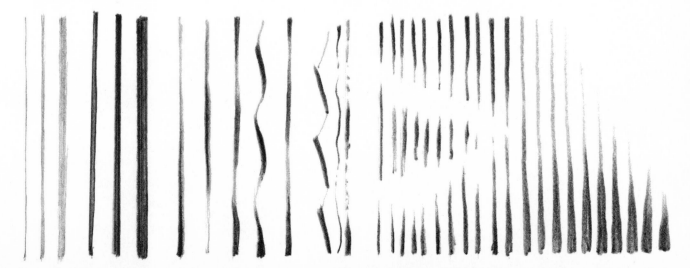

FORM

Form refers to the shape of objects as well as to the shapes used in abstract design. Form is the artist's way of thinking and means of visualization. Lines as such do not exist in nature, but are tools invented by the artist to indicate form.

When working from nature, the artist learns to identify and represent what he or she sees in terms of simple forms. With only a small stretch of the imagination, most shapes found in nature could be fitted comfortably into one of these structures: the rectangle, the cube, the circle or sphere, the cylinder, triangle, and pyramid. Any object can be seen as composed of these basic shapes or combinations or variations of them. The hand can be seen as a block, a mountain as a pyramid or triangle.

Often students do not recognize these simple structural shapes and feel overwhelmed by the complexity and diversity of nature. They become distracted by the details and fail to see indications of masses and forms that underlie, support, and give meaning to the superficial characteristics. To draw accurately, however, details must be ignored in favor of seeing the major shapes that structure the form.

In each section of this book, we will stress this type of geometric simplification as applied to different subjects. Once it is understood, you will find that you can draw anything. Complicated still lifes can be seen through a basic geometric format. The model in a different pose may be understood first as a block, cylinder, or sphere; then reduced to simple patterns of structural forms with appropriate shading before surface details are added. Once basic forms have been established, textures, colors, and values may be introduced with confidence (see Figure 2.8).

To begin the study of form, we recommend certain exercises that should help you to recognize basic shapes and to understand their nature.

Figure 2.8
Forms of differing shapes are revealed by the play of light across the surface. Planes have a general shadow cast over the whole surface. Note, however, that the shadows change subtly as they pass from the edge to the interior of the plane. On the circular shapes—sphere, cylinder, and cone—the play of light gradations is more obvious. The highlighted area on the sphere and cone fades into the background. This "disappearing edge," as it is called, helps to reinforce the relationship of the object to the entire space of the drawing and also tends to balance the heavy dark of the shadowed edge.

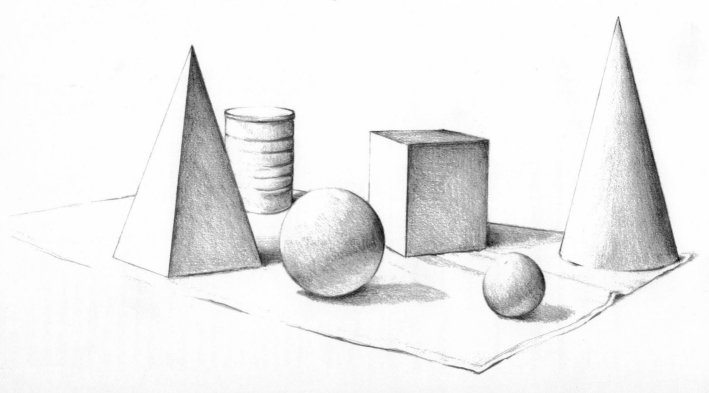

Figure 2.9
GEORGES SEURAT (French, 1859–1891)
A la Gaîte Rochechouart (or *Cafe Concert*)
(conté crayon and white lead paint), 307 x
234 mm. (12 1/8 x 9 1/4")

Courtesy of the Fogg Art Museum, Harvard University.
Bequest of Grenville L. Winthrop

The use of tones in this drawing defines
forms, creates space, and establishes a
mood. The textural effect is the result of
the grainy tooth of the paper.

Exercise 2

SIMPLE SHAPES
(Time: 10–15 minutes; material: soft pencil)

*Look around your home to find diverse and complex
forms and try to see them as simple geometric shapes.
Draw these, first delineating the basic geometric shape
and then noting how the form of the piece appears
within it.*

Exercise 3

FORM, LIGHT, AND POSITION
(Time: 30 minutes; material: soft pencil or vine charcoal)

*Find a box or construct a cube out of cardboard, and
paint it white. Do the same with a cylinder, a sphere,
and a cone. Place these forms on a white tablecloth
and shine a bright light on them. Leave the rest of the
room more or less in shadow. Notice how the form is
revealed in the play of light and dark upon the sur-
face. Also observe how, in all but the sphere, the form
changes shape subtly as you move around it. We are
often too quick to identify a form without noticing*
*these subtle changes caused by perspective and light-
ing. Draw these forms just as you see them, paying
careful attention to the shape of the form and the light
and shadows that fall upon it.*

*Then change the lighting and the position of the
forms. Do new drawings of the same forms to see how
light and position change the nature of the forms. Un-
der certain lighting conditions and viewing positions,
the forms may change considerably in appearance. A
cylinder might look like a circle when seen from the
top, or a rectangle when seen from the side. Learn to
recognize three dimensionality through values and per-
spective. See what view and lighting best reveal the
true nature of the three-dimensional form.*

VALUE

Exercise 3 leads to the third primary ele-
ment—value. Value refers to the use of light
and dark in a drawing (see Figure 2.9). The

43

subtle or abrupt changes in tones from black to white are one of the chief means of determining the three-dimensional nature in forms in space. We recognize roundness in the modulated shadows, the gradual shift from dark to light on the surface of the cylinder or sphere, flatness in the distinctly shaded planes, and sharp value contrasts on the pyramid or cube.

Although most forms are not as obvious and easy to read as the sphere, cube, or cylinder, combinations or variations of basic value patterns generally can be recognized. Intricately modeled surfaces are also revealed by subtle or broad value distinctions, and it is quite possible to render accurate drawings of a three-dimensional object using only shadow and light, without the use of line. However, it is generally helpful in the beginning to seek out simple value patterns to help structure and organize more complex forms.

This is a classic exercise for learning to render values. Although you may not wish to draw an egg on your own, the egg shape appears frequently in the human figure and in other complex shapes. The same shading principles used in drawing the egg may be applied when drawing similar forms.

This principle underlies all value exercises: once basic forms or value structures have been mastered, they can be applied in hundreds of different situations. Gradations of light and shade on the "egg" shapes of the human rib cage or upper forearm are the same as those found on an egg (see Figure 2.10).

Continue Exercise 4 by drawing the egg from several different positions, and arranging the lighting in several different ways so that when you see an egg shape appearing in another subject, you will have had experience in rendering the basic form and will be able to seek out similar elements of shape and value.

Exercise 4

FORM WITHOUT LINE
(Time: 30 minutes; material: soft pencil or vine charcoal)

Place an egg on a white sheet. Shine a bright light on it from above, in front, and slightly to one side. Then draw the egg, considerably larger than life, carefully indicating all the gradations of light and shadow on both the egg and the sheet, using no lines whatsoever.

Exercise 5

MULTISIDED FIGURES
(Time: 20–30 minutes; material: soft pencil or vine charcoal)

Find or construct a multisided figure with 8 or more surfaces. Then draw the form showing the varied qualities of light that fall on each plane. Note how this light might not be solid, but may change subtly as it moves across the surface of each plane.

Figure 2.10
The egg, delineated in tones. Notice the reflected light, the highlight, and the cast shadow.

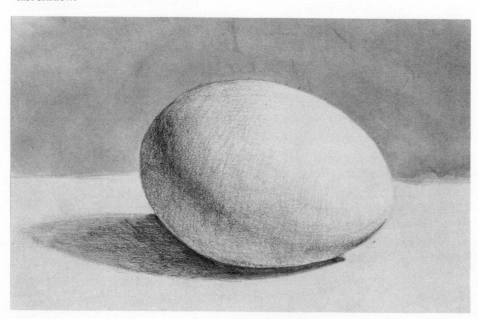

Exercise 6

LIGHT AND SHADOW
(No drawing)

Look for lights and shadows wherever you are: on the surfaces of sculpture, across a lawn in late afternoon sunlight, on people's faces. Try to observe shadows and light rather than objects themselves. This exercise calls for a relaxed mind, almost an absence of thought. Don't identify what you are seeing, simply see it. It may be helpful to squint as you look at shadows so that they become more distinct. This helps to bunch shadows into definite shapes so that they can be seen more objectively.

As you become more familiar with the shadows, you will recognize the play of values within individual shadow shapes. Besides the basic flow of dark and light, there are three other distinctions that you should be aware of—highlight, reflected light, and cast shadow.

The *highlight* appears as a line or area of very bright light on the surface of a form just opposite the immediate light source. In drawing, this highlight may be emphasized by erasing into it, or "heightened" with white chalk, pastel, or conté crayon (particularly useful on tinted paper). The highlight often suggests the most forward moving part of the object.

Reflected light appears on the edge of a shadowed form because of the reflection of light off an adjoining plane. It is not as bright as the lighted area that comes directly from the source, and generally appears when a shadowed form is placed next to another dark surface. The use of reflected light helps to convey a sense of three dimensionality and sets the form off from other dark areas around it.

Cast shadows do not define the surface of a form. They are the dark shadow cast upon a surface by an object that stands between the surface and the light source. Cast shadows are very easy to see and draw. However, their use must be limited since their dark mass may appear as a blob or blotch, which will dominate the reading of the image and confuse the legibility of the underlying surface. To avoid this damaging effect, cast shadows must be softened or eliminated. Through experience you will learn that not all shadows are useful, and, consequently, you may choose to repre-

sent only those darks that add to the definition of a form and the composition of the picture. This could mean the elimination or playing down of one shadow, or the introduction of another. An artist may even completely change the light source of the picture to create a value pattern that will help to make shapes more convincing.

Values also may be used to create space and emphasis in a picture. Since dark areas generally recede and light ones come forward, you might set an area back by assigning it a dark tone, or bring another forward by bathing it in light. Rich blacks often draw the viewer's attention whereas gray may be used as a neutral tone. Neutrals are often of less descriptive importance than sharp dark and light contrasts, but they function as an important part of the design of the drawing.

Used in design, values can have as strong an impact on the viewer as the subject matter, although often on an unconscious level. Artists can use patterns of light and dark in a realistic or abstract picture to convey a sense of harmony or discord, excitement or calm, balance or imbalance. How we understand or relate emotionally to a work of art may well depend on the artist's conscious choice and arrangement of value patterns.

Dark and light also have character and personality that the artist may use to convey emotion. A scene immersed in shadow will read differently, perhaps more mysteriously, than the same scene in light.

SPACE

The word *space* can mean different things in relation to a drawing. It can refer to the sense of three-dimensional space suggested within the confines of the paper, or it can refer to the area that separates one form from another on the picture plane. An aspect of the second spatial delineation is often called *negative space, interspace,* or *background.* The observation of this space is an essential tool for enabling us to see forms objectively. A beginner often identifies a familiar object without examining its shapes and proportions carefully. In the resulting draw-

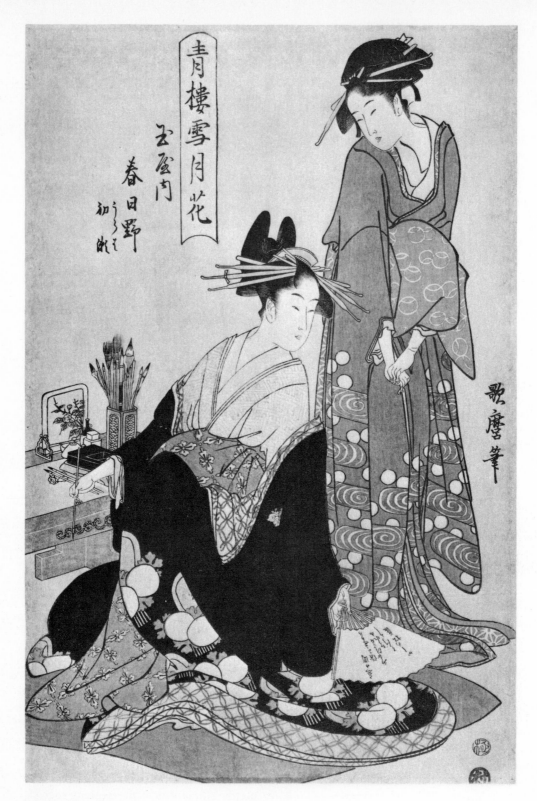

Figures 2.11 and 2.12
UTAMARO (Japanese, 1753–1806)
The Beauty Kasugano Inscribing a Fan Series; Seiro Setsu Gek-ka (block print)
Courtesy of the Museum of Fine Arts, Boston. Spaulding Collection

Japanese prints are noted for their masterful spatial design. Space is used here
to sculpturally define and separate shapes, but it also maintains an identity and
beauty of its own. The placement of calligraphy is planned to enhance the de-
sign of the image and to give meaning to the space it fills.

ing, the form may be distorted and proportionally incorrect. By combining the awareness of the form with the accurate observation of the shape of the surrounding space, it is possible to get a more objective understanding of the form to be drawn.

The manipulation of negative space is helpful, not only in rendering individual forms, but also in establishing a relationship between forms and in creating a composition (see Figures 2.11 and 2.12). Consequently, in each chapter of this book, we will include several exercises dealing with space, its observation and representation.

Figure 2.12

Exercise 7

THE SHAPE OF SPACE
(Time: 15–20 minutes; material: soft pencil)

In the section on form, you were asked to draw familiar objects with primary geometric shapes. In this exercise, you should first draw the geometric shape, and then, rather than draw the object itself, draw the shape of the space around the object. Look at this space very carefully. Try to see its angles, proportions, and exact shape. This is a process much like carving a block of marble. Imagine that you are cutting away all the extra marble so that a form will be revealed.

Exercise 8

NEGATIVE SPACE 1
(Time: 15–20 minutes; material: soft pencil)

Place two or more objects fairly close together. See the

geometric shape that would include both of them, and then carefully outline all the negative space between and around the shapes.

Exercise 9

NEGATIVE SPACE 2
(Time: 15–20 minutes; material: soft pencil)

Do the same thing with forms that are farther apart. Try to see the exact size and shape of the space involved.

Three-Dimensional Space

Many conventions have been used by artists to convey the impression of three-dimensional space. The most familiar is the system of **linear perspective** developed during the Renaissance. In this method, objects diminish in size as they move back in space, parallel lines meet at a vanishing point, and forms overlap when they are on the same visual path (see Figure 2.13).

Artists in ancient Egypt, the Orient, Medieval Europe, and among the American Indians have used a type of "tiered perspective" in which the lower sections of the drawing represented closer scenes and higher sections showed more distant scenes. Other types of perspective have been introduced by groups

Figure 2.13
The parallel lines in your room all lead to one point, the vanishing point. It is on the horizon line at your eye level.

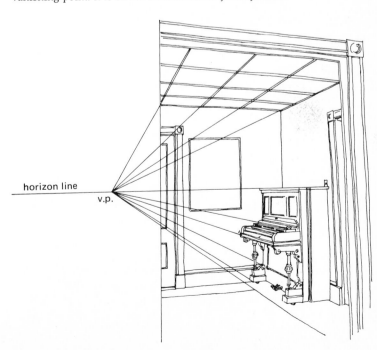

horizon line
v.p.

and individuals to serve specific purposes; particularly in the twentieth century many artists have abandoned traditional means to develop their own personal sense of pictorial space.

Of all the spatial possibilities, linear perspective seems to be the more natural and familiar form because it comes closer to what we see in objective observation.* There are certain rules and conventions of linear perspective that we will discuss in Chapter Four, Landscape. At this point, we simply suggest that you try to become familiar with the ways in which forms change shape as they are seen from different points of view, and how they diminish in size as they move away in space.

Lines above the eye level seem to go down as they recede, lines below the eye level seem to come up, and parallel lines on either side come toward the middle. Where do these lines meet?

Exercise 10

VANISHING POINTS
(No drawing)

Stand in a long room. Trace with your fingers the lines of the ceiling, walls, and floor as they move away from you in space. Continue along the same path until your fingers meet at a point. This is called the "vanishing point." Look for other lines that are parallel to the floor, walls, and ceiling lines. They will go to the same point.

Exercise 11

BASIC PERSPECTIVE
(Time: 15 minutes; material: soft pencil)

Draw a cube around a chair and try to see the angles of the lines at the top, bottom, and sides of the chair as they move away from you in space. If you are standing above the chair, these lines will seem to go up. See where they would meet if they were extended infinitely. Then remove the "negative" space so that the chair is revealed. Look within the chair for lines that would be parallel to the original lines of the cube; for instance, the lines of the seat, supports, arms, and so on. Take these lines back to the same point as the lines of the cube (see Figure 2.14).

*Linear perspective is predicated on the use of one eye rather than two. In normal vision we take in slightly different information from each eye, then collate this information to help us make accurate spatial judgments.

You may have noticed now that the vanishing point where parallel lines meet is at your eye level and right in front of your eyes as you look toward the horizon. This point is on the ideal **horizon** where the earth curves away from view.

Another type of "realistic" perspective is called **aerial perspective.** The principle behind aerial perspective is that forms, colors, details, and such become less distinct as they move away in space. This device is used in addition to linear perspective to establish a sense of space in a picture or for purposes of emphasis.

Those forms and lines that are muted and smaller than similar forms will appear to be farther away. If they are muted but not diminished in size, they will simply read as being of lesser importance. Bright colors, sharp lines, clear-cut details, and strong contrasts of light and dark come forward in space and attract the viewer's attention. These devices may be used to emphasize areas in single objects and also to create a sense of perspective and emphasis in a whole scene or composition.

Figure 2.14
First the box is drawn in perspective. Then the negative space is removed and the chair, in perspective, is revealed. From this angle, the top of the chair back is nearly at the viewer's eye level.

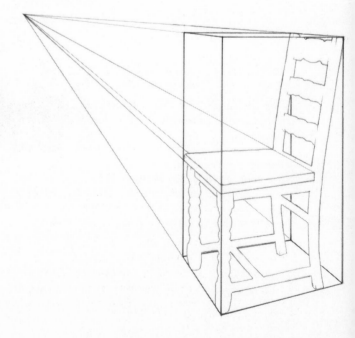

Figure 2.15
MANUEL RIVERA (Spanish, 20th century)
Untitled (pen and black ink, black wash
spattered through a stencil), 622 x 449 mm.
(24 1/2 x 17 11/16")
Courtesy of the Fogg Art Museum, Harvard University.
Gift of Fernando Zobel de Ayala

The artist shows how textural patterns
can suggest a meaning and mood even
in the absence of recognizable subject
matter.

Exercise 12

*LINE, VALUE, AND LOCATION
IN SPACE 1*
(Time: 30 minutes; material: soft pencil)

*Draw a series of the same simple object (such as or-
anges) in a row. Use strong, dark lines on some and
lighter, duller lines on others. Cover some in shadows
of various shades of gray, leave others light, make
some black. Then put the paper on the wall and see
which forms come forward and which recede.*

Exercise 13

*LINE, VALUE, AND LOCATION
IN SPACE 2*
(Time: 5–10 minutes; material: soft pencil)

*Do a line drawing of an orange or other object with a
simple shape. As you follow the edge of the form,
make some line sections light and others dark, some
broad and others narrow. Notice how the surface
seems to move back and forth, in and out of space as
the* **line quality** *varies.*

TEXTURE

The concept and observation of the fifth pri-
mary element—texture—really cannot be sepa-
rated from the other elements—line, value,
and form—for it is these that reveal textural
qualities to the eye (Figure 2.15). Patterns of
lines, light, and shade are read by the mind
through sensory memories and imagination as
having a certain textural quality. Artists learn
through experience which lines and value ele-
ments put together might signify a certain
kind of tactile experience.

It is not necessary to laboriously draw
every detail of a surface for it to disclose its
identity to the viewer. A few indications of
textures with intelligent editing may be suf-
ficient. For example, you do not have to draw
every cable stitch to characterize a cable knit
sweater. In fact, it is often better to suggest a

textural pattern over a part of a surface and allow the viewer's imagination to carry it across the whole form. In this way, the viewer becomes an active participant in the creative process.

In addition to tactile sensation, textures often contribute to the emotional content of a drawing and may suggest a meaning far more important than the subject matter. A wheat field by Van Gogh, for example, conveys a very different feeling than one done by Millet or Rembrandt.

In this sense, texture plays a big part in abstract art as well as representational art. Artists working abstractly will use texture to create designs, tactile sensations, and moods as does the realistic artist, but will simply leave more to the imagination of the viewer by eliminating the subject matter.

The best way to learn the use and function of line, value, and shape in creating textures and establishing moods is through the study of other artists and by experimentation with a variety of mediums (Figure 2.16).

Exercise 14

TEXTURAL QUALITIES
(No time limit; various mediums)

Draw different objects and forms, and try to describe their textural qualities. Use brush, pen, charcoal, pencil, and other drawing materials to discover their textural possibilities.

Figure 2.16
This pen-and-brush drawing utilizes hatching, cross-hatching, cross-contour scribbles, dots, and dry and wet brush techniques to create a variety of textural effects. Besides evoking a sun-dappled glade, the marks themselves stand as a strong abstract pattern.

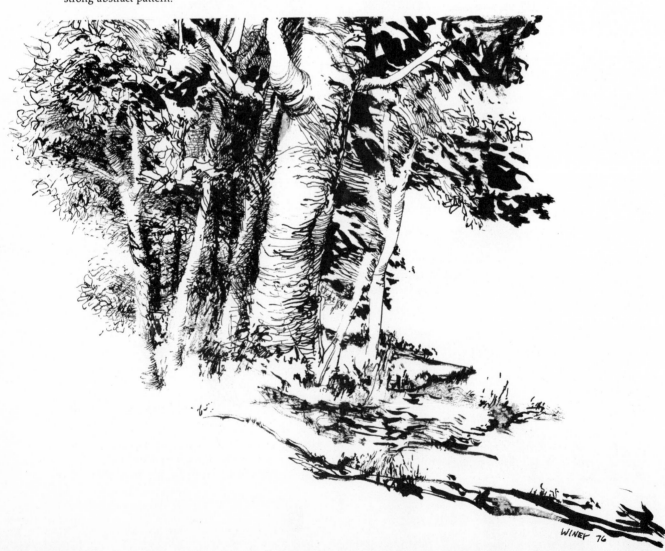

Experiment with various mediums in an abstract way. Try to use lines, forms, or textures that express certain emotions. For example, label one page "anger." Then try to use elements that express abstractly what anger is for you. It is not necessary to do this drawing when you are feeling angry. Do the same with "joy," "sorrow," and other emotions.

COLOR

Color may well be the most subjective element of all. Its potential as a drawing tool extends the artist's creative possibilities in all directions—defining forms, establishing values, textures, and space, stimulating the senses and the emotions, unifying **compositions.** The theory and practice of color use is, however, an advanced as well as a complex study, and within the scope of this book we can give only a brief introduction to the subject. Color usage will be discussed in many of the following chapters and applied to specific drawing problems.

Many students have an unreasoned anxiety about the use of color; however, one need only look at children's art to realize that it can be used naturally and spontaneously. Although individuals have widely differing sensitivity to color in nature and art, it is quite possible for anyone to learn to use it. We suggest that the hesitant beginner become reacquainted with color through experimentation —cautious and otherwise. These experiments could include such relatively safe techniques as tinting a drawing with watercolor washes, or the more adventurous use of colored markers, crayons, and even pastels (with a minimum of blending). The only way to overcome a fear of colors is to use them.

Before beginning experimentation with color, there are a few technical terms and principles that the student should know. First of all, what is color? Technically, color is composed of waves or impulses of light. If you have seen daylight through a prism or a rainbow, you observed a spectrum of colors, of hues—violet, blue, green, yellow, orange, and red. Each color is created by an impulse of a differing length; violet is the shortest, red is the longest. Of these hues, red, yellow, and blue are designated *primary* colors. They are basically pure hues. Green, orange, and violet, created by the mixture of these primary colors, are called *secondary* colors.

For a surface to appear as one color or another, it must reflect some color waves and absorb others. The exceptions to this rule are white, which reflects all colors and absorbs virtually none, and black, which absorbs all colors and reflects none.* A blue object, for instance, absorbs all the light impulses except those of a blue wavelength, which it reflects.

Usually surfaces reflect more than one color; as a result, few things are pure in hue. By the reflection of more than one color, differing tones register on a surface. If a surface reflects blue and yellow, and absorbs red, the result is green. The wide range of greens visible in our environment testifies to the fact that each surface reflects different amounts of blue and yellow, and may even reflect a bit of red. The introduction of this third primary color, in whatever small amount, produces a "neutralized," or *tertiary*, color.

Pigments used in drawing or painting are materials of either dry, semidry, or liquid consistency, which contain chemicals to absorb and reflect specific qualities of light. A pigment's closeness to pure color is referred to as its **saturation** level. Tertiary hues are colors dulled away from saturation by the introduction of a complementary color (see Figure 2.17).

Complementary refers to color that, when added to another, completes the color spectrum. Red is the complement of green because, by adding red to the blue-yellow combination, all colors are present. The larger the percentage of the complementary color used, the greater the neutralizing effect.

The neutral, brown, is produced by a more-or-less equal mixture of red, yellow, and blue. A slight increase in one of these colors changes the quality of brown. For example, an increase in yellow would produce a yellow-brown, or *ochre*. An increase in red produces *sienna*. Gray, produced by combining black

*Light turns to heat once absorbed. Light-colored or white clothes are worn during the summer because they reflect, rather than absorb, light.

and white, changes its character through the introduction of a primary color.

If the complement is introduced to the colors in a relatively small amount, the effect is to diminish the intensity (saturation) and perhaps to darken the color. The introduction of white neutralizes intensity and lightens. Black may be used to neutralize and darken, but it is usually avoided since it dulls and weakens other colors.

The subjectivity and relativity of color use comes, in part, from the fact that colors actually take life and impact from surrounding colors. This juxtaposition determines the color intensity and even affects its hue. The eye can visually blend juxtaposed colors to one degree or another. Seurat used this principle to develop *pointillism*, a style of painting in which small dabs of unblended colors are placed next to each other on a viewer's canvas. Viewers, standing at some distance, blend the color with their minds and eyes for an effect of shimmering sunlight.

Each color has a certain visual intensity in relation to other colors. Some colors naturally recede in space, others appear to come forward. The purer the color, generally, the more it advances with white, in its brilliance, in the front. More neutralized colors recede. The purer colors surrounded by neutrals stand out and attract attention.

Individual hues have relative weights and sensual values as well as spacial characteristics. Blues and greens, considered cool colors, appear to recede and rise when used in relation to other colors. Yellow and red are warm colors, which come forward, appear heavy, and give the impression of heat. These effects may be due to the color wavelength or to our associations, blue with the cool, receding sky, yellow with the sun, red with fire.

Although these are the usual reactions and associations to colors, they are not rules or recipes for color usage. Artists learn, through study and experience, to manipulate colors to convey meaning and mood to the viewer. Many of these effects may go against the above mentioned principles and still create an effective, even natural, image.

One way of using color in a general sense is to establish a certain **key,** a unifying color scheme that moves throughout a picture like a leitmotif in music. A bright, or high, key using primary and secondary colors may convey excitement; neutral, or low, key colors may seem more quiet, somber, or subdued.

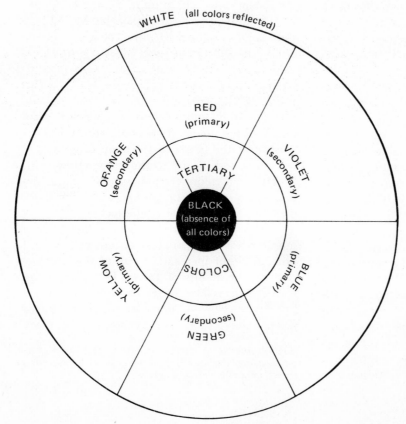

Figure 2.17
The color wheel illustrates primary, secondary, and tertiary colors. Tertiary colors are made by blending one color with its "complement" on the opposite side of the wheel.

Color serves a multitude of purposes in any given drawing—establishing value patterns, locating objects in space, describing surfaces, structuring compositions. It would be impossible here to cover its uses and possibilities adequately. Let us say simply that color may fulfill all the elemental functions in a drawing, but with the extra **chromatic** dimension. As you follow the exercises in this book, and continue to study color on your own, you will discover many unimagined problems and possibilities. As color is more fully integrated into the drawing process, however, the concern may begin to fall under the category of painting.

The distinction between a colored drawing and a painting can be ambiguous. The main determining factors are in the choice of materials and in the artist's apparent intention. A drawing often materializes a thought process in a spare manner that allows the viewer to share in the act; a painting may cover up the artist's creative footsteps.

Although the dry mediums (pastel, charcoal, and so on) are traditionally drawing materials, pastels can be layered to create an image closer in its essence to a painting. Likewise, watercolor, oil paints, and acrylics, primarily tools of the painter, can be used economically on paper to make a drawing. Don't worry about it—these distinctions are better left to aestheticians.

Exercise 16

BLENDING COLORS
(No time limit; material: cake-type watercolor assortment, watercolor paper and brushes)

Dilute your colors by adding water to lessen their brightness. Apply them to make a series of circular shapes using each of the primary colors next to each other on the page. After they dry, make other circular shapes that slightly overlap the first. Begin by using only the primary colors. As you overlap one with another, you will make a secondary color. By overlapping one color with the same color, you simply increase the intensity or darkness of the color. Continue to do this kind of overlapping, allowing each layer time to dry before adding the next. Introduce the secondary colors in your pallet. Use triple overlaps, and so on. Then use browns, white, and black to see their effects. Try blending the colors on your pallet before applying them. See how easy it is to get a brown?

Exercise 17

TINTS AND SHADES
(No time limit; material: pencil and watercolors)

Try using the wash, or watered-down colors, to tint a pencil drawing. Use the wash in both cooler and darker tints for shading. Use it both in the subject and in the background. You may find that neutral, or tertiary, colors make more effective backgrounds because they tend to recede, and purer colors make more effective foregrounds since they naturally advance.

Exercise 18

ABSTRACT DESIGNS
(No time limit; same materials)

Use the colors to make an abstract design. Use both shapes and lines in colors of varying intensities. Try to develop a predominant color scheme to help structure your image.

Exercise 19

MIXING WITH MARKERS
(No time limit; material: colored markers, crayons, and colored pencils)

Experiment with markers. Find those that are marked "permanent." (The authors have had good luck with Eagle Prismacolor markers and pencils. Both have bright, durable colors.) Use the markers like paint, applying them in large areas or lines as you prefer. Try blending the colors by overlapping. Sometimes the lighter tones can be used to fade and blend other colors. Markers like these are an excellent, safe introduction to color practice, lessening the trial-and-error uncertainty of color mixing found in other liquid mediums. Use the colored pencils and wax crayons in the same way, describing forms, making abstract patterns, blending by overlap. Try integrating these with the markers or using them in conjunction with pencil, ink, or watercolors.

Exercise 20

EXPERIMENTS WITH PASTELS
(No time limit; material: chalk, pastels, and conte crayon)

Do similar experiments with these dry mediums. Colors generally can be blended with the fingers or a stomp. We recommend, however, that you start out using them freshly with no blending at all. It is easy enough to ruin a color scheme by overlapping once too often, let alone by smearing all the colors together. If you decide to try blending, do it cautiously; first, two colors at a time, then more if you wish. Try fresh color application over a "fixed," blended area. You may mix these with other colored or black and white mediums to see what effects are possible.

THE ART OF STILL LIFE is the rediscovery and celebration of the familiar world. Subject matter is all around us—an old boot, a wine bottle, a grouping of shells, or an interior. Through the drawing process we learn to find new interest and magic in objects and environments we have taken for granted for years.

Still life as an art form came into its own in the sixteenth and seventeenth centuries. Prior to that time, the subject matter was studied primarily for scientific interest or as preparation for use in figurative compositions.

Dutch and Flemish artists were the first to cultivate and master the art embodied in everyday objects. Their elegantly draped tables, silver goblets, and bowls of glistening fruit can still dazzle our photographically sophisticated eyes. Since that period, still life has maintained its appeal. It is often the first subject that is drawn or painted by art students, and many go on to make it their primary concern.

Included among the subject matter found in still life are natural and man-made objects of almost any shape and function: bowls, tea-

CHAPTER THREE

Still life

pots, bicycles, shoes, tools, wagons, vegetables, flowers, fruit, scrap metal, boxes, birds' nests, shells, paper bags, stones, bones, baskets, clothing, roots, furniture, garbage cans, footballs. . . . Cézanne painted human skulls along with the familiar plaster casts and baskets of fruit. Rembrandt did studies of hanging carcasses of beef. Others chose to interpret pipes, plates of fish, or loaves of bread. Andy Warhol's ''Campbell Soup Cans'' may be classified as still life, as can Renoir's **impressionistic** flowers and many of Picasso's **cubist** collages. In this chapter we will work with forms traditionally found in still life to study principles of representation, proportion, perspective, and composition.

ABSTRACT TEXTURAL EXPERIMENTATION

There are many ways to draw and enjoy a still life; the simple act of looking and putting lines on paper is a reward in itself, even with-

Figure 3.1
KATSUSHIKA HOKUSAI (Japanese, 1760–1849)
Flowers in a Bowl (brush and ink)
Courtesy of the Museum of Fine Arts, Boston. Bigelow Collection

out a "satisfying finished product." Early drawings might take the form of a doodle, an explorative scribble or some roughly blocked-out shapes. These in turn may be developed into an abstract design or a more refined study as perceptions improve. If you wish to develop a method in which objects are represented naturalistically or accurately, however, you must begin by describing the three-dimensional form, then developing textures and values.

Before beginning the study of still life as such, familiarize yourself with the tonal and textural possibilities of your chosen mediums. Every medium offers different effects, and combinations of mediums expand the range of possibilities. Besides the list of materials and exercises presented here, you should try others on your own. First experiments with

texture should be loose and spontaneous; effects are often discovered by accident. Later on, try consciously to recreate various surfaces using the techniques developed in your experiments. Don't neglect to study works of professional artists. By copying their effects, you will vastly increase your textural vocabulary and options.

Exercise 1

CHARCOAL
(Time: 15 minutes; material: soft, compressed charcoal and newsprint)

In your first experiments with charcoal, do not draw anything recognizable. Rather, explore in an abstract way the range of values and line qualities inherent in the medium. Hold the charcoal flat on the page as described in Chapter One, and make marks from light gray to black. Make dotted or stippled lines; wavering,

intermingling lines; and so on. Then blend the charcoal with your fingers, erase into the blended marks, or draw over them (see Figure 3.2).

The first way to learn about texture is to experiment. When you make a pattern, try to imagine a real object whose surface resembles the pattern you have just drawn. Then apply the same technique when drawing that object.

Exercise 2

SOFT PENCIL

(Time: 20 minutes; material: soft pencil and medium quality drawing paper)

Try the same experiments described above with pencil, using a better quality paper so that the lighter lines will register more easily. Hold the pencil in the manner described in Chapter One, using both the flat side of the lead and the point. First experiment with values using varied pressure on the tip. You will find that you cannot get the dense, unreflective black of charcoal and must go over your marks several times to develop a deep, black tone. Try cross-hatching and other techniques to build value areas, then experiment with combinations of marks, lines, and tones to suggest different types of textures. You can use an eraser to soften your lines and tones, or try blending them with your fingers.

Figure 3.2

Figure 3.3

Exercise 3

BRUSH AND INK

*(Time: 20 minutes; material: Japanese brush, India ink,
and water in pans for washes, medium quality paper)*

*Japanese brush offers broad possibilities in line, value,
and texture. Use ink thinned with water to make a
continuous range of value changes, then experiment
with line and textural effects with both filled and dry
brush. Splatter the ink for a dappled effect or scrape
into it with a knife once it is dry. Try using brushes of
differing sizes and qualities, Chinese calligraphy or water-
color brushes, to extend your range of possibilities.*

Exercise 4

PEN AND INK

*(Time: 30 minutes or more; material: drawing pen
and India ink on good quality paper)*

*Pen techniques depend primarily upon the use of line
to build tones and textures. However, spontaneous ef-
fects can be achieved by splattering the ink, or rubbing
and scraping it once it is on the paper. If you feel
threatened by the technical difficulties of pen work and
the permanence of the mark, try spreading the ink
with your fingers or using an ink-dipped stick to make
blobs, dots, and scribbles. These same effects might be
used for textured surfaces later on. Then begin your
experimentation with hatching and cross-hatching
techniques. It will take practice before you can order
and space the lines evenly. Try varying the width and*

quality of your line, using **stippling** *effects and so on.
Early efforts may feel awkward, but once proficiency is
gained, the pen can be used spontaneously and ex-
pressively.*

THE STUDY OF FORM: PERSPECTIVE AND PROPORTIONS

Knowledge of perspective and proportions is
essential in any naturalistic drawing or
painting problems. After learning the basic
principles involved using simple still life
forms, you can apply these same principles to
render and design the more complex shapes
found in landscape, figure, architectural, and
mechanical drawings.

The Basic Form

To begin your study, choose a form, such as
an apple, which can be easily repeated. Hope-
fully, the simplified rendering of the object
will not distract your attention from the exer-
cises (see Figure 3.4).

Figure 3.4

Figure 3.5

Exercise 5

SHAPE

(Time: 15 minutes; material: soft pencil or compressed charcoal, apple or other simple shape for subject)

Draw your subject from various viewpoints to become familiar with its shape. Try to discover a simple way of representing it.

Exercise 6

SPATIAL INTERVALS
(Time: 10 minutes; material: soft pencil or compressed charcoal)

Take several of the same objects and arrange them in a row. View them looking straight on so that all objects are approximately the same distance away from you. Add another row of similar objects behind and parallel to the first. You will notice that the row in back is higher than the one in front. Objects may overlap one another or appear above or below, depending on the vantage point. You will also note that forms in the second row are smaller and closer together. Add a third row behind the second, and draw all three from the front, carefully checking the negative space in between them. Judge also the difference in size of the objects in the three rows. The farther apart the rows, the greater the apparent size difference. Use your fingers or the end of your pencil as shown to measure and compare the sizes (see Figures 3.6a–g).

After Exercise 6, you may be surprised at how much difference in size there really is. When judging similar objects at different spatial intervals, we recognize them without considering their visual size (see Figure 3.6). In a drawing, however, a viewer consciously or unconsciously depends on changes in size and placement as indications of distance, so these measurements must be fairly accurate.

To see the graduated proportional

Figures 3.6 A–G
You can use your drawing tools as aids to determine angles, tilts, placements, and alignments. This kind of measurement works not only for still life, but for any drawing problem, whether figure, landscape, or perspective. By holding your pencil vertically, you can measure the degree that an object slants (A,D). Simply observe the shape of the space between the set vertical of your pencil and the "lean" of the object (C). Then reproduce this same angle on your paper.

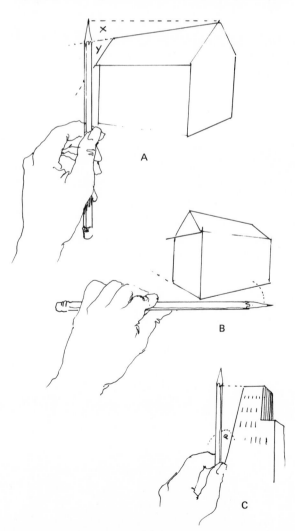

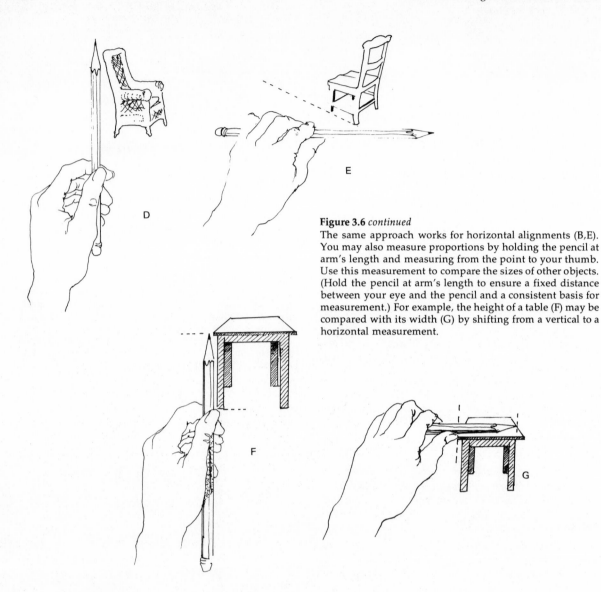

Figure 3.6 *continued*
The same approach works for horizontal alignments (B,E).
You may also measure proportions by holding the pencil at
arm's length and measuring from the point to your thumb.
Use this measurement to compare the sizes of other objects.
(Hold the pencil at arm's length to ensure a fixed distance
between your eye and the pencil and a consistent basis for
measurement.) For example, the height of a table (F) may be
compared with its width (G) by shifting from a vertical to a
horizontal measurement.

changes in receding objects, we will continue
our exercises by viewing the objects from the
end of the row, rather than from the front.

Exercise 7

PERSPECTIVE 1
(Time: 15 minutes; same materials as above)

*View one row of objects from the side, and you will
see that the objects directly in front of you are lower
and larger than the objects at the end of the line. All
objects together form a diagonal line, which recedes to
the vanishing point on the horizon line (eye level).**
See Figure 3.7.

*Eye level is the actual height of your eyes, not the direc-
tion that they are looking. The **real horizon line** is at eye
level. In the following exercises, the terms *eye level* and
horizon line will be used interchangeably.

Figure 3.7

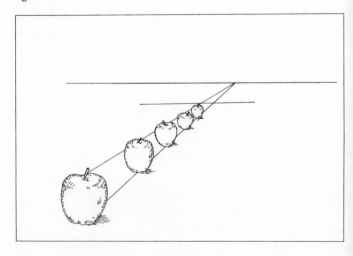

Exercise 8

PERSPECTIVE 2

(Time: 20 minutes; same materials)

Now draw all three rows of objects from this angle, measuring and using negative space for accurate proportional judgments. You will see that the three rows not only rise, but also seem to come closer together as they recede into space. If you imagine them continuing in space, you will see that they converge at a point directly in front of your eye. If you stand to the right of the rows, they will appear to converge to the right. If you stand in the middle, they will converge in the middle. Change the height of your vantage point, and the vanishing point will change with you.

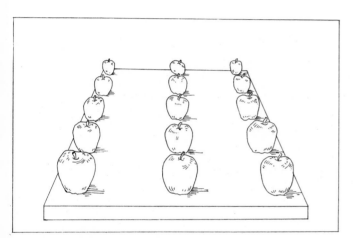

Figure 3.8

Exercise 9

FORMS IN SPACE

(Time: 20 minutes; same materials)

Arrange and draw the objects randomly on the table. Each object is on its own visual plane at a set distance in space. The image area is actually made up of an infinite number of spatial planes (see Figure 3.9).

Objects below eye level are placed higher as they recede into space; objects above the horizon line would appear to descend as they recede. To see this more clearly, continue your experimentation with perspective and proportion, using a standard, rectangular cardboard box.

Rectangular Forms

Exercise 10

CHANGING VANTAGE POINTS

(Time: 20 minutes; same materials)

Place a box on the table; draw it from the front from varying heights. The horizontal lines in the front and back of the box establish visual planes and will be higher or lower in relation to one another, depending on the height of viewing. You will also notice that the shape, size, and angles of the top change with the viewing position. Try to measure the angles and shape as accurately as possible, using negative space to make your judgment more objective.

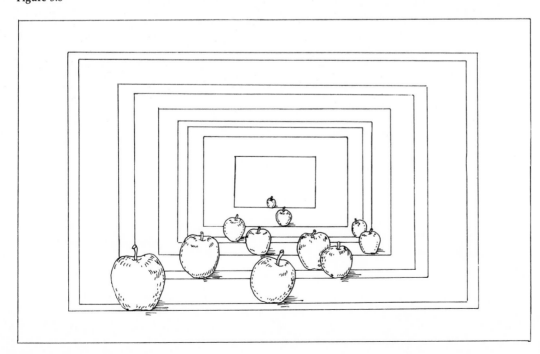

Figure 3.9

Exercise 11

CHANGING SHAPES
(Time: 20 minutes; same materials)

Place several boxes of different sizes on the table parallel to one another in a line, and view them from the front. Note the variety in trapezoidal shapes of the tops and sides when viewed from different heights and positions. All receding lines will return to the same vanishing point (see Figure 3.10).

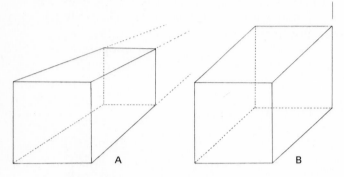

Figures 3.10 A and B
There are two forms of linear perspective: *perspective diminution,* in which parallel lines recede to the same vanishing point, and *isometric perspective,* in which parallel lines remain parallel. Although isometric perspective is unquestionably easier to handle, the results are not spatially convincing. In fact, (B) gives us the optical illusion of getting larger as it recedes, although the sides are actually parallel. This is not to say that you cannot use isometric perspective in a drawing, but if you do use it, it should be by conscious choice. Isometric perspective is often used in architectural drawing and drafting.

In viewing the boxes from the front, you will have noticed that *the horizontal lines, parallel to the top and bottom of the picture plane, remain horizontal. The vertical lines on the sides of the boxes, parallel to the sides of the paper, remain vertical. The only lines that are diagonal are the receding lines, which return to the single vanishing point.* The situation changes when boxes are viewed from the corner. In this case, two sets of lines recede. Only the verticals remain as they were. Both sets of hori-

zontals return to the horizon, but to different vanishing points. The use of one vanishing point is called *one-point perspective.* When two vanishing points are used, the study is called *two-point perspective.*

Exercise 12

TWO-POINT PERSPECTIVE
(Time: 20 minutes; same materials)

View a single box from different angles and trace both sets of receding lines to the horizon. Then try to represent this new perspective in a drawing (see Figure 3.11).

Continue the study of one- and two-point perspective by drawing a tabletop. This will be the base for most still life studies and must be drawn accurately so that objects will sit firmly and convincingly on the surface. Even if you are viewing the table from the side, you may be tempted to draw it as if you were seeing it from above, since this view describes the rectangular shape that you know to be a table.

Exercise 13

CHECKING YOUR IMAGE 1
(Time: 20 minutes; material: plexiglass sheet, 8" × 10", and lithographic crayon)

If you wish to really see the shape of the table as it recedes in space, you can use a drawing aid guaranteed to objectify your perceptions. Use a clear sheet of plexiglass at least 8" × 10" and a greasy marker, such as lithographic crayon. Hold the sheet vertically in front of you and trace the tabletop directly onto the glass. You will find that you have drawn something of an odd trapezoid, quite unlike the rectangle that you know to be the shape of the table. Try to see this shape without the aid of the plexiglass, and draw it as accurately as possible. Compare the shapes. The disparity in results may surprise you, since you probably drew much more tabletop than was visible through the plexiglass. Keep trying until what you see matches up with what appears through the glass.

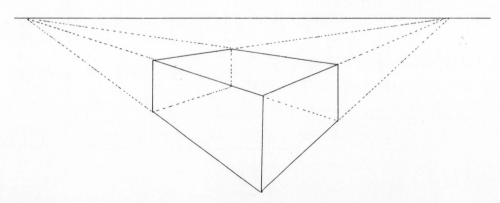

Figure 3.11

Exercise 14

CHECKING YOUR IMAGE 2
(Time: 20 minutes; same materials)

View and draw the table from several different angles and heights. Use plexiglass at first, then draw the form on a piece of paper. Use one-point and two-point perspectives as necessary.

The Cylinder

You will find, just as with the table and the boxes, that the shape of the cylinder changes as you view it from different angles. Although this is not obvious when viewed from points on the side, the shape changes radically when looking at the ends from different positions.

Exercise 15

ELLIPTICAL SHAPE
(Time: 15 minutes; same materials, plus a cylindrical shape and marking pencil)

Use a coffee can or other cylindrical shape, painted white. Draw a series of equally spaced lines around the side of the can parallel to the top and bottom. Stand the cylinder on end and begin to draw it as viewed from directly above. Then lower your vantage point. You will see that the top changes from a circle to an oval, or elliptical, shape. Force yourself to see the shape and proportions of this ellipse. It may be difficult at first. As you continue to lower your vantage point, the ellipse of the top will narrow until it becomes a horizontal line at eye level. The lines around the cylinder will similarly change their semi-elliptical nature, appearing more curved the farther they are from eye level.

Exercise 16

CROSS CONTOUR ELLIPSES
(Time: 15–20 minutes; same materials, plus transparent drinking glass and greasy marker)

*To see the changing nature of the cross contour **ellipses**, draw parallel horizontal lines around a transparent glass. Then draw the glass both standing and placed on its side.*

Exercise 17

FORESHORTENING
(Time: 15 minutes; same materials)

Draw different types of cylinders: cigars, bottles, cardboard tubes, and so on to see how their shapes change when seen from different angles. This change, called **foreshortening,** *may be defined as the optical illusion that a form becomes distorted as it recedes or comes forward in space. The closer aspect appears larger, the farther aspect smaller, and the midsection shorter, depending on the viewing position.*

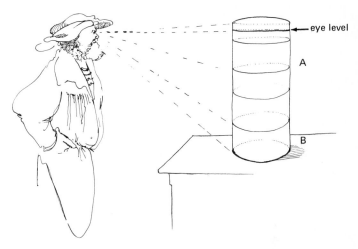

Figure 3.12

THE OBJECT ALONE AND IN COMPOSITION

Our first concern in selecting, arranging, and representing a still life is with the relationship of forms in space. The problem is one of composition: the development of the total pictorial image. Every composition should have a center of interest as well as a unifying structure of lines, forms, and/or values. Beyond these requirements, however, there is an almost unlimited range of creative possibilities. There can be no hard and fast rules about what makes an effective composition. Each student, through study, experience, and personal inclination, must come to an individual understanding of the principles and problems involved.

Composition in a drawing or painting is organized according to principles of balance, movement, harmony, structure, and design. By applying these, an artist can arrange the elements in his or her picture and imbue them with meaning and mood. In the following pages, we will introduce these principles with exercises and examples to help you rec-

ognize and use them in still life, landscape, figure, and abstract drawing exercises.

These principles include:

Center of interest: focal point of the drawing.

Balance: arrangement of forms according to their **visual weight.**

Movement: use of line, shape, value, and color to direct the viewer's eye around the composition.

Harmony: the sense of visual ease conveyed through the organization of the picture.

Structure: the basic geometric construction of the picture.

Design: the abstract organization of forms, lines, values, space, textures, and colors into a unified and complete image. Design holds the picture together.

Shoes

Our investigation begins with a familiar subject—shoes. Through their arrangement and graphic development, we will learn to apply the principles outlined above.

With their diversity of form and evident personality shoes provide an enjoyable and informative study in themselves. The variety of styles can lead to caricature as well as textural and design abstractions.

Exercise 18

SIMPLIFYING SHOE SHAPES

(Time: 25 minutes each; material: soft pencil, medium quality paper)

Grasping the complex shapes of a shoe in various positions can prove difficult at first. However, if reduced to

geometric shapes or gestural lines, or viewed using accurate observation of negative space, even a misshapen shoe can be understood simply and directly. Choose a shoe with a particular meaning for you—an old boot, dancing shoe, a beat-up tennis sneaker. Make it come alive with active, expressive gestural lines. Then continue to investigate the form in a second drawing using construction lines. You may find that the shoe can be contained in a combination cube and cylinder; however, each shoe will involve its own basic forms. If you have difficulty really seeing the shape of the shoe, draw it using and seeing only the negative space. Continue with contour and cross contour line drawings as you did with other objects in Chapter Two.*

Exercise 19

A SHOE IN DETAIL

(Time: 25 minutes or more; same materials)

Do a long study of a shoe using lines of varying widths and values to describe folds of leather or cloth, broad tones for values, and restrained suggestions to indicate patterns, laces, stitching, and so on (see Figure 3.13).

Exercise 20

SPACE AND COMPOSITION

(Time: 20 minutes each; same materials)

*Do several drawings of the individual shoe, utilizing its relationship to the space it occupies. Draw several squares or rectangles of varying sizes on your page. Draw the shoe, placing it differently in each square. Draw it large, filling the entire space, or very tiny, up in one corner and surrounded by the white of the page. In other drawings, cut off, or **crop,** part of the shoe with the border. Look at these drawings from a distance. Which ones look complete? Which do not? Why? These are your first compositional exercises. Try to change the unsatisfying drawings, using your in-*

Figure 3.13

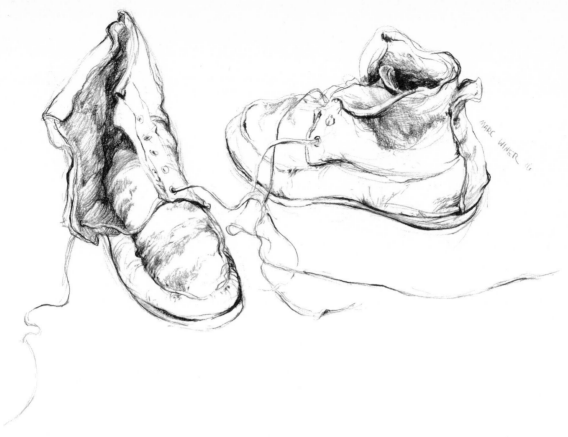

Figure 3.14
This drawing depends upon a very few gray marks counterpointed by some strong blacks to indicate shape, surface, and placement. You need not "gray in" an entire surface to indicate texture.

tuition or instincts to direct you. Make the margin of the drawing larger or smaller, add some shadows or another shoe. Look at your drawing from a distance once again, and continue to make modifications.

To see the large relationships of forms and space that make a composition, we must use a different type of perception than needed in the previous exercises. This perception, called **field vision,** involves a broad, all-inclusive awareness of an area. It is this awareness that helps us to see a composition as a whole, rather than as a scattered collection of separate pieces.

To view a composition, it is often necessary to stand at a distance. If you stand too close, you may inadvertently focus on some relatively small and unimportant aspect. Before drawing anything, examine your subject from several different positions, each time trying to envision its graphic potential. Then, as you draw, stand back from your picture from time to time, and use your field vision to reassess the development of the whole (see Figure 3.14).

Exercise 21

FORM RELATIONSHIP
(Time: 20 minutes; same materials, plus two or more shoes)

In the study of two or more shoes, the relationship between forms must be established in the beginning. View the arrangement as a whole before beginning to draw. Then sketch the rough shapes of the shoes, concentrating on the accurate development of negative space. Use gesture, construction, and contour lines to develop the individual shoes. First use two similar shoes, a matching set, then a variety of different types. Draw them in different positions in relation to one another. Try to make one shoe the most important, the center of interest.

In a composition, one form or area should stand out from its surroundings because of its development, intrinsic interest, or strategic location. If the entire image is developed to the same degree, and all forms are of equal importance, the picture could be monotonous or confusing. There are several devices you can use to draw attention to the center of interest:

1. Place the center of interest in the foreground, making it larger than similar forms.

2. Use strong contrasting values, dark lines, or details in the center of interest to make it stand out from a **neutral** background.

3. Use lines of perspectives, movements of color or values as visual guides to direct the viewer's eye.

4. Make the focal point somehow different from its environs—a dark form among lights; a light form on a dark background; a human, animal, or building alone in a landscape; a brightly colored form surrounded by neutral hues; a detailed object among simply suggested ones.

The artist generally has the center of in-

terest in mind before beginning to draw. Then he or she develops the image to enhance the important area while maintaining the unity of the composition.

The center of interest is not always the first thing that the viewer sees. Rather, it is the point that will be discovered or returned to after the picture has been thoroughly examined. There may be secondary points of interest along the way to hold the viewer's gaze momentarily. Often these will be similar in form or color to the main focal point, and their placement around the image area directs the eye to the focal point and unifies the design as well. In the next exercise, determine

Figure 3.15

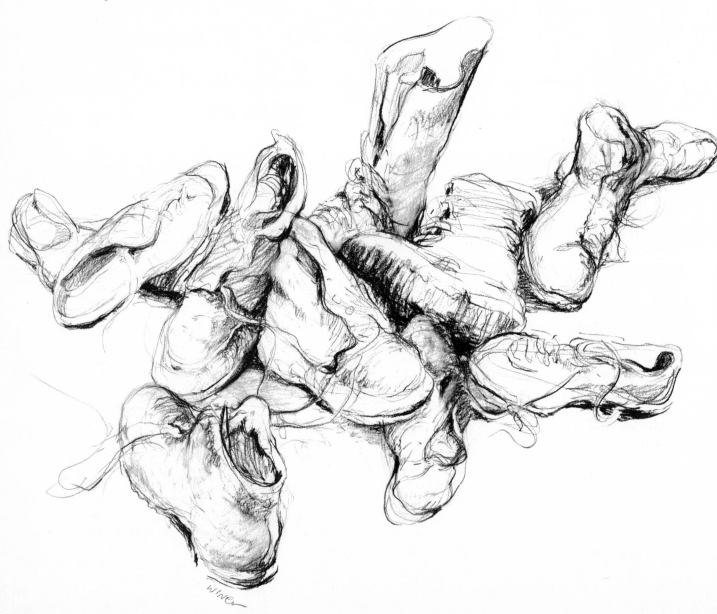

the center of interest and secondary focal points at the outset. Develop these areas using the devices listed above.

Exercise 22

THE COMPOSITIONAL PROCESS
(Time: 30 minutes to 1 hour; material: soft pencil and good quality paper)

Arrange an assortment of shoes thinking about the design of the picture you are about to draw. Look at the shoes from different points in the room. Try to imagine a picture from each position. Would the design be pleasant? Too cluttered? Too sparse? What would serve as the center of interest? Rearrange the shoes, separating some and placing them at a distance. Try different spacings, wide and narrow; then look again. Determine the best vantage point and begin to sketch, first seeking out the larger general shapes of the groups. Rough in the shapes using light gestural or construction lines. Keep these first lines light so that it will not be necessary to erase them later. Then, as you become confident about placement of forms and their real shapes, you can increase the strength of the lines as necessary.

Then sketch in individual shoes, and add a general value scheme. A consistent pattern of light and dark can pull a disjointed composition together. By squinting, you may be able to recognize a movement of dark, like a line, that passes through all the shoes and their groups. If you do not see this line, try to simply follow the movement of your eye as it passes around the arrangement. Develop the values to follow this eye movement even if you have to add some darks or lights where they do not appear. Use the values imaginatively to direct the eye toward the center of interest.

Finally, add the strong contrasting values and details to the focal point, and, to a lesser degree, to the secondary points of interest.

Creating a composition is quite a different activity from simply drawing what you "see." In this process, you are concerned with arranging, editing, balancing, and designing. It is not only necessary to describe the forms, but also to place and develop them in a pleasing or stimulating fashion that involves the viewer with the subject, construction, and meaning of the picture.

Compositional design can add to and enhance the meaning conveyed by the subject matter, although often in a subtle or unconscious way. To understand this, try a couple of experiments with your shoes.

Exercise 23

COMPOSITIONAL DESIGN 1
(Time: 20–30 minutes; material: soft pencil, medium quality paper)

Dump all the shoes in a pile, then kick the pile so that the shoes fall at random. Sketch this random pattern, trying to capture the chaos resulting from the kick. Then do another drawing of the same shoes arranged neatly. Put the two drawings on the wall and see how you emotionally respond to each picture.

Exercise 24

COMPOSITIONAL DESIGN 2
(Time: 20–30 minutes; same materials)

Pile or arrange many shoes together. Take one shoe and place it some distance from the group. Do a drawing of the scene, carefully establishing the space between the single shoe and the pile. Although the single shoe is inanimate, you may get a sense of loneliness or isolation because of its distant placement.

To explore compositional balance, continue with the last exercise, the single shoe placed at a distance from the group.

Exercise 25

COMPOSITIONAL BALANCE
(Time: 30 minutes each; same materials)

Do several drawings of the separate shoe and the group. In some drawings view the group from the side so that all the shoes are more or less equal in size. Then view the arrangement from a position nearer the single shoe, so that the shoe appears to be a large shape in the foreground and the group is drawn relatively small in the background. Reverse this in another drawing, developing the single shoe carefully, and leaving the group lightly suggested. In each drawing accurately delineate the space between the single shoe and the group. Put the drawings side by side on a wall and view them from a distance. In some, the side of the picture with the single shoe may seem much lighter, almost lifting upward, and the end of the picture with the pile of shoes may seem to be heavy and sinking. You may even get the illusion that the picture is tilting on the wall.

It is possible for a single object to balance a number of objects or a small object to balance a large one. Consider children on a seesaw. One child at the far end can balance several children sitting closer to the fulcrum, or middle, on the other side, because of the

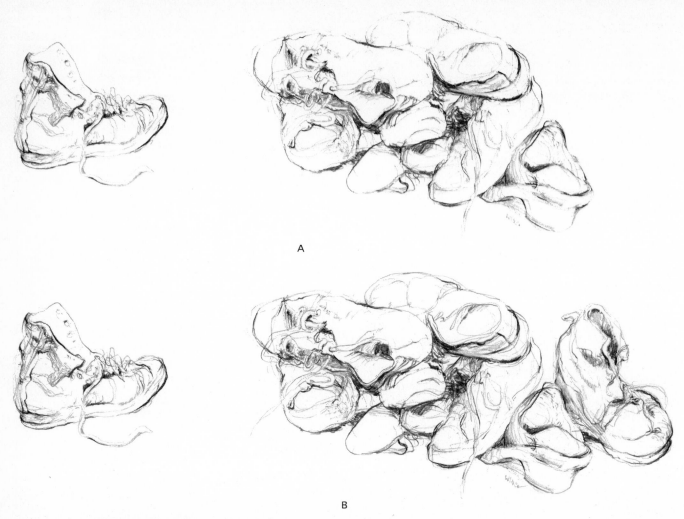

A

B

Figures 3.16 A and B
In (B), another shoe is added to the composition on the right. This improves
the balance of the composition.

principles of leverage. In a drawing, the center line of the picture is the fulcrum, and forms on either side can balance each other depending on their size, placement, and development. Objects that are large, carefully detailed, or dark appear to be heavier than smaller simplified, or lighter ones.

Exercise 26

BALANCE AND IMBALANCE
(Time: 15–20 minutes; material: soft pencil and eraser)

Take a drawing that appears to be imbalanced, and try different techniques to correct the problem (see Figure 3.16). Darken the single shoe or lighten the group, add values to the background, erase or introduce new elements as necessary. Continue to look at your drawing from a distance to see the picture as a whole.

Movement in composition is established by the flow of the viewer's eye from one area to another; the action of discovery and exploration. Eye movement is directed by the use of perspective, directional lines or shapes, repeated values or color patterns throughout the image area.

Exercise 27

MOVEMENT
(Time: 20 minutes each; material: soft pencil)

Construct a composition with the single shoe pointing in the direction of the other shoes; then try it with the toe pointing out. Compare the two positions for eye direction and movement.

You will notice in comparing the two drawings that the one with the shoe pointing "in" directs your eye back into the picture and the one with the shoe pointing "out" carries your eye off the page. The second drawing might make a less effective composition

68

because it encourages the viewer to leave the picture area. The primary function of movement in composition is to encourage the viewer to study the image until all its aspects are discovered and appreciated.

In designing a composition, you must first attract the viewer's attention, then keep his or her attention until the picture is fully unfolded. To do this, visual escape routes must be blocked, and the eye must be directed in a consistently active pattern around the image. There are many guiding mechanisms in compositional design. To discover them, examine different pictures, photographs, paintings, or drawings. Notice how your eye moves, and try to understand the techniques employed by the artist to guide you.

Harmony refers to the use of line, value, and color to produce a sense of ease on the part of the viewer. A balanced, simple composition may be easy to look at and understand. A complex or disordered composition can be more disconcerting and difficult to comprehend. The most immediate analogy is in music. Certain notes naturally combine harmoniously. Others clash, creating "noise." The artistic elements are combined like notes, sometimes harmonizing, sometimes clashing.

Each combination evokes a different kind of emotional response.

A picture does not necessarily have to be harmonious to be a good composition or a great work of art. If it is somewhat hard to look at, it may convey an emotional sense of chaos, suffering, or anxiety, like your scattered shoe sketch. An organized, harmonious design may convey a sense of order and stability. Both effects can be useful. You may find, however, that your most successful pieces are neither too chaotic nor too orderly. Interest is achieved by a balance of the two. Once again, study the works of other artists. Observe your emotional responses to their compositions, and try to understand why you are affected.

Structure in composition refers to the organization of elements in a picture. Every successful composition, no matter how complex the subject, is based on recognizable structure, which provides unity and adds to the mood or meaning. Simpler structures, based on primary geometric forms such as triangles or circles, may convey a sense of order to even the most chaotic scene. More complex compositions are often built on a flowing or erratic line pattern or combinations of geometric shapes (see Figure 3.17).

Figure 3.17
Here the rhythm of the shoes is intensified by the connecting action of the laces.

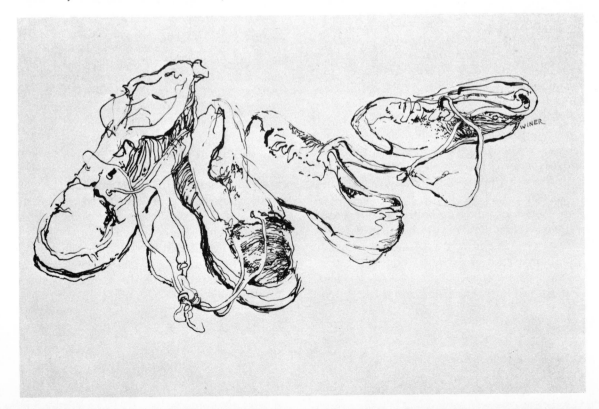

Exercise 28

STRUCTURE

(Time: 10 minutes each; material: soft pencil, eraser)

To understand structure in composition, look at several of your shoe drawings. Try to imagine a geometric shape or a primary line movement that could hold the objects together. You may identify a triangle or a circle, a sinuous, curving line flowing from form to form, or a series of parallel lines passing diagonally across the picture plane. Use your imagination to identify this pattern. Do not look at individual shoes. Add to or eliminate parts of each composition to reinforce the emerging structure.

Design in composition may be thought of as the arrangement of the drawing elements, creating an impression of unity, or completeness in both representational or nonrepresentational art. When viewing a picture at a distance, we may recognize its design before we can identify the subject matter. This design may either please or disturb us, attract or repel us through its underlying use of line form and color. Even a picture of a pleasant subject may repel us if designed poorly. Likewise, an unpleasant theme may be engrossing due to the vitality of its design.

Design is both the first and final concern in creating a work of art. Before beginning to draw, an artist will often make several **compositional sketches** in which the subject matter is only casually suggested, if suggested at all. A compositional sketch may appear to be a balanced pattern of unidentifiable lines or tonal areas. In the final phases of the drawing, these lines and areas will be developed into recognizable forms. As the artist continues to work, he or she will regularly stand back from the image, turn it upside down or look at it in a mirror, evaluating the development of the design, without being concerned with the subject matter.

The concept of visual design forms the foundation for all the arts and crafts as well. A chair is conceived with both functional and aesthetic considerations. It should please the eye as well as the rear end. Interior design, when successful, provides a room with comfort and ease of movement as well as visual ease. All the forms in a room must correspond

to, and balance, one another, or the room could convey a sense of disorder even if neat.

When developing your design, learn to recognize patterns of forms, values, and lines as they relate to one another in the picture plane. Notice, from a distance, where something is missing or where there is too much, what should be developed, and what suggested, where to apply shadows, and what to leave in light. These are not representational concerns at the moment, but abstract ones. By viewing your drawing from a distance, you may be able to recognize the design problems in the image area and resolve them without affecting the objects themselves. In the end, your attention to design will make your image stronger and more readable.

Exercise 29

DEVELOPING DESIGN

(Time: 30 minutes; same materials)

Place your favorite shoe drawing at a distance on a wall. Look at it carefully for a while. Try to see if there are any areas that bother you. That is, not only badly drawn areas, but those that distract you or offer nothing of interest. These may be big empty spaces or cluttered collections of lines. Not surprisingly, you may find that there are few areas like this in your favorite shoe drawing. Now put up one of your least favorite shoe drawings. Study the differences. Rework the areas that dissatisfy you in the second drawing, erasing and drawing over them. Does anything help? Try hanging the drawing upside down. Now you may be able to see areas that need change and development more clearly. Forget that you are drawing shoes; you are now creating an abstract composition. Add darks where you think they are needed; lighten other areas to unify the design. If the picture still does not seem to balance out, turn it sideways and make some changes. If that doesn't work, throw it away. Some pictures are hopeless.

As you continue to draw and to look, you will develop a finer sense of the nature of composition. You will find that it is generally unnecessary (and even destructive to the image) to draw everything that you see. To create an adequate design, you must learn to edit your drawing in the same way that a film editor edits a film, eliminating passages that would distract the viewer's attention from the main themes or simply confuse the issues.

Exercise 30

EDITING

(Time: 20 minutes; same materials)

Take the drawing with the chaotic kicked shoes. Put it on the wall and view it from a distance. Eliminate a few shoes by taping pieces of paper over them. See if by cutting some out, you can make a more pleasing or balanced design. Draw a few shoes from imagination where you feel they should be.

Use your feelings, not your intellect, to make compositional decisions. If you have the feeling that a shoe would look good in one location, try it and see what happens. Of course, some of your feelings will prove right and others will prove wrong. Gradually, however, you will develop a sense of which feelings to follow and which to ignore. Then, as you learn the principles of composition, you can combine this knowledge with your intuitions, inklings, and hunches to make more reliable decisions.

Exercise 31

FINISHED COMPOSITION

(Time: 30 minutes to 1 hour; material: soft pencil, eraser, good quality paper)

Arrange the shoes again and do a final drawing from them. Do several quick (2–5 minutes) compositional drawings, each in a small framework. Begin by drawing squares or rectangles of different sizes and dimensions. Then sketch the shoes in interesting designs within these shapes. You may draw the shoes from various angles and positions, using more or less of the ensemble, or use your imagination to add or eliminate. Look at your collection of possibilities and choose the one that seems most interesting to you. Then do a longer drawing from the sketch.

Draw a border exactly the shape of the frame of the original sketch. Then place the basic shapes of the shoes and the negative space accurately within the border. Make certain that the frame and shapes are proportionately similar to those from the compositional sketch. Your original drawing was pleasing to you in part because of a particular combination of shapes. You will not get the same effect by rearranging these shapes or placing them haphazardly.

After the basic shapes are arranged, lightly sketch in the individual shoes. Determine your center of interest and introduce a general value pattern to describe your eye movement and to structure the composition. As you continue to develop your drawing, you may lighten receding forms and develop those that

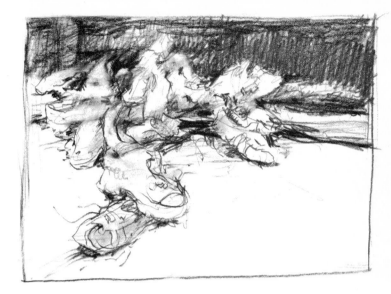

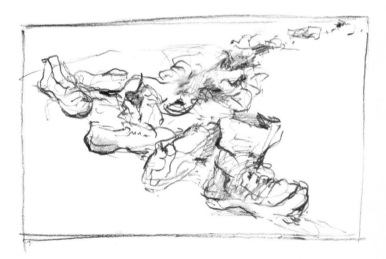

Figure 3.18

are coming forward in space, to enhance the three-dimensionality of the image. These are devices of **atmospheric perspective.**

Apply details, textures, and strong value distinctions to the primary and secondary points of interest. Use carefully placed details to enhance the overall pattern and to guide the viewer's eye to the focal points of the picture.

Check your drawing regularly from a distance as you work to seek out any compositional problems. Turn it upside down and sideways; look at it in a mirror. But most important, stand back. It is impossible*

*In a small room or studio, reducing lenses can be quite handy. These look like magnifying glasses, but produce the opposite result.

to see a drawing or anything else objectively when you are in the thick of it. First, you are too close to see the whole thing unless you are working very small; second, you are too emotionally and physically involved in the action to be able to make any but superficial judgments. By standing back you break the emotional bonds and can view the picture more objectively.

Finish the drawing with last-minute touches, still viewing the piece from a distance. Decide where things can be added and removed. When you make a decision, act on it immediately, following your intuitions. This is not to say that you should not take the time to ponder and evaluate. When you do not know what to do, wait. If you are really stuck on a problem area, put the drawing away for a while—several hours, several days, or even several months. This will give you a fresh eye to see and evaluate your work.

SPECIFIC STUDIES IN FORM AND TEXTURE

In the following sections, we delve into the traditional objects found in still life and the problems involved in their rendering and interpretation. Although the exercises listed here are geared to particular forms, most of them can, with slight modifications, be interchanged with any other exercise in this chapter. Choose the exercises that interest you and apply them to the subject you wish to draw.

Most articles required in these sections can be found around the home or neighborhood. The challenge lies in choosing appropriate ones and arranging them skillfully. The components of a still life not only determine the compositional design, but the meaning as well. Objects all can be taken from one environment—shells, driftwood, and an old anchor would speak of the sea. Forms from different environments can be juxtaposed to tell a more complex story. Every object will have a significance, and combinations of objects expand the possibilities for interpretations. A human skull, by its very presence, introduces a serious tone to the still life. Household objects—irons, brooms, buckets—would evoke another type of thought.

Arranging a Still Life

A still life can be as simple as a solitary glass on a table or as complex as a banquet. Decide on your format first; then choose the appropriate components. Keep the whole still life in mind when selecting its parts. Variety, of course, adds to the interest of a composition. An unusual object may be placed among simple, familiar ones as the center of interest, but a collection of too many fascinating forms can look like a junkyard. On the other hand, an assemblage of "junk" can make for a bold and imaginative subject.

In building a still life, objects must be selected not only for their innate interest, but for shape, value, and textural qualities. Then they should be arranged to compliment each other; dark against light, smooth forms next to those with varied or complex surfaces. Don't put all the objects in a straight line; place some in the foreground, some in the middle, and some in the back. Overlap the objects to create varied intervals and interesting negative shapes.

Look at your arrangement from a distance and try to envision what the resulting picture will look like. Try different arrangements before settling on one. In the beginning you may not really know what kind of placement will lead to a good drawing; however, after some experience you will learn what to look for and what to avoid. Examine still life compositions drawn by other artists as well as observing natural or spontaneous arrangements. Reproduce the ones that interest you.

Lighting the Still Life Composition

A thoughtful arrangement of lights can enhance composition, define the individual forms, and influence the mood of a still life. It can also make your seeing and drawing processes much easier. Experiment with your light source before beginning to draw to find just the right arrangement for your purposes. Natural light from a window may be ade-

quate; but for specific effects a portable light is a must. We recommend one or two 100–150 watt floods mounted in reflector units on extendable stands. The most effective general lighting comes from above, slightly in front, and to the side of the arrangement. However, interesting effects can be produced by placing the light behind or below the objects, creating silhouettes or dramatic shadows. Make certain that your artificial lighting reinforces the three-dimensional existence of the components. Poor lighting can obscure forms or throw cast shadows randomly, creating a confusing image.

Points to Remember

1. Begin each study with gesture and construction sketches to help you organize the composition and to familiarize yourself with individual objects.

2. Make certain that spatial relationships and proportions are carefully established.

3. Maintain an overall value scheme that unifies the forms, encourages and directs eye movements, and adds to the balance and design of the composition.

4. Save your details for last. Use them to develop the center of interest, to clarify individual forms, and to enhance the composition.

NATURAL FORMS

Every natural element requires its own mode of interpretation and stylistic effects. Students often unintentionally draw flowers to look as if they were made of wrought iron, or draw wrought iron with the delicate lines more suited for the delineation of ephemeral forms.

Figure 3.19

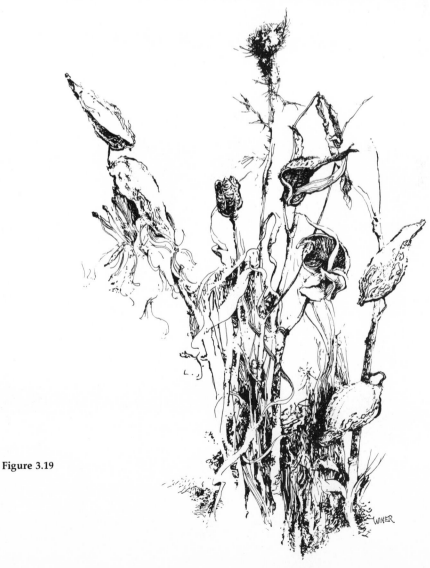

Consequently, your job is not only to define the form adequately, but to portray its essence.

Exercise 32
REMEMBERED FORMS
(Time: 10 minutes each; material: soft pencil)

Draw several natural forms from memory, trying to capture their shape and textures. Draw vegetables, roots, fruits, flowers, weeds, and stones. Find these objects and draw them from life. Study each separately, using different techniques to describe their surfaces. Then, combine them in a composition, emphasizing textural differences as part of the design.

Exercise 33
A SENSE OF TOUCH
(No time limit or medium requirements)

Close your eyes and pick up a natural form from your still life collection. Examine every surface detail with your fingers. Then put it back. Do a drawing from your tactile sensations alone. The resulting work may accurately capture the essence of the subject, but not its exact shape. This is a good way to learn the real meaning of texture in drawing. Remember that draw-

ing, as with other art forms, is not simply the product of one sense, but is an unconscious blending of understanding and knowledge acquired by all the senses over a lifetime. You could not expressively draw a texture unless, at some time, you had touched a similar surface.

Exercise 34
CREATING A DESIGN
(Time: 30 minutes; material: soft pencil, good quality paper)

Make an enlargement of a part of one of your natural forms. Pick a detail of the surface and look at it microscopically. Then create a design out of the textural elements by cropping, editing, and the selective application of values. First draw a framework, then fill it with your image, remembering compositional considerations of space, balance, and movements.

Exercise 35
CONTOURED IMAGE
(Time: 20 minutes; same materials)

Do a contour drawing of your original collection of forms. Try to vary the width, darkness, and action of your line to describe the objects, without adding any surface, details, or shading.

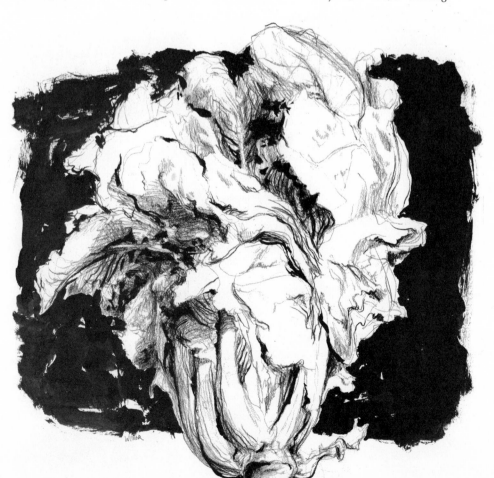

Figure 3.20

For the next exercise in this section, draw a still life imbued with an emotion.

Exercise 36

DRAWING WITH AN EMOTION
(Time: 30 minutes; no medium requirements)

Begin by deciding upon an emotion or mood and feeling it as deeply as possible. Then create an image, using natural forms, to convey that mood. You may either imagine the objects and the composition or draw from an actual arrangement. Act spontaneously on your vision, developing the image as you feel it should be. If you are working from an actual still life, alter or distort the forms as necessary to express yourself.

Exercise 37

ABSTRACTING FROM NATURE
(Time: 30 minutes; mixed mediums on large paper)

Working again from an actual still life or your imagination, create an abstract drawing using natural forms. Simplify, change, or cultivate the shapes or textures into a design. Try using very large paper to build a formal arrangement of the invented pattern.

MAN-MADE FORMS

Man-made objects range in size and complexity from a straight pin to a spaceship and beyond. Textures include smooth, reflective polish, glass, woven fiber, rubber, and rust-corroded iron.

Begin your study by following Exercises 32, 33, 34, and 35 from the previous section on natural forms, applying them to simple objects, a spoon, bowl, and so on. You may find these shapes more difficult to draw than you would expect. Use negative space to help you define the form, then introduce textural effects to suggest the surface. Do not hesitate to try new mediums, alone and in combinations.

Mechanical Objects

Exercise 38

EXTENDED DRAWING
(Time: 30 minutes to 1 hour; no medium requirements)

*Do an extended drawing of a complex mechanical form, preferably one made of several different materi-*als. First, indicate a three-dimensional geometric form in which to enclose the whole. Then look for secondary shapes and details. Keep in mind the interrelatedness of the working parts as you develop the structural and surface qualities of the machine.*

Exercise 39

ENLARGING AND ABSTRACTING
(Time: 30 minutes; no medium requirements)

In a framework, do a drawing of an enlarged part of the original object. Abstract the image concentrating on the placement of forms, lines, and values in the framed area. Use details such as knobs, switches, and belts to compliment the abstract qualities of your drawing.

Exercise 40

FOUND OBJECTS
(Time: 1 hour; no medium requirements)

Go to a junkyard and pick objects that interest you— car bumpers, axles, springs, and machinery of all kinds are good possibilities. Create a drawing using your imagination to arrange and combine them in unusual ways. You may find that some shapes remind you of an animal, a person, and so on. Picasso made a famous sculpture of a steer skull, using a bicycle seat as a head and the handlebars as the horns. Try drawing a creature from your assembled parts.

Exercise 41

BICYCLE
(Time: 30 minutes; material: soft pencil)

Draw a bicycle. First, establish a rectangle or trapezoidal shape enclosing the whole. Then remove negative spaces to identify the form and position of the seat, wheels, frame, and handlebars. The negative space drawing may seem tedious; however, if you are interested in learning "to see" better, you will find the spaces intriguing, and the final result may be more pleasing and accurate than might have been achieved using other drawing methods.

Exercise 42

BICYCLE CARICATURE
(No time limit or medium requirements)

Try doing bicycle caricatures and outline drawings. Have fun with them, exaggerate and abstract.

Exercise 43

BIG FORM
(Time: 1 hour; material: soft pencil)

Do a study of a car, this time beginning with a larger three-dimensional format. After familiarizing yourself

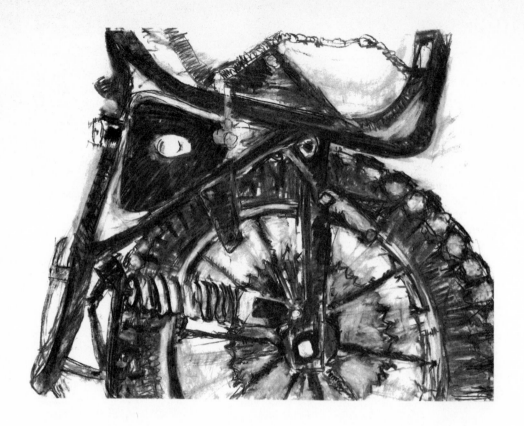

Figures 3.21 and 3.22

Courtesy of Alex Queen

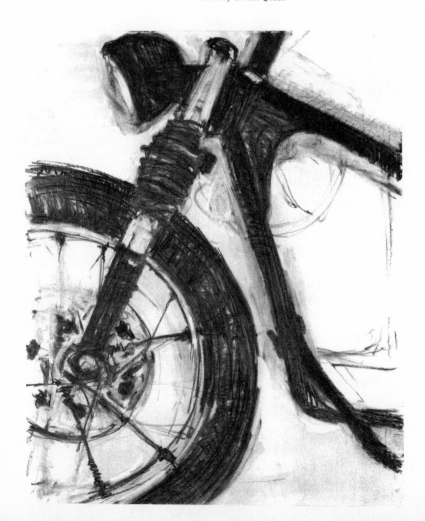

with basic shapes, take some time to describe the finish, the glass, and the wheels. Do different types of cars—old cars, new cars, sports cars. Then try your hand at motorcycles, trains, and horse-drawn carts. Although these go somewhat beyond the scope of traditional still life, they will challenge your sense of proportion and design while providing wonderful studies in shape and texture. When working from a huge shape such as a train, choose a descriptive vantage point, then make basic perspective notations. Be sure to think progressively from mass to detail.

Bottles, Glassware, and Ceramics

Bottles and glassware have three visually exciting qualities that have made them so popular in still life compositions: varied shape, reflections, and transparent distortion. Each aspect provides a challenging problem for both perception and drawing technique. Bottles can be utilized in still life without any indication of their transparency, using only the shapes as design elements. Be careful—the apparently simple, balanced curves can be deceptively difficult to reproduce. (The same is true of ceramics and other glass forms.)

Exercise 44

BOTTLE ARRANGEMENTS 1
(Time: 30 minutes; material: soft pencil, eraser, good quality paper)

Set up a still life with different bottles or ceramic shapes. Sketch them using gestural and construction lines. Then do a long study ignoring the reflection and distortion. Simply try to capture the exact nature of the curves. Use negative space to help you to be more objective in your perceptions.

Exercise 45

BOTTLE ARRANGEMENTS 2
(Time: 20 minutes; same materials)

Draw another arrangement of bottles, using only varied tones (no lines) to define the shapes and relationships. Make some bottles black, others different shades of gray. Leave others white, allowing their outlines to be defined by the tones of the surrounding or overlapping bottles.

The three-dimensional quality of glass and ceramic objects can be revealed with cross contour lines and also with the in-

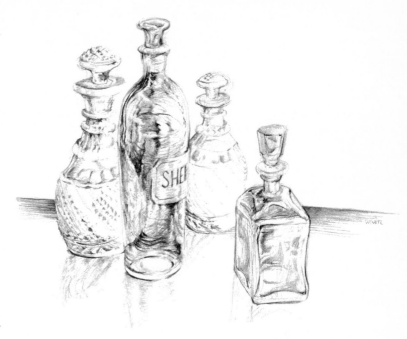

Figure 3.23

dication of labels, lettering, or patterns as they follow the curving surface. Cross contours follow the elliptical pattern as described in the earlier section on cylinders. In these forms, however, there is a general change in elliptical sizes as the bottle widens and narrows.

Figure 3.24
When drawing an elliptical object, try to "sit" it firmly by turning (rounding) the corners in space. If you are putting letters on the surface, use guidelines that curve with the ellipse to reinforce its shape. Letters must be carefully drawn or they will immediately attract attention. As the letters near the edge of the cylinder, they will bunch together. (B) illustrates some common mistakes: making sharp corners that don't turn into space; careless, frontal lettering.

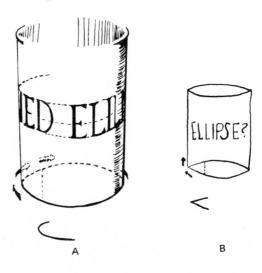

A B

Exercise 46

ELLIPTICAL CHANGES
(Time: 30 minutes; same materials)

After drawing the shape of a bottle, place the label on the cross contour curve (see Figure 3.24). This form and the pattern of the lettering will help to convey the curving surface. Try to see and draw exactly the spread and width of the letters as they follow the curve. Do a similar exercise with a ceramic vase. Use one with a simple ornamental pattern in your first studies, then advance to those with more complex designs. Chinese vases are particularly intricate and challenging for advanced work. When indicating reflections or the distortions caused by the transparent curves of the bottles, spend some time (3 to 5 minutes) looking at the bottle without drawing. You will find that reflections and distorted forms register as fluid stripings. The all-important highlights do not develop gradually from surrounding grays as in nonreflective surfaces, but appear suddenly and brightly in the midst of dark tones.

Exercise 47

TRANSPARENCY
(Time: 15 minutes; material: soft pencil or compressed charcoal)

Draw a collection of transparent bottles playing with variations in line quality to indicate shapes, labels, reflections and overlaps.

Exercise 48

BOTTLE COMPOSITION
(Time: 15 minutes; material: soft pencil or compressed charcoal)

Make a composition using bottle shapes. Don't draw them on a base; rather see them simply as a floating pattern of forms in space.

Exercise 49

EXTENDED STUDY
(Time: 45 minutes; material: soft pencil, vine charcoal, stomp, and eraser, good quality paper)

Do an extended study of a single bottle, trying to capture exactly the shape, tones, reflections, and distortions. Leave the highlight white or erase into it. Build up the values gradually and carefully, saving the darkest tones for last. Do similar experiments with amber bottles, clear glasses, and bottles of varying shapes. The reflections and distortions will be quite different in each.

Woven and Wooden Objects

Baskets of all shapes, sizes, and weaves; straw, cane, and wicker furniture; tapestries, weavings, macramé, lace, and ropes are included in the wide range of woven objects

Figure 3.25

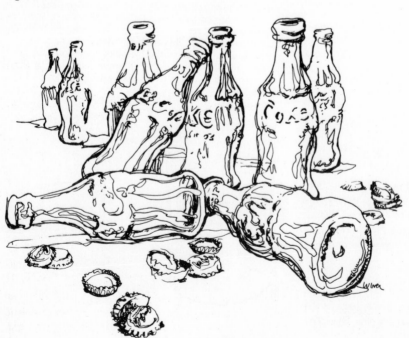

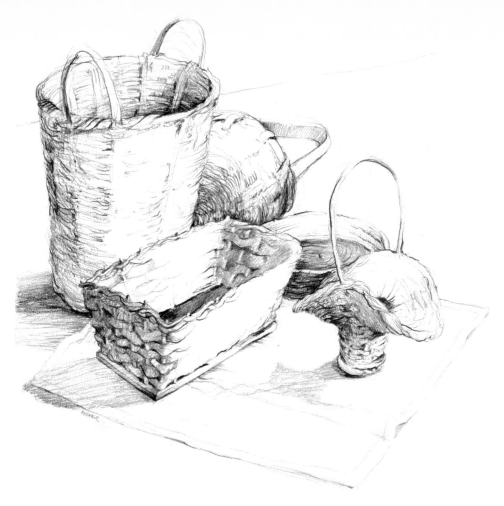

Figure 3.26
Textures can be suggested across an entire surface by economical but accurate indications on a few parts of the object.

suitable for still life. Wooden forms range from the weathered grain of an antique bench or barrel to the polished surface of ultramodern furniture and crafts. From the vast assortment, many forms and textural possibilities are apparent.

In a drawing, indications of woven patterns and wood grain can not only enliven the surface of the object, but can eloquently establish its structure. Fibers might be indicated by abrupt marks or soft, broken lines; wood grain by a pattern of active flowing lines of varied widths and values, conforming to the shape and type of wood. Your indications of the weave or grain can be abbreviated as long as sufficient information is given to explain the construction. Often an overabundance of textural marks can deaden an image. Apply textures to follow value patterns and lines of construction, possibly indicating them

densely on shadowed planes and sparingly on lighted surfaces (see Figure 3.26).

Exercise 50

DESIGN
(Time: 30 minutes to 1 hour; material: soft pencil, pen and ink, good quality paper)

Draw several baskets, ropes, or other woven objects separately. Then put them together in a grouping. Design a composition playing off the differences in woven patterns, developing values through the use of textural indications.

Exercise 51

WOODEN FORMS
(Time: 30 minutes to 1 hour; material: soft pencil, pen and ink, good quality paper)

Choose several wooden objects with different types of grain. Some may be old and weathered, some polished and stained, others made from varieties of unfinished

79

wood. *Do drawings of these objects emphasizing the way the grain conforms to the shape. Be aware of the grain as a value delineator, and notice how the highlight appears on the polished pieces. Do a composition based on these objects. Use details and sharp value distinctions to emphasize some objects; leave others only lightly suggested. This type of approach establishes a sense of space as well as enhancing the design and interest of the composition.*

Paper

Fold a piece of paper once or twice, and you will see a range of values that not only describe individual folds, but also modulate over the subtle curves of each surface. Wrinkle the paper, and more planes and value changes will appear. If you have a strong direct light, you also may distinguish the tex-

ture, or **tooth,** of the paper as revealed in minute value patterns.

Exercise 52
WRINKLED PAPER
(Time: 15–20 minutes; material: soft pencil or vine charcoal)

Fold or wrinkle different types of paper—newsprint, toilet paper, heavy wrapping paper, onion skin, manila, and so on. Each type will wrinkle in a different way. Try to recognize and reveal these differences in a drawing of each.

Exercise 53
HIDDEN ANGLES
(Time: 15 minutes; material: soft pencil or vine charcoal)

Toilet paper can be unrolled on a table to form a train of soft, undulating angles. To draw them, you must be aware of the action of the paper underneath the parts that are visible (see Figure 3.27).

Figures 3.27 A and B
When drawing any undulating, curving surface (B), try to imagine the action of the material that is hidden from view.

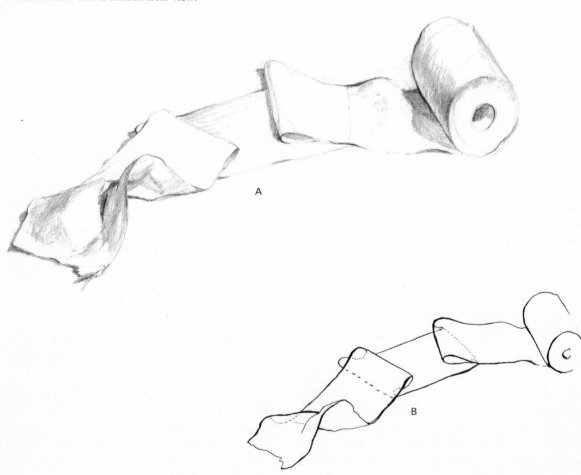

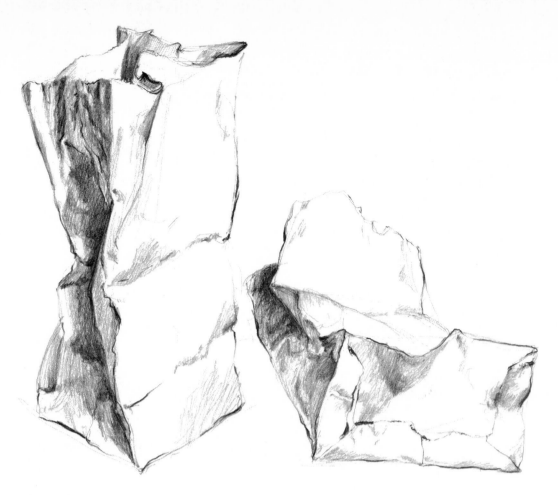

Figure 3.28

Exercise 54

PAPER FACETS
(Time: 30 minutes to 1 hour; material: soft pencil)

Wrinkled paper bags, like diamonds, have facets. Open one and draw it from all angles, capturing the play of light on the interior and exterior facets. Squint to determine the major facets, and assign a different value to each. Then break the facets down in smaller, secondary facets, each with its own value.

Exercise 55

EXTENDED STUDY: PAPER BAGS
(Time: 1 hour; material: soft pencil or vine charcoal)

Arrange a collection of bags as you did with the shoes. Use bags of different sizes, some lying down, some standing, some open, closed, or half opened. Wrinkle some and leave others as they were. The bags may now take on personalities of their own. Anything can convey character and personality if you represent its gesture sensitively. Try to imagine that the bags are people. What would they be feeling, thinking, or doing in these postures? Structure the value distinctions in your composition to convey a mood.

Figure 3.29

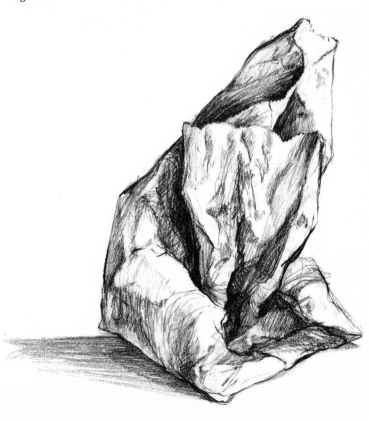

1. Drapery conforms to the shape that it covers. To simplify a given piece of drapery, begin by seeking out and drawing the form underneath. Look for large shadows and planes that reveal the shape of the underlying form, then concentrate on the major folds that define and conform to that shape. It is rarely necessary to draw every wrinkle in a piece of cloth. As with other types of surfaces, use only enough pattern to serve your purposes. Anything more will prove to be distracting.

2. Drapery falls in distinct and recognizable patterns. *Diaper folds, half locks, spiral folds, zigzags, pipe folds, drop folds, and inert folds* radiate from stress and support points in characteristic designs (see Figure 3.31). If a piece of cloth is attached to the wall by a single pin and allowed to hang loosely, folds will fall in pipe-like formations. By adding a second pin to support the drapery, diaper folds or half locks appear as folds from the first support point gather and vanish into folds from the second. If the cloth is stretched tightly between the pins or dropped to the ground, a very different pattern of folds is created.

3. Particular types of folds and wrinkles are established according to the tailoring and nature of the material. Heavy, coarse cloth folds in broader, larger patterns than does fine, delicate fabric. Each cloth conveys a character unique to its consistency.

4. Folds in drapery can be delineated with values that follow a basically geometric structure. Although folds generally appear to be rounded, it is possible to organize the pattern of light and dark in almost rectangular planes. Often a top plane, a side plane, and an underplane can be identified and rendered in different shades of gray. If a fold lies between the light source and the underplane, a cast shadow will appear beneath the body of the fold. Reflected light may also appear on the side plane.

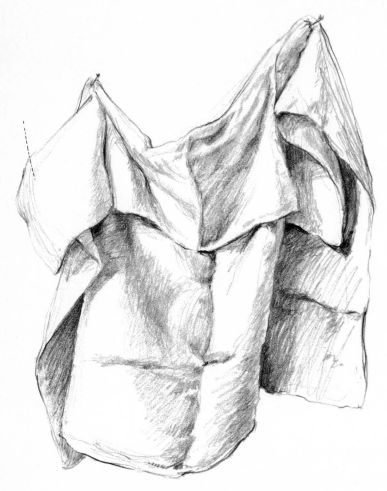

Figure 3.30
Drapery after a painting by Rembrandt Peale

Drapery

Even before the classical Greek era, drapery, with its pleating, varied textures, and active patterns, challenged and stimulated artists. Beyond its intrinsic fascination, however, drapery serves a practical purpose in still life and figure work, where the distinct pattern of folds can describe an underlying form or reinforce the action of a pose (see Figure 3.30).

The network of folds, creases, and shadows in a piece of draped or hanging cloth can be an overwhelming problem for the beginner unless it is organized and simplified. To bring order and understanding to this traditional drawing problem, it is necessary to identify certain principles, or laws that govern the action and nature of folds:

For those students who are overly attached to details, the study of values on drapery may prove to be a tempting, but hazardous, assignment. Cloth, like any other structure, must be ordered, its basic forms and movements identified and developed, its superfluous details eliminated. Before beginning the drawing of any drapery or draped object, seek out the structure and the primary action of the cloth in gestural or constructional lines. Add a major value structure that will conform to the shape of the underlying object, then continue to develop the individual folds. Follow this procedure in the next exercises.

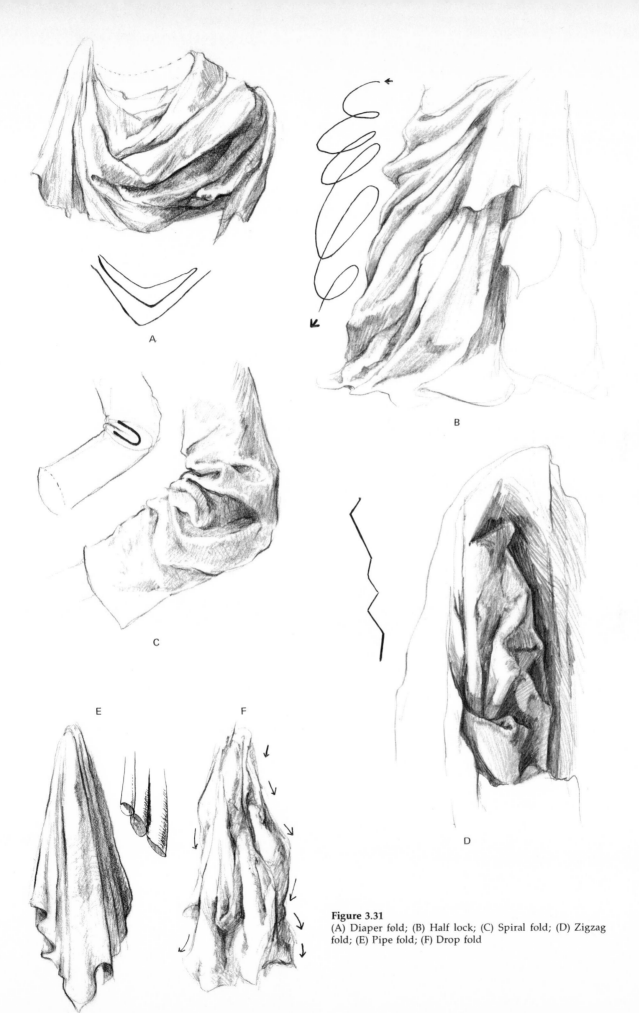

Figure 3.31
(A) Diaper føld; (B) Half lock; (C) Spiral fold; (D) Zigzag
fold; (E) Pipe fold; (F) Drop fold

A

B

C

D

E

F

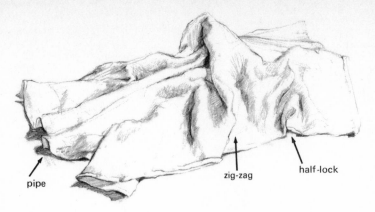

pipe

zig-zag

half-lock

Figure 3.32
Inert drapery usually contains several different kinds of folds.

Exercise 56

CHANGING FOLDS

(Time: 20 minutes each; material: soft pencil, vine charcoal, or conte crayon)

Draw a white cloth hung on the wall with a single pin. Add a second pin. By arranging the two pins closer together or farther apart, higher or lower, you change the nature of the folds you see. Draw the drapery in several positions to become familiar with the nature and action of the cloth. (See Figure 3.32.)

Exercise 57

DRAPERY OVER OBJECTS

(Time: 30 minutes; same materials)

Place drapery over some objects. Start with a chair. Do a drawing using gestural lines to indicate the way the drapery falls, revealing the form underneath. Then do a longer drawing using values to describe fold structures and surfaces. Continue this exercise by drawing the cloth over other types of objects. (See Figure 3.33.)

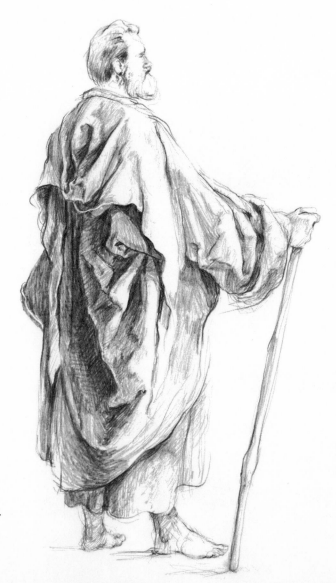

Figure 3.33
Drapery after Albrecht Dürer

84

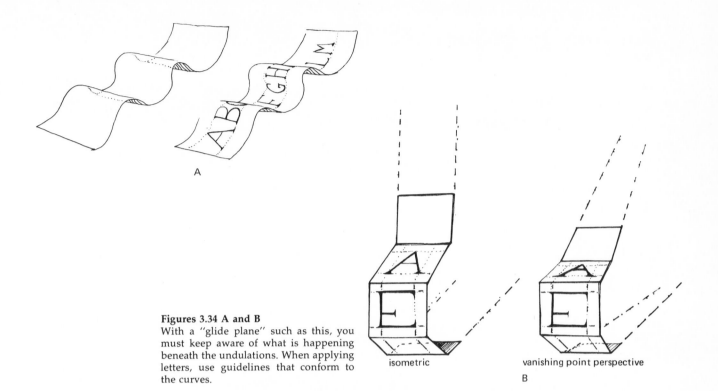

Figures 3.34 A and B
With a "glide plane" such as this, you must keep aware of what is happening beneath the undulations. When applying letters, use guidelines that conform to the curves.

isometric vanishing point perspective

B

Exercise 58

COMMON DRAPED OBJECTS
(Time: 30 minutes to 1 hour; same materials)

Conclude your drapery studies by drawing drapery on the forms it normally covers. Start with a pillow in a pillowcase. Flattened out, the pillow is fairly consistent and easy to represent. Bunch up the pillow to increase the challenge. Then advance to forms of clothing. Try not to be distracted when you see a printed or patterned cloth. These patterns can be effective in indicating the action of the cloth and fold directions. Unless the underlying form is understood and described, however, they will simply add to the confusion of the image (see Figure 3.34).

SELECTION AND ARRANGEMENT

The parts of a still life, like characters in a play, may be of greater or lesser importance, but each is subordinate to the whole. In beginning to work from a still life, remember not to be distracted by flashy characters or dazzling performances. Rather try to view the complete production objectively. Carry this concern with the whole from the choice and arrangement of objects at the beginning to the placement of last-minute details.

Exercise 59

DEVELOPING THE COMPLETE STILL LIFE
(Time: 1 to 3 hours; no medium requirements)

Assemble objects from any or all of the previously mentioned categories. Look through the attic for curious items such as old trumpets, mah-jong sets, or lacrosse sticks. Use house plants and other familiar forms to offset or balance the unusual ones. Set them on a table, experimenting with different arrangements before settling on one. You could spread the objects out, place one on top of another, arrange them at different levels, one on the floor, and so on. Drapery can be placed under or over objects or hung from the wall behind. Choose the best viewing location and do several compositional sketches. Develop the drawing as you did with the final shoe exercise, seeking a balanced, interesting, abstract design, using a well-integrated value pattern and details of surface as necessary for emphasis. You might also try still life drawings using only line or only value patterns. Try exaggeration and abstraction. Study the works of professional artists for other technical and compositional possibilities.

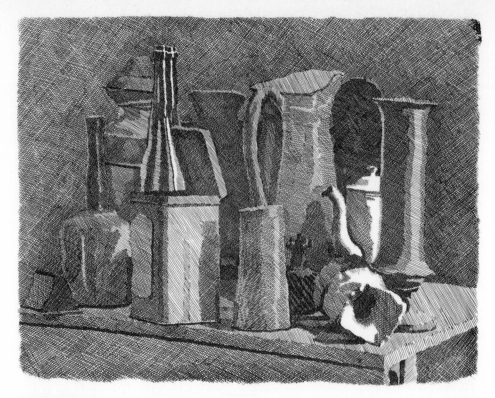

Figure 3.35
GIORGIO MORANDI (Italian, 20th century)
Still Life with a Coffee Pot (etching)
Courtesy of the Fogg Art Museum, Harvard University. Gift of Meta and Paul J. Sachs

INTERIORS

In the study of interiors, our visual and conceptual awareness must broaden beyond the arrangement of objects on a table to the arrangement of forms within an environment. As in still life, we are concerned with the representation of familiar, inanimate forms in perspective and proportional relationships. Here, however, the forms and the space they occupy are generally larger and more complex.

The first concern must be with choosing an area to draw. For this, imagine your eye to be like the viewfinder in a camera, limiting your range of vision. Seek out areas that offer variety, spatial definition, and challenge. In your drawing, freely rearrange forms or alter the value pattern, but retain the basic architectural structure of the room for reference.

Exercise 60

ROOMS
(No time limit; material: soft pencil, sketchbook)

In preparation for the next exercises, carry a sketchbook with you and draw different types of rooms from several viewpoints: airport waiting rooms, restaurants,

living rooms, bathrooms, kitchens, bars, discothèques, courtrooms. Sketch the furnishings and the people in the rooms, but do not become too concerned with specific details. Concentrate instead on perspective, structure, design, and representing a general ambiance.

Furniture

Before developing more elaborate interiors, do some studies of furniture. Through drawing, familiarize yourself with the three-dimensional substance of chairs, couches, tables, and shelving. Consider different styles of furniture for their structural and design possibilities: antique and contemporary couches, wicker, stuffed, wooden and metal chairs, benches, stools, and bookcases.

Exercise 61

CHAIRS
(Time: 20–30 minutes; material: soft pencil)

Do studies of several types of chairs. Draw each within a three-dimensional block as described in Chapter Two; then delineate the structure, design, and surface of each type. Do the same with different types of furniture. Study each form from several angles, using one- and two-point perspective as necessary.

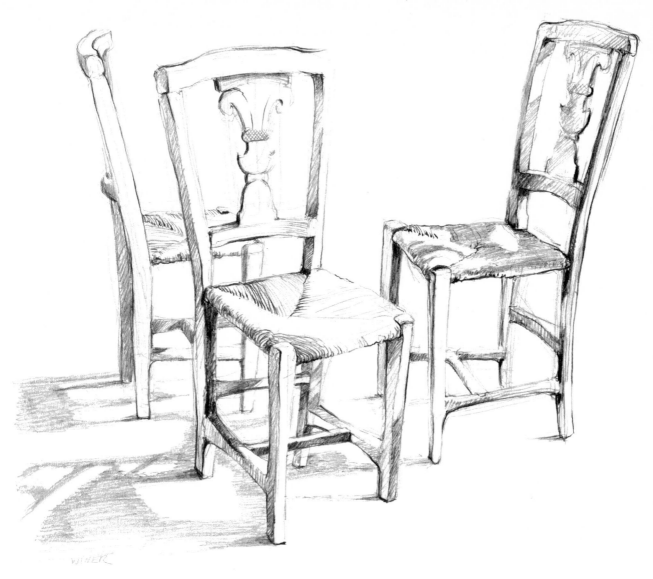

Figure 3.36

Exercise 62

STACKED CHAIRS
(Time: 20 minutes; material: soft pencil)

Stack some chairs or stools on top of one another. Begin to draw by using three-dimensional construction lines to indicate the shape and perspective of the whole pile before going on to execute the individual chairs. Be sure to make the structural lines distinct, or the results will look like a wood pile, regardless of the amount of detail you apply. Finish your drawing by defining textures and details, developing a few individual chairs to a greater degree than others. Distribute darks throughout the design, allowing them to flow with your eye, providing movement and organization while strengthening the transitions between chairs.

Exercise 63

ROOM DRAWINGS 1
(Time: 2 hours; no medium requirements)

Choose an area in the room where floors and ceiling meet two adjoining walls. Begin by sketching this structure as if it were the inside of a block viewed in perspective. Find the two vanishing points and take all appropriate lines to these points. Much of the furniture placed in the room will recede to the same points. Make notations of the basic shapes and locations of the furniture and other objects in the room. Block them in simply, using three-dimensional geomet-*

*See Chapter Four for a discussion of drawing interiors in two-point perspective.

Figure 3.37

ric forms. Then determine a light source. Use a general patterning of values to guide the eye through the drawing. Finally, refine the shapes, adding details as the last step.

Exercise 64
ROOM DRAWINGS 2
(Time: 30 minutes; material: soft pencil)

Do another drawing of a room, spontaneously using contour lines. Add people that you see in the room or place them from your imagination. This will probably not prove to be as accurate as your long study, but you may create an intriguing image and develop a better understanding of line and form. For variety, try the same interior using only tones.

Exercise 65
INTERIOR COMPOSITION
(Time: 1 hour; no medium requirements)

Create a composition from your room just as you did with other still life exercises. Rearrange objects, crop unexpectedly, add a new light source, simplify, and abstract as you wish. Try to create a new room from the old ingredients or introduce new elements to the old architectural structure. Remember that you are creating a composition as well as drawing a room. You should always be aware of lines of movement, balance, and design as you draw, looking at the forms from a distance, thinking abstractly as well as representationally.

THE TERM "LANDSCAPE" evokes varied and personal images for each individual. The midwesterner might think of the vast sky over the plains, the New Englander of the rolling hills and trees that form his or her line of vision. Each locale and region has a character that must be grasped and developed for a truly descriptive drawing, and the artist who can portray this character successfully can help to determine how we will view our physical environment. To some degree, we have come to "see" England through John Constable's eyes or Mt. Ste. Victoire by way of Cezanne. We develop new images from our immediate observations and an understanding of the pictorial statements of others. Our own landscape drawings are essentially extensions of the perceptions of the past.

In the following pages we will discuss various approaches to landscape, including the choice and organization of a scene, material suggestions, perspective, and composition. The last sections will include discussions of individual components and will conclude with a section on color and a summary of linear perspective.

90

CHAPTER FOUR

Landscape

CHOOSING A LANDSCAPE

When viewing the multitude of leaves on a tree or the billowing, yet insubstantial, forms of a cloud, it becomes clear that all their facets cannot be put on paper. Nature has air, wind, light, sound, and a very full palette of color with which to engage us. We are truly "earthbound" with our limited drawing tools. Still, with the right combination of lines, tones, and space, we can recollect and communicate our experience and make the viewer a participant in our multisensed response to nature (see Figure 4.2).

Just as you had to learn to write by using letters to communicate your thoughts, you must learn a language to materialize your ideas about landscape. The first step in mastering this language is to simplify what you see to make your view understandable to yourself. This requires that you learn to see in units, or with **"field vision,"** forgetting for the moment all those attractive details, looking, instead, for large general forms, values, and movements. Then you must develop a vo-

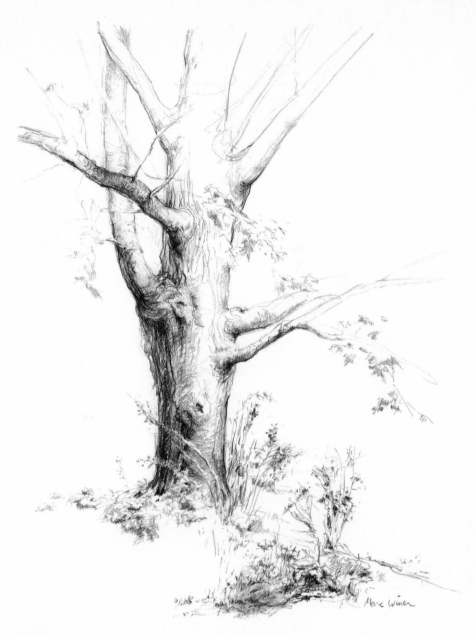

Figure 4.1
MARC WINER
Sugar Maple, Groton (pencil)

cabulary of marks and tones that will convey your perceptions through suggestion.

Exercise 1

GESTURE DRAWINGS
(Time: 2–5 minutes each; material: soft pencil or charcoal)

Everything in nature has a gesture, a sense of motion, whether it is the changing pattern of clouds, the active surfaces of water, rolling hillsides, or the outspread branches of an oak. Being your first landscape studies with a series of gesture drawings, both of scenes and individual forms. Look at the landscape or object that you are about to draw with the idea of becoming it, feeling its growth and motion. Then, with scribbles and flowing lines, allow your hand to move through the interior of the forms, following the action of your eye (see Chapter Five, The Figure). Do these sketches on a regular basis, as quick studies, preparatory drawings, and warmups. Through your understanding of gesture, you will be able to construct an active and vital landscape, and an organized composition.

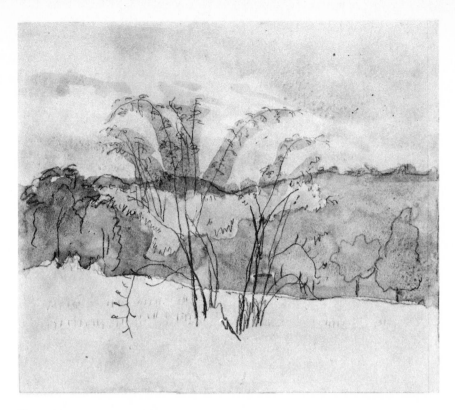

Figure 4.2
JOHN GWEN (British, 1876–1939)
Landscape (charcoal and watercolor on white paper), 244 x 290 mm (9 9/16 x 11 7/16″)
Courtesy of the Fogg Art Museum, Harvard University. Anonymous gift

This landscape conveys much charm with its combination of strong planar divisions, wash, and expressive lines.

Figure 4.3

93

At the start, the individual landscape or scene you choose to work from is not so important. Don't spend a lot of time looking for the "perfect scene" or one that inspires or awes you. All those splendid vistas and favorite views can actually be detrimental to the job at hand, since you may be frustrated if you cannot represent them as you would like. The real excitement in landscape springs not from the view itself, but from the appearance and development of the image on your page. The original physical view is only the impetus. This same advice holds true even for experienced artists.

Figures 4.4 and 4.5 show two studies from a large series of drawings and lithographs of a clump of weeds that engrossed a student for six months. To the untrained eye, a clump of weeds would remain just that, but

to the student versed in the possibilities of line, contrast, composition, and space, the weeds offered a fertile subject. Landscape drawing, then, not only presupposes an ability to "see" the real object, but also requires some notions of how it can be transformed and developed on paper.

Some Practical Suggestions

One of the best things about doing a landscape drawing is that it keeps you outside involved with your surroundings for substantial periods. It is difficult just to look at even a beautiful vista for long without having your attention wander. Drawing allows you to *connect* with what you are looking at, to see it more profoundly, and to make yourself a part of it.

As you begin to work outside, you will find that some special adjustments must be made that were not required in the studio. Unless you are stopping by the side of a road with a car, your materials must be comfortably portable. A light drawing board is a must. Use clips or pushpins to secure your paper. Even a light breeze, unnoticed while walking, will lift the corners of your paper and disturb your drawing process. Often a portable easel is useful, as well as a light folding chair (unless you can find the right natural configurations to sit on). Probably you will need a hat or sunglasses. The light bouncing off your paper must be adjusted to, but you can block out light coming from directly above with a visor. Carrying a sweater is recommended on all but the warmest days, for sitting down and drawing for two hours is very different from walking around as far as your body temperature is concerned.

In choosing a spot from which to work, make sure you will not be plagued by shadows cast across your paper. Dappled shadows from trees, for instance, will form a stronger pattern than just about anything you can draw. Finally, this caution—if you have a pocketbook or other valuables, keep them next to you and in sight. "Losing" something is a depressing way to end an outdoor drawing session.

Figures 4.4 and 4.5
Courtesy of Walter Bender

ORGANIZING A LANDSCAPE FOR DRAWING

In beginning any landscape study, it is necessary first to determine the limits of the area that you wish to draw. Even a small view contains so much that it is necessary to limit the range of your vision from the beginning. We suggest that for each study you draw a margin within the borders of your paper to contain the image. The margin should function as an imaginary window or viewfinder to focus your attention on a given area. For the actual drawing, the margins help in constructing a composition by setting limitations on the space of the image and defining negative areas between and around forms.

You may make an actual viewfinder from cardboard as a supplement to the imaginary one formed by the margins of your paper. Cut a square or rectangular frame from a piece of cardboard and look through the opening. The edges of the cardboard will establish the area of your view and should correspond proportionally to the drawn margins. The view will expand as you hold the viewfinder closer to your face. In the absence of a prepared viewfinder, you may delimit your landscape by looking through your cupped fingers.

After establishing the boundaries of your subject area, you should generally begin drawing by **blocking in** the shapes of forms and space. *Blocking in* means using gestural or construction lines quickly and loosely to give basic indications for major shapes, placements, directions, and composition over the whole paper.

Exercise 2

BLOCKING-IN SKETCHES
(Time: 10–15 minutes each; material: vine or compressed charcoal)

Begin your landscape work with a series of blocking-in sketches, no one taking longer than 15 minutes. Choose an area or scene close at hand; your backyard will do if you have one. Use charcoal because it will not allow you to get too involved with details. First, draw a margin (frame) on your paper, the size that you want your image to be. Then, before drawing anything else, study your subject for 3 to 5 minutes,

projecting how it will look in black, gray, and white on your paper. Consider how you could simplify the shapes. Look at interspaces between objects.

Begin to draw using only four values—white and three shades of gray—to indicate the forms. Assign one value to an object, that is, a tree or a clump of bushes, and another value to an object next to it. Strongly state each object so that it reads against its neighbors, but don't draw lines around the contours. Do a minimum of 10 of these drawings before going on to the next exercise.

No matter how overwhelming a landscape looks, keep things on your paper organized and legible. By following the procedure described in the previous exercise, you should learn to see your subject simply and distinctly, at the same time understanding and controlling what is going onto your paper. The resulting drawings will probably appear without much spatial sense, possibly just plain flat. Don't worry; help is on the way.

Figure 4.6

The next exercise introduces one of the essential concepts for indicating space in a drawing—the device of planes. In this context, *planes* refers to your familiar notions of foreground, middleground, and background. These planes may not actually be apparent in your view, and you may have to assign them arbitrarily. To a great degree, the structure

and legibility of your drawing will depend upon the establishment of these spatial divisions.

Exercise 3

SETTING UP PLANES
(Time: 20 minutes; material: vine charcoal and newsprint)

Draw margins 1 inch inside your paper. Look at your landscape with the idea of determining a foreground, middleground, and background. In your drawing, block in each plane with a different shade of gray. The lighting in your actual view may not be distinct enough to help you in the organization of planes, or you may wish to change the given lighting for purposes of design and emphasis (see Chapter Two, the section on Values).

man-made structures. In these directions you are establishing a coherence on your paper that probably does not exist in your physical landscape. You also have taken a first step toward creating the illusion of depth.

Exercise 4

MORE DEVELOPED PLANES
(Time: 20–30 minutes; same materials)

This exercise expands upon the last two and will require the use of a margin. Begin as you did in the previous exercises, lightly sketching in your major shapes and planes, assigning a different value to each plane. Following this, decide what are the next most important forms and draw them simply over the toned areas.

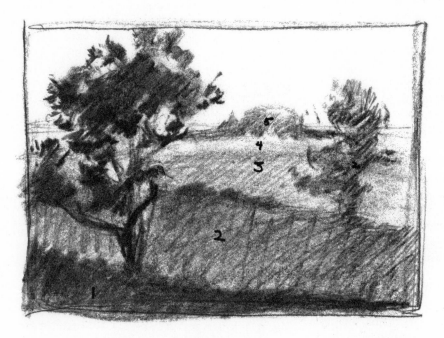

Figure 4.7

The planes may get lighter as they recede (the foreground being very dark), or vice versa. The best way to determine which is the most effective value pattern would be to do some preliminary **compositional sketches** *with different lighting arrangements in each.*

In this exercise, individual objects are important only as part of the planes that they occupy. When you put in forms such as buildings, trees, or mountains, maintain the same value that was assigned to the particular plane area. Be accurate in relating objects to one another. Gauge the interspaces (negative shapes) carefully. Compare the size of one shape against another, natural forms against

For instance, after blocking in a tree, perhaps the bunches of leaves could be presented in a pattern of oval shapes with jagged indented borders; the large mass of a rocky cliff face could be subdivided into individual facets and shapes. At this point, begin to break up the major value areas by bringing some lighter tones into the dark through erasing and by darkening some areas in the lighter planes. The patterns of dark and light will help to integrate the planes and will carry the viewer's eye throughout the image.

What is essential in this exercise is that you develop a progression to your visual thinking. *Start with the simple shapes and planes, as they will clarify your observation and organize your page design. Then go on to the next most important forms, and so on. Far from being a rigid system, this way of thinking about*

Figure 4.8
JEAN FRANÇOIS MILLET (French, 1814–1875)
Landscape "Vichy, 12 Juin 1866" (pen and ink)
Courtesy of the Museum of Fine Arts, Boston. Gift of Martin Brimmer

and controlling the development of your drawing will allow for those happy accidents.

If there are elements in your landscape that you feel you cannot draw, such as a building or a bridge, indicate them to the best of your ability. Don't give up and not do what you are capable of. You may not be able to draw an accurate building on the first try, but what you can draw will be recognizable and perfectly acceptable for the purposes of this exercise. In each case, block out the basic geometric structure of the form, and draw it as a simple shape. The form then can be developed as secondary shapes and details are added. Later we will give specific information on drawing man-made forms.

PERSPECTIVE IN LANDSCAPE

The devices of **linear perspective, aerial perspective,** and **overlapping** provide the clues needed to suggest depth. All three principles can be applied and manipulated to enhance a composition.

Linear perspective, or perspective diminution, refers to the fact that objects appear smaller as they recede. In other words, if an object is drawn smaller and placed closer to the horizon than other similar objects, it is seen as being farther away. Perspective lines and shapes guide the eye of the viewer into

the composition. By the careful arrangement of perspective lines, you can direct the viewer to look at any point in the image area.

Aerial perspective develops from the fact that as you get farther away from an object, more air comes between it and you. Depending on the kind of particles and the amount of moisture in the air, the air becomes less transparent, and objects at a distance become less clear. By rendering more distant objects with limited value contrasts, fewer details, and indistinct edges, you can enhance the sense of depth in your picture. Atmospheric perspective also can be established to obscure or set back unimportant forms, allowing more essential ones to come forward.

Overlapping means drawing one object in front of another so that the front object hides part of the one in back. By rearranging overlaps (moving one object slightly in front of or behind another), relationships can be established and clarified on your page that do not exist in your physical view.

Drawing objects in perspective, then, need not be the difficult task that many beginners think, particularly since the "mechanical" perspective needed to draw buildings is only one aspect of the concept. The following exercises will give you the opportunity to explore some of the basic principles involved. For more explicit information, refer to the per-

97

Figure 4.9
FREDERICK L. GRIGGS (English, 1871–1938)
Sellenger, Church and Church House 1917 (wash over pencil)
Courtesy of the Museum of Fine Arts, Boston. William A. Sargent Fund

The entire space of this drawing relies on the rising, receding tones and lines of the stairs.

spective sections in Chapters Two and Three or in the last section of this chapter.

Exercise 5

PERSPECTIVE DEVICES 1
(Time: 15 minutes each; material: charcoal, large newsprint)

Decide on several landscapes or photographs. Draw at least eight small sketches from them, employing the three perspective devices listed above to establish your space. Diagonals—a pathway, plowed furrows, rivers, or fences—will lead the viewer's eye into space. You also may introduce some elements into the picture against which the size of receding objects can be gauged. Fences, cows, people, cars, and buildings may be utilized for proportional references as well as for psychological diversions or contrasts.*

*It is often difficult to judge depth or distance in a picture developed solely from natural forms. We may not be certain how far away a hill is because we have no way of knowing its size. However, we can judge the distance of an automobile or a house because we are familiar with its basic proportions. By placing a car, house, or other form whose size is easily identifiable close to a form whose size is less identifiable, we can help the viewer to make accurate spatial determinations.

Exercise 6

PERSPECTIVE DEVICES 2
(Time: 20–30 minutes; material: soft pencil or charcoal)

When you feel familiar with these perspective devices, draw some landscapes combining them with suggestions of foreground, middleground, and background. Use no details, and remember to keep your planes clearly stated by assigning them different values (see Figure 4.9).

COMPOSITION

Although the perspective devices in the previous section will create the illusion of distance and three dimensionality, their integration into a composition will determine their ultimate effectiveness. As in any drawing concern, the composition* in landscape is not given in the physical world, but must be

*Refer to Chapter Three for principles of composition.

Figure 4.10

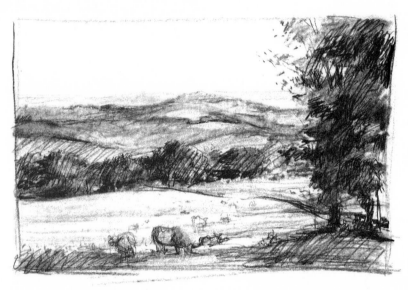

Figure 4.11
Although the photograph (Figure 4.10) and this landscape drawing seem to have little in common, the photo was the source for the drawing. The little bit of leaves seen in the upper right of the photo made no sense, so I moved the entire tree into the composition. I used the idea of the bands of shadows evident in the photo to set a strong frontal plane (and added the cows for interest and scale). I also tried to counterpoint areas by assigning different values to planes to get around the overall "grayness" of the photo.

worked out through trial and error on your paper (see Figures 4.10 and 4.11). Not everything in your view will aid your composition, just as your scene may lack some needed elements. Forms must be introduced, restructured, or eliminated to make your drawing interesting as well as legible. Often value structures must be established in the early stages of drawing. Light moves quickly across a landscape; the shadows that appeared in the beginning of a drawing session may have changed position or vanished by the end.

Drawing any view requires some preparatory thinking. Attacking a large landscape or any big space—courtyard, harbor, football stadium—makes this preparation indispensable. First, you must choose the elements in the scene that best describe and characterize your conception of the landscape. Then consider the limits of your image determined by the margins on your paper and the limits—top, side, and bottom—of what you want to show. Within this space, forms may be introduced, eliminated, or rearranged (see Figure 4.12).

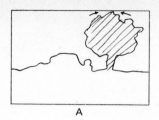

A

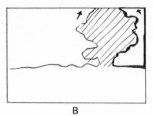

B

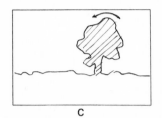

C

Figure 4.12
When composing your landscape, keep aware of how your objects relate to the borders of your image area. In (A), the tree just touches the framework, creating tension. We respond to lines and forms as having visual energy. How objects are made to relate can strengthen or decrease the potential energy. By placing an object so close to the frame line, the energies of both object and frame are compressed into a very small space and become doubly charged. Use this kind of visual dynamite with care.

The interrelationship of an object and an edge often seems ambiguous. Sometimes a question is raised in the viewer's mind as to whether this close placement was intentional. Was the artist just being careless or was the tension of object and edge designed? Always stay aware of the relationships to your edges, and in that way control the meaning of your drawing.

In (B), the tree locks into the margin, creating the strong negative shape X as a result.

(C), showing a tree with the "air" circulating above it, makes a different kind of statement. None of these arrangements is "better" than the others. What is important in evaluating them is not to determine their relative merits, but to encourage you to be aware of what objects can say by their placement.

Decide early how much sky to depict in relation to land. A very low horizon with a vast amount of sky goes beyond design and speaks of the psychological as well as physical dominance of sky over land. Conversely, a land mass that fills 85 percent of your compositional space relegates the sky to a mere supportive role. When drawing the desert or plains, the sky might be spread across the page, suggesting vastness, openness, space. When depicting a canyon or cliff face, the sky might be jammed into the very top of the design.

Exercise 7

SIMPLE COMPOSITIONS
(Time. 15 minutes each; material. charcoal or soft pencil, eraser, newsprint)

Draw four compartments on large sheets of newsprint. (Don't just divide the paper into quarters, as your drawings will touch.) After choosing a landscape, sketch the scene in each square, placing the horizon at different levels, from very low to very high. Examine each drawing from a distance and see how the composition affects you.

Exercise 8

DEVELOPING YOUR COMPOSITION
(Time: 30 minutes; same materials)

Work on the drawings you did in Exercise 7. Separate each picture and continue to draw on them individually. Rearrange the forms to develop the composition

Figure 4.13

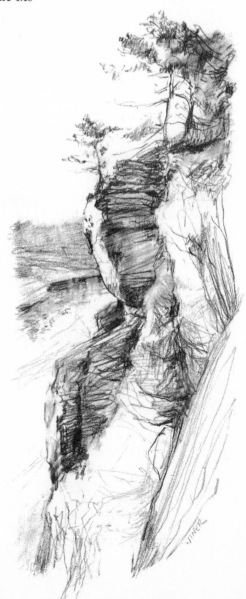

100

without looking at the original view. For example, a tree, building, or stream, which originally appeared on the right side of your view, may be erased and redrawn on the middle or left side of the picture so that it relates better to the design of the whole. Apply values to enhance the abstract structure of your image. Active, consistent patterns of darks or lights can pull disparate compositional elements together.

Landscape need not mean only vistas. At times you may choose to create an image from individual forms or small areas of land. These may be developed as a series, like the studies of weeds described earlier in the chapter, or investigated intently for structural or surface details. Much of our enjoyment of nature comes from the study of small patterns and textures. Although we have stressed working with large, important shapes, it is important to appreciate the power of smallness and detail. The extended drawing of an individual form is a splendid way to relax and fight daily cares by focusing your attention.

Figure 4.14
PIET MONDRIAN (Dutch, 1872–1944)
Sunflower (charcoal)
Courtesy of the Smith College Museum, Northampton

Exercise 9

NATURAL FORM STUDIES
(Time: 1 hour; material: hard pencil (2H, HB, or 1B), good quality paper)

Find a comfortable place to sit outside and do an extended study of weeds, roots, leaves, growing flowers, or other natural forms. Begin your drawing with some quick sketches to familiarize yourself with the form, then do a long drawing, concentrating on details of structure and texture, trying to get as microscopic in your observations as possible. You might do a series of drawings studying different types of buds, shells, or rocks, or concentrate on the pattern of sticks and pebbles in a limited area (see Figure 4.14).

Exercise 10

FINISHED COMPOSITION
(Time: 2 hours or more; material: charcoal, pencil or pen and ink, good quality paper)

The final composition should develop on the principles of perspective, but these should be integrated into the image so that none becomes too obvious. This will be a finished drawing requiring the use of design elements and skillful representation of landscape forms. You may wish to refer to the following section on components for clues to help you draw the elements of earth, trees, clouds, water, or man-made forms.

Choose a scene and do the preparatory thinking described earlier in this section. Then build a drawing, trying to capture the character and mood of the scene. Start to block in your layout within a margin. Decide the value structure for foreground, middleground, and background, and whether you will exaggerate or maintain a realistic scale. These ideas might change as the drawing materializes, but they will offer direction at the start. Develop your drawing by adding details and strong contrasts to enhance the balance, movement, structure; and design of your composition.

Figure 4.15
HELEN REIMANN (American, 20th century)
Remembered Landscape (pencil)
Courtesy of the artist

Using Photographs

At this point, we should say something about the use of photographs as a valid and necessary adjunct to working from nature. Photographs are valuable when you can not work out of doors, and they also offer you an infinite variety of different types of settings. In addition, they are compact and make a large view comprehensible at a glance while predetermining many of the tonal and compositional choices needed for a strong image.

The last two reasons, however, are also among the drawbacks of using photos. Photographs have already done *too* much of your work, and they present it in a finished, impressive image, taking away your options to play with the visual elements. Also, not to be forgotten is the fact that a camera records everything, and all those details are very seductive. A photograph of a tree, for instance, could show each individual leaf, every limb, the light and shade on the leaves, the textures across the bark, the moss and discolorations, and possibly little pieces of ivy growing up the trunk, not to mention tiny knotholes. All these together are a feast for the eyes, but generally they are not the stuff of a good drawing. Students often want to draw everything they see in a photo (or in a physical landscape), but this is unnecessary, as well as impossible. The purpose of drawing is to suggest, not to mirror, nature. Particularly at the beginning, you must choose those essential features that will help your drawing. You are after the essence of the tree; leave the discolorations and tiny knotholes to the camera. Work from a photograph, then, the same way you would from a natural setting, using the elements to make an inventive drawing. You may rearrange some of the forms that you find, combine aspects of two or more photographs, edit, and apply your own values and color scheme. Use the photograph as a tool, not as a crutch.

In choosing the photo to work from, stay away from small snapshots and postcards. Snapshots, due to their size and frequent lack of clarity, often require that you work too hard to decipher them. Postcards are also on the small side, and the color is usually "jazzed up," interfering with tonal distinctions. Magazines are the best source. Many states publish excellent picture magazines; Arizona, Vermont, and Missouri, to mention only a few. If you keep your eyes open, you can find good landscape photos in just about any kind of magazine. Use photos that contain a wide range of values, preferably in color rather than black and white. Those with sharp contrasts and many silhouetted objects do not give you much to work with, although the image may attract you.

As you work from photos (or physical landscapes), you will discover that many scenes you like and thought were suitable just do not make for a good drawing. Fabulous sunsets fall under this heading; but you should find that out for yourself.

Any of the exercises in this chapter can be done from photographs. Exercise 11, however, is specifically tailored to working from a photograph.

Exercise 11

WORKING FROM A PHOTO
(Time: 30 minutes; material: vine charcoal or soft pencil)

Take your chosen photo and place it level with your drawing surface so that it is comfortably and completely visible—you should not have to strain to see it. Draw a frame about 9" × 12", but control the proportions so that they are the same as your photo. If the proportions are not accurate, it will be impossible to transfer the composition. Check the photo for large compositional aspects, and roughly sketch in the important masses, assigning different values of gray to each plane. Try to indicate the spatial relationships and the same shape for land and sky as they appear within the cropping of the photo. Follow these suggestions, not because the picture is sacred, but to train your eye to see relationships. By forcing yourself to understand shapes (positive and negative) in a controlled format, you will be preparing yourself to approach a large physical landscape. The methods and perceptions are very much the same.

Block out and develop your drawing from a photograph in the same manner described in Exercise 2, avoiding details. Try to understand what makes a picture an effective abstract design, irrespective of details. Do many of these studies for practice, spending no more than 30 minutes on each (see Figures 4.16, 4.17, 4.18).

Figure 4.16

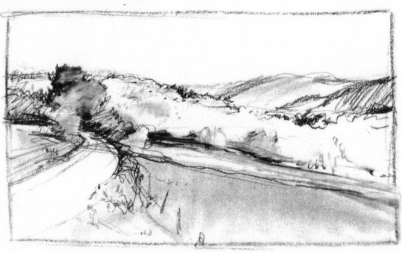

Figures 4.17 and 4.18
Both of these drawings are based on the photograph (Figure 4.16). Figure 4.17 is the more linear approach. It offers a different relationship of horizon from that found in the photograph. The few grays and blacks are counterpointed against the white of the paper and serve as directional thrusts.
Figure 4.18 is a more straightforward, blocking-in approach, but it has changed the photograph to separate the planes into distance areas.

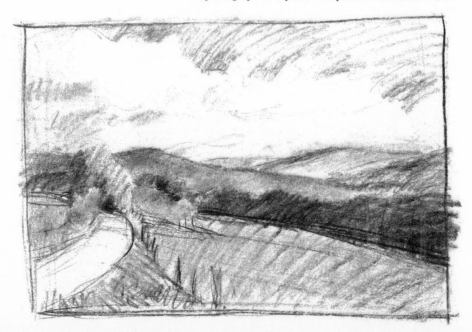

THE COMPONENTS OF LANDSCAPE

To construct a believable landscape, you must understand and be able to control the individual components: earth, trees, clouds, water, and man-made structures. As essentials in landscape, their presentation must be convincing so that they can be integrated successfully into a composition. Obvious inconsistencies—a tree that doesn't grow out of the ground, a building that doesn't recede in space, a lake that sits on an angle—will detain the viewer's eye and destroy the continuity of the image.

In the following pages we will discuss several landscape components, describing methods for dealing with each. As you include the different elements in your composition, it is important that you be specific in your notations. For example, rather than drawing just any tree in a landscape, learn to recognize and indicate the special qualities that make each type of tree unique. *At the same time, don't develop formulas for drawing elements, and use them over and over. Try to build on your previous drawing experience with each landscape form, but investigate it freshly each time.* This careful attention will train your eye and hand while making your image more convincing.

KEEPING A SKETCHBOOK

As a major part of your study of the components of landscape, you should maintain a sketchbook, making regular entries of the forms that you see in nature. In this way, you will deepen your awareness of the environment as well as develop an arsenal of references. In each of the following sections we will suggest various studies to put in your sketchbook; following is an excellent one to start you off.

Exercise 12

LANDSCAPE SKETCHBOOK
(Drawing series; no medium requirements)

Landscape drawing, together with still life studies, can be used to keep an unusual but accurate diary of the passing of one year. Keep a sketchbook with entries at least twice a week to include both the changes occurring in a particular landscape and a record of smaller objects used or available seasonally. For example, October is a perfect month for finding seeds and seed pods (like milkweed) together with dried plants (thistle). Clusters of nuts (hickory or acorns) make good subjects. Pumpkins are part of November and present a challenging drawing problem. Turkeys or any birds offer marvelous textural possibilities. In winter, draw skates, sleds, sweaters, leafless trees, hats, caps, and so on. All these make for repeated interest. In spring, do studies of buds, tadpoles, fishes, and wild flowers.

As an extension of this exercise, keep a drawn record of changing forms outside the same window, once a week for a year (see Figures 4.19, 4.20).

Figure 4.19

Figure 4.20
When drawing a pumpkin, consider how the coils curve from the top and then return to a spot directly underneath. As the coils near the edge, they will be overlapped by those closer to the viewer and will get smaller. Always consider how the structure of the invisible patterns of an object is reflected in the part we see.

Land

Every region has character, mood, texture, and design embodied in its terrain. The United States varies greatly from region to region—the rocky shores of Maine, New England's rolling hills, the lush swamps of Florida, the Great Plains, the Rockies, the endless salt flats and desert, the valleys of California. As you draw the land, composition and basic arrangements of forms are the primary concerns. Then individual surfaces must be established. In the following pages we will discuss a few design and textural possibilities useful for approaching different regions.

When drawing vast open spaces, you must deal with two large, often unbroken areas, one above and one below your horizon line. The land around you or in your photograph may present many possibilities for development, but the individual scene probably will not be perfectly arranged for a drawing. Various elements—distant mountains or plateaus, riverbeds, stone walls, fields, lone farmhouses, gas stations, and scattered trees—may be introduced, set apart to enhance the openness or barrenness of the terrain, or grouped together as a center of interest.

Hills and valleys are more diverse in their natural structure than the plains. They present innate compositional possibilities, broken up as they are by shadow structures, vertical and diagonal land movements, trees, lakes, and rivers.

In a mountainous vista, the summits with their masses and broken textures dominate the view. It is generally advisable to suggest a sense of distance in this type of drawing by setting up spatial planes. Sometimes this can be accomplished by the introduction of a detailed area in the foreground. For example, a line of trees or the edge or a road at the bottom front of your picture plane offsets the distant peaks and gives the viewer a sense of physical and psychological place.

Deep in the mountains, canyons, or caves, the solidity of rocks overwhelms our vision, and the sense of distance must be reversed from the vista described above. The rock faces should be made to feel close and substantial by the dense organization of forms and textures. Angular roads or waterways to-

Figure 4.21
J. M. W. TURNER (British, 1775–1851)
Scottish Highlands (pencil)
Courtesy of the Museum of Fine Arts, Boston

This pencil drawing is so understated that it barely exists, yet it possesses space, mass, and light and also makes a statement about the particular place.

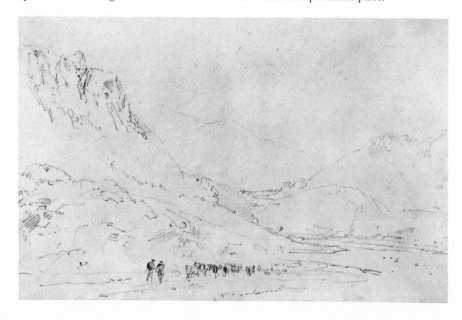

gether with scattered vegetation may add movement and variety to the composition (see Figure 4.21).

Exercise 13

REARRANGING THE LAND
(Time: 1 hour each; no medium requirements)

Working from several photographs, create compositions to describe different types of terrain. Rather than making a drawing by copying any single photo, take elements from each picture that best describe your conception of the region. For instance, you may take a general arrangement of land and sky from one picture, but put into it a grouping of trees or hills from another. A third photo might give you a roadway, a few people, or cows.

Develop your drawings by establishing textures for the major shapes. A rocky cliff face may be faceted like a paper bag, displaying a variety of tones that correspond to particular mineral deposits. Vegetation may break up the surface of a mountain or a desert. In one picture, try contrasting the jaggedness of stone with the soft contours of a desert or the pulsing force of the sea.

Exercise 14

IMAGINING THE LAND
(Time: 1 hour or more; no medium requirements)

Create a landscape entirely from your imagination, based on travel experience and images remembered from pictures, movies, or television. Use drawing elements and natural forms to establish a mood.

Exercise 15

ABSTRACTING THE LAND
(Time: 1 hour or more; no medium requirements)

*Create an abstract design from a particular earth formation or area. Break down jagged cliffs into an active, **cubist** construction; change the elements in a rolling prairie into a **linear** pattern; reduce the dense fabric of Spanish moss in a Louisiana bayou into an expressive design of interwoven strokes. Unless you are working from vivid memories of a very familiar setting, begin by carefully studying several pictures of the region that interests you. Seek out the qualities of form, light, and texture that best describe the area. Then, without referring to your pictures, make a drawing based on the recollections of the scene. Begin to put down descriptive marks and patterns; develop them into a design. If it is a jungle scene, for instance, dark vertical lines of trees and sweeping curves of vines could blend into a knotted tangled web. The broad horizontal expanse of the ocean might be attempted, using varied geometric stripings.*

Trees

Any tree, bush, or shrub must first be understood as a unit; each has a distinctive mass and gesture. In drawing, seek out the gestural action of upward growth in defining the trunk. Then, investigate the geometric mass of the leaves as a whole as well as the forms of individual leaf clusters around a branch.

Develop the gesture with flowing lines beginning with the visible roots as they interact with the earth, continuing through the trunk and into the leaves. These lines will define the character of the tree, whether it is the twisted, interlocking lines of a scrub pine, the upward thrust of the sequoia, or the curves of a willow. *Work from the center outward.*

The three-dimensional structure of the trunk and branches may be understood as a progression of ellipses or a series of cylinders, which gradually narrow in size until they reach the twigs at the end of each branch. These ellipses can be suggested with a few cross contour lines (see Figure 4.23). As each semicylindrical branch grows out of the other, there is a definite point of connection, usually defined by a socketlike formation. The indications of these transitions are pivotal points that can make or break the reality of the image. Do not neglect the transition of the tree emerging from the ground; a hard line around the bottom of the trunk destroys the relation of earth to tree.

Exercise 16

TREE GESTURE
(Time: 3–5 minutes each; material: compressed charcoal or charcoal pencil)

Do a series of short gestural drawings in your sketchbook, trying to capture the action of different types of trees, bushes, or shrubs, using flowing or erratic lines as necessary. Allow your eye to flow all over the tree—the trunk, limbs, branches, and leaves, back to the trunk and so forth. Don't look solely at the contour or the mass. Let your hand spontaneously follow the flowing movement of your eye, creating the image with loose, active strokes. Try to make your drawings sufficiently descriptive to identify each tree from a reference book. Go back to the same trees the following day and take a closer look. Then do another gestural study. Continue this process until you can indicate an individual tree quickly and simply.

Figure 4.22

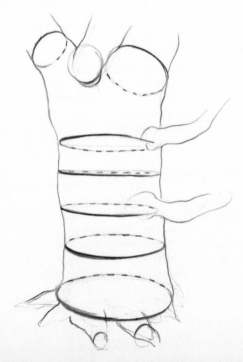

Figure 4.23

Its tonal nature makes charcoal perhaps the easiest medium for gestural studies of trees. The linear materials of pencil and pen require you to be more accurate yet just as suggestive with your individual marks. Try using these other materials for your gestural studies after you are comfortable with charcoal.

Exercise 17

CROSS CONTOURED TREES
(Time: 30 minutes; material: soft pencil or pen)

*Find a relatively large tree whose lower branches are exposed. Establish the basic shape of the tree, and then do a **cross contour** drawing of the trunk and limbs to understand the progression and pattern of ellipses. You will see that the ellipses or cylinders of the branches come forward and back in space, twisting, turning, rising and dropping. Indicate these changes of direction with the depth and angle of each ellipse. Then apply patterns of shadows as they appear, by darkening or repeating the cross contour lines (see Figure 4.24).*

Exercise 18

DRAWING ROOTS
(Time: 30 minutes to 1 hour each; no medium requirements)

Do a series of drawings investigating the visible roots of different types of trees and bushes, to show how they grow out of the ground (see Figure 4.25). As a variation, try drawing a tree growing out of a clump of weeds.

Indicating leaves and bark means creating a texture, and only experimentation together with research into other artists' approaches will give you satisfactory results. The pen techniques of Titian and Dürer are masterful statements, as are the charcoal drawings of Corot and Constable.

The depiction of various types of bark involves a primarily linear approach. Every tree will develop a unique design based on its type and particular growth pattern. The lines of bark follow either a vertical or a horizontal pattern. Birches have fine black lines running horizontally around their white limbs; beeches wrinkle like the skin of an elephant's leg; oaks, elms, and chestnuts follow a vertical line, the textural nature of the bark being coarse and dense; apple trees, palm trees, and cypress all demand quite different techniques.

Although the linear quality of bark can be readily suggested, leaf structure must be wholly invented. Leaves bunch together in different ways depending upon the type of

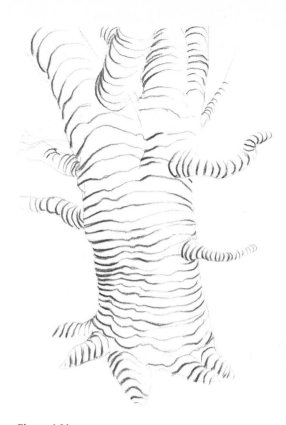

Figure 4.24
Approach a tree trunk as you would any cylinder. Subtle indications of the openness of the ellipses will help to round it out. The limbs, branches, and visible roots also should be considered in terms of structural ellipses.

Figure 4.25

tree. In some, the leafy masses seem to be one solid, cloudlike shape, in others, the leaves grow in definite layered patterns. Both these masses and layers can be broken down further to find secondary shapes using the process of looking from general to specific.

In drawing foliage, it is not necessary to indicate every leaf. As you develop the patterns of bunches and the irregular shape of each leafy mass, together with a few essential clues to the specific leaf shapes, you can suggest multiplicity with very few marks. By overlapping the bunches, making some smaller, placing some behind the trunk and limbs, and suggesting the interaction of leaves and branches, you should be on your way to creating a "real" tree.

Exercise 19

LEAF MASS
(Time: 15 minutes; same materials)

Leaves don't grow separately, but are grouped together around a branch. The groups form leaf masses, which can be understood basically as a geometric shape. The masses themselves can be defined by values in the same way that any geometric shape can. Do studies of different types of trees, emphasizing the geometric

Figure 4.26

shape of the whole and of the individual masses with appropriate shading (see Figure 4.26).

Exercise 20

TEXTURAL EXPERIMENTATION
(Time: 40 minutes each; material: charcoal, pen, pencil or brush, and ink)

Do several drawings of the same tree, bush, or shrub, using different mediums in each. Push the mediums to find out their textural potentials when applied to a specific object. Put each drawing up when you get home and continue to work from memory. Concentrate on value contrast, linear qualities, and design.

When grouped together, individual trees become swallowed up in the larger whole. Viewed at a distance, a group of trees can be understood as a general geometric shape, then broken down into distinct areas of foliage and wood. The foliage may have a general pattern of lighting that runs through the grouping; it will generally be dark on the underside of the overall leafy mass, light on the top. Groups of trees can describe land terrain by their placement, and they also serve compositional purposes in directing the eye and providing a sense of movement (see Figure 4.27).

Exercise 21

SPATIAL INTERVALS
(Time: 30 minutes each; material: pencil, pen, or charcoal)

Make several drawings of a clump of trees, thinking about spacing, variety, balance, and composition to develop a lively sense of spacial intervals and design rhythms throughout your image. Trees can be packed close together, articulating with one another, or spread apart. They can line up, following the undulations of a ridge or riverbank, or be arranged in foreground, middleground, and background to create a feeling of space.

Exercise 22

MEMORY/LIFE STUDIES
(Time: 30 minutes each; no medium requirements)

Draw a favorite tree from memory. Then draw it from life for 30 minutes. Draw it again from memory the next day, then again from life. Keep this up until the memory and life drawings closely resemble one another.

You will probably find that you are learning as much about the tree from trying to remember it in your drawing, as from looking at the actual tree.

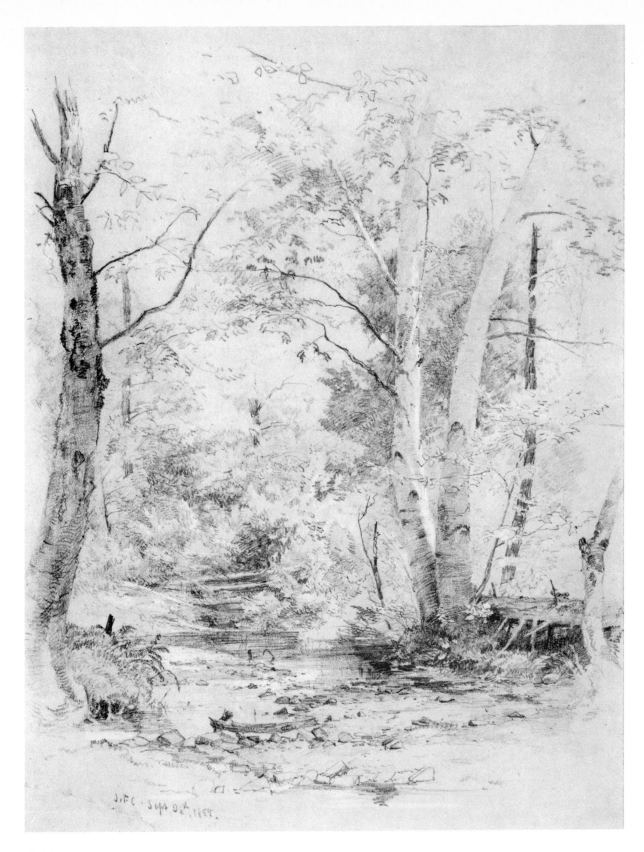

Figure 4.27

JASPER CROPSEY (American, 19th century)
Conway, New Hampshire, Birch Trees (pencil, heightened with white)

Courtesy of the Museum of Fine Arts, Boston. Gift of Maxim Karolik

With very few marks, Cropsey suggests a dense glade suffused with light. Part
of the wonder of this drawing lies in how much texture and space have been
described with such restrained use of darks.

Exercise 23

TREE SKETCHBOOK
(Drawing series; no medium requirements)

Record a study of one new tree each day in your sketchbook for a full spring, summer, and fall. Include some that were already drawn, if they have changed appearance. At first, your attention should remain with the general form. However, later you may concern yourself with details of structure, leaves, and bark. Label each species.

Figure 4.28
Changing light conditions can totally transform the essence of a place. In (A), the slanting light has broken the canyon into sharply contrasting forms and tones. The more diffuse light on (B) brings out the calmer edge of the horizon as a major feature. The effect is quite different from the intense energy of (A).

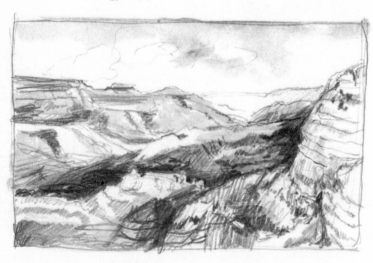

A

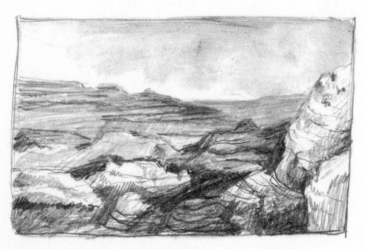

B

Light

The concept of light, its physical presence together with its spiritual and psychological importance, underlies all great landscape art. In drawing, light qualities can define the mood of a region, the weather, and the time of day, as well as serving compositional and structural purposes.

Many people have difficulty discerning the changing qualities of light, but to the landscape artist, it is a primary source of inspiration. Claude Monet did approximately 40 paintings of the facade of Rouen Cathedral, each at different times of day and under various lighting conditions. Through these studies, he immersed himself in the nature of light and its relationship to color. Each of these paintings seems to present us with a totally different substance.

In preparation for doing your own landscape work, try to be aware of the quality of light in various areas, at different times of day, and under diverse weather conditions. Study the drawings of artists such as Constable, Turner, Rembrandt, and Rubens to learn their solutions to the problems of light in landscape (see Figure 4.28).

Clouds

Clouds range in shape from massive, dirigiblelike cumulus, to thin sheets of stratus, to high, wind-striated cirrus. Sometimes all three types are visible in the same sky. Clouds can be widely spaced, seemingly motionless, or can completely join together, churning on a stormy day.

The variety of cloud forms can offer psychological and philosophical possibilities as well as purely pictorial ones. In a drawing, different shapes can be introduced to the sky to serve specific purposes. For instance, thin cirrus clouds could intensify the barrenness of a landscape, just as a fat cumulus could complement the barrenness by contrast. In your sketchbook, keep a record of clouds under all weather conditions and apply them when needed for composition. Remember, too, that clouds do not merely sit on a flat plane, but exist in the domelike space of the sky. They

Figure 4.29

can be developed in perspective to indicate depth and to strengthen a design.

The mere fact that clouds are composed of water particles does not mean that you have to draw them as being fluffy and insubstantial. They can be made to read as sculptural three-dimensional masses or simple two-dimensional shapes, depending on the tone of your drawing. In the beginning, however, you might draw them naturalistically to familiarize yourself with their forms.

Clouds generally show light from the top, except at sunrise and sunset. To capture their three-dimensional shapes, you must first round the whole form by placing shadows on the underside, then break up the mass into the smaller rounded shapes. You may notice subtle cast shadows on clouds, thrown by clouds above, or light on the bottom of a cloud, reflected off other clouds or the land itself. At times, clouds may register as darker and denser than the land, if a shaft of bright light strikes the earth during an overcast day. Keep aware of the spatial, tonal, and compositional possibilities of the banded shadows that clouds throw across the land.

You need not gray in the entire sky area to represent its color. For the majority of drawings, the sky can remain completely undelineated. Squint at a landscape and see how very light the sky is compared to the land. *Let the paper do most of the work for you.*

Exercise 24

CLOUD SKETCHES
(Time: 2–5 minutes each; material: charcoal or soft pencil)

Do a series of gestural cloud sketches, working spontaneously, trying to capture both form and movement. Try this exercise without looking at your paper, simply observing and scribbling as the clouds change shape.

Although it is easier to create cloud forms with the smoky qualities inherent in charcoal, marvelous effects also can be produced with pen, pencil, or brush.

Exercise 25

CLOUD EFFECTS
(Time: 20 minutes; various mediums)

Experiment with various mediums to create cloud effects. Use free-flowing pen lines or controlled cross contour effects; try ink washes, alone or combined with pen lines; also try conté crayon and pastels. First, make basic sketches with pencil of the cloud shapes in nature; then go home and develop them with other mediums.

Exercise 26

CLOUD SKETCHBOOK
(Drawing series; no medium requirements)

Keep a sketchbook with different cloud forms, making an entry once a day. Check your cloud drawings against technical sources to type them. Study clouds in different types of weather conditions. The clouds often will be moving and changing shape, so you will have

to work fast and commit a lot of important information to memory.

MASTER DRAWINGS
(No time limit or medium requirements)

Copy some master drawings of cloud forms as indications of different types of weather. Excellent sources are Dürer, Constable, Ruisdael, Homer, Titian, and Turner. Use mediums that were used by the artists; try other mediums, defining the same shapes. Then, developing on the information gathered from these sources and your sketchbook of clouds, do several longer studies to illustrate different types of weather conditions.

Water

Water, like the clouds it forms, derives much of its surface appearance from the wind and takes on many guises. Unlike clouds, however, water must conform to a body of land, its terrain, mineral structure, and vegetation.

The languor of swamp water seems an entirely different substance than a swift, glittering trout stream. Ponds, rivers, lakes, puddles, waterfalls, and oceans all can offer different moods and pictorial possibilities.

A lifetime could be spent comprehending the infinite surfaces, shapes, and actions of water. Photos are helpful here, since they freeze the everchanging patterns. When drawing water in nature, however, it is necessary to watch your subject for at least 5 or 10 minutes to get a feel of recurring movements and directions. Then decide on a few marks, lines, or tones that express its particular qualities.

With its reflective surface, water can say a great deal about the surrounding land. In a drawing, develop both water and land simultaneously and be clear about specifics in the meeting point. Students often seem to forget that riverbanks, bridges, and boats continue into the water rather than just sitting on top. You might suggest this fact by continuing the

Figure 4.30
FREDERICK L. GRIGGS (English, 1871–1938)
River with Stone Bridge (pen and ink on cardboard), 136 x 192 mm (5 7/16 x 7 5/8")
Courtesy of the Fogg Art Museum, Harvard University. Gift of Harold B. Warren

lines of the form into the water, letting them scatter into its semitransparent surface and reflections.

In setting up the general mass of water, be certain to establish it on a horizontal plane, not at an odd angle. Then begin to investigate its surface. Remember that water is a texture, and, as with any texture, you should look hard for suggested patterns and squint to isolate value relationships. Even completely still, reflective water is darker in tone than the sky it mirrors, and the patterns of reflections will continue to add value distinctions. Unless you are working from a completely motionless pond, the reflections on the surface will be distorted and possibly broken. Slight indications of this discontinuity may be all you need to place the surface. Keep looking and concentrating to isolate the strongly linear but liquid shapes of the reflections, while finding simple ways to suggest them.

Exercise 28

SURFACE RECORD

(Time: 45 minutes; material: soft pencil or charcoal)

Choose a protected area with reflective water. Go to the same spot twice a day for a week. Keep a drawn record of the different appearances of the surface of the water and reflections under different weather conditions.

Exercise 29

RUNNING WATER

(Time: 15–30 minutes each; material: soft pencil)

Do studies of a running stream, drawing its action at different points. Indicate the foliage and construction of its banks, the rocks in the water, and the action of the water as it passes a spot. Learn to use textural marks to indicate flowing patterns over different surfaces: foam as the water breaks over the rocks, waterfalls, and the translucent veils of mist. Contrast these with the still water caught in a sectored part of the stream.

Exercise 30

DIFFERENT WATER TYPES

(Time: 15 minutes to 1 hour each; no medium requirements)

Draw different types of water masses—lakes, ponds, puddles, wide, rolling rivers, and oceans—in your sketchbook. Indicate the surrounding land, the surface

action, and reflections as simply as possible. Develop patterns of marks and tones to define each type.

Exercise 31

WATER-LAND INTERACTION

(Time: 2 hours or more; no medium requirements)

Do an extended study of an area where water and land interact—the marshes of the Maine coast, the swamps of Florida, and so on. Work from real life, if possible, and try to infuse your drawing with the atmosphere of the place. Here the application of an overall value structure is essential. Use what you have learned about trees and earth. Do a similar study of a seacoast, contrasting the rocks or sand with the action of the waves.

Drawings and paintings of the sea usually follow two approaches. The first, as described above, involves the edge of sea and land; rocks, cliffs, beaches, and wharves come under this heading. The second major approach relates the sea to the sky without the appearance of land. Boats and ships are often depicted in this type of seascape as centers of interest and to set the scale and perspective scheme.

In drawing a coastline, it is essential to indicate the difference in textural and tonal structure of the beach, rocks or cliffs, and the water. It is often helpful to assign one value to the rocks in general and one primary value to the sea. Of course, the foam can be suggested by the white of the paper. Often the linear distinctions of sea and land or sea and sky are not clear, and the values have to be strong to separate the two areas.

The second seascape can develop its drama from the contrast of an active sea against a solid object, possibly a storm-tossed boat. Boats, moored or in movement, are an important aspect of a seascape and must be made to sit convincingly in the water and in space.

For any seascape, it would be valuable to study the action of waves, both at sea and over rocks or beaches. Waves begin as minor swells, lifting in an arch or pyramid slightly above the surface of the water. They gradually curl and fall, spewing foam, before settling in preparation for the next swell.

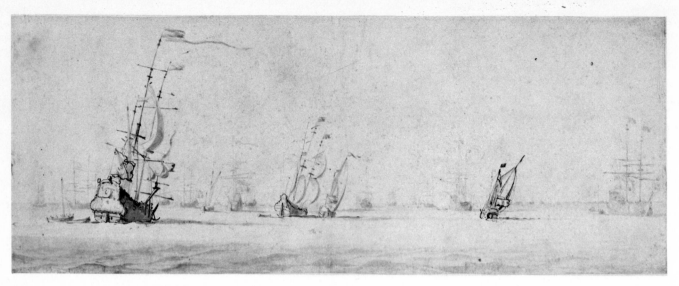

Figure 4.31
WILLEM VAN DE VELDE THE YOUNGER (Dutch, 1633–1707)
The Dutch Fleet Going to Anchor Off-Shore (pen, brown ink, black chalk, with gray wash), 186 x 497 mm (7 5/16 x 19 9/16″)
Courtesy of the Fogg Art Museum, Harvard University. Bequest of Marian Harris Phinney

This deceptively accessible marine view is built on a thorough knowledge of the sea, ships, air, and wind, together with a sound background in drawing principles. The artist has set his frontal plane with a gray wash in which some swells are evident. Then he placed his ships back, using diminution as well as atmospheric perspective. He enhanced these devices with a deft and understated line. The whole image conjures the fresh wind for the viewer.

Exercise 32

WAVE SKETCHBOOK

(Drawing series; material: soft pencil or charcoal)

Keep a sketchbook record of the sea; draw the way waves form and break, how they cover and withdraw from rocks and the beach. These notes may appear like abstract patterns of lines and values at first. Refine them later to describe more accurately the action of the sea that you observed. It also would be valuable to study boats, both at dry docks and in the water, and to watch and draw the way that different types of sailing crafts react to the action of the water (see Figure 4.31). (Photos may be helpful here.)

Exercise 33

WATER ACTION

(Time: 30 minutes to 1 hour; material: soft pencil or conté crayon)

Based on your sketches taken from the sea, do a drawing that shows the action of the water, either in relation to the shore, to a boat, or to the sky. Concentrate on capturing the flow of the waves and the values of earth, boat, sea, and sky. Begin your drawing with a series of gestural lines; then keep working in the same flowing manner, refining the marks and tones to describe the surface and structure of the various elements, still maintaining the feeling of action inherent in the scene.

MAN-MADE FORM IN LANDSCAPE

Nearly everywhere we look in nature, we see the workings of man. Not just in the parks, cities, farms, and reservoirs, but in the woodlands, waterways, and prairies. People have altered the face of the countryside, planting forests, building roads and dams, changing the course of rivers.

Often, human action is not so obvious in natural settings, but in areas such as parks or farmland, we can easily see the efforts of the human mind to order the natural elements, whether for functional or aesthetic purposes. In drawing an area obviously shaped by people, emphasize the organization of the scene. The drawing of a city park requires quite a different approach to lines, values, and textures than a woodland setting.

Exercise 34

CONTRASTING SCENES

(Time: 30 minutes each; material: soft pencil or charcoal)

Draw two scenes from your imagination and memory, using basically the same elements—a public garden or

park in a city, the other a wilderness scene. In both, include these elements: road, water, trees, bushes, shrubs, and grass. Compare the results of your two responses. Then look carefully the next time you are in each setting for textures and other characteristic qualities. Do another drawing from memory after your return from both places.

Our major concern in studying man-made structures is with buildings, roads, bridges, fences, towns, and cityscapes. Here we are required to use our knowledge of perspective. If you feel uncertain about the principles of drawing three-dimensional forms in perspective, return to Chapter Three, the section on rectangular forms, or see the last section in this chapter.

Man-made forms contrast strongly with the organic configurations around them because of their linear structure. They cannot be adequately described in gestural marks, as can trees, water, or clouds, but must be developed with more geometric control. No matter how unusual the building, it should be reducible to a basic three-dimensional shape—a cube, sphere, cylinder, or combination. A barn, for example, could be part cube, part prism (its roof) and part cylinder (its silo). Secondary forms within the basic geometric structure also must be established as simple shapes and developed in perspective. Be careful to capture the particular quality of each structure as you continue to draw. For instance, with a suspension bridge, first establish its overall shape, then develop it in open, flowing lines.

In drawing a barn, try emphasizing its enclosing mass through distinct values and textures.

Create connection between the land and the structure. If you have a house on the hillside, make certain that its foundation relates to the hill, both by its shape and by the interaction of the stone or brick with the surrounding earth. A stone wall is, in part, buried in the ground, as are fence posts and telephone poles. Stress transitions between these forms and the earth as you did with the roots of trees.

When dealing with man-made forms on water, this relationship of structure to surface is particularly important. Be sure, when depicting a dock, jetty, or bridge, that you first determine the surface plane of the river or ocean and make certain that the individual supports line up convincingly right on the water. This should require only a few quick perspective notations. Be certain also to gauge the amount and shape of space between the supports. Remember that the size of the supports and the size of space between them will diminish as the form recedes.

Man-made forms serve compositional purposes in your drawing as well as representational ones. Being geometric, they are easily identifiable in the midst of the organic forms of a landscape and are often the center of attention, even when small. In Chinese landscapes, for example, there is usually a tiny temple hidden among the rocks or a distant boat in the water (see Figure 4.33). These are

Figure 4.32

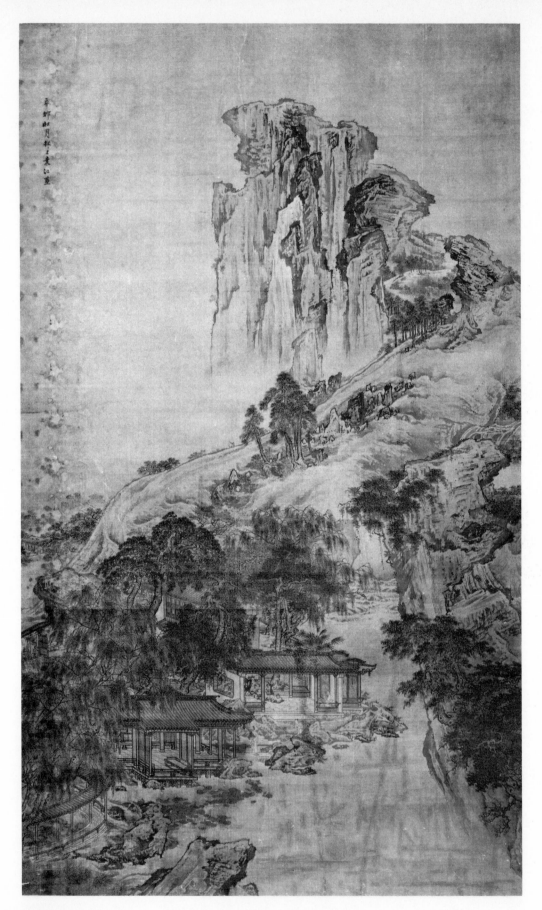

Figure 4.33
YUAN CHIANG (Chinese, 18th century)
Landscape (brush and ink)
Courtesy of the Museum of Fine Arts, Boston. Gift of Edward Jackson Holmes

minute in relation to the surroundings, but catch our eye because of their familiarity and placement. The artist will generally lead us to them by subtle direction lines and tones.

Sometimes man-made structures can direct the eye through a landscape with perspective indicators. A broad road, dominant fence, or large bridge placed at a diagonal is not only a formidable pictorial mass, but also a directional guide with receding lines that can forcefully lead the viewer's eye into the pictorial space.

Exercise 35
STUDYING STRUCTURES 1
(Time: 30 minutes each; material: soft pencil or charcoal)

Do several studies of individual structures in landscape, concerning yourself first with the three-dimensional nature of the form and its immediate relationship with the land. Begin by developing the overall form as a simple geometric shape in perspective. Then add secondary elements and details such as porches, doors, windows, and ornaments, each in perspective. A relatively unimportant aspect of a building can be very distracting if it is out of perspective. Do similar studies of individual bridges, barns, mines, shacks, docks, and boats.

Exercise 36
STUDYING STRUCTURES 2
(No time limit or medium requirements)

Keep a sketchbook for your landscape trips, and draw buildings, bridges, fences, and roadways that interest you. Concern yourself at first with the structure of the

form, then with its position in the composition of the landscape.

Exercise 37
MAN-MADE FORMS IN COMPOSITION
(Time: 30 minutes each; material: soft pencil or compressed charcoal)

Divide your paper into four compartments. In each, do a drawing from reality or a photograph that shows a man-made form (a lone building, small grouping of structures, or a few scattered forms) in a landscape. Develop the composition, using the man-made structures in different relationships to the pictorial space. In one, make the buildings small and distant. In another, bring them to the foreground, cropping off part of the buildings with the frame of the compartment. In each case, be certain that the building is defined in perspective.

Exercise 38
BUILDING GROUPS
(Time: 30 minutes to 2 hours; material: soft pencil or pen and ink)

Do several studies of groups of buildings in a landscape. Start with farm buildings grouped together with fences or stone walls surrounding them, then ghost towns or villages on the plains or mountains. Contrast the man-made structures with the texture of the organic surroundings. Do a final drawing of a cityscape. First, organize the whole area into a geometric form, then develop buildings within as secondary shapes. As a variation, try doing a cityscape using only tones, no lines (see Figure 4.35).

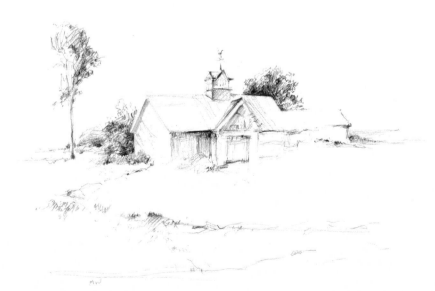

Figure 4.34

Figure 4.35
WALTER BENDER (American, 20th century)
Central Square (lithograph)
Courtesy of the artist

In this cityscape, the scribbled lines have been organized into readable shapes, but the usually solid forms have an open, fragmented quality that allows light to penetrate.

COLOR

The use of color in a landscape drawing adds tremendous dimension, but also extra problems in technique and in composition as well. Colors must be applied to support pictorial construction, values, and movements, while believably describing the landscape itself. In the scope of this book, we will speak only of the use of watercolor and pastels. Other mediums—oils, acrylics, or egg tempera—may be applied to a drawing, but more often their use would constitute a painting.

In preparation for exercises with watercolor, it would be helpful to begin using ink wash to familiarize yourself with the effects and possibilities of a liquid medium.

Exercise 39

WORK WITH LIQUID MEDIUMS 1
(Time: 1 hour; material: ink and brush, water and watercolor paper)*

Sketch your landscape lightly and loosely in pencil. Then, after thinning the ink with various amounts of water, apply your lightest gray to the sky (or the plane that you want to be the lightest). Let this dry, apply your next darkest area, and so on. Indicate all

*See Chapter One for a discussion of watercolor paper.

major planes first, then go on to describe major objects within these planes. Continue your wash drawing by applying ink for the darkest areas and details (see Figure 4.36).

Exercise 40

WORK WITH LIQUID MEDIUMS 2
(Time: 15 minutes; material: cake-type watercolor, pencil, and watercolor paper)

Once you are familiar with the liquid medium and its effects, follow the procedure described previously, using diluted watercolor as a tint. Begin by loosely sketching the general form of a landscape in pencil, then lightly apply the tinted wash. If you keep your colors diluted with a lot of water, you do not have to worry as much about color relationships, since the weaker colors will not clash.

This is an excellent, nonthreatening way to start with color, since tints will relate to each other more easily than will highly saturated colors. As you become comfortable with tints, try using purer colors.

Exercise 41

WORK WITH LIQUID MEDIUMS 3
(Time: 1 hour; material: pencil, watercolor, watercolor paper)

Start as in the previous exercise, but use purer, stronger color. Before beginning to paint, determine your progression of areas from lightest to darkest.

120

Figure 4.36
JEAN BAPTISTE COROT (French, 1796–1876)
Landscape with Large Tree on Left (pen, brush,
and sepia)
Courtesy of the Museum of Fine Arts, Boston

Then begin to apply paint to the lightest areas. Once a dark goes down in this medium, it cannot easily be lightened.

With liquid color, *most of your thinking takes place on the palette.* Experiment with mixing colors, and test them on a piece of scrap paper before applying them to the drawing. Try mixing your greens with a little red to cut down their intensity. You don't have to use pure blue from the cake for the sky; instead, mix in a little complementary color so that the blue is not too electric. Experiment with creating and using neutral areas to offset highly saturated colors. Try using cool, bluish tones in your shadows for variation.

Purer watercolors can be applied over tints, introduced in washes, or applied with a **dry brush.** To apply color to a large area in your drawing (the sky, for example), it is often necessary to use a standard wash technique. Begin by wetting the surface of the paper in the area that you wish to paint. Use a large brush or small sponge filled with water to wet the general area thoroughly. Start to

apply color by brushing horizontally along the top of the page with a broad brush filled with water and paint. Continue to make overlapping strokes with the brush dipped in water, spreading the color until it covers the assigned area. You may also try soaking a small area and dripping some color onto it, letting the color spread as it will.

Pastels are a popular medium for landscape drawing since they offer such an extraordinary range of colors and values. They can be mixed by blending or drawing one over the other. Blending should be kept to a minimum at first, however, to avoid creating a brownish mess. Refer to Chapter One, Basic Techniques and Materials, for technical information on pastels.

Exercise 42

WORK WITH PASTELS 1
(Time: 15 minutes each; material: 7 pastel colors,
tinted pastel paper)

Begin your study of a single landscape or photograph by doing some compositional sketches. Use four colors

for the earth and three for the sky. Choose those earth colors that can stand for various planes and a few (not all blue) for the sky. Create margins on your paper to frame several compositional sketches, and, using your colors, block in the general scene. Add a few details as necessary, but be careful in your overdrawing. Keep your areas legible and unsmeared. Do several of these sketches, trying different combinations of colors and different compositional designs. Change the height of the horizon line and rearrange forms as necessary.

Exercise 43

WORK WITH PASTELS 2
(Time: 15 minutes each; material: pastels, tinted paper)

Try experiments with blending by building up layers of color. Begin by using two shades of green. First, apply a layer of one green, then apply a layer of the other over the first at right angles, so that the first shows through. Do a similar experiment by first applying a complementary color, perhaps red or rust, to the paper, and draw over this with a green, allowing the undercolor to show through.

*For creating a sky, you can use three or four different shades of blue, drawing over them with white to help blend the edges. Remember, however, not to restrict yourself to just blues in the sky. Try infiltrating other **pastel** tones along with blue and gray.*

Exercise 44

WORK WITH PASTELS 3
(Time: 1 hour or more; material: set of pastels [minimum of 12], tinted paper)

Working from the original scene or photograph, begin a new drawing on a larger scale. Maintain the same composition and general color scheme as in your most successful compositional sketch. After lightly blocking in the primary colors, work into these, cautiously at first. You can draw over pastels to a certain degree, but eventually the new marks won't register and will just slip. At this point, spray on a little fixative and let it dry. Then continue to draw lightly, so you won't break down the "fixed" layers. Remember to be careful when placing darks. Putting extreme lights (like those found in the sky) over darks can be tricky.

LINEAR PERSPECTIVE

Linear perspective in landscape drawing serves several purposes: first, it establishes a sense of three dimensionality by reproducing (more or less) the proportional relationships that we actually see; second, its receding lines act as guides, which can lead the eye into and around the composition; third, perspective establishes a vantage point, the viewer's position in relation to the scene.

If perspective is to serve compositional purposes, it is often necessary in your drawing to rearrange or alter the scene—move a road, change the angle of a building, raise or lower the eye level. This type of compositional alteration, along with the creation of landscape and cityscape from the imagination, requires a solid foundation in the principles of linear perspective. The exercises in this section have been designed to strengthen your understanding of these principles and prepare you for more advanced work. If the exercises are to be understood, it is necessary for you to do them. Reading alone is not sufficient. NOTE: Actual scenes may not fully conform to the rules set out here. Use the principles as guides when looking at nature, but be prepared to change your conception, when necessary, to be in accord with reality.

The Principles of Perspective

1. Objects or parts of objects diminish in size as they recede into space.

2. Receding parallel lines appear to converge at a point on the horizon line called the vanishing point.

3. Objects closer to the viewer overlap those farther back in the same line of vision (see Figure 4.37).

In the following pages, we will be using several terms to explain these principles. Briefly stated, they are:

Diminution: visual illusion that objects become smaller as they recede into space.

Eye Level: the height of the viewing point in a picture.

Foreshortening: visual illusion that part of an object is smaller as it recedes into space.

Horizon line (ideal horizon line): line where land and sky would meet if the terrain were completely flat (see Figure 4.38).

Horizontal lines: lines that run from side to side, parallel to the flat plane of the earth and to the top and bottom of the paper.

Figure 4.37
Overlapping forms

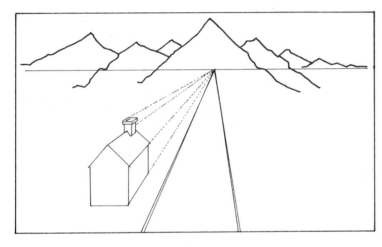

Figure 4.38
Objects recede to a point on the "real" horizon line.

Parallel lines: lines equidistant from one another at all points. (Parallel lines that recede appear to come closer together as they approach the vanishing point.)

Receding lines: lines that move back into space.

Vanishing point: point where parallel lines meet as they recede into space.

Vertical lines: lines that run from top to bottom, perpendicular to the horizontal lines and parallel to the sides of the page.

Eye Level

The height from which you view a scene or object determines the shapes that you see. Place several objects on a table and view it from different heights. Begin with your eye at floor level. Here you look up from a "worm's eye" view, seeing the bottom of the table and the objects upon it high above you. A perspective drawing at this eye level would give the viewer an impression that he or she was very small.

Gradually stand, keeping constant watch on the changing shapes of the table and objects, until you are about even with the objects on the table. This is a more familiar position. If the objects were houses on a street, this point of view would be closer to the normal human vantage point. Continue to stand until you are directly above the table. Here you have a "bird's eye" view. A drawing of a scene from this eye level would give the viewer a sense of being very tall or very high up. Notice how forms from a lower vantage point overlap one another. They do not when viewed from above.

Exercise 45

CHANGING LEVELS
(Time: 15 minutes each; material: sketch pad, soft pencil)

Draw a street that you know from three different viewpoints, one from ground level, one from two or three stories up, one from 10 stories up. Do the same with a landscape. Begin at the bottom of a hill, then stand at a higher level and draw the same scene. Do a third drawing from a higher level, notice how the scene has changed.

Figure 4.39

Horizon Lines

In a perspective drawing, receding lines return to a point on the ideal horizon line. This may be different from the visible horizon line where earth meets sky, formed as it is by mountains or buildings that rise from the surface of the ground. The ideal horizon is the line where the earth would join the sky if the terrain were completely level. The sea and sky meet at the ideal horizon line, which is at eye level. This line changes height as you raise and lower your vantage point, and the amount of earth or water that you see changes with it. View the ocean, plains, or desert sitting on flat ground, and you will see only a short distance before you. Stand on a high cliff, and you see for miles. Look at the horizon from either point, and *you will see that it is exactly the same height as your eye* (see Figure 4.40).

Figure 4.40
Different eye levels: (A) of person on the street; (B) seven stories up; (C) somewhat below ground level, looking up at a building on a hill

When you establish a horizon line in a drawing, you are essentially establishing eye level and telling the viewer at what height he or she is standing in relation to the scene.

Vanishing Point

The vanishing point is the place where receding parallel lines meet. If the parallel lines are horizontal, like lines of a road, the roof lines of houses or telephone wires, they will recede to the vanishing point on the (ideal) horizon line. Vertical or diagonal lines may recede, but will not go to the horizon line. The vertical lines of a tall building will converge at a point somewhere in the sky; the walls of a deep well will converge at a point in the earth (see Figure 4.41).

Figure 4.41
This building actually receded to three vanishing points—two on the ground and one in the air.

Receding horizontal lines above the horizon will appear to go down to the vanishing point; those below the horizon will appear to rise as they recede. The horizon line is the great equalizer.

Every set of parallel lines recedes to its own vanishing point. In a natural scene, like the interior of a room or a courtyard, several sets of parallel lines might be apparent: lines of walls, furniture, or floor tiles. Each will recede to its own vanishing point. Don't despair. Generally there are only one or two major vanishing points that you have to worry about.

In making a perspective drawing, it is necessary to determine each vanishing point by continuing the lines of only one object. Once that vanishing point is established, all lines parallel to the original lines will converge at that point.

One-Point Perspective

The most familiar example of one-point perspective is a view looking down a long, straight road or a railroad track. With flat terrain, you can actually see the vanishing point on the horizon line. Parallel lines on structures along the road or track will go to the same vanishing point—lines of houses, sidewalks, fences, and so on. In an interior view, one-point perspective is found when looking down a long corridor or directly toward a back wall. Lines of the floor, walls, and ceiling will all converge at that one point, as will lines of windows, doorways, and all furniture parallel to the walls (see Figure 4.42).

Figure 4.42
Interior in one-point perspective

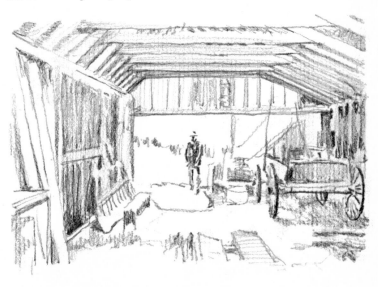

Two-Point Perspective

When looking at the corner of a building, room, or rectangular object, or at a place where two roads come together, we are confronted with a two-point perspective problem. In this case, there are two primary sets of parallel lines and two vanishing points on the horizon line. Each perpendicular horizontal line will recede to a different vanishing point. For example, the front and back of a house will recede to one vanishing point; the sides will recede to the other vanishing point. All other lines, parallel to these, will return to the appropriate vanishing point.

Stand at a street corner. Use your peripheral vision to view both streets as they recede into space. Notice the level of the horizon line; trace the lines both above and below your eye level as they recede to their vanishing points. Do this for both sides.

When drawing the interior of a room in two-point perspective, you will be facing the corner where two walls meet. The lines of each adjoining wall will recede to a vanishing point; the left wall to a vanishing point on the right, the right wall to a point on the left. These points will appear to be very far apart, and you will have to turn your head to locate them.

In beginning a drawing of this type of scene, establish both vanishing points and draw two lines from each, one above and one below the horizon. The lines will intersect at the corner of the room, and a vertical line connecting them will establish the two walls. As the lines continue, they will define the ceiling and floor of the room (see Figure 4.43).

Exercise 46

*INTERIOR IN TWO-POINT
PERSPECTIVE*
(Time: 30 minutes; material: soft pencil)

Draw an actual interior in two-point perspective. First, trace the walls back to their vanishing points and indicate these points on your paper. Draw lines from the vanishing point indicating the walls; then develop the interior, adding furniture, windows, and such, all of which should recede to the vanishing points.

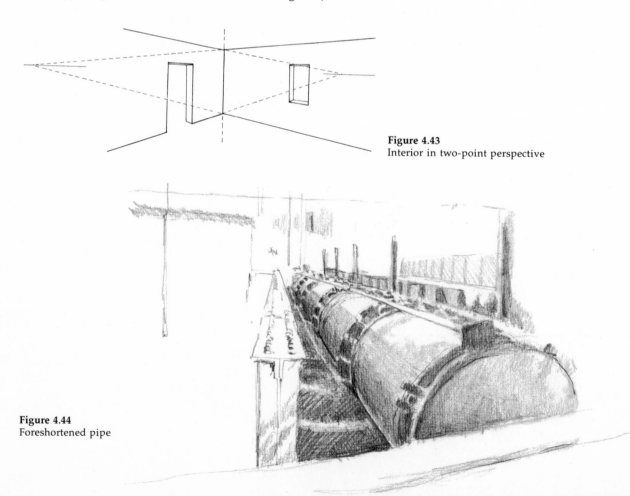

Figure 4.43
Interior in two-point perspective

Figure 4.44
Foreshortened pipe

Diminution and Foreshortening

In both diminution and foreshortening, size proportions are determined by the use of perspective lines. In *diminution*, if you want an object in the background of a picture to appear to be of similar size to an object in the foreground, take the lines from the first object to the vanishing point. Draw the second object, using these receding lines, at the position in space where you want it to be. Once the size is established, the object can then be moved **laterally** across the road or across the page as is necessary for the composition of your picture (see Figure 4.45).

In foreshortening, (see Figure 4.44) there are mathematical principles to determine the proportional relationship between the width of the front of an object and the length of a foreshortened side. But for the beginner, it is much simpler to determine this relationship by eye and common sense. Draw lines to the vanishing point from the corners of a square.

Stop the line at different places and draw vertical and horizontal lines to establish the side of a three-dimensional block. If the block were a house, how long would you want it to be? Each set of lines will make the house a different length. Judge the length of the house by eye to determine a logical size. Remember that the length of a building closer to the horizon line will be shorter proportionally than that of a building closer to the front plane. Look at buildings on a long street to familiarize your eye with the proportional relationship of foreshortened forms.

Determining the Middle Point of a Rectangle in Perspective

If you want to divide a foreshortened plane in half, draw a diagonal connecting each corner. They will meet at the center of the side. A vertical line through this point can help place the top of a roof (see Figure 4.46).

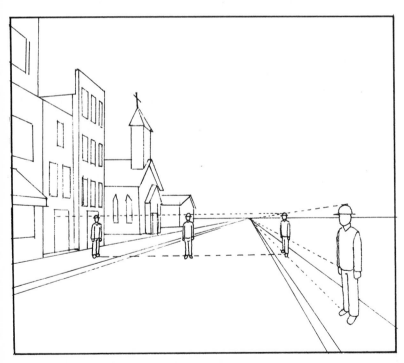

Figure 4.45

Figure 4.46
(A): Finding the middle line. (B) and (C): By determining the middle point in a rectangle, you can go on to make rectangles of similar proportions receding into space.

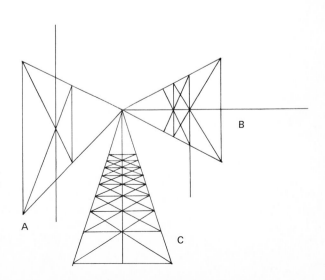

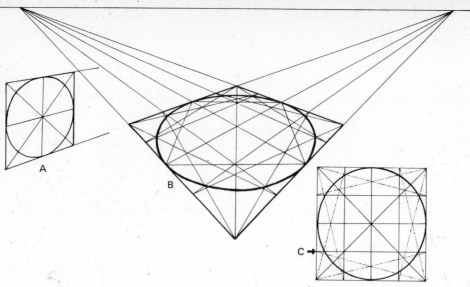

Figure 4.47

(A) Simple circle in perspective. Use your eye to help you form the ellipse. Remember that the far side will be both shorter and narrower than the side closest to you.

(B) A more complicated approach will give you a more accurate circle, providing several points to help you place the perimeter. Divide the circle into 16 parts (subdividing as described in Figure 4.46). Connect the corners as shown, with dotted lines. The edge of the circle intersects these lines at point (C), marked with an arrow. You must still use your eye and a steady hand to determine the arc of the ellipse accurately.

Drawing a Circle in Perspective

Begin with a rectangle that recedes to the vanishing point. Establish a center line (as described previously) on the horizontal lines and find the middle of the vertical lines as well. Then connect these middle points with a curving line to create an ellipse. Note that the side of the ellipse closest to the horizon is narrower. Erase the rectangle, and you have your circle in perspective. This is a very simplified way to draw a circle. Figure 4.47(B) shows a more accurate but complicated approach.

Exercise 47

SCENES IN ONE- AND TWO-POINT
PERSPECTIVE 1
(Time: 30 minutes each; material: soft pencil)

Copy two newspaper or magazine photographs of street scenes, one that shows one-point perspective and one showing two-point perspective. First determine the horizon line and vanishing points in your drawing; then establish the buildings, using lines of perspective to structure major forms and details.

Exercise 48

SCENES IN ONE- AND TWO-POINT
PERSPECTIVE 2
(Time: 30 minutes to 1 hour; material: soft pencil)

Draw an actual street scene using one-point perspective. First establish the horizon and vanishing

point. Then block in the buildings in perspective. Develop the drawing by adding details as they appear in perspective. Do a similar scene using two-point perspective.

Exercise 49

IMAGINARY STREET SCENES
(Time: 30 minutes to 1 hour; material: soft pencil)

Draw a street scene from your imagination using one-point perspective. Include one receding street, at least three houses, a sidewalk, several trees and people along the street. Add any details to the houses, street, or environment that come to mind. Begin by establishing a horizon line at a natural eye level. If the horizon is too high on the paper, you will be forced to draw the buildings from a "bird's eye" view. If it is low, you will establish a scene looking up at houses in a "worm's eye" view. To make the horizon at a natural height, place it about one-third of the way up from the bottom of the page. Begin to draw houses by establishing the front rectangle, then take a line from each side back to the vanishing point. Draw the tops of the doorways slightly above the horizon to allow an imaginary person of your height to enter (see Figure 4.48). Remember to keep vertical lines vertical, nonreceding horizontal lines horizontal. Only the receding horizontals return to the vanishing point.

Do a similar exercise using two-point perspective. This time use two streets that would naturally come together at a right angle. Keep your vanishing points far enough apart to make a believable view (see Figure 4.49). Unless you are drawing very small, it will be necessary to place one or both vanishing points off the surface of the drawing paper. To

128

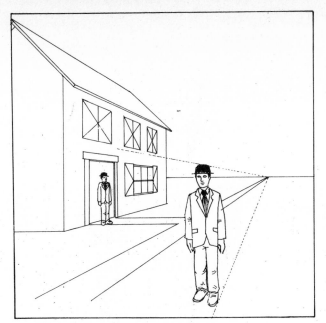

Figure 4.48
The top of a natural "doorway" would be somewhat above the horizon line (eye level) to allow viewers to enter without hitting their heads.

Figure 4.49
(A) Even in this relatively normal view, you must be standing at quite a distance from the object to be able to see both vanishing points at once.
(B) To have vanishing points this close together, you would have to be viewing an odd-shaped building or a normal building at a tremendous distance.

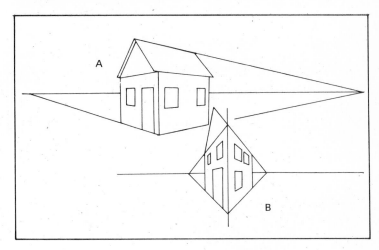

do this, work on a large table or the floor. Attach three sheets of paper together to form one long sheet. Draw a horizon line across the three sheets with a yardstick and place vanishing points on the two side sheets. Draw your scene in the middle sheet, taking perspective lines back to the vanishing points on the adjoining pages.

> *Begin to draw by establishing the intersection of the two streets and the edge of the building on the corner. Take lines back to both vanishing points from the corner of this edge and establish the shape of the building as if it were a box. Set up three other buildings on each street, beginning with the corners and taking lines to both vanishing points. Place houses, sidewalks, trees, and people in proper perspective. Remember to keep your vertical lines vertical.*

Exercise 50

IMAGINARY INTERIORS IN
PERSPECTIVE
(Time: 1 hour each; material: soft pencil)

Do two studies of an imaginary interior, using one- and two-point perspective. Include in each picture a table, chair, doorway, and window, which will be drawn in perspective. You also may choose to include other furnishings and people. Begin as you did in the previous exercises, establishing horizon lines and vanishing points. Then set up the walls, floor, and ceiling. Once again, place your horizon at a natural eye level and, in the two-point perspective scene, place your vanishing points at a reasonable distance from one another.

Figure 4.50
Diminishing
street lights

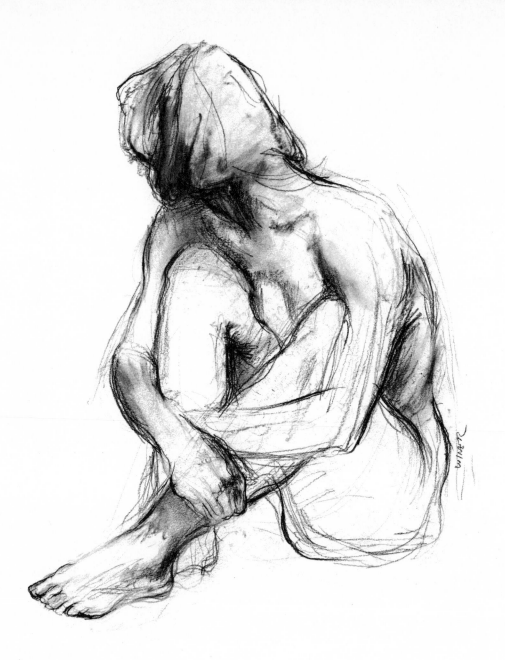

I N THE HISTORY OF ART, the human figure
has remained the most consistent and in-
exhaustible inspiration. Our fascination stems
from the fact that as we observe and draw
another person, we add to our own self-
knowledge and awareness. Figure study en-
tails not only working from the nude but also
from clothed figures in ordinary circum-
stances. In this chapter, we will deal with
both.

Many people feel intimidated when first
working from a model, knowing that the com-
plexity of the body, with its animation and
flexibility, would require years of study to

draw it well. The apparent difficulties should
not be discouraging, however. Just as in any
other drawing problem you must learn to or-
ganize and simplify what you see in order to
make complex issues understandable.

*The first task is developing a progression
to your visual thinking: learning to see and
work from the general to the specific.* Begin
by trying to see the body as a whole without
preconceptions. Don't seize upon details, but
rather note the basic forms and proportions,
then move on to the subtler shapes, shadows,
and lines.

You may notice that you have some in-

CHAPTER FIVE

The figure

hibitions about looking at a nude body, and it could take a certain amount of training and experience before you can allow yourself to see it objectively. Because of this, it would be useful for you to draw the people that you see every day, so that you become familiar with the basic structures and movements of the body before working with a nude.

Exercise 1

SKETCHING PEOPLE 1
(Time: 1–5 minutes; material: pencil)

Carry a small sketchbook all the time as you did for landscape drawing. You could regard it as a diary with *consistent entries or simply as a scratch pad for doodles, notations, and sketches. The essential thing is to integrate the action of drawing into your day.*

Draw all kinds of people in a full range of activities: sitting, standing, walking, watching TV, waiting for buses, asleep on trains. Remind yourself to see and note the whole shape or posture of your subject first. These will be very quick drawings, allowing you only enough time to identify and draw the general forms.

Continue to use this sketchbook to supplement your work from the model. As you develop new skills and techniques studying the nude, apply them to your investigations of clothed figures.

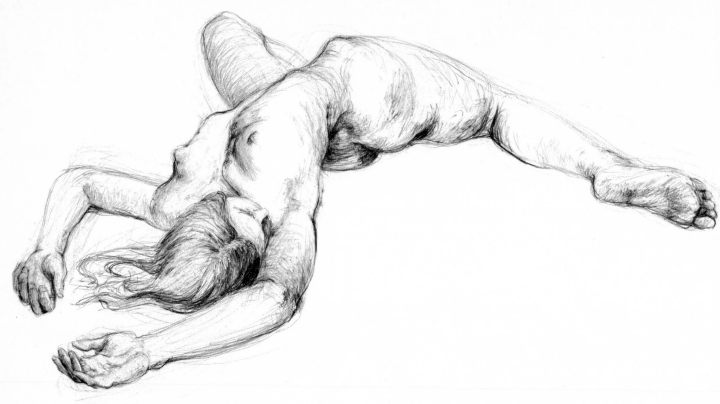

Figure 5.1
MARC WINER
Twisting Nude, No. 4

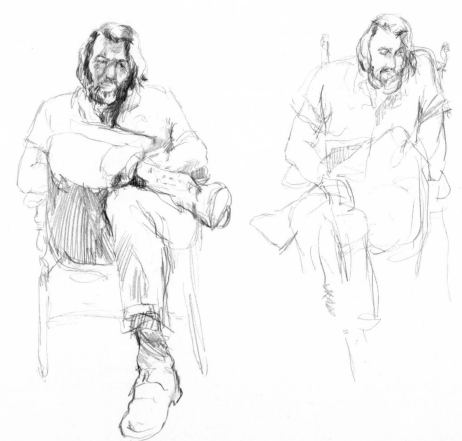

Figure 5.2
Two Drawings of a Friend

Exercise 2

SKETCHING PEOPLE 2
(Time: 5–15 minutes; material: pencil)

*Draw a person who will hold a fixed position. Perhaps you can get a friend to pose for you. First, lightly sketch out the **gesture** of the person as you did in Exercise 1. Then continue to develop your drawing by examining the subject's posture more carefully. How does the person hold him- or herself? Is the head erect, tilted to one side, or leaning forward? Are the shoulders slouched or straight, relaxed or tense? Does the stomach or chin stick out?*

Exercise 3

SKETCHING PEOPLE 3
(Time: 15 minutes to 1 hour; material: pencil)

*After lightly sketching in the larger essentials of your subject, try to make your drawing more convincing by indicating specifics of clothing, hair, or glasses. The twisting of a shirt pattern when stretched over a body can go a long way toward describing the form underneath. Wrinkles, folds, belt, and glasses all may be used, not only as textural devices, but also as **three-dimensional indicators.***

Exercise 4

SKETCHING YOURSELF 1
(Time: 1–5 minutes each; material: pencil or charcoal)

*You might begin the process of objective observation with yourself. Try first of all to assess your particular body type, postures, and movements. Make several quick sketches of yourself in characteristic attitudes. Look at yourself the way you would look at another person. See yourself the way another person would see you. This exercise can be done from visual and **kinesthetic** memory or with the aid of a mirror.*

Exercise 5

SKETCHING YOURSELF 2
(Time: 15 minutes; material: pencil or charcoal)

Make a longer drawing of yourself, sitting or standing in front of a full-length mirror. First, make a quick sketch in the chosen position, then indicate details, such as clothing, facial expression, hair.

The result of this exercise will not be a finely honed self-portrait, and you should not worry if it doesn't look like you. You are not expected to be able to draw a convincing self-portrait at this point. However, if you look objectively at your drawing, you will find many elements that do speak of you. (See Figure 5.3.)

When doing these exercises, be objective in your observations. Try to see other people

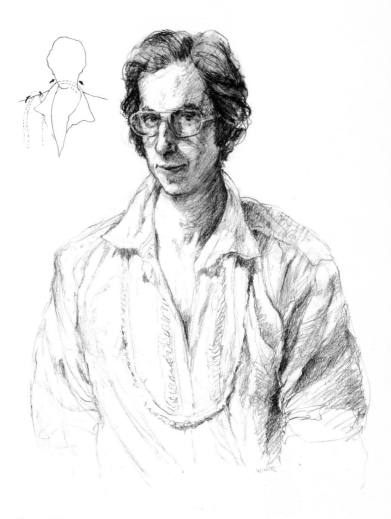

Figure 5.3
Extended self-portrait showing how clothes, glasses, and such can be used as three-dimensional indicators. Note that the wrinkles of the shirt across the body suggest the shape of the form underneath.

simply as they are, without value judgments, and try to do the same when observing yourself. One of the major problems in seeing occurs when our tastes and judgments cloud our perceptions. We think ourselves or other people too fat or too skinny, unattractive or beautiful without looking beneath these stereotypes. If you look at other people (and, most importantly, yourself) without preconceptions, you will undoubtedly find an interesting, even entrancing, subject. Then, as you begin to draw, continue to maintain this objectivity. Seek out the forms and structures underneath the surface. Indicate the shapes and shadows, lines and textures, simply and accurately.

The exercises in the next section will call for the use of a nude model. The studies from the nude are essential to understand the way we appear in clothing. We will continue to discuss and draw from the clothed figure later in the chapter. It should be noted, however, that any exercises described here can be effectively adopted to drawing a clothed figure.

WORKING WITH MODELS

If you are working independently of an art school, you will have the responsibility of hiring a model. Friends may be willing to pose for you, but they may not be so willing to work in the nude. In addition, they may prove to be unreliable or unprofessional. An experienced model knows how to use his or her body to create and maintain effective and artistic poses. A nervous amateur may lack the sensitivity and stamina necessary for the work, and may create an uneasy atmosphere as well. The best recourse would be to hire a professional through a local school or center for adult education. Many schools have lists of models and would be willing to give you information if you demonstrate a serious and sincere interest. You may find models listed in local newspapers or on college bulletin boards, or you may place a notice yourself. Since models generally charge $4 to $5 per hour, most students hire a model as a group.

Find a large space to work in. Allow each student enough room to work comfortably, at least five feet from the model. It is difficult to see a pose if you are much closer than this. Be certain that the space is well ventilated, well lit and reasonably warm. The model will need space to move around in and possibly some props such as chairs, stools, or poles to lean on. A rug over a cold floor or stand is essential. Many models prefer a changing room.

A typical session with a model lasts 2 or 3 hours. During this time, the model will pose for periods of 20 to 30 minutes with 5 to 10 minutes break time between sets. Most professional models like to choose their own poses, although many will ask what type of poses you prefer—long or short, sitting, standing or lying down, active or relaxed.

Sessions generally begin with a series of short gesture poses followed by a selection of longer poses. Refer to the following exercises for a list of possible activities. These are presented in order of difficulty, but need not be followed chronologically. Avoid arguments over the length and type of pose by determining the sequence beforehand.

Some of the exercises require the use of bright spotlighting. You may use large 75–150 watt reflector bulbs mounted in ceramic cartridges or in reflector units (available at hardware stores). They generally have spring clamps and should be mounted as high as possible in the room. If there is no space on the ceiling, an easel or an extending camera tripod can be used.

It is best if students can use easels; however, if these are not available, drawing boards can be situated vertically on the back of chairs. (See the section on easels in Chapter One under Materials.)

Needless to say, models must be treated with sensitivity and respect. They are professionals doing a demanding job. Be certain that the conditions are adequate, that models are called well in advance, and that payment is received on time.

You might begin each drawing session by choosing one or more of the warm-ups described in Chapter One and continue with a series of gesture drawings.

Gesture Drawing

In gesture drawing, the model takes a series of poses that last for one minute or less, while the student draws the complete figure. This is usually done by making a series of scribbles to indicate direction, lines of movement, shapes, and important locations. Hopefully, this scribbling will get you back to that time in your life when just moving your hand over paper and leaving marks was natural and fun.

Gesture drawing should be regarded as a physical activity. Fully utilized, it demands the use of arm, back, and even leg muscles. Your attitude and activity are similar to those of the warm-up exercises. When drawing, use

large, loose, flowing strokes. Try to capture the action of the pose, what the pose is doing, not what the model looks like.

Gesture embodies three very important functions: first, it is a preliminary or warm-up exercise designed to relax; second, it helps you to see and deal with the whole body; third, in defining primary structure and movement, it forms an **undersketch** for more elaborate drawing. This last point is extremely important. The gesture of the pose, its action and design, should be the first thing seen when beginning to draw the figure. Often an artist will indicate the gesture in a series of quick scribbles before developing a more finished drawing. Even if these scribbles are not actually drawn, the observation that they represent will necessarily precede any other type of figure drawing. Picasso and Matisse, for example, could never have done their expressive contour drawings if they were not thoroughly aware of the underlying gesture. In many of the following exercises, we will suggest that you begin longer drawing with quick gestural notations.

Although gesture drawing urges you to see and draw quickly, it is not necessary to rush—a minute is plenty of time to make adequate notations of movement, balance, and rhythm. By working smoothly and fluidly, you can capture the spirit of the pose and maintain a sense of relaxation. Putting down hasty, sporadic marks can work against this important goal. Gesture is designed to relieve you of the problems involved in trying to make a figure look convincing. It should be easy and fun. If it isn't, you're working too hard to "make a drawing."

Before beginning to draw, look at the *entire* pose for a few seconds. Even in a very quick pose, this moment of looking will increase your comprehension of the whole. See if the pose has a general shape or thrust that might serve as an indication of its action. *Notice how the feet relate to the head.* Look for lines of movement that can both define the balance and weight of the pose while uniting its parts. In action, the body operates as a series of movements and countermovements. These create a rhythmic line that can give unity and direction to the pose (see Figure 5.4).

Students often ask, "Where do I begin?"

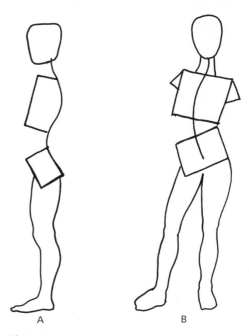

A B

Figure 5.4
Movement and Countermovement. (A) Side view. The action of the spine defines an in-and-out movement as it curves around and under the rib cage then in at the small of the back and out again to attach to the pelvis. The block-like forms of rib cage and pelvis tilt in opposite directions even when the body is "straight." (B) Front view. When the weight is shifted predominantly to one leg, the supporting hip is raised. To maintain balance, the spine curves and the shoulders slant in the opposite direction to the slant of the hips.

Since this is not a fast contour drawing, we suggest that you start inside the body with lines that are basic to the feel of the pose, indicating the movements described above. In most cases, you should not start with the head in a gesture drawing nor add it as an afterthought. When you are about to indicate the head, see how it too is part of the whole direction of the pose. Don't stick a pumpkin shape willy-nilly on top of the shoulders. Try indicating the general shape and position of the head along with a quick notation of the nose, eyes, or jaw. Don't go into any detail.

As you draw, look at your paper only occasionally to make sure you are in the right place, and then return your eye to the model, rather than glancing at the model and then trying to do most of your drawing from memory. This exercise will help you to see the body as a structural whole. It will also instill a sense of vitality in your figure work since, in the physical action of gesture drawing, your own **kinetic** system is activated.

Figures 5.5 A and B
Gesture drawing developed

your charcoal off the page, and do not take your eye off the model. Begin at one point on the model, preferably in the interior—an armpit or the navel, for instance. Continue to draw across the surface of the form until you have examined the whole body. At first, the result of this exercise may be a great incomprehensible scribble, but eventually, as you learn to guage distances more accurately, the scribble will come to look more like the pose. You should stand at the side of your easel to rid yourself of the temptation to look at your drawing.

Exercise 8

CONTINUOUS MOVEMENT 1
(Time: 2–10 minutes; material: compressed or vine charcoal, large newsprint)

In this gesture exercise, the model moves slowly, but without stopping through a series of repeated movements (see Figure 5.6). Draw fluidly and continuously without lifting the charcoal from the paper. Don't try to make it look like a person, deal only with lines of movement. The result will probably resemble a stroboscopic impression of motion.

Figure 5.6
Continuous movement drawing

Exercise 6

SHORT GESTURE DRAWINGS
(Time: 1 minute each or less; material: compressed or vine charcoal, large newsprint paper, at least 18" by 24")

Do a series of 15 one-minute gesture drawings. Stand up straight and far enough from the easel* so that your arm is doing the drawing, not your hand or fingers. Hold the charcoal between your thumb and fingers as shown in Chapter One. (See Figure 5.5.)

 The following exercises are necessary variations to the basic gesture sketches and are used as supplements to Exercise 6.

Exercise 7

LEARNING TO SEE
(Time: 30 seconds to 5 minutes each; material: vine or compressed charcoal, large newsprint)

Do a gesture drawing without looking at your paper at all. Let your eye move over the model and let your hand follow in one flowing movement. Do not take

*For a discussion of easels, see Chapter One.

Exercise 9

CONTINUOUS MOVEMENT 2

(Time: 10 minutes; material: vine or compressed charcoal, large newsprint)

A variation on Exercise 8 has the model moving slowly and then stopping in an unexpected pose for 20 seconds, then continuing to move. In this exercise, you may draw continuously in the same flowing lines described above, or simply wait until the model stops moving to draw.

Exercise 10

MEMORY POSE

(Time: 5–10 minutes; material: compressed charcoal)

The model assumes a pose for 2 or 3 minutes while you just look *at the pose to grasp the most essential relationships. After the model leaves the stand, try to draw the pose from memory, thinking of the gestural lines and the major shapes of the body. This is a superb exercise for training* **field vision.** *Since details will be of little help in putting down a convincing image, you will learn to ignore them and see only the basic structure of the pose.*

Exercise 11

KINETIC SENSATION

(Time: 10–15 minutes; material: compressed charcoal, newsprint)

Another type of gesture drawing is based totally on **kinetic** *sensation and* **empathy.** *Again, the final work may not look much like a human being. Begin the exercise by trying to sense yourself in the model's position, being aware of his or her weight distribution, movement, tensions, and body type. Then draw from*

these sensations, looking solely at the model, allowing anything to come out as it will. For example, if you see a stretch or a pull, you might represent it with a straight line; tensions or pressures, with a series of short, nervous lines; or relaxation with a flowing gestural curve (see Figure 5.7).*

Exercise 12

SKELETAL GESTURES

(Time: 5 minutes; material: soft pencil, charcoal)

An anatomical gesture drawing may be developed by seeing the movement of the spine and activity of the rest of the body that results from this spinal movement (see Figures 5.8, 5.9). Before beginning to draw, notice the angle and position of the spinal column. To see this angle, compare the line of the spine to an architectural vertical or horizontal line in your immediate field of vision, like a doorway or a floor board. Measure with your eye how the line of the spine diverges or curves away from the set perpendicular.

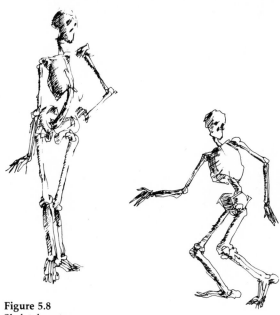

Figure 5.8
Skeletal gestures

The line of the spine is most obvious from the rear, where it forms a valley and a ridge directly down the middle of the back. It also may be seen in the front by tracing a line through the center of the neck, between the collar bones, the breasts or chest muscles, then through the center of the stomach and the navel to the pubic area. Many models have a thin white line visible, or a line of hair running the length of the torso, which follows and reveals this spinal line. By carefully judging the angle, the curve, and the direction of the line, you can see the extent to which the pose is

Figure 5.7
Kinetic
sensation
and empathy

twisted, turning, or bent. You also may note how this line relates to the lines of balance mentioned earlier.

When beginning to draw, indicate first the direction of the spine. See if this direction is carried through to the arms and legs or if they are working contrary to this primary flow. Note the position and shape of the head, rib cage, and pelvis as they are arranged on the spine. Their arrangement, along with the direction of the arms and legs, describes the action, thrust, and balance of the pose. Draw the limbs and forms as simple shapes (see Figure 5.9). A further discussion of the spine and primary skeletal structure will be found in Chapter Six, Anatomy.

Exercise 13

EXTENDED GESTURE

(Time: 5–10 minutes; material: compressed or vine charcoal, charcoal pencil, or soft lead pencil)

One way to approach the extended drawing without losing your freedom or relaxation is to do a longer gesture sketch. Here you see and draw all over the figure in fluid lines during the whole term of the pose. This is something like a series of gesture drawings over one another. Begin by using light lines, pretending that you have only a minute to draw the whole pose. Then pretend you have been given a second minute, and so

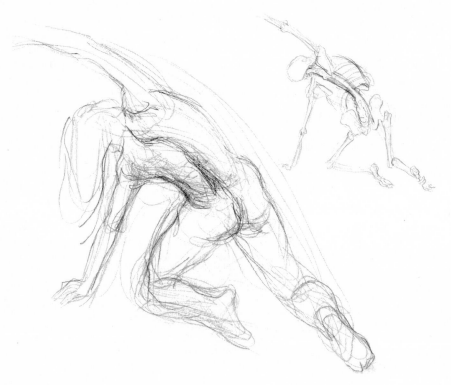

Figure 5.9
Gesture showing spinal movement and skeletal gesture

After a period of gesture drawing at the beginning of each drawing session, continue into the longer and more difficult exercises. Try to maintain the sense of relaxation even when doing a demanding study. You may find yourself responding to a short pose with quickness and vitality, but tightening up and slowing down when allowed five minutes or more to draw. With this tightness may come an overconcern with details and a loss of the proportional accuracy that came spontaneously in the gestural sketches. No matter how long the pose, try to see the figure as a whole first.

on. With each minute, maintain the flow of the gestural line, but try to define the shapes of the figure more accurately, using darker lines if necessary (see Figure 5.10).

There are many options open for the choice of longer figure studies, ranging from the extended gestural sketch to a fully developed composition. Often artists will simply draw without any special plan, but many times a teacher or student will choose to select exercises that will facilitate a particular awareness and understanding of the figure. In the remainder of this section, we will list exer-

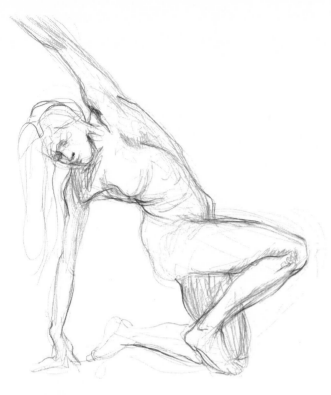

Figure 5.10
Extended gesture drawing

cises used to solve various drawing problems. The student may then choose those that are appropriate or invent new ones based on the exercises listed. A later section in this chapter, The Finished Drawing, explains by example how these exercises may be combined to create a total work.

Before describing this, we will present a series of brief essays explaining specific areas and concepts in figure drawing. These include: proportion, foreshortening, hands and feet. You may wish to refer to this section intermittently while doing the exercises. The last section includes discussions of color, the clothed figure, multiple figures, and the figure in composition.

Geometric Simplification

By seeing the shapes of the body as if they were geometric forms, you can train yourself to seek out the general structure of the figure. This conscious, analytical approach involves breaking down the body into component parts and simplifying them to understand

how all parts relate to the whole. Observe how physically separated forms in the pose can be connected. For example, the line of the hip might lead into the line of the neck.

In these exercises, be aware of the primary underlying structures of the body. You might refer to the next chapter, on anatomy, to familiarize yourself with the forms that mold the surface. Students are often quick to indicate obvious but superficial characteristics, such as body hair, nipples, and so on, not realizing that they are formed by and over inner structures of bone and muscle. Frequently, these elements are rendered insistently geometric. It is important to remember, however, that within any organic image strong geometric shapes—circles, triangles, or squares—will pop out and demand attention.

Exercise 14

GEOMETRIC SHAPES 1
(Time: 5–10 minutes; material: pencil or charcoal)

Begin by drawing a geometric shape in which the entire figure is contained. It could be rectangle, circle, triangle, or trapezoid, depending on the nature of the pose. After noting this, look for the large fundamental shapes within the body. For example, see the arms together as one shape, the legs as another, and the torso

Figure 5.11 (top)
Two-dimensional geometric drawing of a figure

Figure 5.12 (bottom)
Two-dimensional shapes have been played down, and the natural form is revealed.

as a third. Observe how the generally oval shapes of the head, rib cage, and pelvis relate to one another. The idea here is to look at the body simply as a collection of shapes, not as a human form. By simplifying in this manner, a difficult and complicated pose might be seen first as a triangle, an unusual hand position might be seen as circular (see Figure 5.11).

Exercise 15

GEOMETRIC SHAPES 2
(Same time and material as in Exercise 14)

Use the same approach described above, but do not make the shapes rigidly geometric. Keep aware of their underlying mechanical shape, but imbue your line with a more sensitive and investigative quality. Be more aware of how the geometric shapes can be related to the organic form of the model (see Figure 5.12).

Solidity and Mass

Another geometric exercise involves representing the forms of the body with three-dimensional shapes. For example, draw the head as an **elliptical** sphere, mounted on the cylinder of neck, the torso and pelvis as blocks, and so on. Each individual part is seen as a solid geometrical shape, from the rib cage to the phalanges of the fingers. (Many art supply stores sell small wooden models constructed according to this principle.) This exercise pays special attention to the planes of the figure and demands shading appropriate to the forms (see Chapter Two on forms).

Exercise 16

THREE-DIMENSIONAL FIGURE
(Time: 15–30 minutes; material: compressed charcoal or soft pencil)

Have the model take a relatively simple position, and set up lighting so that the form is well defined by light and shadows. Overhead lights placed predominantly to the front and one side are best. Begin by drawing the form lightly as if you were doing the two-dimensional geometric drawing in Exercises 14 and 15. Then, over this initial sketch, draw three-dimensional forms as you see them, shading and modeling the surfaces in general ways, as you did with eggs, blocks, or cylinders in Chapter Two (see Figure 5.13).

When dealing with longer poses it is important to observe the body from all sides in order to understand the shapes involved.

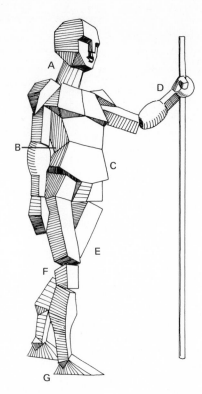

Figure 5.13
Three-dimensional figure. This is one way of representing the body in geometric shapes: (A) the forward set of the neck from the shoulders; (B) the arch of the back; (C) the tilting masses of the torso and pelvis and the relatively flat stomach region that connects them; (D) the block of the wrist and the variety of shapes in the arm; (E) the outward turning mass of the thigh; (F) the beveled block of the knee; (G) the distinct wedge shape of the foot.

Walking around a pose allows you to see not only how the figure occupies its space, but also helps you determine the most descriptive angle for drawing. Students will often struggle with a difficult and confusing pose when moving one or two feet would clarify the relationships. If you have a tough or structurally disguised view, move! As you walk around the pose, keep your eye glued to the model. Try moving in close and backing up, sitting on the floor, or even standing on a chair. Each view will say something essential and unique about the pose.

Contour Drawing

The contour is the line around the edge of a form. It is often the first line that the beginner draws when working from the model. How-

ever, although it offers a certain security because it is obvious and familiar, the dependence on contour creates several problems. First of all, unless you are working with a flat object, the contour edge exists as part of a continuum. In other words, like Columbus, you are observing a rounded surface, but seeing only the apex of the curve. Most beginners tend to see only the contour and not recognize it as part of a three-dimensional form.

The greater problem occurs when, in closely following a contour, you completely lose a sense of the whole figure. It may prove very difficult to make a contour drawing with accurate proportions and gesture because you are concentrating on one small area at a time. Because of these problems, the immediate value of contour exercises for beginners is as a means of investigating individual shapes, not as a way of understanding an entire pose.

In drawing the model, contour includes not only the outside edge of the figure, but also the lines around the interior form. Unlike the gesture exercises, which call for short poses and rapid sketching, contour studies (with one exception) demand concentration and a careful line. Properly executed, the contour study offers you the opportunity to look intensely at each curve and undulation in the body.

Often first contour drawings are quickly executed with the comment, "That's all I see." Remember, in this exercise you are training yourself to see subtleties unguessed at before, so go slowly and look hard. Don't worry about how your first drawings look. Your real business is just in seeing the figure, and the resulting drawings are merely a by-product of this process.

Exercise 17

CONTOUR STUDIES 1
(Time: 15–30 minutes; material: soft pencil)

To begin a contour drawing, fix your eye on one point on the edge of the body. Then move your eye carefully along the edge of the form, following each subtle curve exactly. Allow your pencil to follow your eye as if the pencil were touching the edge of the model. Keep your eye on the model as much as possible. Refer to your drawing only when absolutely necessary to keep your forms together. After drawing the exterior form, continue by delineating interior contours, such as muscles, breasts, forms of flesh, and lines of the face (see Figure 5.14).

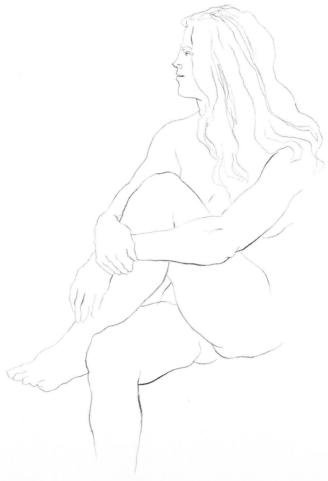

Figure 5.14
Contour drawing

Exercise 18

CONTOUR STUDIES 2

(Time: 10–15 minutes; material: soft pencil)

Try a contour drawing without looking at your paper at all. If you are using an easel, stand right next to it to relieve the tendency to look. Don't look even to find your place. This exercise is more demanding than the previous one since it requires the eye to move in small increments along the edge. Eyes naturally shift and move to collect and collate information, so your eye will want to jump ahead, and it will take discipline to keep moving slowly over the pose. This functions as a remarkable concentration exercise, and the silence and energy of a class engaged in this kind of contour drawing can be striking.

Your drawing at the end of the exercise may be laughably distorted, but often the line will have an attractive, expressive quality quite different from your usual line.

The one exception to the rule that contour studies require care and concentration is the quick "gestural" contour drawing. In our

Figure 5.15
Gestural contour
Courtesy of Anne M. Taintor

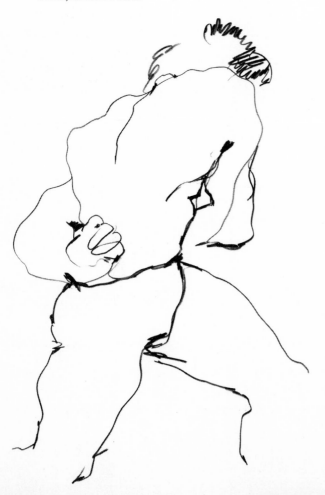

experience, it is easier for a beginner to get a sense of motion with a gestural scribble than a contour line. However, once you begin to understand body structure, quick and expressive contour drawings can be made.

Exercise 19

GESTURAL CONTOUR

(Time: 20 seconds to 1 minute; material: soft pencil or compressed charcoal)

While the model assumes very short poses, make a series of quick contour drawings. Quite possibly you will not have time to make fully connected contour lines, but some striking effects can be achieved by leaving broken edges (see Figure 5.15).

Negative Space

Although it is the most commonly used, the word *negative* does not do justice to the importance of the concept. Consequently, many teachers use *interspace* or *background shapes* to describe this tool, which can be used to solve the most difficult problems in perspective, proportion, shape, and composition.

In figure work, negative space refers to both the shapes that surround the body and those that are created by the limbs of the body, such as the triangular space of "air" visible inside the arm when someone touches the top of his or her head.

Needless to say, the perception and manipulation of these interspaces is essential to seeing and designing with the figure.

In the following exercises, you are asked to see and draw only the shape of the space surrounding the body or created inside. Don't allow yourself to start drawing the figure.

Exercise 20

INTERIOR SPACE

(Time: 20 minutes; material: soft pencil or charcoal, eraser)

Have the model take a comfortable pose with an arm resting on a knee, or with legs separated to create interesting interior space. In your drawing, carefully define the exact shape of these spaces and the shape of the space around the model. Look at the spaces and interspaces but not at the body itself. See the interspaces as if they were abstract forms, and draw them accurately. Pay great attention to the proportions and

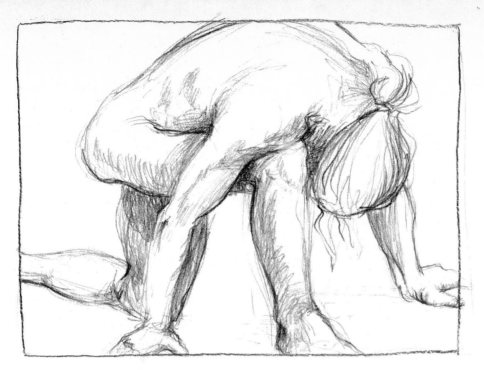

Figure 5.16
Developed negative space drawings with margins

contour of each shape just as if you were drawing an object. If the model is positioned in front of a plain background, indicate the shapes of the background as it surrounds and defines the body.

Exercise 21

FIGURE WITHIN A MARGIN
(Same time and material as in Exercise 20)

In this exercise, draw a continuous margin about 1 inch inside the paper. This will act as a frame for your image and make you more aware of your perimeters. Decide on a section of the pose and fit it into your space so that parts of the body are cut off by the

margin. (Don't draw through the margin, only up to it.) This exercise will increase your abstract appreciation of the interspaces and will coax you into perceiving more subtleties of shape since you are dealing only with a section of the body (see Figure 5.16).

Exercise 22

TONAL INDICATIONS
(Time: 10 minutes; material: soft pencil or charcoal)

Create a sense of the pose by tonally indicating background shapes. Do not use any lines at all. Simply bring the tone or shading up to the edge of the body (see Figure 5.17).

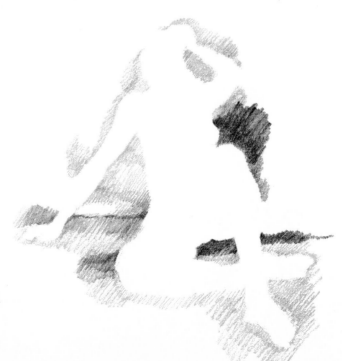

Figure 5.17
Negative space tonally indicated

Exercise 23

DESIGNING WITH INTERSPACES 1

(You may wish to refer to the discussion and exercises on composition in Chapter 3.)

(Time: 10 minutes each; material: pencil or charcoal)

Draw, in contour, three different poses (or the same pose three times) on a single sheet of paper. Turn your paper after each pose with the idea of fitting the shapes into one another. After all three are drawn, spend 10 or 15 minutes abstracting and strengthening the interspaces. Turn your drawing all ways; look at it upside down and sideways to develop your design possibilities (see Figure 5.18).

Figure 5.18 (top)
Three poses arranged in space

Figure 5.19 (bottom)
Overlapping forms

Exercise 24

DESIGNING WITH INTERSPACES 2
(Same time and material as in Exercise 23)

A variation on Exercise 23. Allow the three figures to overlap. Then assign different tones to the overlaps, interspaces, and shapes (see Figure 5.19).

Exercise 25

REVERSAL
(Time: 25 minutes; material: pencil or compressed charcoal)

This exercise demands a reversal that can be done only by seeing the negative spaces and interspaces. Using contour lines, begin by putting the shapes that surround the head and shoulders at the bottom of your page, just as if you were observing the model while standing on your head. Continue to define the rest of the body in this manner, moving toward the top of the page.

Modeling

To be truly expressive, any figure drawing must combine accurate perceptions with an empathetic involvement with what the model is doing and who the model is. Without this subjective element, the drawing will be lifeless and empty. Gesture drawing required that you respond to the model's weight and action with both your eyes and your kinesthetic sense. In the modeled drawing, the kinesthetic sense must extend to the drawing of every limb and surface. Try to feel as if you are molding the figure from clay. To facilitate this awareness, walk around the pose before drawing, this time trying to see the model as a person. Sense yourself in his or her body and position. Then carry that knowledge into your drawing.

Your goal in a modeled drawing is to evoke a lively, solid sense of mass through the descriptive use of line and tone. If you are accustomed to contour work, you may have found that your figure studies appeared flat, lacking depth and sculptural reality. These exercises should help you to be more aware of the structure and volume of the body.

In doing the exercises, use several well-placed overhead lights shining down on the model to define the forms (see the earlier section Working with Models). Then arrange the lights to create a uniform pattern of values. Scattered shadows will only confuse you by breaking up the surface of the body and disguising its structure.

As you observe shadows, note that some define rounded forms by a subtle shift in value; others may be rather sharp at their perimeters as they describe adjoining planes. By

accurately depicting these two types of shadows, you will not only imbue your drawing with a sense of surface modulation, but also will suggest skeletal and muscular life beneath the surface.

Exercise 26

DEFINING BODY MASSES
(Time: 10–15 minutes; material: vine or compressed charcoal, or conté crayon)

Begin your drawing by lightly sketching in the gesture of the model freely and spontaneously. Then, with the same fluid movement, start to define the masses of the body. As you draw, pretend that you are moving your charcoal or crayon over the actual surface of the body, making rounded strokes to define round surfaces and straighter lines to define flat planes. Increase the pressure on the charcoal to produce shadows, to show where the figure goes back into space. Decrease pres-

sure to indicate where it comes forward (see Figure 5.20).

Exercise 27

CROSS CONTOUR DRAWING
(Time: 15 minutes; material: vine or compressed charcoal)

Sketch in the body; use lateral, cross contour lines to indicate the roundness and depressions within it. Stay aware of how the ellipses change shape as they move through space (refer to ellipses in Chapters Two, Three, and Four). To begin, place your pencil or charcoal at the edge of the body. Then, instead of following the contour, move **laterally** *across the body toward the opposite edge, as if your marker and eye were actually touching the edge of the form. Allow the charcoal to dip into valleys and rise over elevated areas, defining the structure, musculature, and forms of the body with carefully placed lines based on accurate, cautious observation of surfaces (see Figure 5.21).*

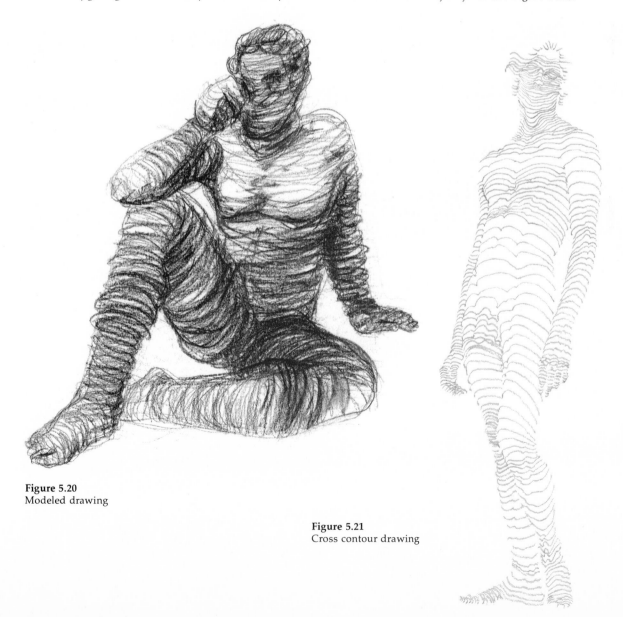

Figure 5.20
Modeled drawing

Figure 5.21
Cross contour drawing

Exercise 28

WEIGHT AND MASS

(Time: 15–20 minutes; material: compressed charcoal or conté crayon)

This exercise requires a **kinesthetic** *awareness of weight and mass. Your goal is to make the body appear as heavy and solid as possible. Use lines, shapes, and tones that indicate roundness and volume. Allow your lines to move across the surface of the forms as in the previous exercise. Then mold and model the shapes as if you were sculpting the body in clay.*

Experiment with lines, shapes, and tones. For instance, try using the darker lines to indicate heavier areas, lighter lines to indicate areas where there is less weight, on the tops of forms: shoulders, upper arms, and so on (see Figure 5.22).

Exercise 29

DESCRIPTIVE LINES

(Time: 15 minutes; material: compressed charcoal, conte crayon, or soft pencil)

Define the weight of the figure by using only *a wide vocabulary of descriptive lines. Don't use any shading. See Chapter Two on line quality.*

Modeling with Shadows

Again, use bright overhead lighting to one side and in front of the model to define the forms of the body with shadow.

Exercise 30

LARGE PATTERNS

(Time: 2 minutes each; material: compressed charcoal or conté crayon)

If you have arranged your lights carefully to one side of the model, you will notice that shadows fall in a simple design across one side of the body, while the other side is bathed in light. If this design is not readily visible, you will probably be able to see it better by squinting. Begin to draw indicating the larger shadow pattern that you see, leaving the lights alone. Try to stay only with the large patterns rather than the small detailed ones.

This exercise forms a foundation for the longer shadow exercises. In these, minor shadow patterns are played down or eliminated so that the more important ones, can be

Figure 5.22
Awareness of weight and mass

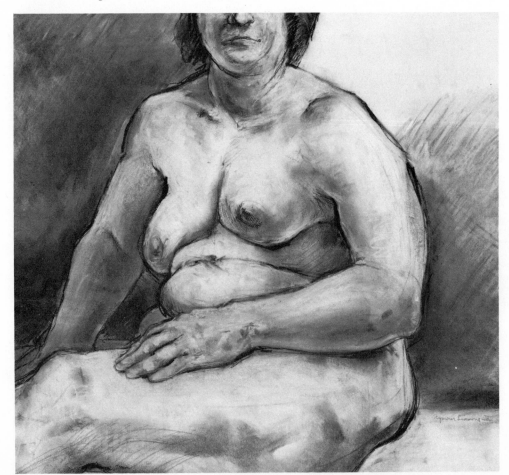

Figure 5.23
High contrast shading

used to define the structure and organize the design of the pose.

Exercise 31

SHADOWS IN HIGH RELIEF
(Time: 15–20 minutes; material: soft pencil or compressed charcoal)

Begin by lightly sketching in the body as a whole. Then draw the shadows as if they were abstract shapes, being sure to place them correctly. Continue the drawing in sharp contrast, indicating only two tones, flat areas of either shadow or light. Try squinting until your eyes are almost closed to set the shadows in high relief. This is the same principle as shutting down the lens of a camera. Less light reaches your retina; consequently less color is perceived and the shadows bunch up into related darks (see Figure 5.23).

Exercise 32

THREE TONAL AREAS
(Time: 30 minutes; material: soft pencil or compressed charcoal)

Distinguish a third tone of middle gray along with the flat areas of dark and light. This middle gray will be

used for the larger shadowed areas, and the darker gray will be reserved for only the deepest shadows (see Figure 5.24).

In this and the previous exercises, the artificial shadow separation may make the figure look rather stiff. However, the next step will require that you draw on the knowledge gained here to make a more convincing and natural figure.

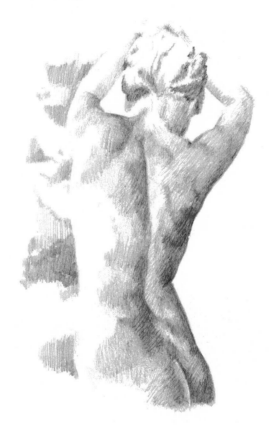

Figure 5.24
Use of three tonal areas

Exercise 33

COMPLETE TONAL DRAWING
(Time: 60 minutes; material: soft pencil, vine or compressed charcoal, or conte crayon, eraser)

In this shadow exercise, draw as accurately as possible the gradation of dark and light throughout the body. Begin by lightly sketching in the general shape of the pose. Then lightly shade in the larger shadow areas. At this point, keep your tones light. As in music, you are setting a **key** *and all your marks must be made relative to it. By staying light, you keep your options open. Develop the values by degree. After noting the middle range of shadow, place in some of your darks,*

147

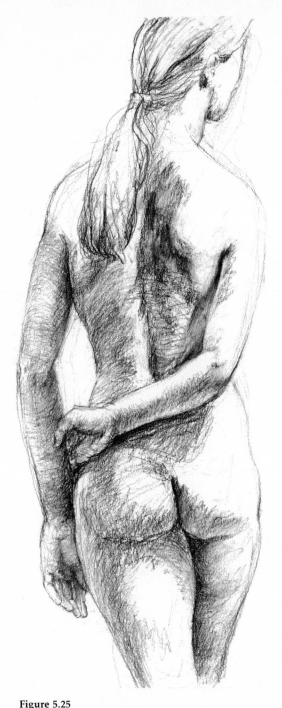

Figure 5.25
MARC WINER (April 1, 1976)

Fully developed tonal drawing. Note reflected light on right arm.

but do not use your darkest darks until you are sure that your drawing needs them. Students are often heavy-handed and go for the deepest shadows because they are the most obvious. However, this approach may create problems in maintaining an even and flexible key.

Observe the subtle range of tone within the larger shadows. Almost invariably, they are not simply

one flat gray. One shadow may begin dark at the edge of the body and become lighter as it approaches the interior; another might do just the opposite. Be aware of reflected light at the edge of certain shadows, and use this device to make your figure appear more rounded. Let the paper work for you; don't be afraid to let it show through and to implement your lines and tones. You might use an eraser to soften the edges of shadows and to clean up areas that may have been smudged. (Refer to Chapter Two for a description of shading devices.) (See Figure 5.25.)

Exercise 34

WORKING WITH TINTED PAPER
(Time: 60 minutes; material: conte crayon in both white and 1 or 2 sticks of dark color, tinted paper.

A variation on Exercise 33, this requires the use of a tinted paper serving as a middle tone to which both shadows and highlights may be applied. Build up values as described in the previous exercise, using the white sparingly for highlights.

PROPORTIONS

The ideal proportions for the mature human body have fluctuated over the last 2,500 years between 7 and 8 heads tall.* Greek statues from the sixth century B.C. were about 7 heads tall. Phidias, the Greek classical sculptor, determined about 450 B.C. that the ideal human form was 7 1/2 heads tall. One hundred years later, the Hellenistic sculptor, Praxiteles, was creating figures that were 8 heads high. Michelangelo apparently agreed with Praxiteles. For the purposes of this book, we will list the proportions as 7 1/2 heads, with the waist at 3 heads, and the hip at the halfway point, 3 3/4 heads. This middle point is very important for the beginner. Many students draw torsos too long and legs much too short. In fact, *the legs are one-half the length of the body.*

Whatever the standard proportions, real people rarely fit into the mold. Some people have large heads, others larger bodies; some are high waisted, others long waisted. Proportions then must serve as a general guide to human structure, not as a law. When looking at a model in a simple standing position, you

*The length of a person's head is the measurement used to judge proportions.

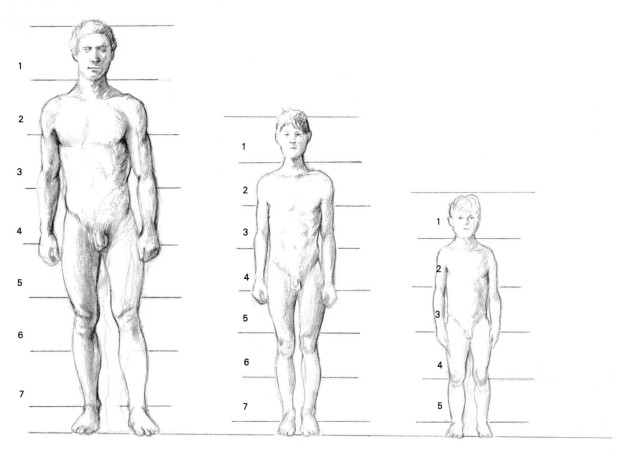

Figure 5.26
Proportions. (A) *Mature male:* 7½ heads tall—3 heads, waist; 3¾ heads, hips & pubic area; 5 heads, knees; 7 heads, ankles; (B) *12-year-old male:* proportions the same as for an adult; (C) *4-year-old male:* 5¼ heads tall—2½ heads, waist; 4 heads, knees; 5 heads, ankles

might set down the standard proportions and then see how the model diverges from them (see Figure 5.26).

FORESHORTENING

"Good grief! How do you expect me to draw a leg in that position?" This frequently asked question refers to the problem of **foreshortening,** the visual distortion of a form that comes forward or recedes in space. When an arm or leg "comes out" at us, it should read as being shorter and wider than when it is held to the side. Our eye, just as a camera lens, sees this distinction, but our brain makes a pyschological adjustment, and we "see," in effect, what we "know." As a result, the arm is drawn extending at the wrong angle, with its shape and proportions inaccurate, as if it were being seen in another, more familiar position.

The only realistic answer to the problem of foreshortening is to draw the form just as it is, not as you imagine it to be. See it as a geometric shape, observe the negative space around it. There is no secret way to understand it. Only training and experience can help you really to see and accept a foreshortened limb.

In Figure 5.27 the hip and leg area of the model dominate the very small visible area of the torso. The feet loom incredibly large, but are in fact proportionally correct given this angle. You will find it enlightening to mea-

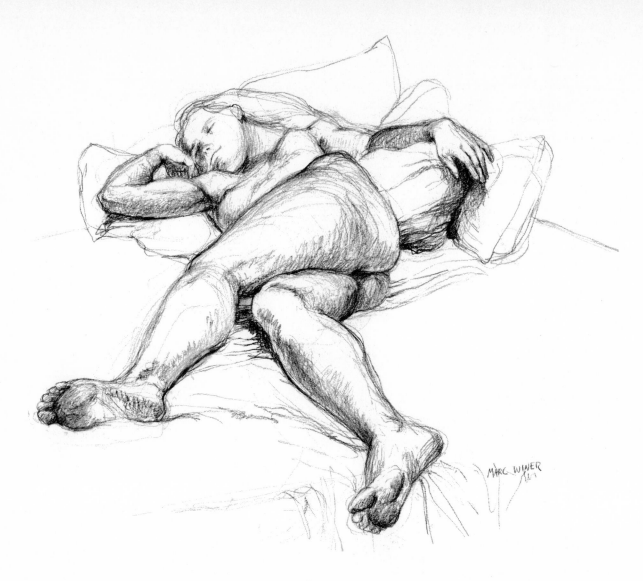

Figure 5.27
Foreshortened figure drawing

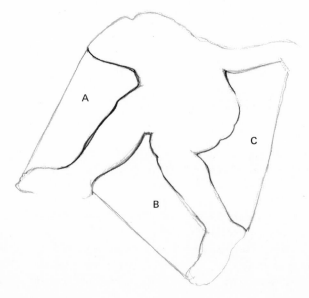

Figure 5.28
Schematic diagram of Figure 5.27, show-
ing negative shapes created by the limbs

150

sure the size of a foreshortened part of a body against another part. It will register bigger than you know it to be. Go by what you see and not by what you know. Figure 5.28 diagrams the negative shapes of the drawing. Notice the short distance from the right knee to the elbow shape (''a'') to really understand the extreme foreshortening in this pose. The tiny distance from the top of the thigh to the jaw indicates that the chest is almost entirely hidden from view. By carefully checking the size of the negative shapes, even an especially foreshortened pose such as this can be understood.

DRAWING HANDS AND FEET

Drawing hands need not be a difficult task. Although many students seem overwhelmed by the overlaps and diverse directions of the fingers, the hand in any position can be approached with understanding if it is seen first as a simple shape. Figure 5.29(A) shows a closed fist that was first perceived as a circle. The fingers were then placed within the circular shape. (B) shows an open hand with thumb extended, originally sketched as a rectangular shape. Then two planes were estab-

Figure 5.29
Hands with structural simplification

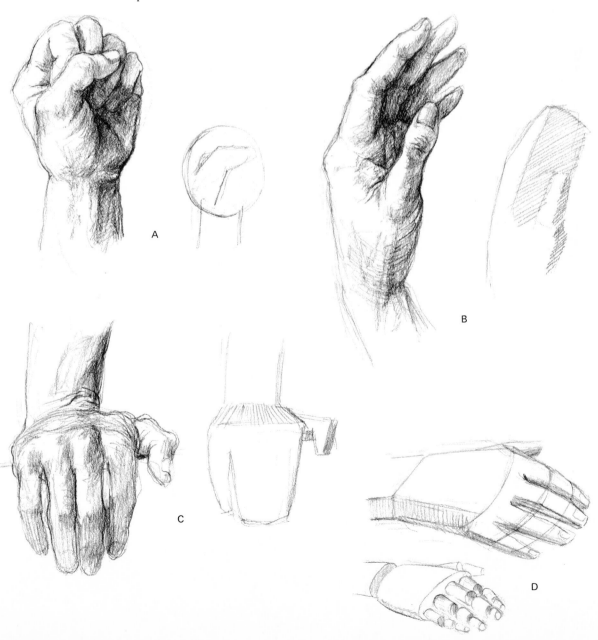

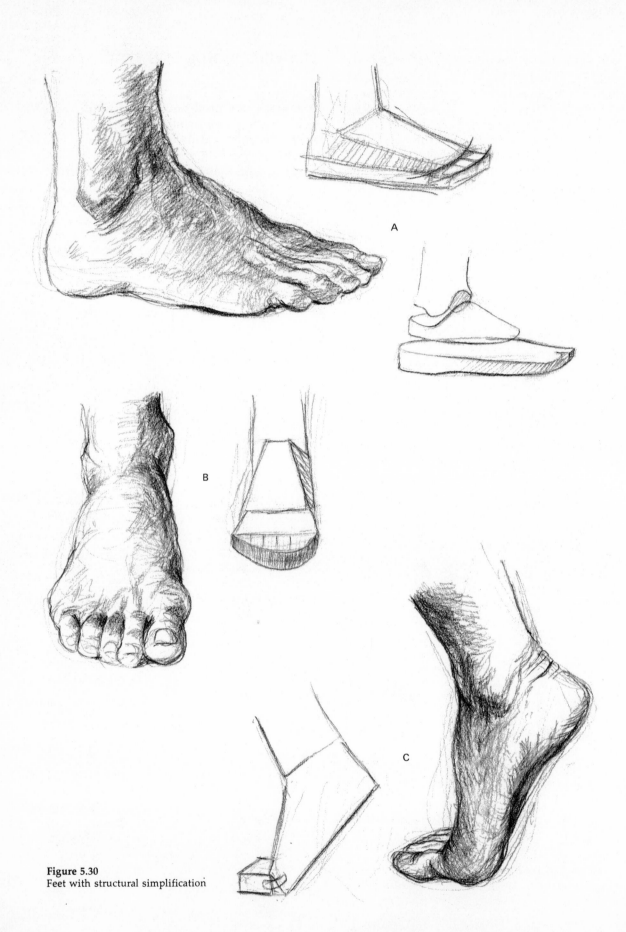

A

B

C

Figure 5.30
Feet with structural simplification

lished, the inner plane set in shadow and the outer plane and thumb, which are light. In (C) the hand appears in an unfamiliar position. The top of the hand is so radically foreshortened in this view that the fingers appear to be growing from the wrist. (D) shows the hand in planes, with the continuing curve of the knuckles. The three larger fingers are the stable directional forces of the hand, and they follow a continuous line from the wrist through the back of the hand, while the thumb and little finger extend out at angles. The thumb is on the side of this primary mass and sometimes seems to be on a different plane than the rest of the hand. The thumb is, of course, very flexible and able to be posed against all the other fingers.

To draw the hand accurately takes practice, even using simple formulas and helpful hints. Don't let yourself be intimidated by the apparent complexity, however. Observe and draw hands in all kinds of positions. Look for the principle geometric shapes that enclose the hand and define its structure. And don't forget to study the all-important connection to the wrist and the forearm. Do studies of two hands together, and of the hands in relation to other parts of the body.

The foot, although basically a wedge, manages to get itself into positions where it is difficult to understand. When drawing the feet follow the same procedure recommended for drawing hands. Look for simplified geometric forms as well as the shape of the negative space around the foot.

In seeking out the geometric qualities of the foot, remember the two basic shapes—the wedge that forms the arch and the flat rectangular form of the sole. Figure 5.30(A) shows these forms from the outer side of the foot. Note also how the pad of the sole is wider than the wedge of the arch (B). (C) shows the inside arch, and also suggests that each toe forms an arch in itself.

Exercise 35

HAND AND FOOT STUDIES
(No time limit; material: soft pencil)

The only way to learn to draw hands and feet is to draw them regularly. Begin by sketching hands and feet in your sketch diary. Do them in all kinds of positions, seeking out the basic structure as described above. Try gesture, contour, and cross contour drawings as well.

Then do a series of long studies of hands and feet, either your own or someone else's. Take your time building up the basic form. Then introduce a value pattern and structural details. Indicate the action of the wrist and ankle. Don't forget to study the relation of the hand to the arm and the foot to the leg. It is very easy to become overly interested in the complex and active forms of hand and foot, giving them undue importance. Study them if you are interested, but always remember to relate them to the rest of the figure.

THE FINISHED DRAWING

In this section, Marc Winer re-creates a procedure that he used to produce a finished drawing. "I call the drawing (see Figure 5.31) 'finished,' not because it is totally completed, but because I am satisfied at this stage that the lines and forms are integrated and say what I want. Certainly this image could be pushed further, but the magic of drawing lies in the very fact that so much can be said with relatively few lines.

"By describing my procedure, I intend to indicate how the various experiences presented in this chapter can be applied in developing a drawing. This must not be taken as a formula for producing a 'finished' work. *There is no such formula.* Each person must work differently. Each will have different intentions and expectations. You should study this section to understand the practical use of exercises and principles, and then introduce them to your own work according to your style and aim.

"In following the procedure, remember that the division into steps is artificial and is only an attempt to simulate a creative thought progression.

"*Step One.* I did several warm-up sketches to loosen my arm and to familiarize myself with the pose. At this stage, I was interested in the general shape and design of the pose, but also in noting its special problems. Very often a subject will have difficult passages that will make or break a drawing. In this case, I realized the success of the work

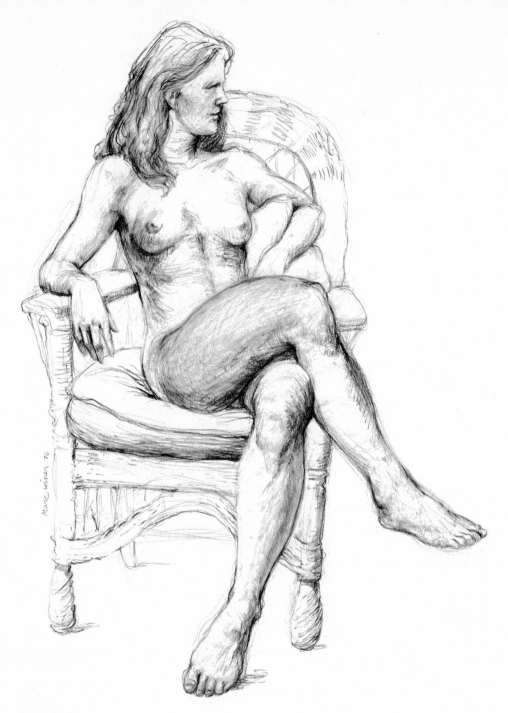

Figure 5.31
The finished drawing

would depend in large part on my ability to "seat" the model in the chair, and to handle both foreshortened legs.

"*Step Two*. I sketched out the chair very lightly, then, just as lightly, drew the model over these lines. I was conscious of the interplay between the organic form and an inanimate object, and, by sketching in the chair first, I hoped to provide a solid support to set off the model's vitality. I then delineated the physical structures of the body, thinking more about movement and design than anatomy. I constantly kept in mind the backward lean of the torso together with the turn of the planted foot to be sure that I captured this aspect of the pose.

"*Step Three.* I began to develop and refine the form, paying careful attention to the negative space in difficult areas, particularly the space defined by the legs, the spaces formed by the chair and the planted foot, and the shape between the left arm and body. By keeping away from details at this stage, I was able to play with the relationship between forms. I constantly worked all over the entire drawing, using lines and light areas to unify the whole image, but also to play off the figure and the chair.

"*Step Four.* I introduced values in a general way, looking for patterns of light and dark. The light was quite strong and many definite cast shadows were evident. Although cast shadows offer an obvious pattern, they can detract from a drawing by their very distinctness. Consequently, I decided to play down the cast shadow and build the form more quietly. In this regard, many of the tones in this drawing were invented. For example, I began at this point to round off the upper thigh in a slightly darker gray to bring it forward and to separate it from the leaning torso. At this stage, I also sketched in the features of the face as well as some details of structure in the body, hands, and feet.

"*Step Five.* Finally, I became concerned with details of shadows, facial features, hands, and feet, while staying aware of the **abstract** interplay of the lines and tones. I often turned the drawing upside down to see how these elements were working, regardless of the image they were creating. I deepened some of the smaller dark areas to work against the larger light areas, such as the blacks in the knees, **conterpointing** the basically light expanse of the lower leg. I still tried to let the paper do a lot of the work by leaving as much untouched as possible.

"This last step, involving the finishing details, the small erasures, and the continual looking (without much actual drawing) took a great deal more time than all the other steps combined.

"My decision to stop came when the image sat comfortably on the page (and the chair), no lines or areas were demanding undue attention, and I felt that I could not put down any more lines or tones without changing the entire character of the drawing."

AN INTRODUCTION TO COLOR AND THE FIGURE

After completing the preceding exercises, you may wish to introduce color to the figure drawing process. Using a new material always presents technical problems but may also help you to break out of old habits. The use of liquid mediums will expand not only your **stylistic** possibilities, but also your manner of observation, encouraging you to look and work with the special sense of flow inherent in the brush. In using color, be aware of the whole dimension of the figure, not only skin tonality, but in value structures and composition as well.

We will begin our experimentation with brush and ink. This is a liberating and dynamic medium particularly when used in gestural drawing.

Exercise 36

GESTURAL DRAWINGS WITH BRUSH
(Time: 30 seconds to 1 minute each; material: Japanese brush, India ink, and newsprint paper)

*The model takes a series of gestural poses while you draw with quick flowing strokes. Try to vary your strokes and your drawing speeds. Experiment with **dry brush** and other types of expressive marks (see Figure 5.32).*

The next series of exercises will require the use of ink **washes.** Have several cups available for mixing ink and water to produce different values. Use a medium sized watercolor brush along with the Japanese brush. Try to carry the vitality of movement and stroke from the previous exercise into the longer poses.

Exercise 37

INK WASHES 1
(Time: 15–30 minutes; material: brush and ink, watercolor paper)

Have the model take a series of longer poses. You may wish to sketch the pose quickly in pencil before using the ink. Then apply a light gray wash with the large brush over all the areas except the lightest. Leave these alone. After the first layer dries somewhat, introduce a darker tone to appropriate areas. Build up values gradually in this manner, layer upon layer,

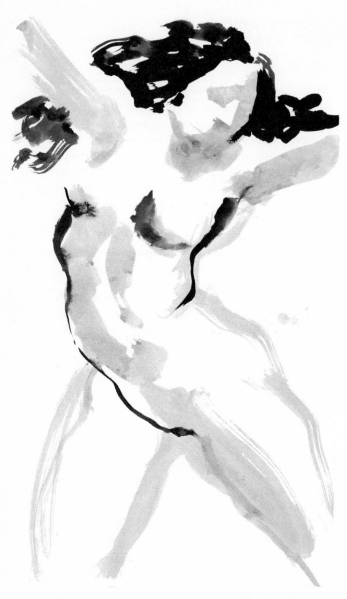

Figure 5.32
Gesture drawing with brush

saving your darkest tints for last-minute details and deepest shadows.

Exercise 38

INK WASHES 2
(Time: 20–30 minutes; same material as in Exercise 37)

Follow the same procedure described above. This time, however, work with background along with the figure. You may choose to keep the background an overall grayish tint or to delineate representational or abstract forms. If you choose to introduce background forms, they will, of course vary in value. Try to keep most of these tones distinct from those on the figure.

After you feel somewhat more comfortable using liquid mediums, introduce color to your figure work. Refer to Chapters Two and Four for a more complete discussion of color usage.

Exercise 39

INTRODUCING COLOR 1
(Time: 10 minutes each; material: watercolor washes, watercolor brushes, paper)

*Use color to tint a contour or open gestural drawing. You may use flesh tones and neutrals or whatever colors you wish. The color may simply cover the figure or follow the lines of the gesture. You can restrict your colors to definite areas and allow a minimum of **bleeding,** or put them on spontaneously, going out of the contour and adding wet on wet.*

Exercise 40

INTRODUCING COLOR 2
(Time: 15–30 minutes; same material as in Exercise 39)

Continue your color work in a longer pose. Follow the procedure described above. Use color tints in the same way you used washes, building up layers according to value, starting out with the lightest and moving into the darker range, letting the colors dry to some degree before adding the next tint. Don't hesitate to experiment with unusual tints, such as blue or green for shadows, spots of red, and so on.

Exercise 41

INTRODUCING COLOR 3
(Time: 30 minutes; same material as in Exercise 39)

Follow the same procedure described earlier in introducing a background to your color figure work. You may choose cooler or neutral tones for the background, but this is not necessary. You can learn a lot about color interaction by experimenting with a variety of tonalities. Remember that background colors will be affected by foreground colors, and vice versa. Integrate some tones from the background within the figure to relate the two areas.

Further figure work with watercolor approaches painting and goes beyond the scope of this book. If you wish to continue to develop your color drawing from the figure, you might use pastels. Although these present problems in handling, they do offer a wide range of hues and tints. Before diving in, however, try some simple color experiments.

Exercise 42

PASTEL WORK 1

*(Time: 10 minutes; material: pastels—1 light, 1 dark tone—
tinted paper of middle value)*

*The model assumes a pose for 10 minutes during which
time you rapidly introduce the dark for the deeper
shadows and the light for the highlight. Use the tint of
the paper as the middle value. Apply the color freshly,
don't rub it in.*

Exercise 43

PASTEL WORK 2

*(Time: 15 minutes to 2 hours; material: pastels—2 light,
2 dark to begin with—tinted paper of middle value)*

*Continue your work with pastels, gradually using
more and more colors. Allow the paper to serve as the
neutral tone, and let it appear in spots even when a
number of colors are being used. After you feel com-
fortable with the pastels, try some blending, carefully
at first, perhaps two colors at a time. Then get more
adventurous. Try spraying a layer of color with fix-
ative, then drawing over it to get an effect like*
scumbling.

THE CLOTHED FIGURE

In the beginning of this chapter, we made ref-
erence to the clothed figure, suggesting that it
should be drawn as preparation for work from
the nude. Now we return to the clothed figure
with a more trained eye to find problems and
opportunities that probably were not apparent
before.

From your experience with the nude fig-
ure and the awareness of shapes of the body,
you may be able to recognize much more of
the subtle distinctions of cloth as it covers the
human form. The planes and wrinkles of
drapery conform to the shape underneath. By
carefully drawing the folds and the play of
values upon them, you can represent the
three-dimensional form in any position or ac-
tivity. The curve and flow of clothing not only
define form, but reinforce the sense of action
as the folds are swept by the gesture of the
figure.

Before beginning to draw from the
clothed model, the student should refer to
Chapter Three, Still Life, for a description and
explanation of drapery (see also Figure 5.33).

Exercise 44

GESTURE WITH CLOTH

(Time: 30 seconds to 1 minute; material: compressed charcoal)

*Ask the model to wear a sheet around his or her body.
Do a series of quick gesture sketches describing the ac-
tion of the flowing patterns of cloth. Use a bright light
above the figure to strengthen and dramatize value dis-
tinctions.*

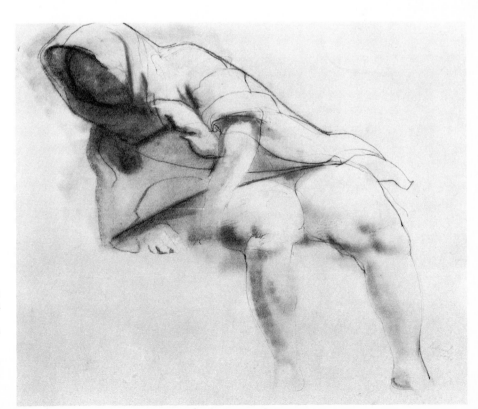

Figure 5.33
RICO LEBRUN (American, 1900–1964)
Reclining Figure (graphite, ink, and brown
chalk on cream paper), 480 × 632 mm
(19 × 25")
Courtesy of the Fogg Art Museum, Harvard University.
Gift of Arthur Sachs, Esq.

Exercise 45

BUILDING A DRAPED FORM
FROM UNDERNEATH
(Time: 10–15 minutes; material: soft pencil or conté crayon)

*Continue the study of cloth on the figure in longer
poses. Indicate the form imagined and observed be-
neath the cloth. Then delineate the cloth over the fig-
ure, first drawing the larger, gestural folds, then devel-
oping the figure with secondary folds and value
patterns.*

Exercise 46

EXTENDED DRAPERY STUDY
*(Time: 40 minutes to 3 hours; material: conté crayon,
vine charcoal, charcoal, or soft graphite pencil)*

*Do an extended drawing of drapery on the human
form. Sketch the imagined nude figure lightly, then in-
dicate the major flows of cloth. Continue by estab-
lishing the linear forms of folds, then build up value
distinctions. As you develop the figure, however, re-
member that lines and values on the cloth should sug-*

Figure 5.34
Seated figure with skirt

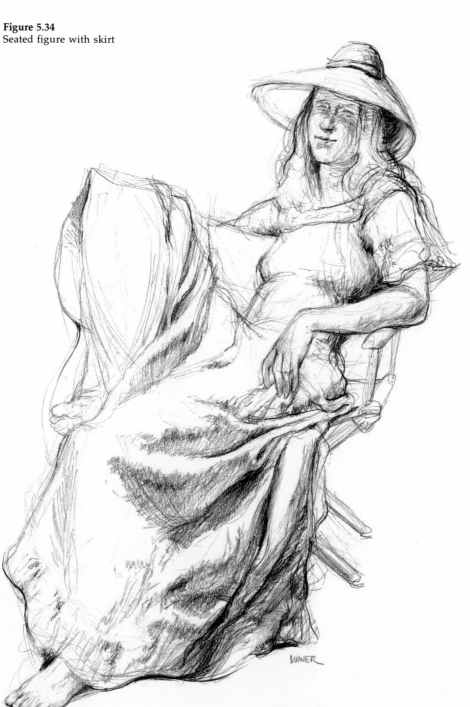

gest the forms underneath. Develop the features of the exposed body, face, and hands along with the drapery.

After becoming familiar with the way drapery adheres to the human form, continue by drawing the naturally clothed model. Here the problems increase, since, in drawing cloth, we become concerned not only with folds and wrinkles, but also with textures, patterns and tailoring. Although these may be employed to help indicate form, they also may prove distracting. Keep the underlying structure in mind and use only those patterns that help to describe the form. Stripes and corduroy act as **directional guides** and may be used as cross contour lines. Plaids and prints may present more difficulties unless simplified. Begin with the easiest patterns.

Exercise 47

THE CLOTHED MODEL 1
(Time: 10 minutes each; material: soft pencil or conté crayon)

Begin your study from the clothed model by first sketching in the nude figure underneath the clothing. Ignore patterns in the cloth and concentrate on those folds that describe the form. Use a bright light for improved value distinctions.

Exercise 48

THE CLOTHED MODEL 2
(Time: 30 minutes to 2 hours; material: soft pencil or conté crayon)

Start again by sketching in the figure underneath, then concentrating on the folds in the cloth and value patterns across the figure. Define the pattern or texture in the cloth itself, using whatever techniques or materials prove effective. Use only enough patterning to describe the material, and those that enhance the value pattern and design of the pose. If you include jewelry, glasses, and so on, stress their spatial dimension. Don't forget to develop the whole figure, the face, hands, and other visible body parts along with the clothing. (See Figure 5.34 as an example.)

COMPOSITION AND MULTIPLE FIGURE WORK

As you gain the ability to draw the model accurately and confidently, you may decide to use the figure more as a tool for self-expression. This may involve the development

of a personal style; the conscious use of distortion, abstraction, or exaggeration; the arrangement of multiple figures in an environment; or a combination of these.

At this level, the problems of design become increasingly important. You must be aware of the relationships of one form to another, the use of values, lines, and spaces as compositional elements. Looking at drawings of the past will acquaint you with previous solutions to these problems (Refer to Chapter Nine, Composition).

Exercise 49

STUDYING OTHER WORKS
(No time limit or specific medium)

Familiarize yourself with the figure work of several different artists. Study them not only from the standpoint of technique, but also for particular use of design and **stylistic** *characteristics. Then, as you draw from the model, try to see and draw just as one of those artists would. It is also valuable to copy works of other artists; however, this should be done only in conjunction with work from a live model.*

When copying choose a good quality reproduction to work from. Try to copy the drawing with the same medium as the original. Don't copy a pen drawing with pencil—you won't learn as much. Besides training your eye to see relationships, copying will allow you to share in the artist's creative process. Copy your chosen drawing exactly; take it apart as you would a clock to see what makes it work.

As a supplement to your work from the posed model, you might find it useful to do some compositional sketches using people in ordinary circumstances.

Exercise 50

DESIGNS WITH FIGURES
(No time limit; material: soft pencil and sketchbook)

Draw several figures on the same page, trying to arrange them to make an interesting design. You may use figures of different sizes or fragments of figures. Establish a consistency among these varied elements by a unified pattern of tones, textures and spacing.

Exercise 51

COMPOSITIONAL SKETCHBOOK
(Drawing series; material: soft pencil and sketchbook, also good quality paper and other mediums)

Keep a sketchbook of compositional studies taken from daily life. Look for settings that might make interesting

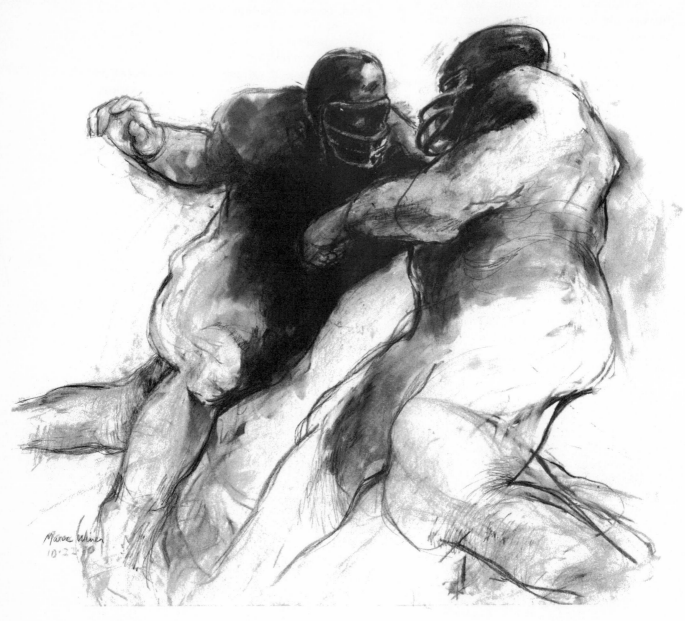

Figure 5.35
Multiple Figure

compositions and jot them down quickly in a framework, seeking out lines of movement and unifying values. Do several sketches of the same scene, trying different croppings and organization. Occasionally, when you have time, do longer studies of these scenes, including extended drawings of some of the more stable elements—the room, furniture or characters. Later you can develop these sketches and studies into a finished drawing, either maintaining the composition from the initial sketch or developing a stronger design.

When you do not have your sketchbook with you, look for interesting scenes and try to remember them. Be aware of spacing, **intervals,** balance, tonal areas and lines of movement. Sketch the scenes in quickly when you get home, then try to develop the sketches, remembering the scene as thoroughly as possible. This is an excellent exercise for training the visual memory.

In working with the figure in an environment, or with multiple figures, the model is no longer important for its own sake, but becomes an element within the whole, just as each object in a still life is only a part of the design of the complete still life, or each natural form a part of the whole landscape. Effective compositions may also be developed by using only part of the figure **(cropping).** In this case the shape of the figure and the shape of the surrounding space must be carefully designed. In every composition, attention must be paid to the design of the entire page and value patterns; lines, forms, and textures must be used to maintain the unity of the whole.

Exercise 52

FIGURE AND ENVIRONMENT
(Time: 30–40 minutes; material: soft pencil, pen and ink, or charcoal, good quality paper)

Draw the figure in its environment. Situate the model comfortably and arrange different objects, furnishings, and such around him or her. Determine how much of the environment and how much of the figure you wish to draw. Then sketch the whole scene lightly. It is not necessary to draw everything you see. Rather, choose forms and elements that make a satisfactory composition. This exercise can be done out of doors, using landscape to set off or complement the figure. As you work, try to develop the picture as a whole. Don't concentrate exclusively on the figure or on any other part of the environment. Build values that unite the image through patterns of light and dark. (You may arrange lighting to create this effect or create your

own value pattern in the drawing.) You might finish the picture, then, by adding rich darks, highlights, or textures to complete your design and enhance your center of interest.

Exercise 53

USING TWO MODELS
(No time limit; material: compressed charcoal, soft pencil)

Find two models who feel comfortable working together. Begin the session by doing a series of 2- or 3-minute gesture drawings in which the models either touch or take closely related poses. Draw the gesture of the models together as if you were doing one living form. Don't draw one model at a time, but keep your lines and eye moving rapidly from one figure to another in a flowing gestural rhythm.

Then do ten-minute drawings of the models, using the two-dimensional geometry exercise described earlier. Envision a shape that will contain both figures. Then build the figures within this shape, moving from one figure to the other so that the picture develops as a whole.

You may continue working from other types of exercises suggested for single figure work. It is essential, however, that you see both figures together, rather than as separate entities. Their relationship, closeness, or distance, establishes to a great extent the emotional impact and the design of the picture.

If you work with several combinations of models, you will see how differently people interact, and how the dynamics of this interaction can affect your drawing.

You may do the exercises using more than two models or placing multiple figures in an environment. Remember to begin your drawing by seeing the whole scene, just as you begin your single figure work by seeing the whole figure (see Figure 5.35).

THE FIGURE IN ABSTRACTION AND IMAGINATION

There are many ways to abstract and recreate the figure from imagination. A study of twentieth-century masters will give you literally hundreds of possibilities. Although numerous, these may, in fact, be grouped into a few categories based on certain principles of abstraction. We will list a few of the approaches taken by contemporary artists, which can be understood in terms of the drawing principles

and exercises presented in the first section of this chapter. To familiarize yourself with these techniques, look up the works of the artists and others whom you admire, and try to understand the sources of their interpretative figure work. The headings listed below are meant to clarify an aspect of the artists' work rather than to define their style.

Gestural abstraction, Willem De Kooning. An expressive active interpretation of the figure through gestural line, often with the addition of color.

Constructive abstraction, the analytic cubists: Picasso, Braque, and Gris; also Jacques Villon, and Robert Delaunay. Cubism and its derivatives break down the figure or any other subject into geometric component parts. Sometimes the form is nearly unrecognizable. Alberto Giacometti and Henry Moore, both sculptors, took a more structural approach to figure abstraction in their graphic work.

Contour abstraction, Paul Klee, Saul Steinberg, Ben Shahn (see Figure 5.36), George Grosz. These artists used a wide variety of contour lines in describing distorted or whimsically abstracted figures.

Cross contour, Savadore Dali, M.C. Escher. Both these artists have used spiraling cross contour lines to define heads and bodies.

Modeling and three-dimensional geometry, Léger, de Chirico, Picasso. Although many artists in this century model and distort their forms in stylized ways, Leger's work stands out in its geometric simplicity. De Chirico would often eliminate identifiable features from his figures, leaving them like bizarre geometric constructions. Picasso, in his precubist and neoclassical periods, geometricized and modeled his forms in generalized, structural ways.

Figure 5.36
BEN SHAHN (American, 1898–1969)
Man Picking Wheat or *Beatitudes* (black ink on paper), 960 x 635 mm, (38 x 25")
Courtesy of the Fogg Art Museum, Harvard University. Gift of Meta and Paul J. Sachs

Shahn offers us a philosophic moment when man, with his large, clumsy hand, thoughtfully holds a slender shaft of wheat. These few, practiced lines are all that are needed to convey this message.

Along with these examples, many artists can be found who present variations and modifications of these techniques. Others create imaginary settings for the figure, distort the figure in unusual ways or combine it with animals or inanimate objects to create wild or mythological imagery. Although the **surrealists** are most closely associated with this activity today, this process has been going on since the beginning of art.

We are not necessarily recommending that you turn to distortion as the next step in the figure drawing process, although this approach may be helpful to cement and challenge your previous knowledge. What is essential, however, is that you continue to work on your own from the figure. Through persistent effort, you will achieve a greater understanding of the human body, and your own personal **style** will begin to emerge.

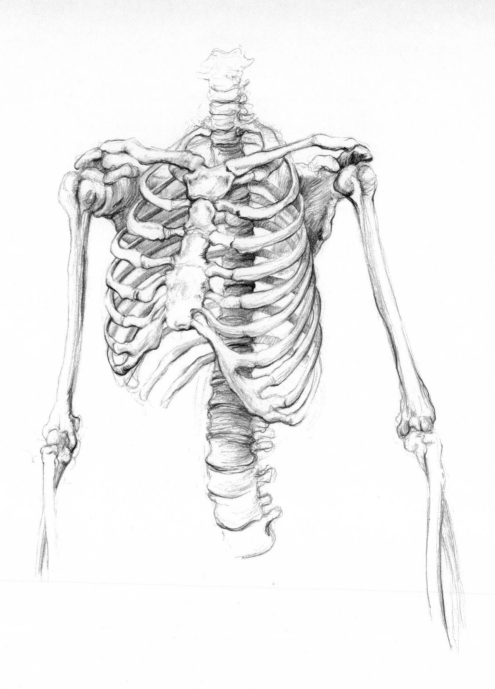

As you grow more familiar with the human form through figure drawing, you will probably realize that some knowledge of anatomy is necessary to understand the features, actions, and postures of the body. For this reason, we have included in this chapter a brief outline of anatomical structure and function. We hope that this will be useful as a reference and that it will lead to more accurate observation of the figure. It should be noted, however, that an over-concentration on bones and muscles can lead to stiff and lifeless figure work. If it is to be truly valuable, the study of anatomy should grow with, and not ahead of, work from the model.

Although anatomical names and classifications may seem confusing, they can, through study and application, become second nature. A familiarity with these names is helpful since they very often describe the shape, function, or position of the body part.

CHAPTER SIX

Anatomy

THE SKELETON

The skeleton, the foundation of the body, is brilliantly engineered to provide the stability and support that allow the human being to stand erect. It also governs a wide range of muscular movements at the joints, while protecting the soft organs of the head and torso. This structure of bone determines the basic appearance of the body since muscles are grouped in specific ways around the bones in order to move them. In addition, many bones may be seen on the surface where their distinctive shapes serve as landmarks that help to reveal the design and proportions of the body (see Figure 6.2).

As the skeleton is the foundation of the body, the spine is the foundation of the skeleton. It supports the three bony masses, the skull, rib cage and pelvis, and orders their movement. The spine is not straight, but is

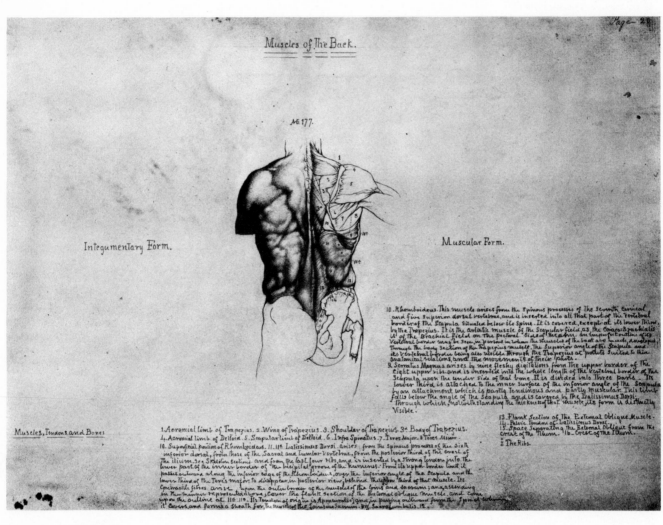

Figure 6.1
WILLIAM RIMMER (English, 1816–1879)
Muscles of the back
Courtesy of the Museum of Fine Arts, Boston

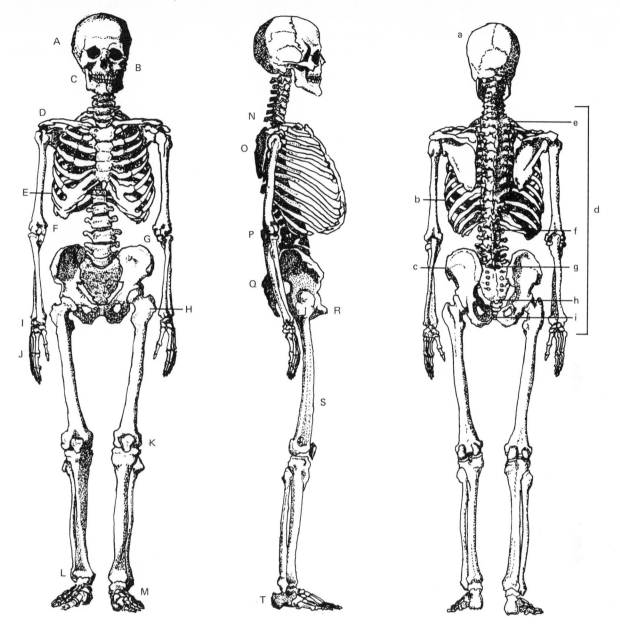

Figure 6.2
The skeleton. Letters A–T refer to bones visible on the surface of the body that may be used as reference points for proportion and design in figure drawing. Letters a–i refer to major masses of the skeleton and sections of the spine.

Front view
A. Bones of the skull
B. Cheekbone (zygomatic)
C. Jawbone (mandible)
D. Collarbone (clavicle)
E. Rib cage (ribs and sternum may be visible)
F. Inner elbow (internal epicondyle of the femur)
G. Crest of the pelvis (iliac crest)
H. Great trochanter of the femur
I. Bones of the wrist
J. Knuckles
K. Kneecap (patella) and bones of the femur and tibia at the knee
L. Inner and outer anklebones (malleolus)
M. Joints of the toes

Side view
N. 7th cervical vertebra
O. Shoulder blades (scapula)
P. Bone of the elbow (olecranon process of the ulna)
Q. Sacrum
R. Pubic symphysis
S. Edge of tibia
T. Heel bone (calcaneus)

Back view
a. Skull
b. Rib cage
c. Pelvis
d. Spine
e. 7 cervical vertebrae (neck)
f. 12 thoracic vertebrae (rib cage)
g. 5 lumbar vertebrae (lower back)
h. Sacrum
i. Coccyx

Drawn from Fritz Schider, *An Atlas of Anatomy for Artists* (New York: Dover Publications, Inc., 1947, 1958), courtesy of the publisher

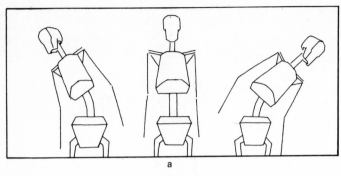

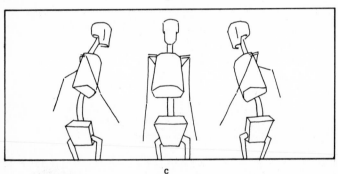

Figure 6.3
Action of the spine begins with the flexible lumbar vertebrae.

(a) leaning
(b) bending
(c) twisting

ure 6.3). The spine curves out and under to support the rib cage (side view), the legs extend out from the pelvis, then pass downward and in, where they support the entire body (front view). This intricate patterning helps to create balance, cushion shocks, and facilitate movement. Even the *individual bones are not perfectly straight*, but bow slightly one way or another to allow better muscular attachment and leverage. In drawing the figure, remember to indicate this flow of lines and form that gives the body grace and support.

JOINTS

The joints are the points in the body where bones come together (see Figure 6.4). There are three kinds of joints: two, called *sutures* and *symphysis*, allow little or no movement between bones; the third, *diarthroses joints*, are the truly active joints of the body. In these

Figure 6.4
Structure of a joint

(A) articular cartilage (breaks down to form lubricant)
(B) ligaments enclosing joint
(C) lubricating fluid (synovial fluid)
(D) bone

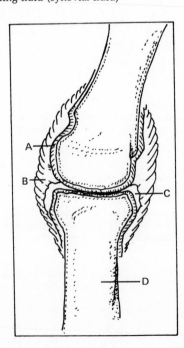

shaped in a slight S curve. This curve allows the masses to sit directly above one another, providing a center of gravity down the middle of the body that continues through the pelvis into the legs and feet. The arms, from their attachment to the shoulder blades and collarbones, are allowed a wide range of movement.

If you look at the basic gestural lines of the skeleton beginning at the top of the spine and extending down into the legs, you will notice a series of in-and-out curves (see Fig-

joints, two bones are joined together by bands of ligaments that encase the joint completely. The bones themselves are covered at the ends with a thin layer of cartilage, which breaks down to form a lubricant. This lubricating fluid allows the bones to slide against each other without friction, and the surrounding cup of ligaments keeps the fluid from dripping out.

There are several kinds of diarthroses joints, each designed for a different range of motions. Most common are the hinge joints (Figure 6.5), like the knees or fingers, which limit movement to a forward and back direction; and the ball and sockets (Figure 6.5), which allow an almost circular motion. There are also variations on these basic joints, as well as compound joints (Figure 6.7), like the elbows, which include two types of joints, closely connected, performing different functions. Complex sets of muscles work on these joints to provide leverage, power, and control.

Figure 6.5
Hinge joint

(a) mechanical hinge
(b) hinge joint extended
(c) hinge joint flexed
(d) knee joint extended

Figure 6.6
Ball-and-socket joint

(a) mechanical ball and socket
(b) turning in and out action
(c) lifting and lowering
(d) forward and back movement
(e) the femur joins the pelvis with a ball-and-socket joint

Figure 6.7
Compound joint (ball and socket with hinge at the elbow)

(a) ulna attaches to humerus with a hinge, radius attaches to ulna with a ball and socket, which allows it to revolve around the other bone
(b) hand in supine position (palm up)
(c) action of both joints of elbow

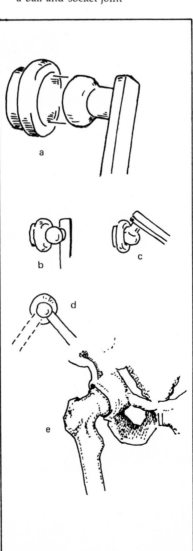

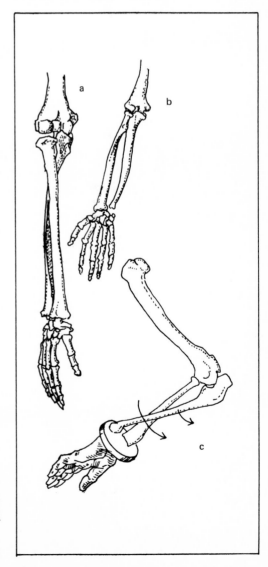

MUSCLES

Muscles* generally pass from one bone to another, over and around a joint. As they contract, they pull one bone using the joint as a lever or pulley. Muscles can work alone or in combination with other muscles to perform varied and complex actions.

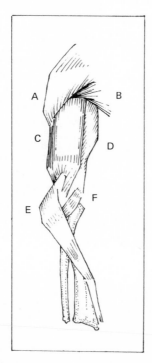

Figure 6.8
Action of the muscles
(A) deltoid abducts
(B) pectoralis adducts
(C) biceps flex forearm
(D) triceps extend forearm
(E) pronator teres turns palm downward
(F) supinator longus turns palm up

For every muscle that pulls a bone one way, there must be another that pulls it the opposite way. Theoretically, when one muscle contracts, its opposing muscle will relax, but often both muscles operate at once with one limiting or impeding the work of the other.

*Muscles referred to in this chapter are the striated, or voluntary, muscles which move the skeleton, as opposed to the smooth and cardiac, involuntary muscles which control the actions of various body functions such as digestion and heart actions.

This mutual action allows the body the slow and steady movements necessary for careful or controlled activity.

Muscles are named by their action, their shape, or the bones they operate (see Figure 6.8). By reading the name and noting the position of the muscle, it is often possible to determine what its function is:

• Flexors: decrease angle of joint (bend the joint).
• Extensors: increase angle of joint (extend the joint).
• Supinators: turn the hand palm up.
• Pronators: turn the hand palm down.
• Adductors: draw bones toward the body.
• Abductors: draw bones away from the body.
• Rotators: turn limb around an axis.
• Levators: raise body part.
• Depressors: lower body part.

THE BODY IN SEGMENTS

In the following pages we will present individual parts of the body, first showing the bone structure and then the musculature. To understand the workings of the body, look carefully at the drawings, trying to see how the muscles relate to bone structure and how the muscles would move the bones. In each section, we will show the body part from several different angles so that the anatomical formations may be traced from source to completion.

These pages will show only the superficial muscle structures since these shape the visible surface of the body. You should know, however, that there are many deeper layers of muscles that help to support and move the body, but they are rarely seen. For clarity, we have chosen not to mention some of the minor superficial muscles. If you are interested in more specific information, refer to the bibliography for anatomy books written especially for the artist.

Also included in each section are specific drawing notes offering suggestions that may help you to draw individual body parts sim-

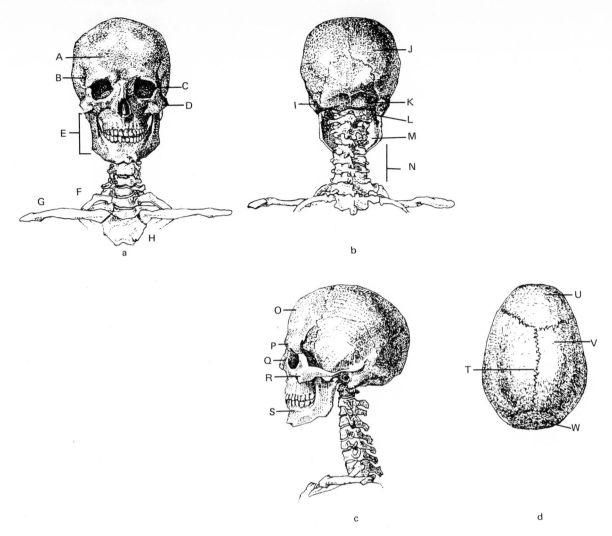

Figure 6.9
Bones of the skull

(a) Front view
A. Frontal eminence
B. Temporal bone
C. Orbital cavity
D. Zygomatic arch
E. Mandible
F. First rib
G. Clavicle
H. Sternum

(b) Back view
 I. Mastoid process
 J. Parietal eminence
 K. Occipital bone
 L. Atlas
 M. Axis
 N. Cervical vertebrae 3–7

(c) Side view
O. Frontal eminence
P. Nasal bone
Q. Nasal cavity
R. Maxillary
 S. Mental protuberance

(d) Top view
T. Sagittal suture
U. Frontal eminence
V. Parietal eminence
W. Occipital bone

Drawn from Fritz Schider, *An Atlas of Anatomy for Artists* (New York: Dover Publications, Inc., 1947, 1958), courtesy of the publisher

ply and geometrically. This discussion is based on the section entitled Solidity and Mass in Chapter Five, on figure drawing. We suggest that you use these notes as a *guide* to observation; do not take them as literal facts. Since bodies vary widely in shape, and constantly appear different from every angle and position, standards of measurement or drawing formulas can never be consistently useful.

The Head and Neck

At birth, the infant's skull consists of a number of soft bones joined together with cartilaginous tissue. The bones harden and fuse together at sutures to become the solid mass of the adult skull (see Figure 6.9). The skull as a whole has only one moveable bone, the mandible or jaw bone.

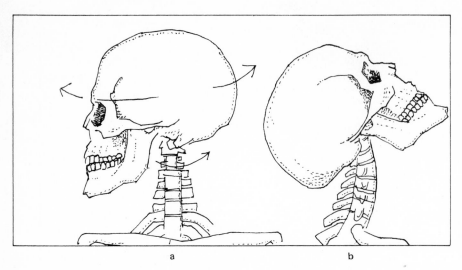

a b

Figure 6.10
Action of the skull on the spine
(a) action of the axis (2nd cervical vertebra) turning
(b) action of the atlas (1st cervical vertebra) nodding

Figure 6.11
Musculature of the face
(A) temporalis (lifts front of jaw)
(B) masseter (raises back of jaw)
(C) zygomaticus minor
(D) zygomaticus major

Drawn from Fritz Schider, *An Atlas of Anatomy for Artists* (New York: Dover Publications, Inc., 1947, 1958), courtesy of the publisher

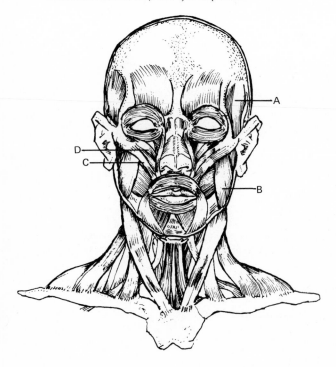

Figure 6.12
Musculature of the neck
(A) sternocleidomastoid (turns and flexes head on neck)
(B) trapezius (pulls head back)
(C) musculature of the throat (affects swallowing and respiration)

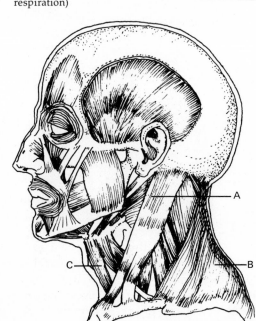

The skull sits on the atlas, the first cervical vertebra, which supports it and allows it a large turning radius. The atlas, in turn, sits on the axis, the second cervical vertebra, a hinge joint that allows the head to nod up and down. The remaining five cervical vertebrae are flexible and extend the possibilities of motion for the head in nearly all directions.

The largest muscles of the face (see Figure 6.11), the temporal and the masseter, are among those responsible for closing the jaw. The temporal begins in a weblike pattern on the temporal bone of the skull and extends downward, passing under the cheekbone (zygomatic arch) to attach to the upper part of the mandible. It raises the front part of the jaw. The masseter passes from the zygomatic arch to the lower back of the jawbone and pulls the back of the jaw up, contributing to the action of cutting and grinding. Smaller muscles in the neck, like the digastric, are responsible for opening the jaw.

The remaining muscles in the face are active in facial expression. The zygomaticus minor, for example, draws up the outside middle portion of the mouth to express grief; the zygomaticus major draws the side of the mouth up in laughter. Others pull on the eyelids, wrinkle the brow, or dilate the nostrils, and so on. By noticing the placement of the muscle, you should be able to determine its action.

In the front of the neck (see Figure 6.12), the sternocleidomastoid muscles, or "bonnet string" muscles, may be seen extending to the back of the ear from a double attachment at the top of the sternum and front of the clavicle (collarbone). Working together, they pull the head forward and downward. Working separately, they pull the head to one side or the other. Between them are the muscles of the throat, which raise and lower the hyoid bone, or tongue bone, participating in digestion and respiration. Over these muscles is a thin sheeting layer called the platysma, which stretches the skin of the neck.

The muscle that forms the back and side areas of the neck is the trapezius. It attaches above to the occipital bone in the back of the head, then descends obliquely around the shoulders to the clavicle in front, back again to the spine and acromion process of the

scapula, and finally to an insertion at the 12th thoracic vertebra. It covers the 1st through 6th vertebrae of the neck, but spreads out to attach to and reveal the 7th. Its action is to extend, or pull back, the head and may also incline the head to one side if only one side of the muscle contracts.

DRAWING NOTES

The head is often thought of as either a spherical oval or a block. Both observations are valuable in aiding the viewer to recognize the three dimensionality of the head. By seeing the head as a sphere, we become aware of the fact that the features curve around the skull, rather than being flat. The use of a block formation helps us to be aware of planes and perspective when drawing the head.*

The major planes are those of the cheek and temple on the side and the angled plane of the forehead, upper lip, and jaw in front. The nose also may be seen in terms of front and side planes. The neck is seen as a cylinder that comes slightly forward even when the head is erect or thrown back.

The Torso

The torso is the large central form of the body (see Figures 6.13 through 6.18). It is structured around the spine and consists of three primary sections, the rib cage, the epigastrium or stomach region, and the pelvis. The top and bottom sections are stable masses, being structured by bone. The middle section, primarily muscular, is flexible and always changing its shape as the body moves.

The rib cage is like a large barrel, supported by the 12 thoracic vertabrae. Ribs form a circle, which surrounds and protects the lungs, heart, and other organs. From the clavicle (collarbone) in the front of the rib cage, and the scapula (shoulder blades) in the back, hang the arms. They are directed in action by muscles of the torso, the pectoralis major (chest muscle) in front, the deltoid (shoulder muscle) on the top, the muscles of the scapular region, the latissimus dorsi and trapezius on the back.

*See Figure 7.3 in Chapter Seven, on the Portrait.

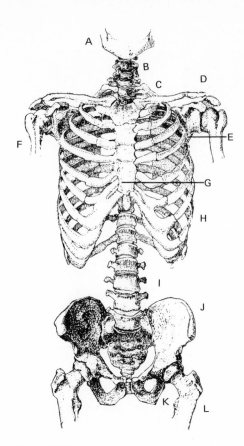

Figure 6.13

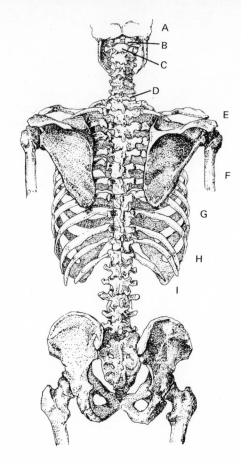

Figure 6.15

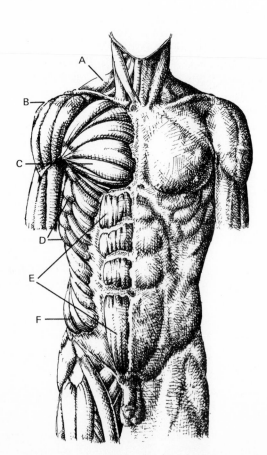

Figure 6.14

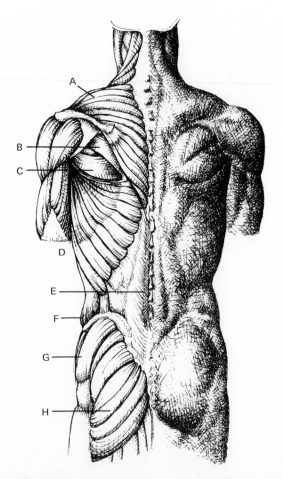

Figure 6.16

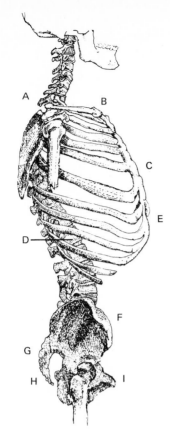

Figure 6.17

Figure 6.13
Skeleton of the torso, front view
A. Mandible (jaw)
B. Cervical vertebrae
C. First rib
D. Clavicle
E. Scapula
F. Humerus
G. Sternum

H. Rib cage
I. Lumbar vertebrae
J. Ilium
K. Pubic symphysis
L. Ischium
M. Femur

Figure 6.15
Skeleton of the torso, back view
A. Occipital of the skull
B. Atlas
C. Axis
D. 7th cervical vertebra
E. Scapula
F. Humerus

G. Sternal ribs
 (true ribs)
H. Asternal ribs
 (false ribs)
I. Floating ribs
 (false ribs)

Figure 6.17
Skeleton of the torso, side view
A. 7th cervical vertebra
B. Clavicle
C. Sternum
D. Ribs
E. Costal cartilage

F. Iliac crest
G. Sacrum
H. Coccyx
I. Pubic symphysis

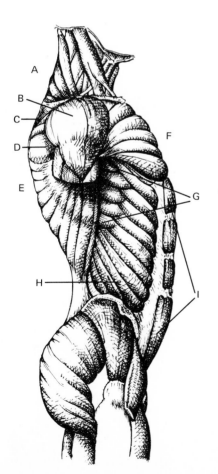

Figure 6.18

Figure 6.14
Musculature of the torso, front view
A. Trapezius
B. Deltoid
C. Pectoralis major

D. Serratus anterior
E. Rectus abdominis
F. External oblique

Drawn from Fritz Schider, *An Atlas of Anatomy for Artists* (New York: Dover Publications, Inc., 1947, 1958), courtesy of the publisher

Figure 6.16
Musculature of the torso, back view
A. Trapezius
B. Infraspinatus
C. Teres minor and major
D. Latissimus dorsi
E. Erector spinae (a deeper muscle, visible only when flexed)

F. External oblique
G. Gluteus medius
H. Gluteus maximus

Drawn from Fritz Schider, *An Atlas of Anatomy for Artists* (New York: Dover Publications, Inc., 1947, 1958), courtesy of the publisher

Figure 6.18
Musculature of the torso, side view
A. Trapezius
B. Deltoid
C. Infraspinatus
D. Teres minor and major
E. Latissimus dorsi

F. Pectoralis major
G. Serratus anterior
H. External oblique
I. Rectus abdominus

The epigastrium, or flexible section, consists primarily of the rectus abdominis combined with the external oblique and erector spinae in the back. The rectus abdominis combined with the external oblique and erector spinae and other deep muscles assist the spine in maintaining the erect stature unique to humans. Working individually, they flex, twist, bend, and straighten the torso on the pelvis. (See Figure 6.18.)

DRAWING NOTES

The torso may be drawn as a wedge shape. Its wide upper border is made up of the shoulder muscles and the collarbone. The narrow lower part is formed by the oblique muscles over the crest of the pelvis and the long stomach muscles that go into the pubic area. There are distinct planes visible on the front back and side.

In action, the stable parts of the torso,

the rib cage and pelvis, can be seen as separate blocks. The upper block tilts slightly back, the lower block is smaller and tilts forward when the body is erect. (See Figure 6.19.)

Secondary masses include the oval rib cage, the blocklike chest muscles, the wedge of the rectus abdominis, flanked by the two blocks of the external oblique, all in the front. Two wedges are visible in the back. The first, formed by the rib cage and shoulder blade, is wide at the top and gets narrow at the waist. The second is inverted, beginning narrow at the waist and widening into the blocklike masses of the gluteus maximus.

The Arm

The humerus of the upper arm is the longest bone in the *upper* body (see Figures 6.20 through 6.23 for the arm). It is attached to the

Figure 6.19
Positions of the torso

Drawn from Fritz Schider, *An Atlas of Anatomy for Artists* (New York: Dover Publications, Inc., 1947, 1958), courtesy of the publisher

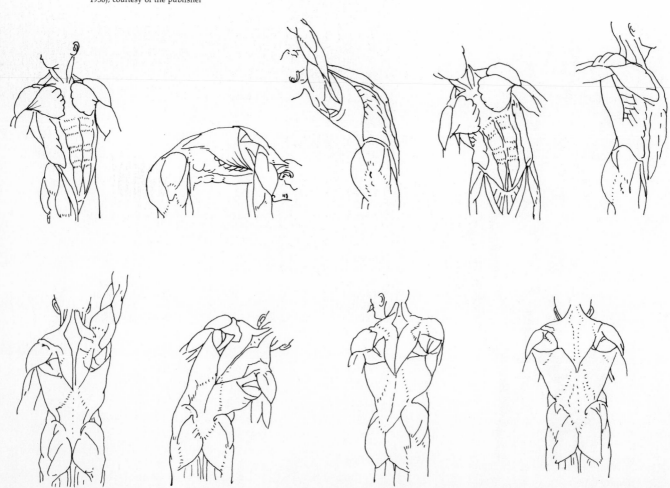

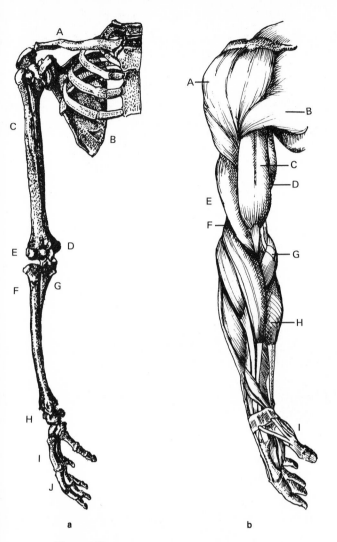

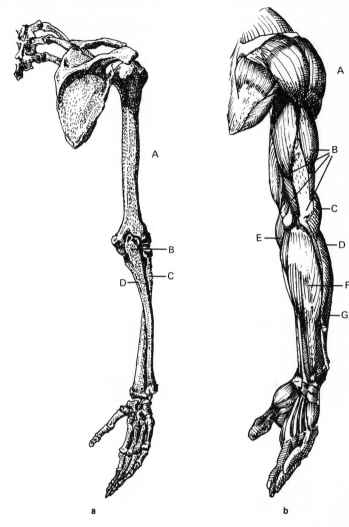

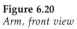

Figure 6.20
Arm, front view
(a) Bones of the arm
A. Clavicle
B. Scapula
C. Humerus
D. Internal epicondyle of humerus
E. External epicondyle of humerus
F. Radius
G. Ulna
H. Bones of wrist
I. Metacarpal
J. Phalanges of the fingers

(b) Musculature of the arm
A. Deltoid
B. Pectoralis
C. Biceps
D. Triceps
E. Brachialis
F. Supinator longus (brachioradialis)
G. Pronator teres
H. Flexors of the hand
I. Muscles of the thumb

Drawn from Fritz Schider, *An Atlas of Anatomy for Artists* (New York: Dover Publications, Inc., 1947, 1958), courtesy of the publisher

Figure 6.21
Arm, back view
(a) Bones of the arm
A. Humerus
B. Olecranon process of the ulna
C. Radius
D. Ulna

(b) Musculature of the arm
A. Deltoid
B. Triceps (3 muscular heads and a common tendon)
C. Supinator longus (brachioradialis)
D. Anconeus
E. Pronator teres
F. Flexor carpi ulnaris (covers the deep flexors of the fingers)
G. Extensor carpi ulnaris

Drawn from Fritz Schider, *An Atlas of Anatomy for Artists* (New York: Dover Publications, Inc., 1947, 1958), courtesy of the publisher

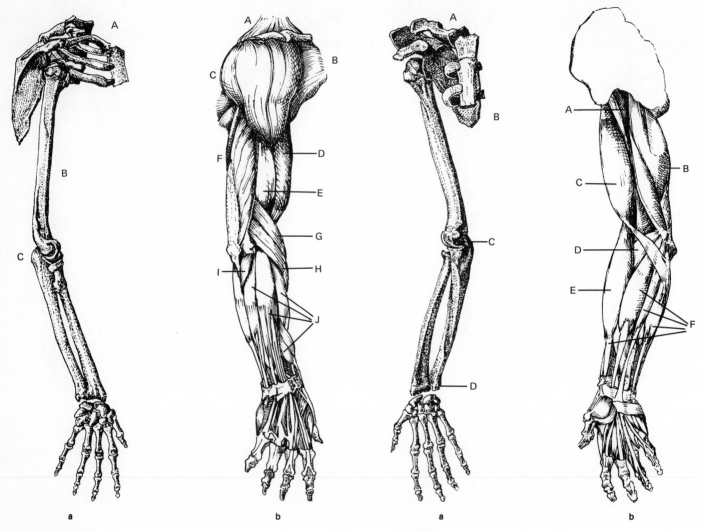

Figure 6.22
Arm, exterior view
(a) Bones of the arm
A. Clavicle
B. Humerus
C. Olecranon process

(b) Musculature of the arm

A. Trapezius	F. Triceps
B. Pectoralis	G. Supinator longus
C. Deltoid	H. Extensor carpi radialis longus
D. Biceps	I. Extensors of the hand
E. Brachialis	

Drawn from Fritz Schider, *An Atlas of Anatomy for Artists* (New York: Dover Publications, Inc., 1947, 1958), courtesy of the publisher

Figure 6.23
Arm, interior view
(a) Bones of the arm
A. Clavicle
B. Scapula
C. Interior epicondyle of the humerus
D. Head of the ulna at the wrist

(b) Musculature of the arm
A. Coracobrachialis
B. Triceps
C. Biceps
D. Pronator teres
E. Supinator longus (brachioradialis)
F. Flexors of the hand

Drawn from Fritz Schider, *An Atlas of Anatomy for Artists* (New York: Dover Publications, Inc., 1947, 1958), courtesy of the publisher

clavicle in the front and the scapula in the back by a ball and socket joint. The ulna of the forearm connects to the humerus by a hinge joint at the elbow. The radius, the other bone of the forearm, is not attached to the humerus. Rather it is fixed to the top of the ulna by a ball and socket joint. The hand is attached only to the radius. When the radius and the ulna are parallel, the palm is turned outward (supination). As the radius crosses the ulna from its attachment at the outside of the elbow to the inside of the wrist, the hand turns over (pronation). The many small bones that make up the wrist feed into the long thin metacarpals of the hand. The fingers, as the final extension of the arm, attach to the metacarpals, forming the knuckles.

Muscles that move the upper arm originate on the torso. The deltoid lifts and pulls the arm forward and back, the pectoralis pulls it forward, and the latissimus dorsi pulls it back and down. In addition, the muscles of the scapular region extend the possible movements of the arm by manipulating the shoulder. Those muscles on the humerus control the action of the lower arm. The biceps and brachialis in front flex the forearm at the elbow. The triceps on the back and side of the arm extend the forearm. On the lower part of the humerus are two long muscles that pass over the elbow: the supinator longus (brachioradialis) which turns the palm upward, and the extensor carpi radialis, which extends the wrist.

Opposite the supinator longus on the inside of the elbow is the smaller pronator teres, which turns the hand palm downward and helps to flex the forearm.

The muscle groups of the lower arm flex and extend the fingers. Both groups begin as narrow muscles attached at or near the elbow and extend to the hand by long thin tendons. The extensors attach to the outside of the elbow (external epicondyle) and travel down the back of the arm. Flexors attach to the internal condyle and move along the inside of the arm.

In the hand, the largest muscles move the thumb and form the mound of the thumb. Smaller muscles spread and move the fingers.

A general view of the arm shows how muscle size relates to action. The big muscles of the upper arm are responsible for the relatively slow but powerful movement of flexing and extending the forearm. The longer, smaller muscles in the forearm move the wrist and hand, allowing it quickness and agility, while the fine work of the fingers is performed by the flexors and extensors of the forearm and the delicate muscles in the hand itself. (See Figure 6.24.)

Figure 6.24
Positions of the arm

Drawn from Fritz Schider, *An Atlas of Anatomy for Artists* (New York: Dover Publications, Inc., 1947, 1958), courtesy of the publisher

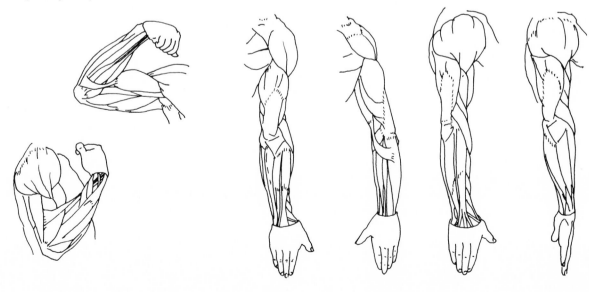

DRAWING NOTES

The delta-shaped shoulder muscle bulges out over the upper part of the arm. From there, the upper arm is like a block formed by the biceps and triceps. The lower arms may be thought of as an egg shape, which forms just below the elbow, extending into the block or cylinder of the wrist. The hand varies in shape from the sphere of the fist to the wedge of the open palm, with hundreds of possibilities between. The extended arm, like the leg and spine, may be seen as a flowing line made of movements and countermovements.

The Leg

The structure of the leg (Figures 6.25 through 6.28) may be divided into three sections, the thigh, the calf, and the foot. The head of the thigh bone, or femur, connects with the pelvis in a ball and socket joint that allows a great range of movement. From its head, the femur extends outward several inches to the great trochanter, then drops inwardly to the knee. Here the small kneecap, or patella, covers the end of the femur. From the knee, the tibia descends to the ankle, with the smaller, flutelike fibula running beside it on the outside of the leg. The lower ends of these two bones form the inner and outer malleolus, or anklebones.

The talus is the keystone of the arch of the foot. It is held in a tight hinge joint between the tibia and fibula, with the fibula attaching on the outside slightly lower than the tibia. After the talus, the remainder of the arch of the foot is made up of small bones in the front and the calcaneus, or heel bone, in the back. The small bones of the arch, with their fluid-filled interspaces, help to absorb any jarring shocks that the foot might receive. Long narrow bones, the metatarsals, form the body of the foot and are followed by the shorter phalanges of the toes.

The muscles that move the upper leg are attached at the pelvis, extending down to grasp the femur. The gluteus maximus, in the back of the leg, extends and turns the thigh outward. On the side, the gluteus medius lifts (abducts) the leg and turns it inward. On the

inside of the leg, the adductors (brevis, longus, and magnus), along with the gracilis and pectineus, turn the thigh, pull it inward, and may also contribute to rotation and flexion. The major flexors of the thigh are on the front of the leg and include the tensor fasciae latae, the rectus femoris, and the sartorius.

The frontal mass of the upper leg is formed by the quadriceps femoris, four muscles that extend the lower leg at the knee. These are the rectus femoris mentioned above, the vastus externus, the vastus internus, and the vastus intermedius. All these muscles attach to the patella (kneecap) by a common tendon, then pass over the patella to attach onto the upper part of the tibia. The patella acts as a pulley, giving the muscles of extension a freer action. It also protects the joint and tendon from injury. Opposite the quadriceps, on the back of the leg, are the three major flexors of the lower leg, the hamstrings (biceps femoris and the semitendinosus) as well as the semimembranosus. The hamstrings, working together, also help to extend the thigh on the pelvis. They finally attach by long narrow tendons to the tibia and fibula.

Between the hamstring ligaments on the back of the leg, the gastrocnemius arises, with the thin, flat soleus below it. These muscles attach to the heel bone by the Achilles' tendon and extend the foot at the ankle. Thinner muscles on the front and sides of the leg include the peroneus longus and brevis, which extend the foot and lift the outside of the sole, the tibialis anticus, which flexes the foot and raises the inside edge, and the extensor digitorum longus, which extends the toes. Small muscles of the foot flex and spread the toes, performing small and subtle actions essential for balance and motion.

Bone and muscle structure in the arms and legs are remarkably similar, despite a great difference in the function and actions of the two limbs. (See Figure 6.29.)

DRAWING NOTES

The thigh appears from the front as an inwardly slanting, long rectangular block of the knee. The lower leg (calf) forms a more

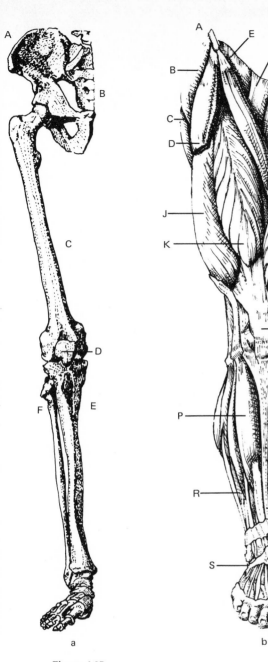

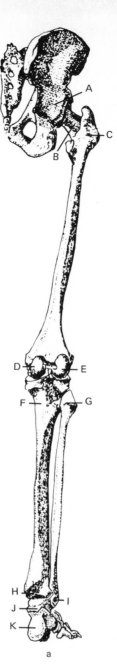

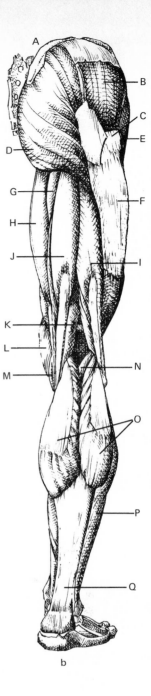

a

b

Figure 6.25
Leg, front view
(a) Bones of the leg

A. Ilium
B. Sacrum
C. Femur
D. Patella
E. Tibia
F. Fibula

(b) Musculature of the leg

A. Iliac crest
B. Gluteus medius
C. Great trochanter of the femur
D. Tensor fasciae latae
E. Psoas iliacus
F. Pectineus
G. Adductor longus
H. Gracilis
I. Sartorius
J. Vastus externus
K. Rectus femoris
L. Vastus internus
M. Patella
N. Gastrocnemius
O. Soleus
P. Tibialis anticus
Q. Flexor digitorum longus
R. Peroneus brevis
S. Extensor digitorum brevis

Drawn from Fritz Schider, *An Atlas of Anatomy for Artists* (New York: Dover Publications, Inc., 1947, 1958), courtesy of the publisher

Figure 6.26
Leg, back view
(a) Bones of the leg

A. Head of the femur
B. Neck of the femur
C. Great trochanter
D. Internal condyle
E. External condyle
F. Fibula
G. Tibia
H. Inner malleolus (anklebone)
I. Outer malleolus (anklebone)
J. Talus
K. Calcaneus

(b) Musculature of the leg

A. Iliac crest
B. Gluteus medius
C. Great trochanter of the femur
D. Gluteus maximus
E. Tensor fasciae latae
F. Vastus externus
G. Adductor magnus
H. Gracilis
I. Biceps femoris ⎱ (hamstrings)
J. Semitendinosus ⎰
K. Semimembranosus
L. Vastus internus
M. Sartorius
N. Plantaris
O. Gastrocnemius
P. Soleus
Q. Achilles' tendon

Drawn from Fritz Schider, *An Atlas of Anatomy for Artists* (New York: Dover Publications, Inc., 1947, 1958), courtesy of the publisher

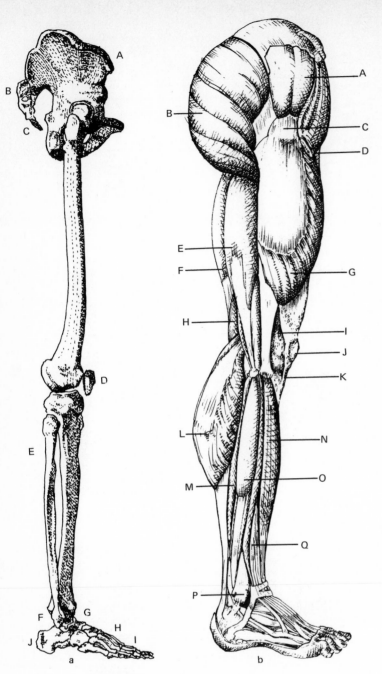

Figure 6.27
Leg, exterior view
(a) Bones of the leg
A. Iliac crest
B. Sacrum
C. Pubic symphysis
D. Patella
E. Fibula

F. External malleolus
G. Talus
H. Metatarsals 1–5
I. Phalanges of the toes
J. Calcaneus

(b) Musculature of the leg
A. Gluteus medius
B. Gluteus maximus
C. Great trochanter
 of the femur
D. Tensor fasciae latae
E. Biceps femoris
F. Semitendinosus
G. Vastus externus
H. Semimembranosus

I. Vastus intermedius
J. Patella
K. Patella ligament
L. Gastrocnemius
M. Soleus
N. Tibialis anticus
O. Peroneus longus
P. External malleolus
Q. Extensor digitorum longus

Drawn from Fritz Schider, *An Atlas of Anatomy for Artists* (New York: Dover Publications, Inc., 1947, 1958) courtesy of the publisher

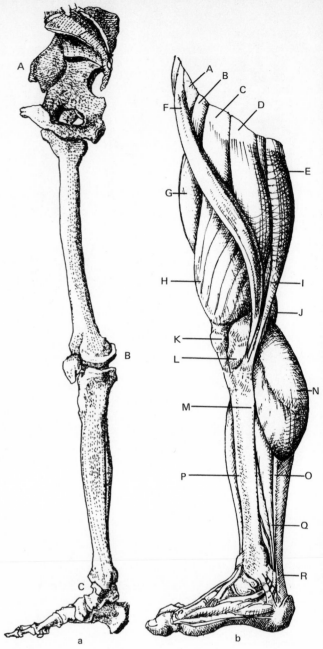

Figure 6.28
Leg, interior view
(a) Bones of the leg
A. Pelvis
B. Internal condyle of the femur
C. Talus

(b) Musculature of the leg
A. Psoas iliacus
B. Pectineus
C. Adductor longus
D. Gracilis
E. Semitendinosus
F. Sartorius
G. Rectus femoris
H. Vastus internus
I. Semimembranosus

J. Biceps femoris
K. Patella
L. Fatty pad beneath patella
M. Tibia
N. Gastrocnemius
O. Soleus
P. Tibialis anticus
Q. Flexor digitorum longus
R. Achilles' tendon

Drawn from Fritz Schider, *An Atlas of Anatomy for Artists* (New York: Dover Publications, Inc., 1947, 1958), courtesy of the publisher

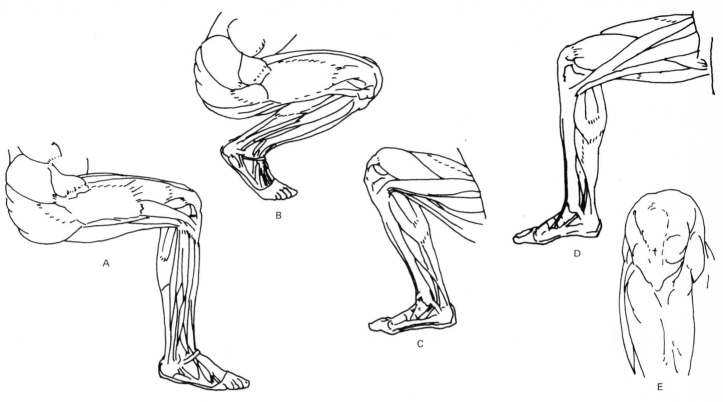

Figure 6.29

Positions of the leg (with front view of the knee flexed)

Drawn from Fritz Schider, *An Atlas of Anatomy for Artists* (New York: Dover Publications, Inc., 1947, 1958), courtesy of the publisher

complex shape. Following a graceful curve, it swells out at the top, in the back and sides, then narrows to the thin wedge of the ankle. The foot itself is very much a wedge shape from the front, back, and outside views, although the arch, which is visible from the inside, is a dominant structural and drawing concern. The toes form minor arches as well, beginning as it were on the top of the foot and arching to the ground. The leg, seen from the side follows a subtle "S"-like curve.

SUPERFICIAL CHARACTERISTICS

Superficial characteristics, in anatomical terminology, refer to details on the surface of the body. They include considerations of skin,

veins, fatty tissue, hair, and so on. These characteristics vary widely from individual to individual: skin may be pale or dark, fine or coarse in texture, smooth or wrinkled. It forms in folds, planes, and wrinkles over the underlying structures of the body. Skin is colored by many different pigments. It is never simply pink, brown, or yellow, but may contain intermediate hues ranging from blue to green, red, or gray.

The appearance of subcutaneous formations such as veins and fatty tissue varies according to body type. Some people have a great deal of fat all over their bodies, others are fat only in certain places; breasts are primarily fatty tissue. Veins are generally more visible in the narrower parts of the body. The legs, arms, hands, feet, and neck all have veins close to the surface. They tend to be more visible in thinner people or those who get a lot of physical exercise.

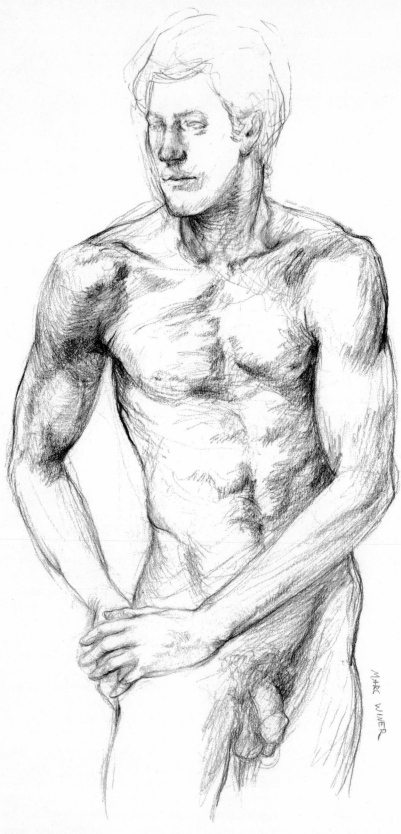

Figure 6.30
Male torso turning

Hair may be found in nearly every part of the body except on the palms of the hands or soles of the feet. It is generally thickest on the skull, where it helps to cushion the head and protect it from injury. In mature people, it grows over the pubic area and underarms. Most people have at least a light layer of hair all over their bodies.

DRAWING NOTES

In drawing the figure, observe and utilize the superficial characteristics, learning to render their forms and textures. However, it is important to remember that these are simply details applied over the internal structures of the body. Skin tones and textures provide indicators of individuality and character, and fatty tissue does shape the body, but these forms must follow the basic physical format dictated by bones and muscles. Avoid being distracted by the superficial details until you have a thorough understanding of the deeper structural foundations.

ANATOMICAL STUDIES

Choose a male model with a muscular physique for active or athletic poses. Dance, yoga, karate, or tai-chi movements are also excellent. These exercises will require long study, however, so the poses should not be too difficult to hold. Arrange a strong lighting source above the model to define the features of the body clearly. (See Figure 6.30).

Exercise 1

SKELETAL SKETCHES

(Time: 2-hour model pose—20 minutes posing, 10-minute breaks; material: conté crayon, charcoal, soft lead pencil, or vine charcoal; kneaded eraser; good quality drawing paper)

Do quick sketches of the model using the exercise listed in Chapter Five as "Skeletal Gestures." This time, however, do these skeletal sketches from several positions in the room. Choose your positions well to give you the clearest view and understanding of the action

and structure of the pose. Move all around the room, and do two or three quick sketches in each position.

Allow the model to take a break after 20 minutes. Choose the three positions that gave you the best skeletal gestures and make a 20-minute drawing in each position. When the model returns to the stand, begin to draw a light **undersketch** *delineating the skeletal structure. Then develop the musculature over the skeleton by careful use of light and shade.*

Remember that not all lights and shadows will be useful in delineating the form and that cast shadows often disguise the surface. Choose only those shadows that effectively describe the muscular shapes and make special note of the places where bones appear on the surface.

Exercise 2

ACTION POSES

(No time limit; material: soft pencil, charcoal pencil, or conté crayon)

Have the same model take a series of poses that describe, in stop action, an activity such as throwing a baseball or lifting something. Begin with quick gestural sketches of the action or continuous movement sketches as described earlier. Then have the model take three 20-minute poses in positions characteristic of the action. Draw each pose from one set position, making note of the different muscular actions involved in each change. Once again, begin with a skeletal sketch and continue to delineate the muscular shapes with the conscious and careful use of light and shade. You may want to draw this same activity several times from several different positions, or, better still, try to imagine what each view would look like. Do drawings of what you imagine, then check your drawings and correct yourself when the model resumes the pose.

Exercise 3

MUSCLE ACTION

(No time limit or material requirements)

After doing these exercises over an extended period, you will have workable knowledge of the muscular action of the figure. Do some drawings from imagination, applying what you know of anatomy and what you remember of the figure. Many Renaissance artists worked in this way. Try to instill a sense of action, vitality, and purpose in your drawings and don't allow muscular delineations to get too stiff. Start with a gesture, skeletal or otherwise, and maintain the gestural freedom as long as you can.

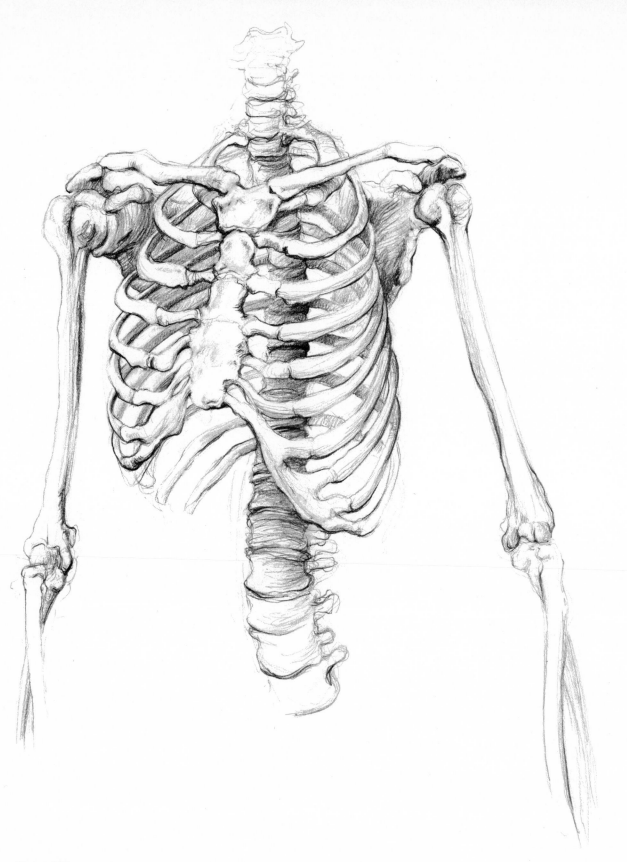

Figure 6.31
Study of rib cage and spine

Exercise 4

BONES AT WORK

(No time limit or material requirements)

Continue the study of anatomy from actual anatomical sources. You may be able to find a skeleton to draw at an art school, medical school, or museum. Try to understand how these bones work. Draw them as you see them, taking your time and measuring the proportions carefully. Draw the skeleton from several different points of view. Then try to imagine and draw it in action.

Exercise 5

CONTOUR STUDY

(No time limit; material: soft pencil)

Refer to some of your more accurate contour drawings, or trace the contour of figures by other artists. Try to draw the shapes of the bones beneath the contour. In another series of drawings, trace the muscles beneath the contour. Use this chapter or other texts for reference.

Exercise 6

ANATOMY DRAWINGS

(No time limit; material: small tablet, soft pencil)

Few students have the interest or the nerve to observe a dissection. If you do, however, there is no better way to learn about anatomy. Often medical schools will allow artists to observe and sketch. If your curiosity is not quite "that" strong, you can still learn a lot by copying from anatomy books. Refer to the bibliography for those written especially for artists. It is not recommended that the student spend long hours copying anatomy drawings at first. This type of learning is more effective when spread over an extended period and thoroughly integrated with your work from the live model.

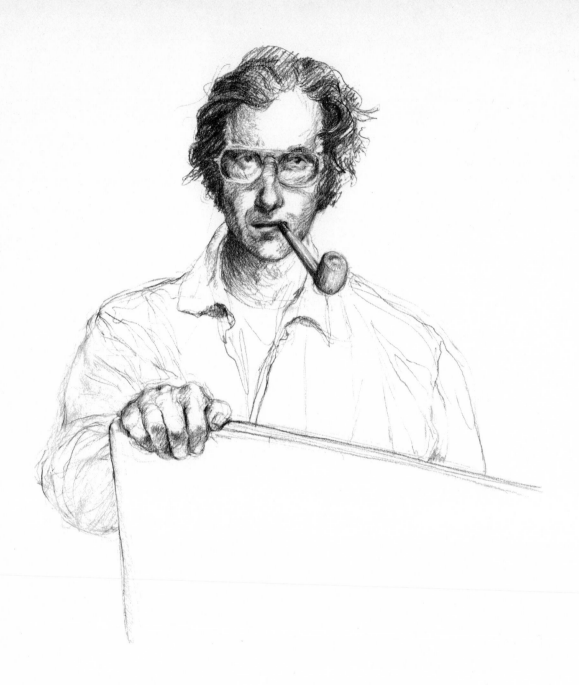

As we look at people, we are often beguiled by particular characteristics—their eyes, their smiles, even their hair. Through the more careful investigation of drawing, however, we find that these features gain much of their significance from their relation to one another and from the general ambiance of the individual. Effective portraiture develops from an understanding of specific features, but, more important, from a recognition of how these came together to make a whole.

In the course of this chapter, we will present the various aspects of portrait drawing, beginning with a discussion of the head, its form and position, and a generalized introduction to the features. The last section will focus on some specific approaches to a portrait including characterization, caricature, children's portraits, composition and self-portrait, concluding with a description of a "typical" portrait sitting.

Following the principle of working from general to specific, we should begin our study of portraiture by discussing the basic form and position of the head.

CHAPTER SEVEN

The portrait

THE HEAD

The shape of the head is actually one of the primary determining factors in characterization. As you begin to draw, you will find heads with a variety of shapes, sizes, and structures—long ovals, short, round shapes, rectangular, and even triangular formations. You also may note that in profile some people have vertical faces, others have faces that slant back at a diagonal.

To simplify form, the head can be thought of in two ways—a cube and an egg (see Figure 7.3). The first approach stresses the angularity of the facial planes and the underlying bony structure of the skull. The egg shape speaks of the curving quality of the skull and about the fact that the features sit on a curve rather than on a flat surface. In some faces, the angularity of the jaw and brow is the most prominent feature; but even an angular face has a basically curving surface, and the back of the head is generally a dome.

Begin your study of various head shapes

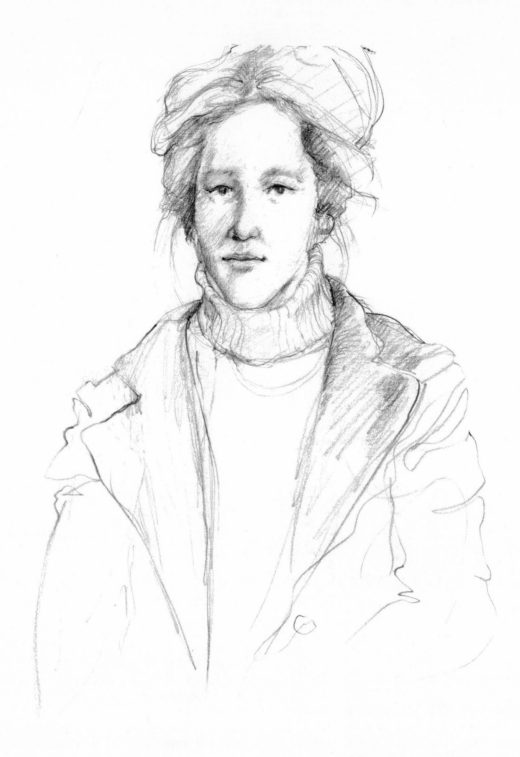

Figure 7.1
MARC WINER
Portrait of M.M., 1975 (pencil)

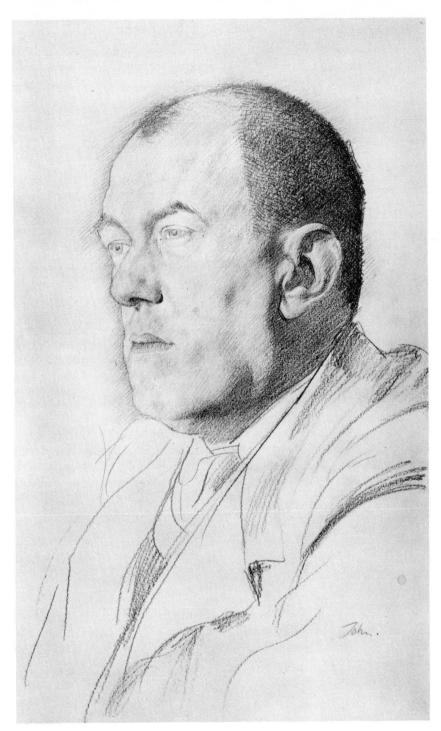

Figure 7.2
AUGUSTUS E. JOHN (British, 1879–1961)
Aleister Crowley (black crayon), 447 x 270 mm (17 5/8 x 10 5/8")
Courtesy of the Fogg Art Museum, Harvard University. Grenville L. Winthrop Bequest

Figure 7.3
Block and egg configurations and development

with a series of blocking-in exercises, establishing the egglike shape of the head, then developing the planes; thereby combining both approaches to create a strong three-dimensional form.

By first blocking in the general structure, you will become aware of the size and shape

of the back of the head. Students often get so interested in the features that they forget to indicate this important mass. You can cover your face with one hand, but it takes five hands to cover the rest of the skull!

Exercise 1

FACIAL PLANES
(Time: 15 minutes each; material: soft pencil or compressed charcoal)

Do a series of drawings, from several different models, in which you establish the basic shape and plane structure of different types of heads. Block in each, stressing first the overall form of the heads; then concentrate on the primary planes. Use a strong light placed above, in front, and to one side of the model to emphasize the planes with value distinctions. The first plane that you will notice is that which defines the side of the head. The front contour of this plane modulates along the cheek and across the temple. Note the angle of the brow, the jaw, and the cheek bone, and also the shape of the secondary planes within the major planer masses. Continue to indicate roughly the planes of the nose, eyes, mouth, chin, and forehead. By squinting, you can see how these shapes are defined by patterns of light and shadow (see Figure 7.4).

After establishing the basic shape of the head, it is necessary to determine and indicate its angle, direction, and position. In most expressive portrait drawing, the head

Figure 7.4
Take care to group your shadows so they structure the form.

will not be straight, but will tilt and turn, often with the face at a slant. The best way to establish the direction of the head is to bisect the basic shape with two simple lines: the first runs vertically down the center of the face, over the brow, between the eyes, and down the nose to the chin; the second is a horizontal line in the *middle* of the head, which indicates the placement of the eyes. As the head turns or tilts, these lines will change shape, direction, and position. Seen from the front, the lines are straight and perpendicular to one another, but as the head changes position, they display their **elliptical** nature, following the rounded surface. These lines establish the placement of the features and also help to indicate the basic three-dimensionality of the head itself (see Figure 7.5).

You may use the position of the two primary lines mentioned above to help block in the basic features. The horizontal line at the bottom of the nose and line of the mouth are parallel to the line of the eyes. As the head changes position, the distance between these lines will change, but *they will remain parallel to one another.*

The basic relationship of the three lines when seen from a front-on perspective is as follows: eyes in the middle of the head;* nose halfway between the eyes and chin; mouth halfway between the nose and chin; top of the ears on a level with the eyes and the bottom of the ear level with the nose. As the head changes position, these relationships will also change. From a top view, the crown of the head becomes a formidable mass, the features bunch up below it. From a lower vantage point, the jaw is the prominent mass and the features group closely above (see Figure 7.6).

A similar type of distortion occurs when the face turns to the right or left. In this case, it is the central vertical line that obviously changes position. When the head is seen straight on in a frontal view, the central line runs right down the middle. As the head turns, the line turns with it and becomes the contour of the face when the head is seen in

*In small children, the foreheads are very large. Features occupy only the lower third of the head, so the eyes are two-thirds of the way down rather than in the middle of the head.

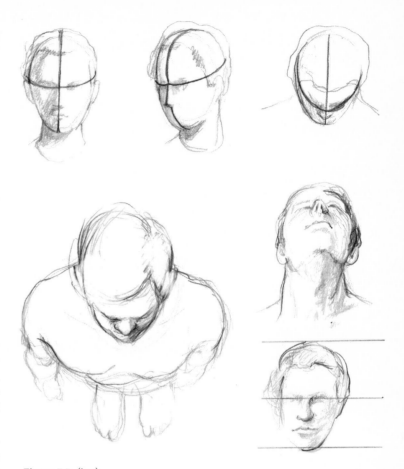

Figure 7.5 (top)
Ellipses

Figure 7.6 (bottom)
Head from three different points of view

profile. Between frontal and profile view, the center line may take an intermediate position, resulting in a three-quarter view (see Figure 7.7). This is the most popular view for portraiture because it is generally more descriptive and expressive than either profile or frontal. The three-quarter view displays a portion of the side plane of the head and more of one cheek than the other. Here you also can see both the contour and the three-dimensional masses of the brow, nose, cheek, and jaw.

In developing the face, be sure to block in all the features together rather than drawing them one at a time. If the features are developed separately, the result is often a lopsided, imbalanced, or proportionally inaccurate face. You must situate the features in relation to one another to establish the correct proportions.

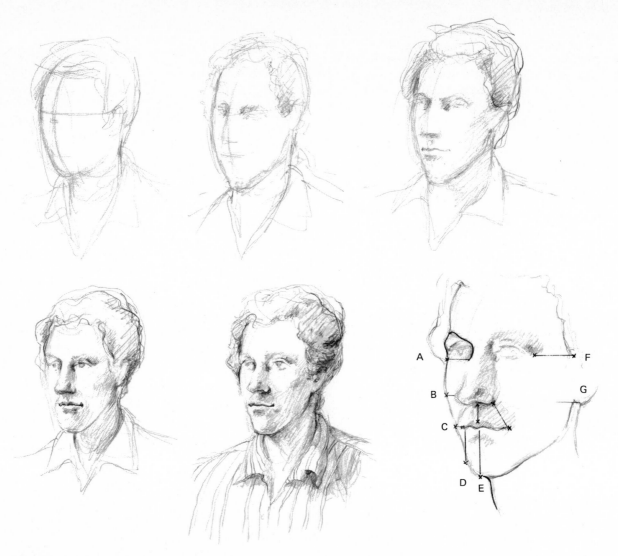

Figure 7.7
When doing a three-quarter-view portrait, develop the features starting from the inside. Once you have an indication of the nose, be careful that you measure the space from the nose to the edge of the face correctly. Then move to the next nearest element, always checking its position against the other parts of the face. In particular, check the distances from the nose and the end of the lips to the edge of the face (B, C, D, E). These spaces may be surprisingly small, but once they are understood, it should be easy to indicate the correct contour for the edge of the face. Also check the placement of ears to nose (F, G).

Exercise 2

BLOCKING IN THE FEATURES
(Time: 20 minutes each; material: soft pencil)

Continue your study of portraiture by developing the features of the face. Have a model take a series of poses, and draw the head as it appears in different positions. Block in the general form of the head; then roughly establish the shape and position of the features using lines as described earlier. Remember in placing the features that the head is a rounded, three-dimensional mass. As the head tilts or turns, the lines

of the features will appear much more elliptical (refer to Chapter Three on cylinders in perspective).

Exercise 3

SHADOWS
(Time: 30 minutes each; material: soft pencil)

An excellent way of identifying the nature and relationship of features is by drawing shadows (see Figure 7.8). Using a light source as described earlier, draw the face delineating only shadows. Look at the shadows objectively as shapes, rather than referring to them as

features, and draw the shapes and their placement as accurately as possible. You may be surprised at the likeness you can get using this type of approach. Do similar exercises with several different models to familiarize yourself with various head types, features, and planes as defined by shadow structure.

Position

It is essential in any good portrait to establish the relationship of the head to the torso. This relationship says a great deal about the character and mood of the subject. A centered, erect head conveys a sense of youth and vitality; a sagging head might indicate age, weariness, or sorrow.

In beginning your portrait study, observe how the head sits above the shoulders. As indicated in our discussion of anatomy (Chapter Six), the head is never directly over the torso even in the most erect postures; it is carried slightly forward because the neck emerges from the torso at an angle.

It is also important that you recognize the shape of the neck and shoulders. These can be both descriptive and expressive agents: a thick neck and heavy shoulders, together with a low set head, describes a stocky, substantial body type; a slender, gracefully curving neck suggests delicacy of form and spirit. The shape and position of head, neck, torso, and limbs are important to every aspect of portrait drawing, from expression to composition (see Figure 7.9).

Of course, a portrait study needn't stop at the waist. Many extend to describe the whole figure. In this case, even greater consideration must be given to posture and composition.

Figure 7.8
Shadow Portrait ("Martine")

Figure 7.9
MARIO CARLETTI DI GAETANO (Italian, 20th century)
Portrait of the Artist's Wife (black chalk on white paper, with touches of graphite), 644 x 480 mm (25 3/8 x 18 7/8")
Courtesy of the Fogg Art Museum, Harvard University. Gift of Giovanni Scheiwiller

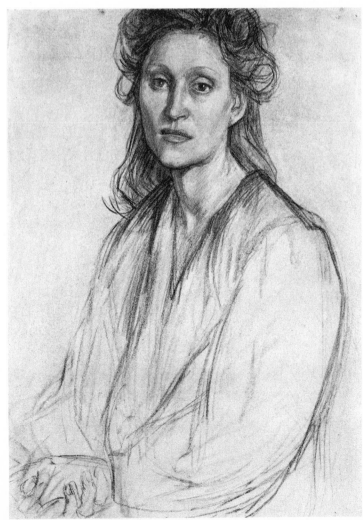

THE FEATURES

The human face is complex in form and is always changing its expression. The slightest nuance—an upraised eyebrow, a tightened lip—can have tremendous emotional meaning. In a portrait drawing, every line and tone must have significance, conveying the exact forms and relationships of the features within the face while establishing the nature and mood of the individual.

The size, shape, and placement of features are the primary factors that determine the unique qualities of a face. Features may be large or small, broad or narrow, close together or wide apart. In addition, most people have one particular feature that stands out. To capture the essence of an individual in a drawing, you must learn to recognize these qualities and represent them accurately. A small change could alter the quality or expression of the face to a great extent.

Features are as varied as individuals, but some similarities may be found among people according to race, age group, or sex. In the be-ginning, it might be helpful to note these similarities, then keep an open attitude and look for variations in the types.

Before focusing on peculiarities, however, study the general anatomy and three-dimensional construction of each feature—eyes, nose, mouth, chin, cheeks, and ears. Through your knowledge of the average feature, you may learn to recognize and draw variations more readily.

Eyes

The eye (Figure 7.10), for all its complexity, is basically a ball sitting in a socket. It is surrounded and protected by the bony structure of the brow, nose, and cheek, and will usually have some descriptive shadows within its cavity. One way to reinforce the round nature of the eye is to wrap the eyelids around the eyeball, allowing the line of the lids to follow the cross contour curve.

The upper lid is the active one, the lower is more stable. The upper lid generally covers part of the top of the iris, and the lower lid usually touches the bottom. Be careful in

Figure 7.10
(A) Remember that the eye is basically round.
(B) The upper lid, although thin, has dimension and casts a slight shadow on the eyeball. This cast shadow, combined with the lashes, causes us to see the edge of the lid as being dark. You should generally underplay this value as well as the values of eyeglasses and eyebrows.
(C, D) When drawing the eye from the side, do not forget that it is still a curved form sitting on a curving plane.

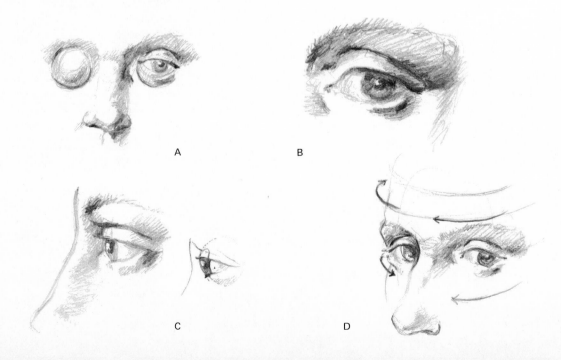

A B

C D

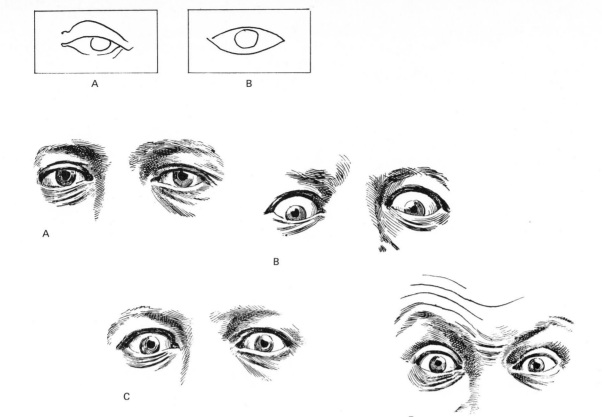

Figure 7.11 (top)
The shape of the eye should be somewhat like (A). Look hard at the unbalanced conformation of the eye to avoid the **schematic** design of (B).

Figure 7.12 A-D (bottom)
(A) ''Calmness;'' (B) ''Wild Excitement;'' (C) ''Surprise;'' (D) ''Uncontrol.''
From Webster Edgerly (pseud. Edmund Shaftesbury), *Lessons in the Art of Facial Expression* (Washington, D.C.: The Martyn College Press, 1889).

drawing the eye not to surround the iris with a ring of white unless you are trying to indicate extreme surprise. (See Figure 7.11.)

The eyes mirror emotions and moods: in laughter they narrow and wrinkle at the corners; lids are wide open when we are alert; they droop when we are drowsy. Anger, rage, pleasure, disbelief, questioning, pain, and joy are all reflected in the eyes. See Figure 7.12 for some nineteenth-century drawings of eyes in various emotional states.

Nose

Noses come in a spectacular range of shapes; however, their basic structure is a wedge that is broader at the bottom and narrower at the top (see Figure 7.13). When viewed from the front, the bridge of the nose has no apparent lines around it, so it should be developed in

drawing through the play of shadow and light. The actual shape of the nose is easiest to draw in profile, but a three-quarter view is the most effective for showing structure. In this view you can see the contour of the nose (although the line may disappear in the similar values of the farther cheek) as well as its three-dimensional shape. Instead of etching a strong outline around the nose, build its form up gradually from the structure of the cheeks using only those shadows that are necessary. In establishing shadows, emphasize ones that actually describe the structure of the face and take care not to overplay the cast shadows on the cheek and upper lip.

The bottom of the nose, like the bridge, is built of planes and may be described in shadows, using reflected light to soften and modulate the surface. Look hard to recognize the exact shape of the nostrils. (Sometimes they may not be visible at all.) When you are

197

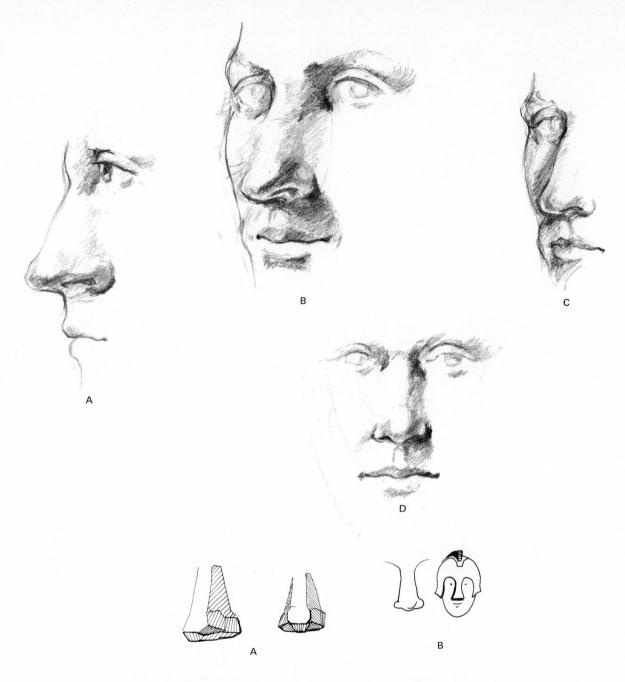

Figure 7.13 (top)
The nose is, perhaps, easiest to draw in profile. Whatever view you choose, be careful to indicate its curving bottom plane. Usually a suggestion of reflected light helps. The nostril is not at the very bottom of the nose, as can be seen in these illustrations.
(B) In a three quarter view, the side plane of the nose often "disappears," since it becomes the same value as the far cheek. If you firmly establish the bottom section of the nose, the area where the nose overlaps the eye, and, especially, the shadow on the opposite side of the nose, the shape of the nose will emerge and still be part of the face.
(C) Of course, if the light source is on the opposite side, the nose itself casts a shadow, which can be used to help structure its shape.

Figure 7.14 (bottom)
In general, it works best simply to locate the shading on one side of the nose (see Figure 7.13D). Often students will etch a line around the nose or will assign equal shadows on both sides, resulting in the "Greek helmet syndrome" shown here.

on the same level as a person, you generally cannot see much of their nostrils and are probably unaware of them—so don't draw the nostrils as two large, dark circles. Instead, observe them carefully and integrate their shape and values into your handling of the rest of the face (see Figure 7.14).

Mouth

The mouth is the most flexible feature of the face and can be the most difficult one to draw. It changes shapes radically during speech, and expressively manifests emotions from laughter to grief. Even subtle changes—a slight downward pull around the corners, a small suggestion of a grin—can alter the entire character and ambiance of the face.

The mouth wraps around an archlike shape of bone and teeth (Figure 7.15). The degree of the arch varies from individual to individual, and, to some extent, it determines the shape and size of the lips. The most extreme example of this is found in a face without teeth; the lips curl inward and almost disappear.

The upper and lower lips are quite dif-

Figure 7.15
(A) This drawing illustrates the archlike structure of bone and flesh that forms the mouth. (A) and (B) demonstrate the importance of precisely seeing and drawing the line between the closed lips. Once you have this line down, the lips should fall into place. (C, D, E) When the mouth is open, that "line" no longer exists, as the lips are stretched and flattened across the teeth. An active mouth is, of course, a great deal harder to draw than a closed, still one and requires a lot of practice before it can be handled effectively. Teeth can be a quite difficult issue. The absolute minimum of marks should be used to indicate individual teeth, just as the whole set should be played down.

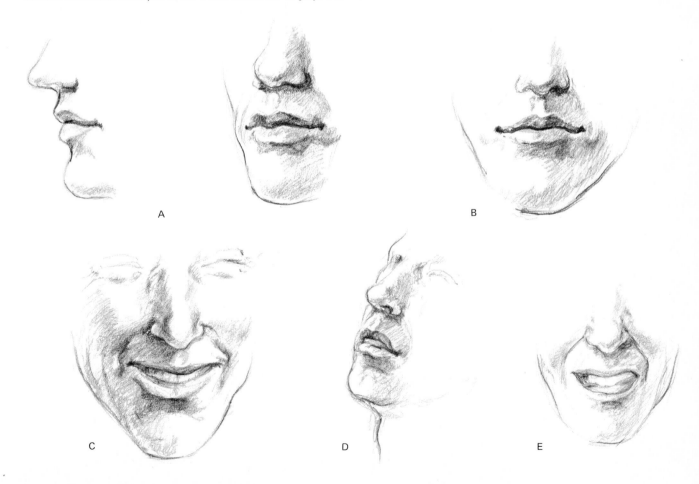

A

B

C

D

E

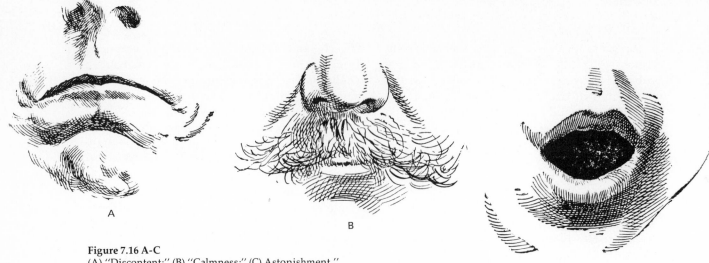

Figure 7.16 A-C
(A) "Discontent;" (B) "Calmness;" (C) Astonishment."
From Webster Edgerly (pseud. Edmund Shaftesbury), *Lessons in the Art of Facial Expression* (Washington, D.C.: The Martyn College Press, 1889).

ferent in shape: the upper is generally bowed; the lower can be more of a broad oval shape. A strong light coming from above will define the shape of the upper lip in shadow, while the perimeter of the lower lip will be determined by the shadow underneath it. When seen from the front, the contour of the lower lip is often nearly invisible. Don't draw a hard line around the lips unless you want to indicate lipstick.

The mouth is surrounded by muscles that are responsible for its wide variety of expressive shapes. It drops open in amazement, tightens in resolve, pulls up or down at the corners in a smile or a frown, or lifts only one side in a sneer. Over time, the muscles around the mouth and the lips themselves acquire a characteristic set, which can display the individual's general emotional nature.

Chin and Cheeks

The line of the chin and jaw are important in determining the mass and tilt of the head. In some faces the jawline is deep and edged by shadow; in others it can be surrounded and hidden by flesh. Chins may be bony or fat, flat or cleft, round, angular, or square.

The jawline begins at the back of the ears and terminates at the chin. You needn't use too many marks to describe this line, but be sure to capture its exact angle. Just as with the nose, reflected light can be an effective device for rounding and enlivening the edge and undersurface of the jaw (see Figure 7.17).

Figure 7.17
This demonstrates why the lower lip is generally light and is often defined in a drawing by the shadow underneath (see Figure 7.15). Light coming from above strikes the lower lip directly, just as it hits the chest. The underplane of the nose and underside of the jaw both require some indication of reflected light to define their structures.

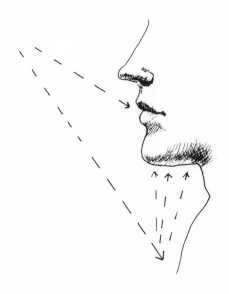

An indication of the cheekbones can play a pivotal role in determining the structure and, possibly, the character of the face. The shape and position of cheekbones are basically defined by subtle lights and shadows. In a drawing, however, these shadows should appear but not be overstressed. Exact indications of the width of the face, together with some very subtle tones, can describe either high prominent cheeks or a relatively flat structure. Deep shadows under the cheekbones will give an effect of emaciation.

Figure 7.18
ADOLPH MENZEL (German, 1815–1905)
Elderly Man in a Military Topcoat (soft graphite on
white paper), 200 x 125 mm (7 7/8 x 4 7/8")
Courtesy of the Fogg Art Museum, Harvard University. Bequest
of Meta and Paul J. Sachs

Ears

The ears may be thought of as convoluted,
dishlike forms, oval in shape. Most of the
structure is composed of cartilage, except for
the lobe, which is fatty tissue. The ears stand
out from the head and slant back at an angle
which may be almost parallel to the profile
angle of the nose. The flap in the front of the
ear, called the tragus, may serve as a measur-
ing point. It is situated in the horizontal
middle of the side of the head. The size,
shape, and position of the ear, together with
the configuration of the channels, are dis-
tinctly different in each individual: channels
may be thick or almost flat; the lobe may be
large, small, or absent altogether; the ear itself
may be quite close to the head or stand far
out at an angle.

In drawing the ears, develop their forms
continuing the line and angle of the jaw. Start
with the large shape and break it down with
sketchy indications of the channels. Take your
time when learning to draw the ear, but don't
be overly concerned about it in a drawing. Ears
are rarely the prominent feature and often a
simple suggestion of them is sufficient (see
Figure 7.19.)

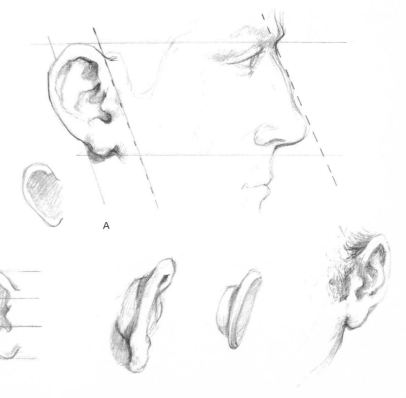

Figure 7.19
(A) This drawing illustrates the parallel
tilt to the nose and ear. (B) The ear can be
divided into thirds for simple analyzing.
(C) When dealing with the ear in a diffi-
cult position, draw it first in this simpli-
fied way to get its shape and tilt before
particularizing it.

A

B

C

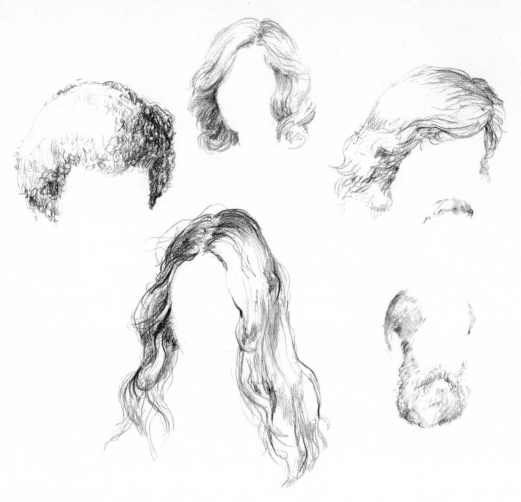

Figure 7.20
Hair portraits can be fully descriptive of a person.

Hands, Hair, and Skin

By their size, shape, and position, the hands can be an extremely expressive feature in portraiture. They can display character (large, firm hands folded in the lap of the sitter), personality (hands held in an expressive or thoughtful position), mood (head resting sorrowfully upon the hands), or occupation (hands of a scholar resting on a book).

Like the face, hands can be quite difficult to draw well. If you have trouble drawing hands, it may be better simply to suggest them, rather than laboring over them, in a portrait study. Refer to Chapter Five for some general information about blocking in hands.

Although the hair mass conforms, more or less, to the shape of the skull, it also has its own form. It may be long and thick, thinning out, well groomed, or messy. Hair styling may add to the design of the face and may even convey information that would help to characterize the sitter.

In drawing the hair, you should begin by indicating the shape of the skull, then describe the mass of hair itself with a play of values, adding linear suggestions to show the consistency and direction. There is no need to draw every hair. Instead, try to capture the texture with a few marks and tones. By making your lines or shadows denser toward the edge of the head, you can reinforce the curving quality of the hair mass.

Beards, mustaches, and eyebrows can describe facial structure as well as indicate character and personality. They can also serve as important value elements in the design of the face, either emphasized or played down for purposes of composition. Eyebrows are extremely effective agents of expression. Draw beards, mustaches, or eyebrows following the procedure used for drawing the hair on top of

the head. If there is no beard, often the beard line and shadow may be subtly introduced for certain types of characterizations.

Exercise 4

HAIR PORTRAITS
(Time: 15–20 minutes; material: soft pencil)

Try some "hair portraits" (see Figure 7.20). By drawing only the hair, its shape and direction, it is possible to get a distinctive portrait or self-portrait.

Skin qualities may suggest age and climatic effects, as well as racial heritage. A child's skin is soft and delicate; maturity may bring coarseness. Aging affects the skin differently for each individual. A woman's face may wrinkle in a consistent pattern of fine lines, while the years may carve deep clefts and craggy planes on a man's face. Harsh weather may give a face a leathery quality and wrinkle it prematurely.

Skin tone and color may present a wide range of value possibilities. When shading skin, even dark skin, however, keep you tones light in the beginning and build up values gradually. Leave your lightest surfaces alone (unless you are using pastels on tinted paper). Suggest lines and wrinkles economically, but be certain to indicate the major ones accurately as they follow the curves and surfaces of the face. In drawing a young person, any wrinkles should be played down or eliminated. Lines drawn around the eyes and forehead can age a youthful face 10 to 15 years.

ACCESSORIES (GLASSES, JEWELRY, CLOTHING)

Glasses must be drawn carefully so that they sit on the nose in proper perspective. They are very much a part of the person who wears them, and they can't be stuck on as an afterthought. Indicate glasses after lightly sketching in the features, then work both in concert.

Figure 7.21
(A, B) Stripes, wrinkles, and numbers should be used to give the body dimension. (C) As a collar turns around an edge, the ribbing will become more dense.

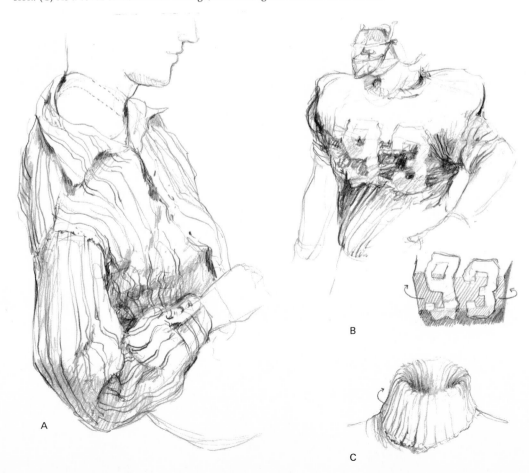

A

B

C

You may integrate glasses into the design of the face through a harmonious development of values; thick, dark frames could destroy the structure of delicately modeled features. The distortion of the lenses, and the cast shadow of the glasses on the cheek, can help in establishing the tilt and placement of the glasses as well as joining the frames to the face.

Clothing and jewelry not only describe the character of the wearer, but can be used to indicate three-dimensional form and position. Collars, cuffs, hats, belts, and ribbing on sweaters, can be powerful spatial devices when shown to curve around the part of the figure that they cover.

When drawing clothing, try to communicate a sense of the particular material and the way its wrinkles and folds conform to the body (see Figure 7.21). Different materials produce very different folds: wool folds softly; satin, with hard geometric creases; cotton folds with a more rolling effect. Refer to Chapter Three for a description of the various types of folds. (See Figure 7.22.)

Accessories may also include objects from the sitter's life and environment, for example, books, sporting equipment, or furniture. These provide a comfortable setting for the model, add some descriptive information, and may serve as compositional devices.

Figure 7.22
HENRI BOYER
Mrs. W. Scott Fitz

Courtesy of the Museum of Fine Arts, Boston. Edward Jackson Holmes Collection

This is the elegant product of a professional portraitist. Often this type of portrait is rather uninteresting, done according to a formula. This drawing, however, has a rich yet delicate presence.

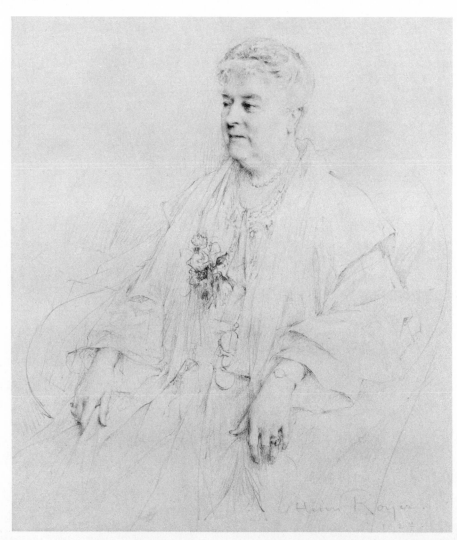

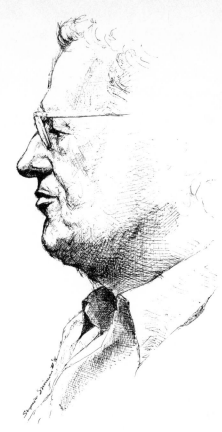

Figure 7.23
SEYMOUR SIMMONS III
Portrait of the Artist's Father (ballpoint pen)

CHARACTERIZATION AND CARICATURE

The shape of the features and the way they fit together, the form of the head, and the facial expression all are a part of what characterizes an individual. Combine these in a drawing with indications of clothing and posture, and you will come up with a descriptive portrait. (See Figure 7.23.)

Portraiture is not all accurate, objective observation, however. There is also a subjective element involved, which plays a major role in the creation of any vital and sensitive study. The subjective element may be termed **empathy**—our ability to identify, either consciously or unconsciously, with our sitter;* to partake of his thoughts and feelings in a personal way. This type of sensitive response is quite evident in Rembrandt's portrait work, but empathy is not a quality limited to genius. It does require, however, a visual awareness of the emotions that have enlivened the model's features and the willingness to seek the same emotion in yourself. Admittedly, you will be introducing your own subjective

feelings into a drawing of someone else, but this will happen to some degree in any case. By consciously responding to your emotions, you may bring a personal understanding to your portrait, which will convey something much deeper and more meaningful than the superficial appearance of the sitter.*

Exercise 5

THE EMPATHETIC PORTRAIT
(No time limit; material: soft pencil, sketchbook)

Your first efforts in learning about empathetic portraiture should be to develop your visual awareness in order to recognize subtleties of expression, posture, and gesture. Try to notice the signs of emotion in the people that you see around you. Sometimes you can feel as though you are reading someone's mind just by looking at them. Observe your own feelings and moods along with the resulting actions and facial expressions. Then try to reproduce emotions and facial expressions before a mirror, drawing what you see.

You could not effectively convey an emotion unless you had experienced it to some degree. In a portrait drawing, then, you com-

*The model in a portrait drawing is called the *sitter*, the· person who sits for a portrait.

*Sometimes this subjective awareness can be strong, actually interfering with our ability to draw the model. This may occur when drawing someone we are very close to; our emotional involvement and deep familiarity hinders our ability to deal with the face and features objectively.

205

Figure 7.24
Actor: Webster Edgerly, 1889
"Frankness, or open-heartedness"
From Webster Edgerly (pseud. Edmund Shaftesbury),
Lessons in the Art of Facial Expression (Washington,
D.C.: The Martyn College Press, 1889).

Figure 7.25
Actor: Webster Edgerly, 1889.
"Moral or physical weaknesses"
From Webster Edgerly (pseud. Edmund Shaftesbury),
Lessons in the Art of Facial Expression (Washington,
D.C.: The Martyn College Press, 1889).

bine both your observations and the deeper expression of your own remembered emotion. Ocassionally in a drawing class, a model is asked to hold a facial expression. As the students draw, many of them unconsciously adopt the expression of the model on their own faces as a manifestation of the empathetic response.

Exercise 6

INDICATING MOOD
(No time limit; material: soft pencil, sketchbook)

Working from magazine or newspaper photographs, *
study expressions, and do a series of drawings to show

*Drawing portraits from photographs has some obvious advantages as well as many drawbacks. Among the advantages are the wide variety of subjects and never-changing facial expressions. Disadvantages include the predetermination of composition and values and the general stiffness that often comes in copying a photo. With a living model the subtle changes in expression and posture can help you to enliven and deepen the characterization. In addition, photographs often dictate a realistic approach, discouraging or limiting our possibilities for interpretation and abstraction.

people who are happy, sad, grief stricken, stern, bored, angry, and so on. Then do some studies of people that you know when they are in different moods. Choose those friends who trust you and who have a sense of humor—your first efforts probably will not be masterpieces! Work spontaneously, seeking out distinguishing characteristics and subtle mood indications.

You also may do drawings of people in subways, buses, parks, and restaurants who display interesting emotional characteristics or facial expressions. In public situations, however, be discreet—some people like to have their pictures drawn, others definitely do not! Use a small tablet and sketch quickly. (See Figures 7.24, 7.25.)

Once characteristic features and expressions are recognized, other factors may be considered in the development of a portrait drawing. Among these are composition and **style.** Compositional considerations include setting, **cropping,** value development, and use of space. The model may be shown full figure or cropped, placed against a neutral background or set in a room surrounded by people or objects. Lighting on both the figure and background must be considered. All these

Figure 7.26
VINCENT VAN GOGH (Dutch, 1853–1890)
Peasant of the Camargue (graphite, reed-and-quill pen and brown ink),
494 x 380 mm (19 1/2 x 15")
Courtesy of the Fogg Art Museum, Harvard University. Bequest of Grenville L. Winthrop

This drawing has the rare quality of combining intense graphic exploration
with strong characterization.

add to the depth of characterization and to the completeness of the image.

The method of drawing may also convey information about the sitter, but often says more about the artist. Compare, for example, the works of Van Gogh, Augustus John, and Lovis Corinth found in this chapter. In each case the subject was similar, a male head, but the resulting drawings were remarkably different. On the other hand, style may develop in response to the sitter. In one instance we might try to adapt our use of line to express certain qualities—softness, strength, nervousness. In other cases we find our style changing without conscious intent and our image taking a totally unexpected form. Often these subjective responses can make very effective characterizations while not being wholly accurate. You may in fact learn a great deal about your subject and about drawing by giving way to subjective inclinations rather than trying to force a realistic portrayal. Use the face as a starting point for an imaginative drawing, an abstract design or an **expressionistic** image.

Exercise 7

THE MEMORY PORTRAIT
(Time: 15–30 minutes; material: soft pencil or charcoal)

Do a portrait drawing from memory. Try to recall the features of someone you once knew or saw recently. The face may be hard to remember at first. Look at someone near you, or try to find someone in the room who slightly resembles your subject. Ask yourself, "How do the features of this person differ from my friend's?" As you draw, allow yourself to remember how you felt about the person. Actually, the feeling that appears in this type of portrait is more important than the likeness.

Children's Portraits

There are many aspects involved in drawing children. The first is the technical problem of getting them to hold still (this may be more or less difficult according to the particular child). One obvious solution is to draw them from photographs, but here, expression is often lost in the mechanics of copying. Pos-

sibly the best solution would be to have the child do a series of short sittings—no more than 15 minutes each—with 10 to 15 minutes in between to let the child run around. Allow the child to talk occasionally so that he or she maintains a lively, interested expression.

In drawing, learn to recognize the general proportions of the child. Young children, for example, have relatively larger heads and eyes compared to adults. Their cheeks may be fuller, their necks shorter, depending on their age and body type.

The real problem in drawing children is in capturing the subtleties of their features. They have not had time to develop the lines and planes that distinguish an adult face and their features often appear compact and soft. Unique characteristics are much less obvious, and, as a result, young children often look alike at first glance. Soft lines and even tones are generally most effective for shading, but of course a few sharp lines can always be used for emphasis.

As the child matures, proportions become closer to those of an adult. Features are better defined and the face is easier to characterize. Still, care must be taken in shading and line work to avoid aging the child too much. Watch the development of your image carefully. It is often better to say too little than too much when drawing a child's face.

Caricature

In regular portrait drawing, it is always necessary to establish a center of interest, a prominent feature—eyes, nose, mouth, cheeks, chin. This feature may be slightly exaggerated or enlarged in your drawing to attract attention to it. When exaggeration is carried to an extreme, however, the result could be ludicrous, funny, or critical. This gross exaggeration is called *caricature*.

Caricatures may be done from memory, photographs, or from the model. The style may be elaborate or quick and sketchy. Refer to the drawings by Beardsley and Rowlandson in the Introduction, and to Steinberg's *The Violinist* in Chapter Two.

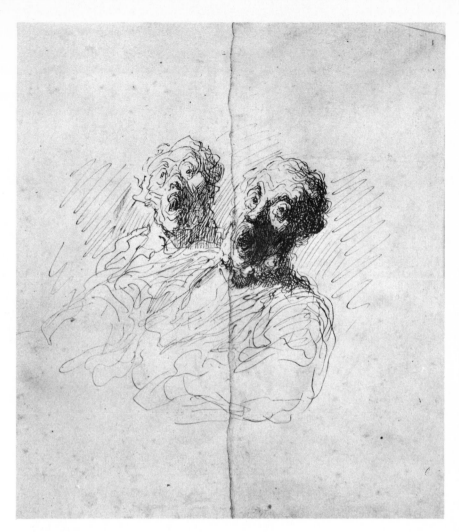

Figure 7.27
HONORÉ DAUMIER (French, 1808–1879)
Two Men Singing (pen and ink)
Courtesy of the Museum of Fine Arts, Boston. Bequest
of W. G. Russell Allen

Exercise 8

CARICATURE SKETCHES I
(No time limit or medium requirements)

*Learn to notice prominent features and characteristics:
then try some caricatures on your own. You might be-
gin with yourself. Try to identify what makes you
unique, and emphasize that quality in your drawing.
Try some caricatures of friends—once again choosing
those with a sense of humor! Be sure to treat yourself
and others with kindness and humor in these drawings.
Caricature can be a devastating art if applied with the
wrong intentions.*

Exercise 9

CARICATURE SKETCHES II
(Time: 5 minutes to 1 hour; material: pencil or pen and ink)

*Working from a photograph of a famous person, or
one with an interesting face, try some extended carica-
tures. You might look at the drawings of editorial car-
toonists for ideas of style and approach.*

SELF-PORTRAIT

An excellent way to begin portrait drawing is
with an always available model—you. In
doing self-portraits (see Figure 7.28) you will
not only learn something about yourself, but
also about the act of "seeing." It is nowhere
quite as evident that the seeing involved in
drawing differs from that which we use ev-
eryday. Although you probably look in a mir-
ror regularly, you may find, when doing your
first self-portrait, that you don't really know
your face at all. You will have to look at your-
self in a completely new, objective manner to
understand your face for drawing purposes.

On the other hand, you could discover
that you are familiar with yourself on an emo-
tional level (as well as in a general physical
sense). This familiarity will imbue your early

209

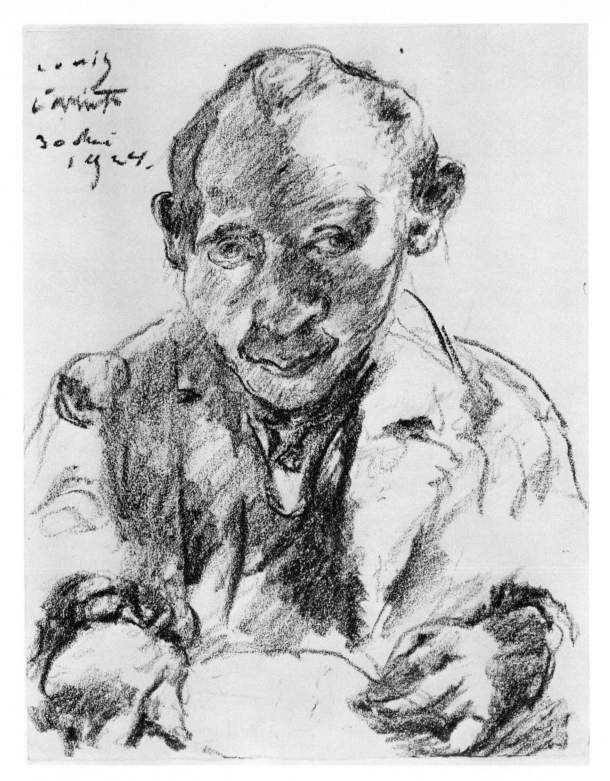

Figure 7.28
LOVIS CORINTH (German, 1858–1925)
Self Portrait (crayon on white paper), 311 x 248 mm (12 5/16 x 9 13/16″)
Courtesy of the Fogg Art Museum, Harvard University. Gift of Meta and Paul J. Sachs

The distortions and scribbled quality contribute to the expressive power of this self-portrait. Its organization demonstrates a mastery of form and an effective use of linear and tonal **counterpoint.**

attempts with a very real and personal feeling, even though you may not capture your features exactly. This sense of self can also appear when you unknowingly introduce your features and body type into a portrait of someone else.

Exercise 10

MEMORY SELF-PORTRAIT

(Time: 1–5 minutes; material: pencil)

Self-portraits needn't be wholly accurate to "look like you." Do a series of self-portraits without referring to a mirror. Don't consider drawing principles at all; just put down lines and marks that may describe how you are feeling. Do these when you are in different moods, or decide to do one at the same time every day for a week, no matter what your mood. Most likely all of these drawings will have a very distinctive sense of you, while not capturing your features exactly (see Figure 7.29).

Exercise 11

EXTENDED SELF-PORTRAIT

(Time: 20 minutes to 2 hours; material: medium pencil)

Set up a mirror (or two mirrors if you want a profile view) with a light above and to one side of your head. Choose a position that is both expressive and representative of your features. Often it is more descriptive to use a three-quarter view rather than to look directly in the mirror. However, expressive drawings can be done from any position. Place your paper so that you need not turn more than your eyes.

*It is very difficult to maintain correct proportions if you start with a strong contour line and try to fill in the features. Begin, instead, by lightly sketching the outside shape of your face and hair area; then work from the inside out, **blocking in** all your features at the same time. Be certain that the features are established in the right spatial relationship to one another and that (unless you are looking from the frontal view) you have effectively established the fact that the features are on a curve.*

Continue to develop the face starting with the eyes or nose, then moving to the next closest element. Watch for proportional error while developing small areas of the face.

Refine the features slowly, moving from one to another, not spending excessive time on any one. Make sure you have placed the mouth correctly under the nose and that you have not made the nose too long (both are common proportional problems). In drawing the mouth, be sure to describe exactly the meandering line between the lips. If this is well observed, the rest of the mouth will be relatively easy to complete. Re-

Figure 7.29
Spontaneous Self-Portrait
Courtesy of Kathy Todd

member that you need not gray in the entire face to indicate skin tone. A few indications of shadow will be sufficient to delineate facial planes and structure.

When doing a basic self-portrait, try to maintain a relaxed posture and expression. Even if you are looking hard, try not to show it in your drawing. Too often, self-portraits show an overintense expression (from staring in the mirror) that doesn't really describe the maker. Self-portraits are also a good place to experiment with facial expressions.

Exercise 12

EXPRESSION STUDIES

(Time: 20 minutes to 2 hours; material: soft pencil)

Try some self-portraits with different facial expressions. These may be hard to hold at first. Hold the expression, then rest your face, then resume the expression again. After a while you may be able to maintain certain expressions for extended periods.

Do some other self-portraits combining different expressions with various hats and clothing. Try pretending you are another person or a character in a play. Have some fun with this. Do both regular drawing and caricature, exaggerating yourself, your costume, or both in the drawing. (See Figures 7.31, 7.32, 7.33.)

Figure 7.30
MARC WINER
Self-Portrait

212

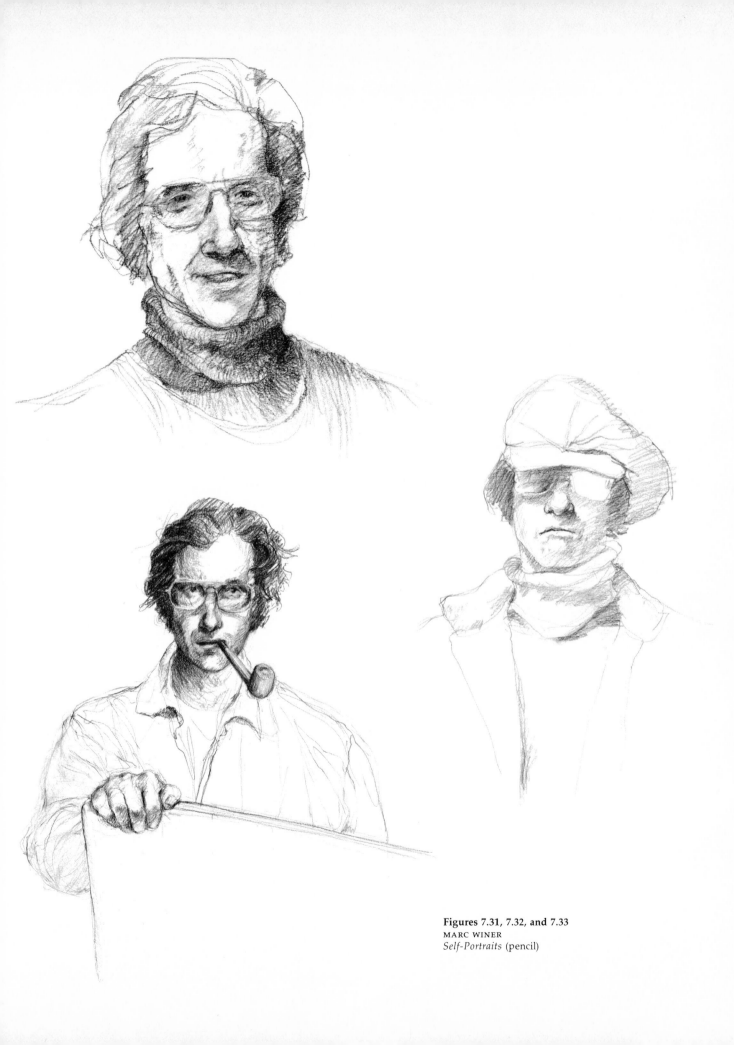

Figures 7.31, 7.32, and 7.33
MARC WINER
Self-Portraits (pencil)

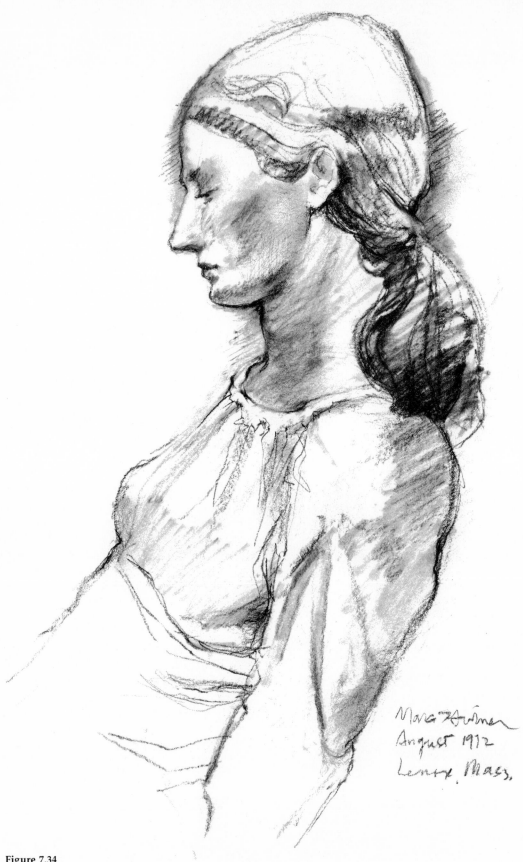

Figure 7.34
MARC WINER
Portrait of a Young Woman, Lenox

THE PORTRAIT SITTING

The following is one way to approach a portrait. It is not the only progression possible, but it is the one we find most helpful.

PRELIMINARY THOUGHTS

Be certain that your subject is comfortable, relaxing into the pose at the beginning rather than starting stiffly. Eventually, he or she will sink into a normal posture anyway. Allow the model to have a break every 20 to 30 minutes.

You may wish to provide music or engage the sitter in occasional conversation. A little entertainment on this order will encourage relaxation and a lively expression. Portraits are often rather vacant looking because the model has "drifted off" out of boredom. Most people enjoy talking and can engage in limited conversation without moving their heads. You will certainly have time to capture their expressions and features when they are not speaking.

PROCEDURE

Begin your study by arranging some descriptive lighting. Then have your sitter take a series of comfortable poses while you do some quick, loose sketches. Indicate body gesture together with rough notations of features. These warm-ups will help relax both you and your sitter.

Choose a pose from your sketches that appeals to you, and have your subject assume it again. At this point, decide the area you wish to draw. A portrait could include only the head, neck, and shoulders, a view from the chest up, or the whole figure. Make your decision based on both compositional considerations and the nature of the model. In some cases, the pose and clothing may be important contributors to the characterization. In other situations, the face alone would be sufficiently descriptive.

Begin to draw very lightly, using gestural lines to rough in the entire figure. Note the position of the head in relation to the shoulders, the placement of hands and elbows, and the position of the feet in relation to the head (if you are doing a full-length portrait). If the model is using a chair, it might be helpful to sketch the chair first, putting it in proper perspective. Then "sit" (draw) your subject in the chair.

In the next stage, you should roughly block in the features of the face, using vertical and horizontal lines to determine the direction of the head and the position of the eyes, nose, and mouth. At the same time, squint down and begin to distribute your large gray tonal areas to unify the composition, to define the figure, and to establish structure in the head and hair. **Spatial notations** should be made now. Indicate the **ellipses** of the cuffs and collars, and show how they follow the shape of the underlying structure.

Since the head will probably be the focal point of your portrait, you should now turn your attention there and *begin to develop the face working from the inside out.* You might start to develop the nose, then move to the next nearest feature, refining the shapes and forms of the face. Then develop the lines around the edges of the face and hair, relating them to the values of the interior features.

The final stages involve strengthening the features, checking the reality of your ellipses, and generally enriching your drawing with darks. Just because it is a portrait does not mean that you can neglect compositional concerns. Put your drawing on a wall upside down and look at it in a mirror to assess the composition abstractly. View it from a distance and make necessary modifications in value, line, and form.

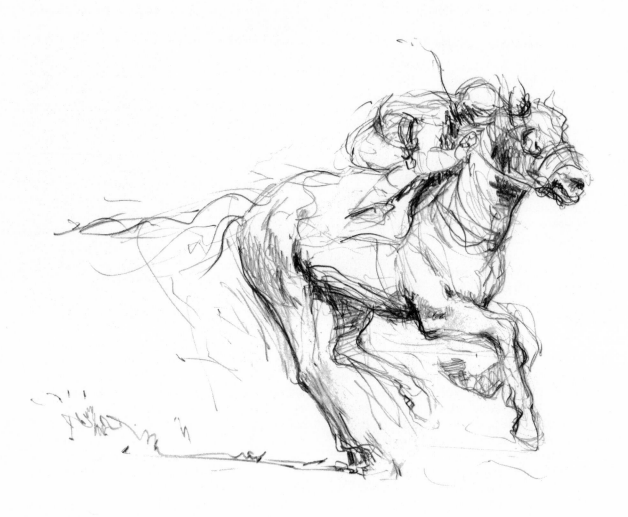

ANIMAL DRAWING DEMANDS the complete application of our drawing skills. The range and complexity of animal movements challenge our knowledge of anatomy and our ability to capture a gesture; their surfaces provide many textural problems—horns, fur, feathers, scales; their variety of expressions and personalities calls for the same sensitive approach required in human portraiture. Animals have inspired art since the time of the first cave paintings, and artists continue to realize new possibilities in their forms and features.

Think of hundreds of animals that you have learned to recognize since childhood; horses, cows, dogs, cats, snakes, birds and insects, not to mention elephants, kangaroos, bats, and moose. Unfortunately, our ability to identify these animals on sight does not necessarily guarantee the ability to represent them on paper. For a drawing, we must learn to isolate the specific forms and features that distinguish one animal from all others. This can be accomplished only through a combination of basic knowledge, accurate perceptions, and drawing skills.

There are several sources for animal

216

CHAPTER EIGHT

Animal drawing

studies: natural settings (either domestic or rural), zoos, natural history museums, or photographs. In natural settings and zoos, animals are often uncooperative subjects, being constantly in motion. In this case, gesture drawings will yield the best results. (Caged animals, however, often repeat their movements. All you need to do is wait and you will be able to develop your sketch as the animal returns to the same position.) Learn to sketch and to commit a great deal of information to memory. Note the unique movements of each species: the powerful rolling shoulders

of a jungle cat, the awkward, jerky steps of a colt. As you learn about your subject and strengthen your visual memory, you can use these gestural sketches as a basis for further development.

Still animals, found in natural history museums or photographs, provide the opportunity for longer and more detailed studies. With these you can concentrate on identifying features and anatomical structure. In beginning your approach to drawing animals, you will be asked to work separately from both living and inanimate subjects. More advanced

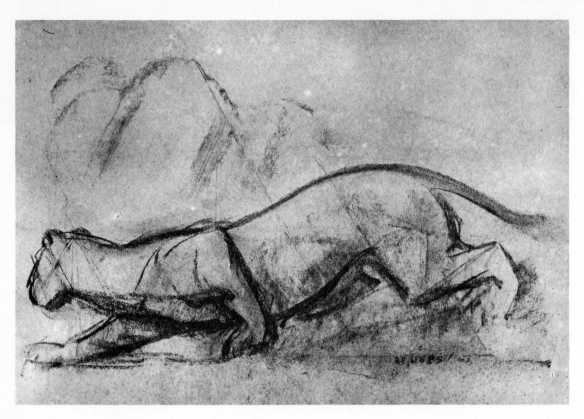

Figure 8.1
HOWARD GILES (American, 20th century)
Stealth (sketch, charcoal)

Courtesy of the Museum of Fine Arts, Boston. Purchased from the
Ellen Kelleran Gardner Picture Fund

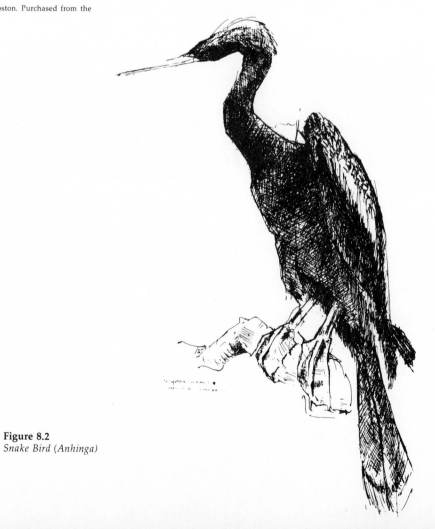

Figure 8.2
Snake Bird (Anhinga)

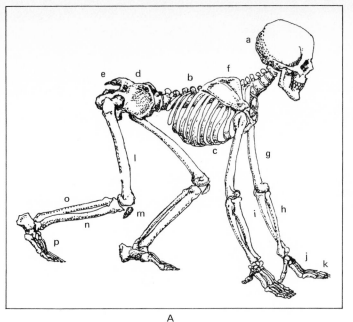

A

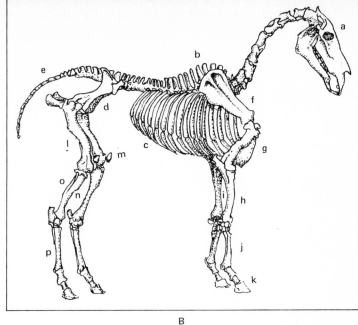

B

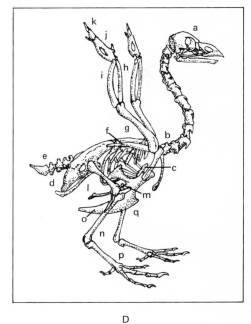

C

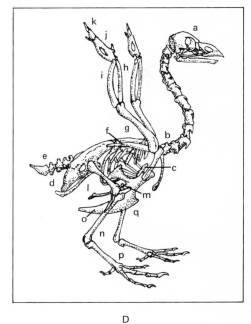

D

Figure 8.3
Basic skeletal structures are similar in most vertebrate animals. Compare
(A) human, (B) horse, (C) cat, (D) bird. Note the long spine of the cat.

a. Skull
b. Vertebral column
c. Rib cage
d. Pelvis
e. Coccyx (human), coccygeal vertebrae
 (horse and cat), caudal vertebrae (bird)
f. Scapula
g. Humerus
h. Radius
i. Ulna

j. Metacarpals
k. Phalanges
l. Femur
m. Patella (kneecap)
n. Tibia (Tibiotarsus in bird)
o. Fibula
p. Metatarsals (Tarsometatarsus in bird)
q. Keel of bird is equivalent to sternum
 (breastbone).

drawing, however, might combine information derived from both sources: through understanding the gestures of a particular animal, you can imbue a drawing from a still subject with life and vitality; or you might develop a gesture sketch into a more finished work by introducing knowledge of structure and detail gained from an inanimate source. At other times, you may wish to place an animal in landscape or other composition drawn completely from memory. In any case, you must have a thorough familiarity with form and gesture, based on knowledge and pre-

vious observations. Before working from actual animals, we recommend that you start with some basic anatomical information.

ANIMAL ANATOMY

Anatomy studies help in both gestural and extended drawings by directing your observation. As you become knowledgeable about bone and musculature, you will be able to

Figure 8.4
Ameba (approximate size 3/100 inch)

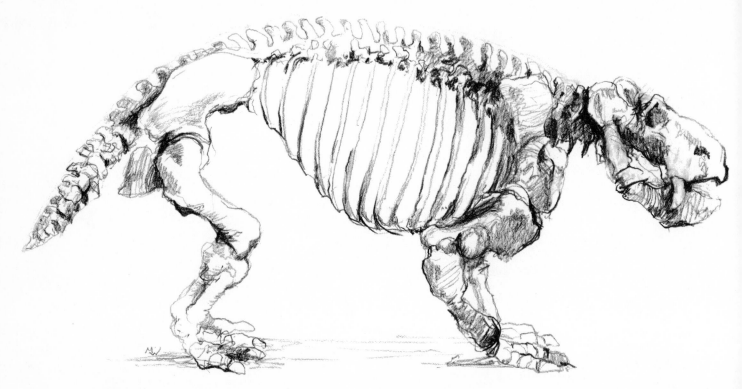

Figure 8.5
Skeleton of a prehistoric reptile

recognize superficial forms as being part of a substantial internal structure. Indications of this underlying structure will help to provide any drawing with greater depth and reality.

When drawing invertebrate* animals, surface form is *the* form; here it is a matter of representing the exact shape and indicating its texture (see Figure 8.4). The activities of these animals are primarily limited to a few basic motions. Through the evolutionary scale, movement becomes much more complex, as does anatomical structure. For studies of vertebrate animals, it is not sufficient simply to understand the outside form; you must have a solid knowledge of the internal structure that shapes the surface.

Start with the skeleton, which forms and supports the body while directing its move-

ments. You will find that most vertebrate skeletons are basically alike and that you recognize most of the bone formations from your study of human anatomy (see Figure 8.3). Learn to perceive the action of the spine and shapes of the head, rib cage, and torso; then use these forms as the understructure for both gesture and extended drawings. Refer to animal anatomy books for more complete information on bone structure.

Another source of bones for study is in the natural history museums. Some may display skeletons of existing species, but most museums will have the bones of dinosaurs and prehistoric mammals. These can be fascinating subjects to draw, and, despite their unusual conformations, will provide you with a great deal of general information that can be applied to almost any other animal (see Figure 8.5).

*Animals without a backbone (vertebral column).

220

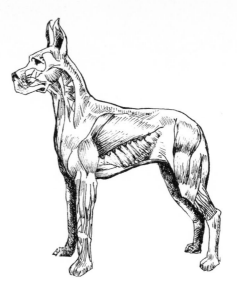

Exercise 1

DRAWING SKELETONS

(Time: 20 minutes to 2 hours; material: soft pencil)

At a natural history museum, draw the complete skeleton of an animal—anything from a rodent to a dinosaur. Then do studies of skeletal sections or individual bones. These can be very accurate renderings or expressive interpretations. What is important is that you become familiar with the formations.

The study of muscles is more complex than that of bones. Although basic musculature is similar in most four-legged animals, the size and shape of individual forms may vary considerably from species to species. Once again, human anatomy will give you a starting point, and books on animal anatomy can provide more detailed information (see Bibliography). It is not wholly necessary for you to learn the names of the individual muscles, but you should be able to recognize their forms and functions when you see them (see Figure 8.6). Learn to identify the unique developments in each type of animal. A cow, for example, is bred for a life of limited movement and has a bony pelvis, while a horse, used to running or working, has powerful hip muscles.

Surface anatomy (including skin, fur, textures, and markings along with horns, hooves, claws, and beaks) takes on many shapes and textures. These formations are often an essential part of the animal characterization (see Figures 8.7 and 8.8).

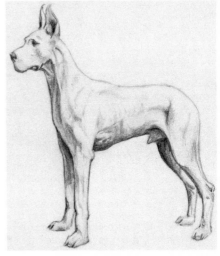

Figure 8.6
A familiarity with underlying muscle structure can help you to understand surface form. Note how the pattern of shadows on the neck and torso of this Great Dane defines the musculature. Study anatomy to know what to look for.

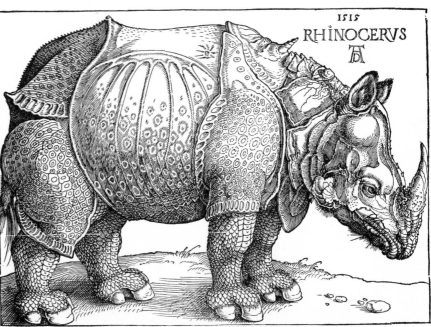

Figure 8.7
ALBRECHT DÜRER (German, 1471–1528)
Rhinoceros (woodcut)
Courtesy of the Fogg Art Museum, Harvard University

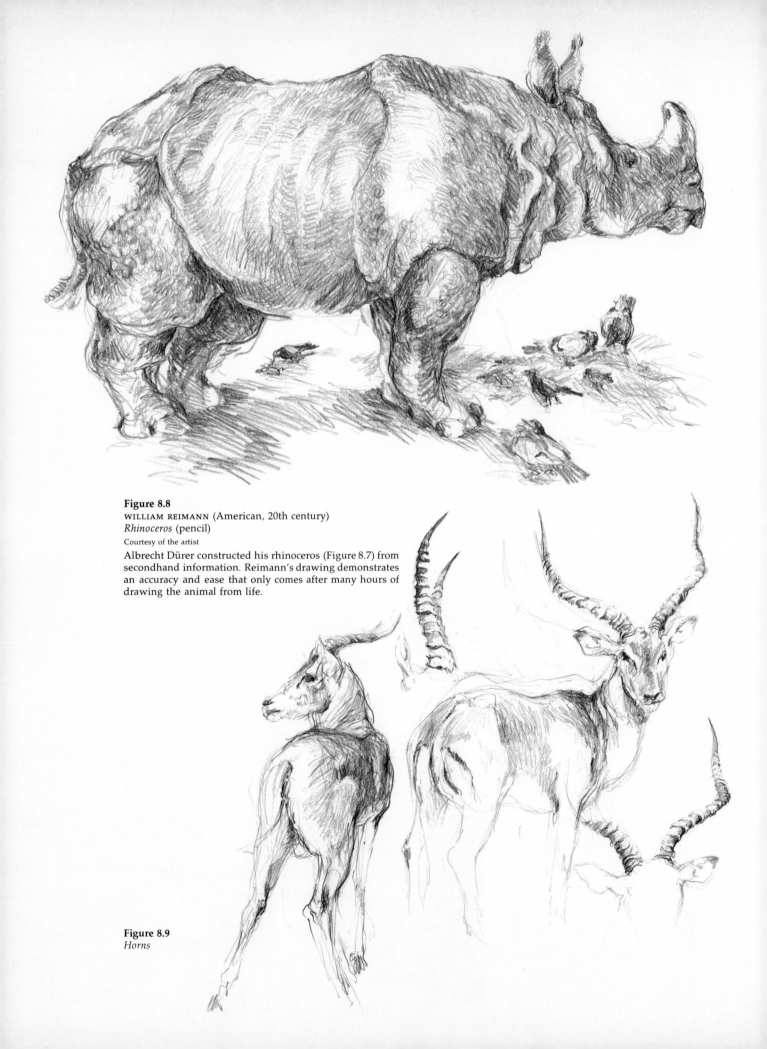

Figure 8.8
WILLIAM REIMANN (American, 20th century)
Rhinoceros (pencil)
Courtesy of the artist

Albrecht Dürer constructed his rhinoceros (Figure 8.7) from secondhand information. Reimann's drawing demonstrates an accuracy and ease that only comes after many hours of drawing the animal from life.

Figure 8.9
Horns

One of the most prominent general characteristics in mammals is their fur. This is quite different according to the species, varying in length, form, texture, color, and markings. Fur, like the hair on a human head, follows a general pattern of growth and often has a distinct shape to its mass. Remember that this shape will conform to the muscular structure underneath. In drawing, it is generally sufficient to suggest the pattern and shape rather than to draw every hair. Wrinkles and folds on elephants, scales on reptiles, and feathers on birds can be simplified in a drawing according to their basic shape and direction.

Other surface forms, including claws, horns, and hooves, should be developed first as simple shapes, then particularized through textural indications. Horns may have a gestural movement: intertwining (deer antlers); linear (sable and antelope horns as well as elephant tusks); others might twist, curve, or curl (see Figure 8.9).

Bird legs and beaks also present interesting shapes and textural configurations. Be certain when drawing these to demonstrate the textural difference between one particular structure and the rest of the body.

Facial features can be considered with surface anatomy. Block in the structure of the head as you develop the rest of the body parts, and return to define the features and expression only after the form is well established.

Animal personalities can be effectively displayed in their faces as well as in their postures. For careful analysis, look at animals in books and natural history museums where the expressions are frozen. You will see that in most animals the expressions seem limited and typical to the species. However, should you get to know any group of similar animals well, you will recognize individual personalities. Dogs and apes have particularly expressive faces that change with their emotions. (See Figure 8.10.)

Approach an animal portrait in the same way you would a human portrait, first indicating basic forms and postures, then blocking in all the features before developing any one specifically. Don't forget to suggest the growth of fur and whiskers around the head, face, and ears, as well as the unique shapes of nose, mouth, ears, and eyes.

Animal drawing should be based on the combined observation of gesture and three-

Figure 8.10
Warthog

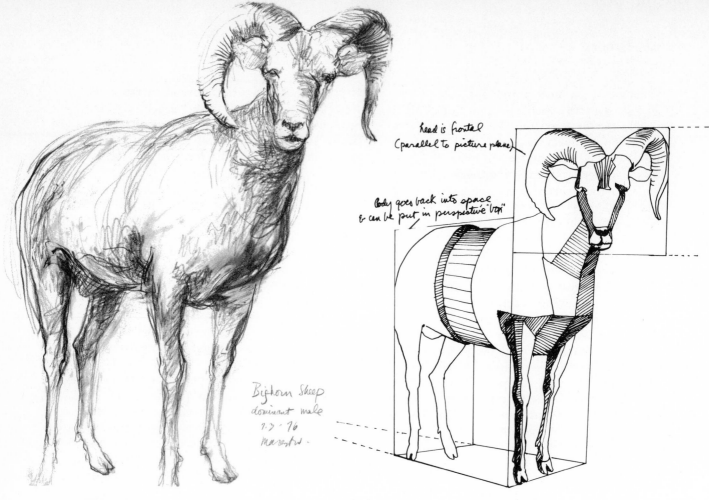

Text within image 1:

head is frontal
(parallel to picture plane)

Body goes back into space
& can be put in perspective "box"

Bighorn Sheep
dominant male
7.7.76
marostud.

Figures 8.11
The form of this sheep may be understood by first blocking in the geometric structure.

Figure 8.12
PABLO PICASSO (Spanish, 20th century)
Le Taureau (3rd state of 11) (lithograph)
Courtesy of the Museum of Fine Arts, Boston. Lee M. Friedman Fund

The *state* of a print refers to its state of development. An artist might print an etching or lithograph several times before he or she considers the work finished.

Figure 8.13
PABLO PICASSO (Spanish, 20th century)
Le Taureau (11th state) (lithograph)
Courtesy of the Museum of Fine Arts, Boston. Lee M. Friedman Fund

Compare this with Figure 8.12, the 3rd state of a lithographic print. The 1st state was a loose, representational image of bull done in washlike tones. The 3rd state shows a stylized but structurally sound figure. After a series of refinements, the essential lines are all that remain. Solid anatomical knowledge and an excellent sense of design combined in the development of both images shown here.

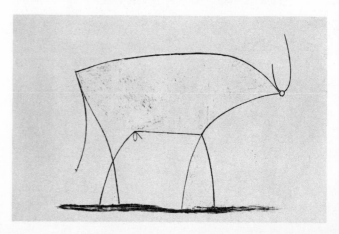

dimensional, geometric structure (see Figure 8.11). Both perceptions help you to characterize the specific animal, its form and postures. At the same time, these observations provide a basic structural knowledge that will enable you not only to draw the animals that you see, but also to draw animals from memory and imagination. (See Figures 8.12 and 8.13.)

In the next few pages, we will present a few exercises that may be used to draw any type of animal. If practiced on a regular basis, these exercises will help to strengthen both the perceptions and the visual memory needed for animal drawing. You may find it valuable to keep a sketchbook for animal studies, to record gestures, longer geometric exercises, and detailed renderings. Later you can refer to these notes to enhance your memory and to help you in solving specific drawing problems. Following the exercises is a section on specific animal characteristics, concluding with a few exercises relating to animals in composition.

GESTURE DRAWING

The key to animal drawing is gesture. From frog to elephant, every animal can be identified by postures and movements. These can be portrayed in a series of quick strokes, as described in the section on gesture in Chapter Five. Gestural drawing captures the action and general form, and may convey a mood or personality as well (see Figure 8.14).

Begin your gesture studies, working from life. Study a particular animal carefully for 10 or 15 minutes before drawing it. Watch the way it walks, sits, gets up, jumps, runs, eats, communicates, looks around. Observe the action of the spine and neck, the motion of the legs in each of these activities. You may notice such things as a dog running with its body at a slight diagonal; a cow rising to its feet by lifting its hind quarter first; the flutter of a bird's wings as it comes to roost (see Figure 8.15). As you watch an animal move, try to sense the motion in your own body. Then carry this kinesthetic awareness into your gesture drawing.

Exercise 2

ANIMALS IN ACTION
(Time: 30 seconds to 2 minutes; material: soft pencil or charcoal)

At a zoo or other appropriate location, do studies of different animals, trying to isolate the particular gestures that describe the animal's character. Watch for repeated actions, such as pacing or head movement. Do many drawings of each animal in various activities and postures, from several different angles. Look particularly for the movement of the spine as well as the

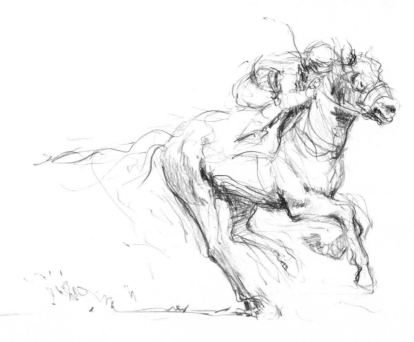

Figure 8.14
Gestural study of a horse

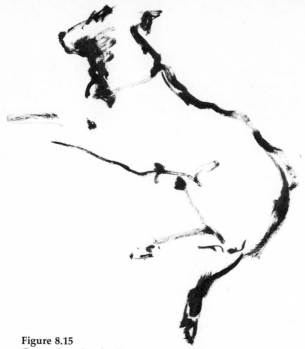

Figure 8.15
Gestural study of a dog.
Courtesy of Anne M. Taintor

position and action of the head, torso, and pelvis. Develop these as simplified forms while watching a repeated activity, try to make sketches of the animal in different stages of the same movement. If an animal happens to be standing still or lying down, take the opportunity to develop the sketch into a longer drawing by elaborating on the basic structural indications.

*You also may do gesture studies at home in front of the television. The poses will be very short, but you may have the opportunity to witness more dramatic actions than you could see at the zoo.**

As you draw animals in nature, much depends upon your ability to remember what you see. Often you are able to catch a quick action and jot it down as a gestural sketch, but by the time you finish drawing the animal has moved. If you wish to develop your drawing further, you must rely upon your memory of the pose and a knowledge of the animal and its anatomy. At first, you may find that you can remember very little of what you saw, but, with practice, more and more information can be gathered and retained. Your previous studies will tell you what to look for. Use these exercises not only to improve your eye and drawing skills but to strengthen your visual memory as well. Try to work on each gestural sketch after the animal

*When drawing at the zoo, be prepared to be bothered by hordes of curious children (and adults).

has changed position; see how much you can remember. Then, reinforce your memory with fresh observations.

GEOMETRIC DRAWING

Geometric drawings are best done from fairly still animals (cows, sheep), sleeping animals, photographs, or from stuffed animals in museums. In any case, animals will display a gesture, a particular posture upon which to build geometric structure. Taxidermists and photographers will generally make an effort to show the animal in a characteristic pose or action, and even sleeping animals express individuality in their position.

Observe your subject, if possible, from several different angles to determine which is the most descriptive view. Then, go on to sketch the animal within a three-dimensional structure (as shown in Figure 8.11) to give it solidity and depth.

After indicating the form of the whole animal, break down the form into individual parts. A horse, for example, may be contained in a narrow, rectangular block, then broken down to find a wedge-shaped head, an ellipsoid neck, wedge-shaped front quarters, a cylindrical middle, and a blocklike hind end. Legs also may be conceived as combination wedges and cylinders. (See Figure 8.16.)

Figure 8.16

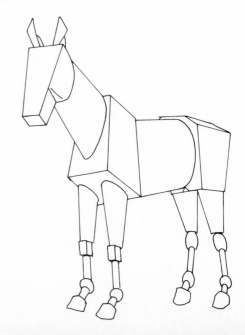

Exercise 3

BUILDING THREE-DIMENSIONAL FORM

(Time: 15–30 minutes; material: soft pencil)

Begin your geometric studies by establishing a three dimensional form to contain the whole animal, preferably a cube or block. Draw this using one- or two-point perspective to establish the animal in space. (You may be able to locate the animal's feet in each corner of the bottom portion of the rectangle.) Then, looking carefully at both forms and negative space, sketch in legs, torso, neck, tail, and head with quick gestural lines. Develop these areas using three-dimensional shapes, cylinders, spheres, cones, blocks, and so on. You may begin by blocking in the head and torso; then divide the torso into shoulder, chest, and hip areas. Use your imagination to recognize the simple geometric structure.

Keep the first lines light, then refine the geometric masses to conform more fully to the shape of the animal. Shade in the basic forms with a simplified value pattern, looking carefully at the play of values by squinting. Don't assign values arbitrarily. Continue to refine the body, maintaining basic geometric simplification processes for even relatively small areas, such as knees, hooves, or features of the head.

Do similar studies from animals in several classes; mammals, reptiles, fishes, and birds. View each from various angles (if possible) to comprehend their three-dimensional shapes more fully.

Exercise 4

FINISHED DRAWING

(Time: 1 hour or more; no medium requirements)

In a longer study, begin in the above described manner, then continue to develop skin textures, features, and markings. Look carefully at shadows to determine the way the musculature is revealed. (This is possible in only certain types of animals.) In the beginning, the animal's head must be treated as only one aspect of the overall form, but after the body has been blocked in, special attention may be paid to expression and facial features. Develop the surface pattern to correspond to the overall body structure, treating fur, skin, and markings as you would any other texture. Suggest them where necessary, rather than developing them all over the animal.

Try to portray the real character and personality of the animal through keen perceptions of posture, movement, and facial expression. Don't allow yourself to be distracted by details, but use them to enhance the characterization (see Figure 8.17).

Figure 8.17
EDGAR DEGAS (French, 1834–1917)
Horse (black chalk on white paper), 228 x 312 mm (9 1/16 x 12 3/8″)
Courtesy of the Fogg Art Museum, Harvard University. Bequest of Grenville L. Winthrop

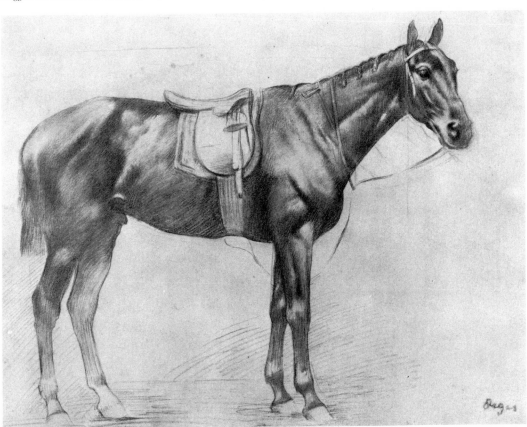

INDIVIDUAL ANIMAL STUDIES

In every animal study, seek out the qualities that speak distinctly of the particular animal. When drawing a specific dog, for example, learn to determine the nature of the movement and anatomy that distinguishes it from any other dog. Identify unique features, but avoid turning them into a formula to be used in drawing the particular breed or species. *Knowledge at every level must be constantly reinforced with fresh observations from nature.*

Horses

The horse is equipped with a strong, flexible neck and long, relatively thin legs. The hips and shoulders are powerful masses supporting the broad curving barrel of the abdomen between them. The head is primarily a wedge, flat on each side, straight down the front, flanked with cheeks in the rear half of the head. Eyes are positioned high in the head, and ears are generally up and alert. Horses are primarily angular and lend themselves well to blocking-in exercises.

There are many types of horses with par-

Figure 8.18
NOGUCHI ISAMU (American, 20th century)
Polar Bear (graphite on paper), 277 x 438 mm (11 x 17 3/8")
Courtesy of the Fogg Art Museum, Harvard University. Anonymous gift

This does not mean that animal drawings need be overly detailed. Very often, a rapid sketch can present an animal as descriptively as a careful rendering. What is important for either an economical or an elaborate drawing is a thorough knowledge of characteristic forms, structures, and surfaces (see Figure 8.18). In the following pages we will introduce some of the distinguishing qualities of animals in several categories: horses, cattle and other large mammals, dogs, cats, birds, reptiles, and invertebrates.

ticular noteworthy characteristics: the massively built draft horse; the tall, lean thoroughbred; the familiar, ambling quarter horse, to name just a few (see Figure 8.19). Each is distinguished not only by its shape, but by its particular style of motion. An excellent source of study for horse movements are the photographs of Eadweard Muybridge, a pioneer in the study of movement and action photography* (see Figure 8.20).

*See Bibliography.

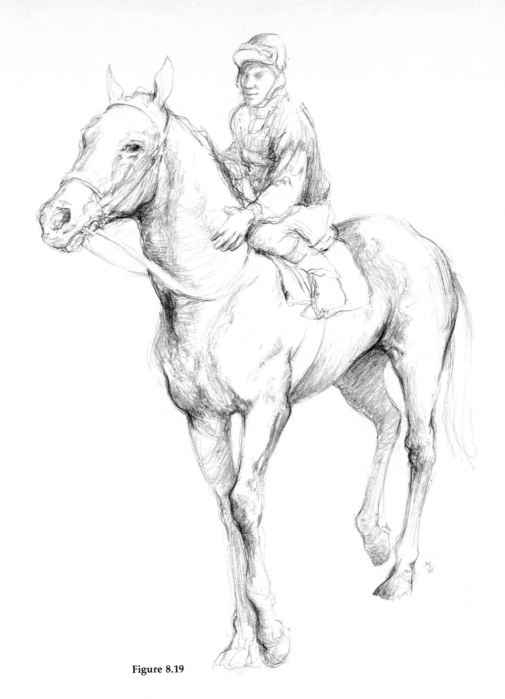

Figure 8.19

Figure 8.20
Horse galloping, after photographs by Eadweard Muybridge, appearing in *Animals in Motion*, edited by Lewis S. Brown (Dover Publications, Inc., New York, 1957).

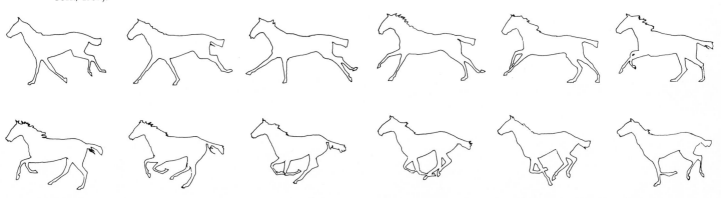

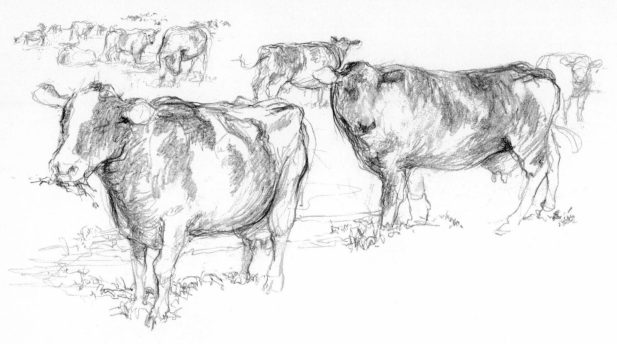

Figure 8.21
Cows

Other grazing animals are similar in basic structure to the horse: deer, camels, goats, sheep, giraffes. Study these animals to note their basic similarities as well as their differences.

Other Large Mammals

Large mammals, including cows, bulls, buffalo, and oxen, differ from the horse group with their broad, heavy bodies and relatively short legs (see Figure 8.21). Their necks are also shorter and less flexible. Cows tend to have deep stomachs, straight backs, and very bony pelvises; bulls have a deeper chest, powerful shoulders, a higher head, and an arched back. The buffalo's legendary silhouette derives from its powerful humped back and large shaggy head. Thick fur often disguises a buffalo's internal structure, but a study of the skeleton reveals the source of the salient features—high vertebrae around the shoulders and a broad, deep skull.

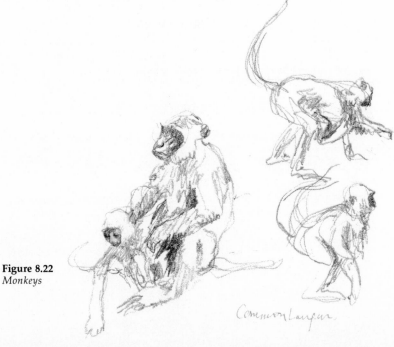

Figure 8.22
Monkeys

Other mammals, including bears, elephants, rhinoceros, and hippopotamus, may at first seem too big to draw. However, geometric masses are easy to identify in these creatures since they are not particularly complex in forms or movements.

Apes and monkeys, on the other hand, are extremely flexible and are therefore more difficult to simplify in drawing. Gestural studies described in Chapter Five should help you here. Note major differences between monkeys (Figure 8.22), apes, and humans; observe posture, length of limbs, faces, hands, and feet along with tails and fur.

Dogs

There is seemingly no end to the types (and combinations of types) of dogs, ranging from the St. Bernard to the greyhound, the German shepard to the dachshund, not to mention

mutts of all shapes and sizes. Each is built differently because of its breeding; each has a particular personality that can be conveyed in a drawing.

Dogs are good subjects because of their abundance and accessibility, but they rarely sit still for long. Learn to block in their form quickly and refine your drawing from memory. Learn to recognize major shapes and structures once these are understood, it will not be difficult to characterize the features of an individual animal. Once again, avoid being overly captivated with fur, markings, or facial expression until the forms have all been established. (See Figure 8.23.)

Cats

Cats are distinguished by their long bodies and sleek movements, (with a few notable exceptions such as the lion, which tends to be

Figure 8.23
Dogs

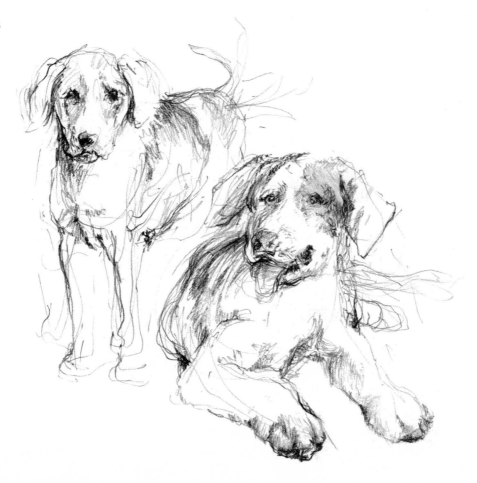

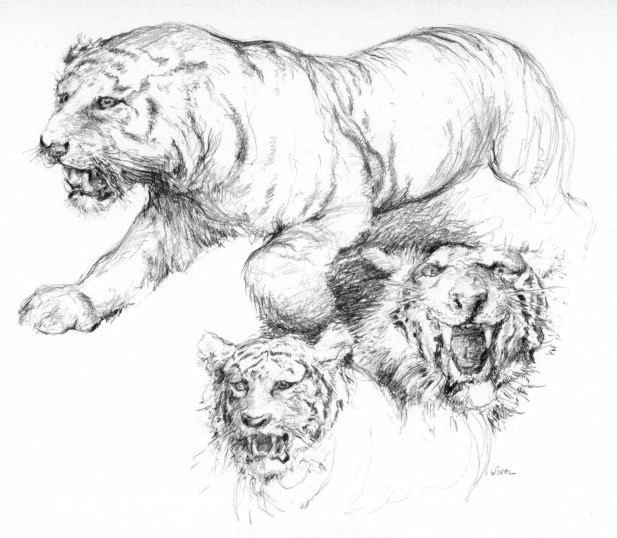

Figure 8.24
Tigers

Figure 8.25
CHARLES SHEELER (American, 1883–1965)
Feline Felicity (conté crayon on white
paper), 559 x 457 mm (22 x 18″)

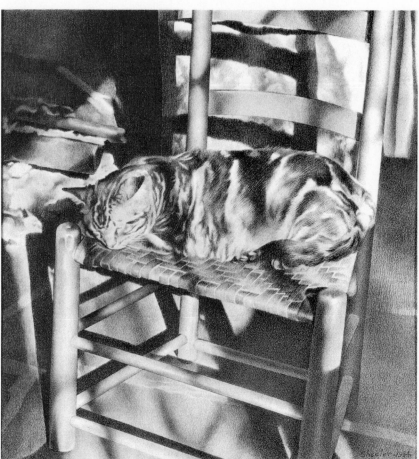

more blocky in shape and solid in its actions). There are many different types of cats, both domestic and wild. They all tend to have large, expressive eyes and rather dramatic natures (see Figure 8.24). In drawing a cat, begin with its gesture. Remember to suggest the long, flexible frame; then, rough in the features using basically cylindrical geometric shapes. The head may be established as a round form or a block depending on the individual animal (see Figure 8.25).

Birds

Birds in flight and birds at rest make for two very different drawing subjects. The first is all wing action, fluttering, soaring, beating rap-idly in complex patterns. Except when folded, the wings tend to be larger than the body of a bird. Wings in themselves can offer exquisite subjects for long study (see Figure 8.26).

Every bird flies, lands, and takes off in a characteristic manner. Once again, refer to Muybridge as an excellent photographic source for birds in motion (Figure 8.27).

A perched or grounded bird folds its wings and presents a compact, but distinctive subject. Individual personalities are still apparent here in the faces and postures of each bird: the sharp, predatory eye and beak of a hawk or owl, the strutting cantankerous posture of a gull, or the fretful hopping of a sparrow.

The general shape of most resting birds is relatively simple. In long studies, however,

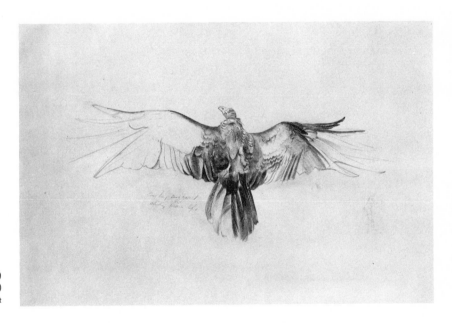

Figure 8.26
ANDREW WYETH (American, 20th century)
Turkey Buzzard—Study from Life (pencil)
Courtesy of the Museum of Fine Arts, Boston. Bequest of M. Karolik

Figure 8.27
Turkey buzzard in flight, after photographs by Eadweard Muybridge, appearing in *Animals in Motion*, edited by Lewis S. Brown (Dover Publications, Inc., New York, 1957)

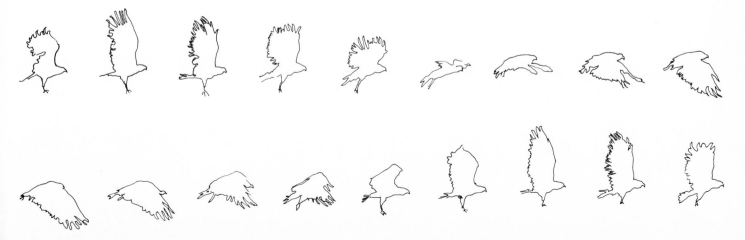

layers of feathers, primarily in wings and tails, can become confusing issues. Look for patterns and develop them in your drawing. Don't apply feathers at random.

Beaks and claws present interesting textural problems, quite different from feathers. In the drawing "Impulsive Crow," by Leonard Baskin, in Chapter One (Figure 1.3), the artist developed the feet with a pen and the feathers, appropriately, with a brush. Both surfaces are merely suggested, but both evoke a specific texture.

Reptiles, Amphibians, and Fishes

In cold-blooded animals, motion is more limited than in mammals and birds. Basic body structure is less evolved and generally less complex. Most reptiles and amphibians may tend to have relatively short legs (see Figure 8.28); fish and snakes, of course, have none.

These animals can present very unusual problems. We find, for example, tropical fish with bizarre body types and colorations, as well as snakes and lizards with scaly textures and dynamic conformations.

Figure 8.29
KURT SELIGMAN (American, 1900–1962)
Caterpillar (varnish, black crayon, and wash on white paper), 710 x 560 mm (28 x 22")
Courtesy of the Fogg Art Museum, Harvard University. Bequest of Meta and Paul J. Sachs

Invertebrates

As we stated in the beginning, invertebrates must be studied primarily in terms of surface form. Skeletons are external in shellfish and

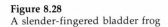

Figure 8.28
A slender-fingered bladder frog

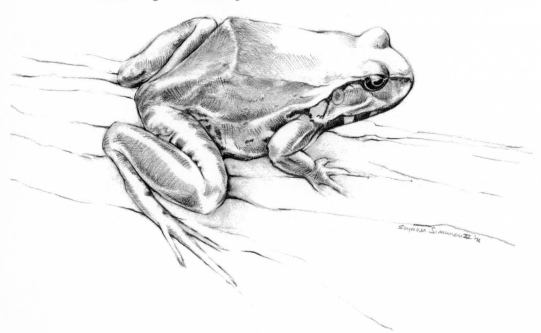

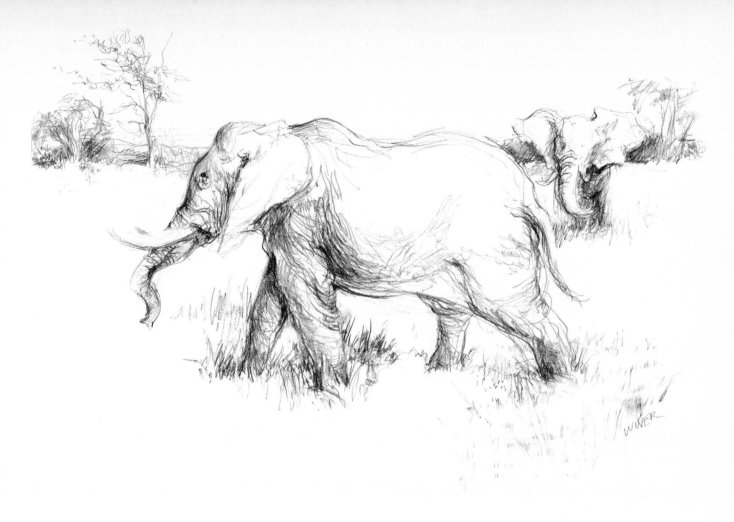

Figure 8.30
Elephants in landscape

insects. Jellyfish, worms, and microscopic animals have no skeletons whatsoever. All these animals offer fascinating subjects for drawing, and present interesting stimuli for abstract design as well (see Figure 8.29). Some animals lend themselves to in-depth study because of their complex physical structure and surface patterns, for example, lobsters, butterflies, caterpillars. Ants, beetles, and spiders are beautifully constructed and might be portrayed through geometric simplification and abstraction or studied carefully in detailed textural investigations.

ANIMALS IN COMPOSITION

Animals, with their characteristic features and evident personalities, lend themselves particularly well to action drawing, caricature, satire, and storytelling.

They can appear in a drawing as major or minor compositional elements. An animal could be the solitary figure in a composition, portrayed either realistically or abstractly. As part of a landscape, the animal may either stand prominently in the foreground as a center of interest or be placed in the background to set the scale (see Figure 8.30).

In the following exercises, we will present different ways of approaching the animal form in composition, in order to offer you some starting points. Study the works of other artists to find more ways that animals have been portrayed in art.* Then expand upon these ideas to develop your own expressive statements.

Exercise 5

NATURAL SETTING
(*Time: 1 hour or more; no medium requirements*)

Working from nature, memory, sketchbook records, or photographs, develop a composition using animals in a

*See Chapter Nine, Composition.

Figure 8.31
EUGÈNE DELACROIX (1798–1863)
An Arab on Horseback Attacked by a Lion (graphite on
tracing paper), 460 x 305 mm (18 1/2 x 12″)
Courtesy of the Fogg Art Museum, Harvard University. Bequest of
Meta and Paul J. Sachs

natural setting. To plan your design, begin with quick
sketches, each within a border. Try different arrange-
ments; place the animal in the foreground, mid-
dleground, or background, with supporting lines and
tonal movements. Settle on one composition and blow
it up to a fairly large scale,* maintaining the same
proportions as in the original sketch. Develop the
drawing as you would any composition, keeping struc-
ture, balance, and movement always in mind. If pos-

*Animal studies lend themselves to large-scale drawings.
Try making a series of pieces 30″ × 45″ or more.

sible, use the gesture or mood of the animal to set the
tone of the scene.

You can introduce elements from the animal's
environment to help structure your composition. For
example, in working from animals in zoo cages, you
might try using the rectangle of the cage as a frame
within the framework of your drawing to intensify the
effects of space. This second frame can also be used to
construct some unusual and unexpected **croppings** for
a more striking composition. Use the bars or other ver-
tical structures to set off the foreground plane.

Exercise 6
DOMINANT FORMS
(No time limit or medium requirements)

Do a similar study using animals and people. Again,
try different compositional schemes, working from pho-
tographs. In one scene, make the animal the dominant
form (for example, place it in the foreground). In an-
other, have the figure play the dominant role. Try a
third drawing in which animal and human are equal
partners (see Figure 8.31).

Exercise 7
DETAILED STUDY
(Time: 1 hour; no medium requirements)

Working from photographs or at a natural history mu-
seum, do a detailed study of one aspect of an animal,
blown up to a large-scale drawing, using margins and
compositional considerations as described in Chapter
Three, Still Life. Choose an area of particular interest:
feathers on a bird's wing, antlers or horns, bones or
skulls, particular facial expressions, and so on. Con-
centrate on textures only after the composition has
been established.

Exercise 8
IMAGINARY STUDIES
(Time: 1 hour or more; no medium requirements)

Create an imaginary animal, combining the features of
several different animal types. Base your study on a
mythological creature or invent one on your own. Try
to think up a setting for your imaginary creature or
place two or more together. (See Figure 8.32.)

Exercise 9
ABSTRACT IMAGE
(No time limt or medium requirements)

Make an abstract image using an animal pattern to be-
gin the basic design structure. Establish the com-
position by developing upon the design of gesture and

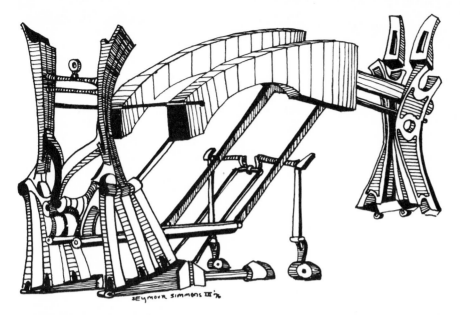

Figure 8.32
SEYMOUR SIMMONS III
Weary Mechanical Horse

markings from the animal itself. Structure values with the design in mind. Try breaking up the form into **cubist** *planes or simplifying the gesture to create a pattern of spontaneous linear movements. You might also use an animal skeleton for this exercise.*

Exercise 10

CARICATURES
(No time limit or medium requirements)

Do caricatures of several types of animals (and people, also). Use them to tell a story. In some cases, you might have the animals take on the actions of a human being. Each would have its own distinct pattern of activities, which could be easily identified with certain types of human behavior. Conversely, you may have caricatures of people taking the role of animals. People are often characterized by their animal-like qualities, such as "the heart of a lion," "eats like a pig," and so on. Create a single scene using animals and people in reversed roles; invent a comic strip or **cartoon,** *using captions or dialogue if you wish. (See Figure 8.33.)*

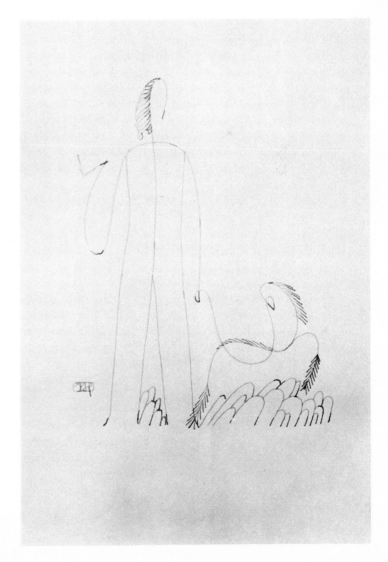

Figure 8.33
JOSEF HOFFMANN (Austrian, 20th century)
Figure Study of Man with Dog (ink drawing)

Courtesy of the Busch-Reisinger Museum, Harvard University. In memory of Louis W. Black

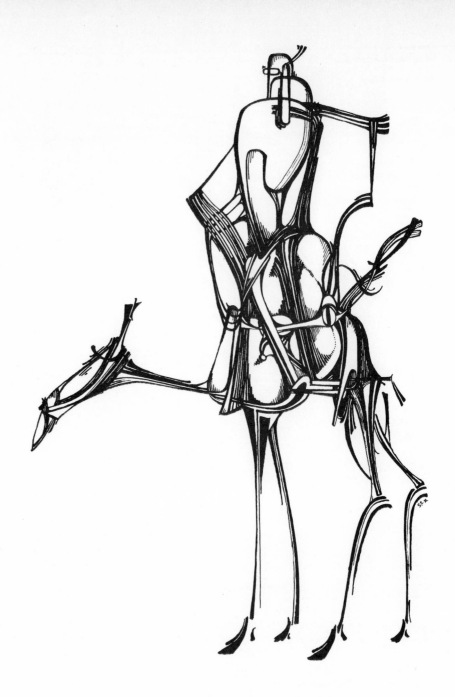

IMAGINATION IS AT THE HEART of every draw-
ing. Whether you suggest a human form
with a modulating contour line, alter the light-
ing when drawing a still life, or rearrange
the elements in a landscape for compositional
purposes, you are applying your imagination
toward the creation of a new image, some-
thing that never quite existed before. This
creation, a spontaneous joining of immediate
perceptions, past knowledge, mood, and style,
is a product uniquely of yourself and the mo-
ment; no one else could have created it, just
as you could not totally reproduce it yourself.

In every aspect of the creative process,
imagination plays a determining role. It urges
an artist to envision a potential drawing when
looking at a familiar object and plays a part in
the choice of medium, style of application, and
compositional organization. Imagination is the
quality that leads us to see new possibilities
and make new statements, not only in artistic
endeavors but in all aspects of life.

Abstraction, like imagination, is an es-
sential element in all drawing. The ability to
abstract leads to the contour generalization of
the human form and the compositional rear-

CHAPTER NINE

Imagination, abstraction, and composition

rangement of landscape elements. The abstract organization of lines, form, value, space, texture, and color unifies and orders the forms in a composition, both in representational and nonrepresentational art. (See Figure 9.2.)

Abstraction, in the context of art, is an expression of a sense of design. Like imagination, a sense of design is a strictly personal quality, unique to each individual. It is an active element of our tastes and of our appreciation of, and response to, various forms of art.

As children, imagination and a sense of design were very much a part of our lives. We actively applied them in our drawings and paintings. Children's art glows with its variety and richness of spirit; the choice of colors, nonchalant abstractions, and scribbled figures display artfulness in their freedom and grace (see Figure 9.3). For many adults the habit of creativity has been neglected over the years, and some people feel that they have no imagination left. More likely the spark of imagination is still alive, but hidden under a pattern of habitual responses.

Our goal, then, might be to coax out the

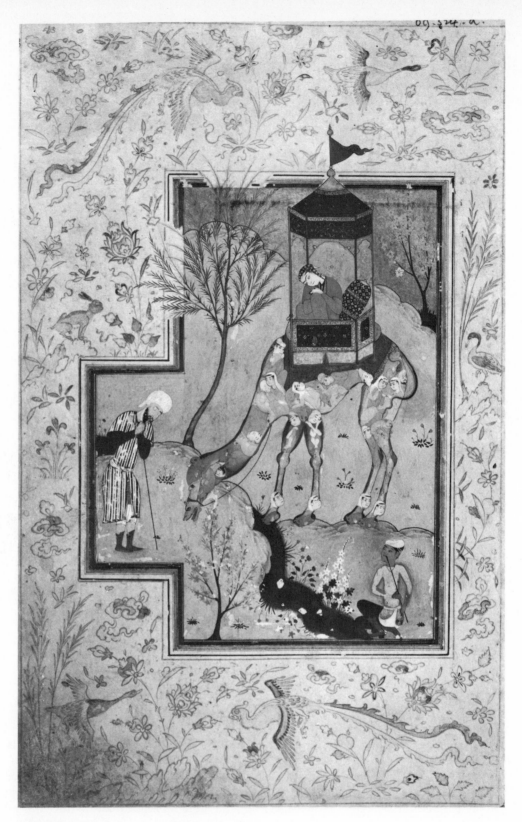

Figure 9.1
(Persian, Safavid, 1573 A.D.)
Page from the Hadtgatu'l Hagigat of Ana't (manuscript)
Courtesy of the Museum of Fine Arts, Boston. Ross Collection

Although the decorative, calligraphic surface of this Persian manuscript illumi-
nation creates a unified image, there is a marked difference between the frame
and the interior scene. The frame contains a monochromatic pattern made up
of naturalistically portrayed birds and flowers; the scene, while more illustra-
tive, hides a subtle element of fantasy. Look carefully at the body of the camel.

Figure 9.2
CHARLES SHEELER (American, 20th century)
Totems in Steel (conté crayon and graphite on white paper), 485 x 577 mm
(19 1/8 x 22 3/4")
Courtesy of the Fogg Art Museum, Harvard University. Bequest of Meta and Paul J. Sachs

In this drawing, Sheeler combines an intensely realistic style with a precise sense of abstract design. The familiar setting was transformed by the artist's creative imagination to convey a sense of power, emotion, and strangeness through the concentrated arrangement of forms in space.

Figure 9.3
Dragon
Courtesy of Sadie Kilmer (age 4)

natural creativity and childlike spontaneity and then to combine them with mature perceptions and technical ability. Often, however, our desire to control our images, to create an attractive picture, or to tell a story interferes with the response to our creative instincts, with stiff and unsatisfying drawing as the result.

During the course of this book, we have tried to provide opportunities for you to use your imagination and sense of design, presenting a variety of creative approaches to each subject. Although we primarily stressed accurate observation, we encouraged experimentation with distortion, exaggeration, and abstraction as well. In the still life chapter, we suggested that you carry out abstract experiments with textures and values, as well as abstracting natural forms for design purposes. In

242

landscape, you were asked to modify the actual scene to create a more personal statement. In this final chapter, we will offer explanations and exercises, expanding upon the principles of abstraction and imagination. Both elements will be combined, first in a discussion of composition, then presented individually in more specific contexts, including nonrepresentational art and fantasy.

COMPOSITION: LEARNING BY COPYING

The creative imagination and a sense of abstract design combine in the development of a composition. Applying our imagination we suggest forms, create the illusion of space, invent textures, and discover distinctive patterns of value and color. Our sense of design helps us to arrange these into an image that is both balanced and active. The principles of composition have been introduced in Chapter Three and developed in different chapters throughout the book. You may wish to refer to earlier sections to refresh your memory about the concepts involved.

It is in composition that an artist's creative abilities find their most complete expression, and it is often on the basis of composition that a work of art is judged. Of course, representational skills, color sense, and style are major considerations, but these must first be integrated into a composition to establish their significance. Composition, then, should be a very personal concern, unique to every individual. Ideally, the principles of balance, movement, harmony, structure, and design should be given original application every time we start a drawing. We can learn a great deal about the potential of these principles through the intensive study and copying of works of art. Copying is among the oldest and most fruitful methods of learning any discipline, whether painting, weaving, mechanics, or mathematics. We grow by first following others, then carrying on where they left off.

Some students have the misguided impression that copying is a negative activity, that it will crush their creative potential and lead them toward an imitative style. Copying

is an exercise, and, like any exercise, it can be stifling if overdone. If, however, copying is regarded as only a part of a total learning experience, it can open many doors, teaching things that could not be gained in any other way, by putting you in touch with the thoughts and actual hand movements of the original artist.

Most artistic exploration and innovation is but a small step beyond what is already known. Artists of integrity and vision first studied and digested previous and contemporary art before expanding the traditions of their chosen field. This has been true from Phidias to Giotto, from Leonardo to the founders of all the modern schools. Rembrandt copied the masters of the Italian Rennaissance; Mondrian began by following the traditions of the Dutch masters; Picasso spent a part of his youth copying Velasquez.

When closely copying a drawing, you become, to some degree, the other artist. Although you do not have to begin the process with the many years of practice, the struggle for inspiration, and the multiple compositional sketches or studies that lead to the final work, you do have to understand intimately the nature of the final image, and in that recreation, you partake of the artist's thoughts.

The most effective approach to copying requires that you use the original medium employed by the artist. In using this same medium, you can become much more personally involved with the artist's activity, learning about technique as well as composition and form. Unlike painting, which often covers its tracks, drawing is very accessible to this kind of investigation. You will find, however, that some drawings are better for copying than others. For instance, drawings by Rembrandt, although magnificent examples of perception, style, and technical skill, are often difficult to copy because of their swift, gestural nature.

When copying, choose drawings (or reproductions) that are large and clear. In your drawing, maintain the same proportions, if not the same size as the original. Copy exactly! You are trying to learn why an artist made certain decisions and marks. By making "slight" modifications of the artist's presentation you defeat this purpose. Try to take the work apart and see what makes it tick.

Carry a sketchbook with you whenever you go to a museum, whether you plan to draw in it or not. Something might unexpectedly catch your eye. You might make quick sketches and refer to them later as a source of new ideas for compositional schemes and design.

Exercise 1

COPYING
(No time limit; medium dictated by the original)

Choose a drawing you feel you can learn from. Place it where it is clearly visible and begin by lightly sketching in the composition and general shapes—the artist wasn't concerned with details until the final stages. Work all over the space; don't concentrate your efforts on one area. Try to maintain the forms and values, while using the exact proportions of the original. Look for negative space as well as patterns of lines and tone that hold the image together. Try to re-create the thinking process and progression of marks that would have taken place in the original.*

Although working in the original medium is the most rewarding means of copying, you should not ignore the learning potential of drawing from other art forms: painting, sculpture, architectural structures. In copying them, you will learn about form, composition, and value relationships, although you will not get a sense of the preliminary process as you do from copying a drawing in the original medium.

Exercise 2

COMPOSITIONAL SKETCHES
(No time limit; material: pencil and mixed mediums)

Working from a painting or a good quality reproduction, do some compositional sketches, stressing large shapes and values. Later blow up these notations onto a 30"–40" sheet of paper. Continue to develop the compositional scheme abstractly without reference to the original. You might try using construction paper to make your large tonal areas. Cut out the shapes of paper either in colors or shades of gray, and glue them to a large paper or board; then draw into these with pencil, pen, brush, or markers. An extension of this exercise would involve sectioning off part of the original composition and abstracting from that area only.

*If you are copying a pen or brush drawing, or a very complex composition, it is generally helpful to sketch in the compositional structure and major forms in pencil first. Then, if mistakes are made, they can easily be changed before the indelible medium is applied.

Figure 9.4
SAM FRANCIS (after Velasquez) (American, 20th century)
Berne, 1961 (pen, brush, and ink)
Courtesy of the Museum of Fine Arts, Boston. Abraham Shuman Fund

Artists have always used works of the masters for inspiration. Francis has created a brisk abstract, apparently after studying a work by Valasquez. The title is actually the only clue to the source of inspiration. Many people would find it difficult to recognize this abstract pattern when looking at Valasquez's decidedly representational work.

Exercise 3

INTERPRETATION
(No time limit or medium requirements)

*Many artists have created innovative personal statements by interpreting another artist's work in their own style. Try this using a drawing or painting with which you are particularly familiar. Begin by copying roughly the original compositional structure and subject matter, but develop on the image, using an abstracting or expressive personal approach. Let yourself go and enjoy the process. Don't feel hindered by representational concerns here. Change the **color scheme,** introduce new elements, leave others out. You may learn as much by this type of approach as by more orthodox copying (see Figure 9.4).*

Exercise 4

RESPONSIVE STUDIES
(No time limit or medium requirements)

Study a drawing, painting, or sculpture for a long period—several weeks, several months, or even longer. In your sketchbook, keep a record of your responses to and interpretations of this piece over the period. With

each study, whether it is a quick sketch or an extended drawing, you will learn more about your chosen subject and your own emerging style.

In the next few pages, we will briefly analyze a few compositions, discussing their design and indicating ways to copy and understand them (see Figures 9.5 through 9.10).

Figure 9.5
CHARLES MERYON (French, 1821–1868)
La Pompe de Notre Dame—Study for the etching (pencil and conté crayon)
Courtesy of the Museum of Fine Arts, Boston. Gift of the Members of the Visiting Committee

Composition can draw a viewer into the image while providing a sense of three-dimensional space. In Figure 9.5, the artist urges us into the heart of the picture by establishing front, middle, and background planes connected by subtle perspective lines that guide the eye. The foreground arch encloses the image area, focuses our attention, and directs the eye within the sweeping curve. The arch itself remains undeveloped, while the center of interest is darker, texturally varied, and more complex.

Before believing everything you read here about composition, look again at the tower area. The artist's intention may have been to set the tower back in a deep space, but the opposite effect occurs. By having the tower touching, and somewhat penetrating, the arch line (see Figure 9.6), Meryon has created a great deal of visual tension and confusion. The central area actually advances beyond the foreground plane of the arch. It is the transparency and ambiguous overlap at the point designated by the arrow that cause the spatial problems in this drawing.

In copying this drawing, begin by structuring the arch in relation to the frame of the image and roughly blocking in the central area. Be sure to establish the forms in perspective. Develop both areas simultaneously, watching for lines that would connect foreground, middle ground, and background. You may sketch the basic forms of the composition first in pencil, then develop the drawing using more precise lines. Before going too far in your copy, you might experiment by moving the tower around to see if you can get it to sit in the background.

Figure 9.6

Figure 9.7
GIOVANNI BATTISTA TIEPOLO (Italian, 1696–1770)
The Rest on the Flight into Egypt (pen and bistre over traces of black chalk on white paper), 430 x 290 mm (16 7/8 x 11 3/8")
Courtesy of the Fogg Art Museum, Harvard University. Bequest of Meta and Paul J. Sachs

The space in Figure 9.7 is relatively shallow compared with that attempted in the previous picture. The three figures sit primarily in the foreground. Within the figures, however, a kind of **bas-relief** space is created by the sharp delineation of shadows. The nervous quality of the lines and washes serves to express the rococo spirit of this drawing, but the composition is stabilized by a geometric (triangular) format. Scenes with Madonna and Child were characteristically arranged in a triangle for many reasons, some having to do with the symbolic reference to the trinity and others for compositional concerns. In this instance, the directness of the triangle simplifies a potentially busy composition while enhancing the emotional unity of the figures.

Within the triangular format, diagonal lines guide the viewer's eye through the image area, directing it to the center of interest, the heads of Madonna and Child at the apex of the triangle. The main diagonal line passes through Joseph's and Mary's hands to the face of the child. This line is supported by secondary diagonals, one of which runs up Joseph's shoulders to Mary's face then continues up into the tree. Other diagonals follow the line of the knees and the line of the feet. These lines reinforce the main movement of the composition but may eventually guide the eye up the tree and out of the picture. Here, however, the downward sweep of the branches returns the wandering gaze to the image area. The crossed boards and inwardly pointing jug serve as directional guides on the bottom of the page. (See Figure 9.8.)

In copying this picture, you may begin by following the sketchy pen lines, using a crowquill or other flexible-tipped pen, or start applying the medium washes, using watered-down India ink or brown ink and a watercolor brush. Both lines and tones flow over the image providing movement and unity. Do not concentrate on only one area at a time, but develop the composition as a whole. Save your darkest values for last; note how they are carefully placed throughout the image. When you apply either pen or brush, maintain a sense of vitality and spontaneity in keeping with the spirit of the original.

Figure 9.8

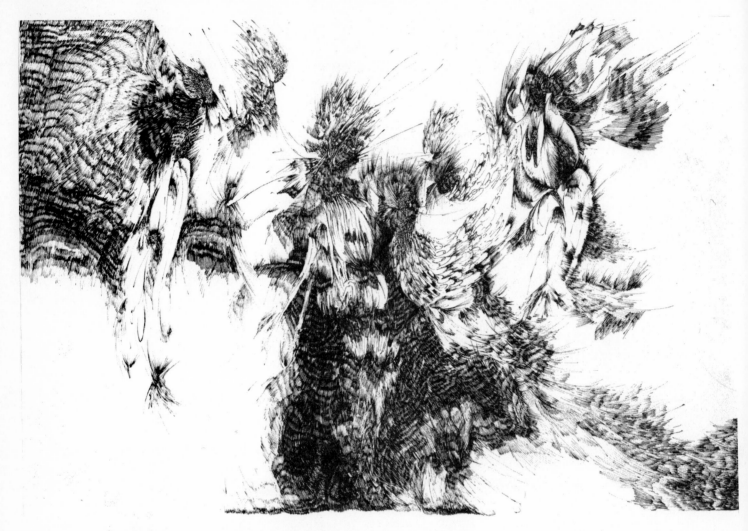

Figure 9.9
ARNOLD BITTLEMAN (American, 20th century)
Martyred Flowers (pen and ink), 657 x 980 mm (26 x 38 3/4")
Courtesy of the Fogg Art Museum, Harvard University. Gift of Dr. Fritz B. Talbot

The emotional impact of Figure 9.9 is quite different than that found in the previous study, despite the fact that both images are built with somewhat nervous marks. The previous drawing was designed to give a subtle sense of order and stability. This was accomplished by the triangular format that unified the image. In the Bittleman, the composition is structured to emphasize a feeling of anguish and energy released. Both artists are attempting to reach our emotions through the composition of their pictures as well as the subject matter. Try to be aware of your emotional response when looking at an image and consider how and why you are affected. Often the compositional structure has more emotional impact than might be recognized at first.

Copying this picture could be simply an exercise in technique and patience unless you can take part in the artist's emotional intent. To do this, you should first look at the picture to develop a **kinetic** awareness of the balances as well as the thrusts. When applying your pen, try to imbue each line with the intensity of those in the original. Begin by establishing marks all over the image area, setting up the diagonal structure, the exploding curves, and the large masses of tone. Then develop the drawing as a whole, gradually building up values rather than concentrating on one area at a time. (See Figure 9.10.)

Figure 9.10

ABSTRACTION

Although we have seen that abstraction is an integral part of every drawing, its most familiar definition applies to the creation of non-representational art. Here, in fact, abstract design principles are most easily recognizable since movements of color, line, form, and texture are not disguised beneath a familiar covering of recognizable imagery.

For the artist, abstract work often is created to solve problems of design, color, form, or texture. At other times it is the expression of a spontaneous outpouring of emotion. The tendency to abstract has been present in art since the New Stone Age; **neolithic** artists created geometric designs on pottery and shields, as well as on sacramental objects.

Often a design is developed from abstract forms found in nature. By looking carefully at the pattern of lines over a few square inches of birch bark, or at the silhouettes of intertwined branches at dusk, you will see that nature displays very powerful abstractions. We organize and identify these forms as being part of some object, but we have the choice to see them instead as patterns. Many artists build compositions by isolating natural forms and developing upon them; still others find potential in man-made forms, or develop designs from patterns that flow from their unconscious.

Many students, when faced with an exercise calling for abstraction, find that they are hesitant and uncertain about what to do. They may feel that unless there is a definite subject matter to work from, they will have no criteria upon which to judge the success of their drawings. As we have said before, *the principles of composition are the same whether the work is realistic, abstracted, or totally non-representational.* Values are arranged, textures developed, and lines applied in space to convey meaning and mood in each approach. The merits of an abstract work are judged on the same basis as those of a representational work: does the compositional design maintain a balance and movement? does the image attract and hold our attention? does it stir us or enrich us?

The preference for representational or abstract art is ultimately a matter of taste; however, abstraction should not be ruled out simply because of its unfamiliarity. Through your experience with nonrepresentational imagery, you can learn much that will be helpful to you no matter what style you choose to pursue later. In the following pages, we will include exercises that will develop upon those presented earlier in the book, to give you greater insights into the methods and theories of abstraction. These should be followed with an open and relaxed attitude. Try not to have predetermined ideas of what the final image should look like. Allow yourself to develop the drawing from your natural, spontaneous sense of design.

Figure 9.11
NICHOLAS KILMER (American, 20th century)
Horsing Around (pen and ink)
Courtesy of the artist

Figure 9.12
DAVID SMITH (American, 1906–1965)
Composition (tempera on white paper),
445 x 570 mm (17 1/2 x 22 3/8")

This abstract brush drawing, despite its decidedly nonpresentational format, begins to imply a recognizable pattern or texture. We could "imagine" that it represents either a natural or a man-made structure.

Exercise 5

USING MAN-MADE FORMS
(No time limit or medium requirements)

Take several familiar man-made forms, and blow them up in a drawing, overlapping them in the framework until only abstract, unrecognizable patterns emerge.

Exercise 6

USING NATURAL FORMS 1
(Time: 1 hour; no medium requirements)

Find a natural form: look at a piece of bark, a small area of earth, a cloud formation; investigate an insect wing or a drop of swamp water through a microscope. Make a detailed study in a framework, approximately 12" by 18". Don't try to identify the forms you see; simply abstract and render the lines, colors, and values.

Exercise 7

USING NATURAL FORMS 2
(Time: 20 minutes each; no medium requirements)

Make several small sketches, each within a framework, based on the long study you just did. Rearrange the lines, values, and colors to make a new composition.

Look at each drawing from a distance while making compositional decisions (see Figure 9.12).

This is a gentle introduction to abstraction, and creating a design in this way may come relatively easily. Truly expressing yourself through design, however, may prove to be a more difficult problem. The next exercises call for you to identify, locate, and draw from feelings that may not be readily apparent. You may not be aware of some of your deeper emotions or they may be hidden under more superficial thoughts or feelings. Operate under the assumption that the feelings are there within you, and that, through proper encouragement, they can be aroused for the purpose of self-expression.

Exercise 8

MUSIC
(Time: 15–30 minutes each; material: markers, crayons, or pastels; large sheets of newsprint)

Music can be an aid to encourage the emotions. Select several records that have particular appeal for you. Choose some that you listen to when you are happy,

251

some that make you want to dance, some that you put on when you are sad. Stack them on the record player in random order. As each record comes on, apply marks in color on your paper. Don't try to create a recognizable image, but if one appears, develop it as you wish.

This can be an enjoyable exercise for several people to do together, using a very large sheet of paper and plenty of colors. Allow each person to work on the entire image, rather than restricting everyone to separate corners of the paper. If a friend starts to develop a pattern and then leaves it, you may continue to work on the pattern in your own way. See what happens. Everyone could have a totally different response, or a remarkably similar one, to each piece of music.

Figure 9.13
SEYMOUR SIMMONS III
Quixotic Figure (pen and ink)
This picture was one of a series of spontaneous equestrian figures. With no initial intent or conscious purpose, lines in each drawing evolved into horsemen of one type or another.

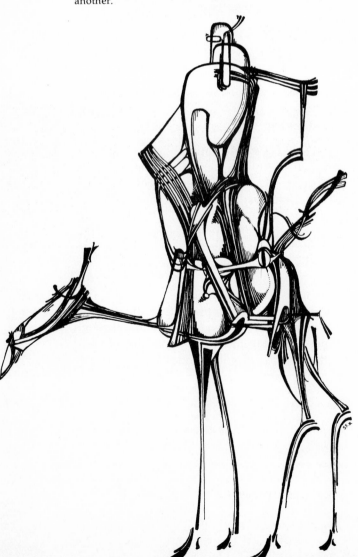

Exercise 9

WITHOUT MUSIC
(No time limit or medium requirements)

Do the same type of exercise described above without music. Draw in a sketchbook or on odd pieces of paper whenever you are under the sway of an emotion—joy, sorrow, anger, passion—or physical sensations, such as pain, tension, or pleasure. Try to express the feelings in abstract terms, through your drawing. Often an emotion changes subtly during the course of a drawing. It may intensify, decrease, or turn into another emotion altogether, possibly into one that was hidden at the beginning. If the emotion changes, allow this to be reflected in your drawing. You may wish to start again with each change in emotions or incorporate several emotions into one picture. This can be a therapeutic technique and also a sort of personal diary. Date your drawings if you wish and add some explanatory notes. Once again, begin each drawing with no concrete image in mind. However, if an image starts to appear, don't discourage the development, rather follow it to its conclusion.

Exercise 10

AUTOMATIC DRAWING
(No time limit or medium requirement)

Create a spontaneous or "automatic," drawing. Clear your mind of thoughts (see the relaxation exercises in Chapter One). Allow your hand to move at random on the paper. Look at what you have done, and develop this scribble into an abstract design or a recognizable form as you wish. This type of approach to drawing was very popular with the **surrealists.** *In it, their unconscious, undirected imagination was brought into play to create the initial image. This image would then be refined through their sense of design and imagination (see Figure 9.13).*

IMAGINATION

The sources of an imaginative response are varied; we might see design potential in natural forms or discover a new compositional scheme by looking at another artist's work. We may get ideas from music, literature, or dance. At other times, imagination develops from unconscious memories or associations. Often this type of response manifests itself in terms of fantastic or dreamlike imagery. No matter how unusual or bizarre these images,

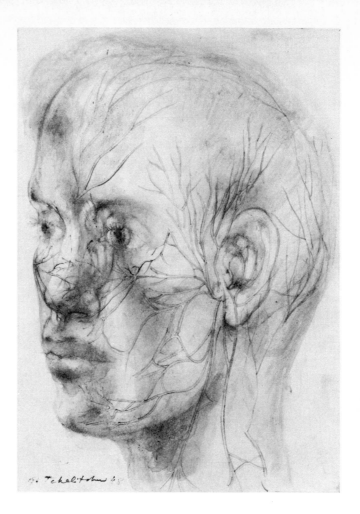

Figure 9.14
PAVEL TCHELITCHEW (American, 1898–1957)
Head of a Man (gray wash on white paper), 358 x 253 mm (14 1/8 x 10")
Courtesy of the Fogg Art Museum, Harvard University. Bequest of Austin A. Mitchell

The veiny structure across the face and head gives this basically simple portrait a provocative and ambiguous quality. It may have been done as a preliminary study for a major painting entitled *Hide and Seek*. In the painting, a tree is formed from the hands, feet, heads, and bodies of children. The pattern across the man's head is reminiscent of the intertwining figures and branches in the painting.

they are not without sources or meanings. Rather they are based on experiences of the past, which have been brought together in the mind for symbolic or expressive purposes. Artists for hundreds of years have turned these manifestations of the unconscious into works of art, sometimes presenting the images just as they emerge; at other times, using the images to invent new forms, to convey messages, or to create a design (see Figure 9.14).

Imagination in art, then, occurs when new images are derived from old. An imaginative Greek first had to see a horse and the wings of a bird to conjure up Pegasus, the flying horse. A flexible mind took the two natural forms and combined them to create something very different—a unique form with a specific symbolic purpose.

The ability to recognize imaginative potential in familiar forms comes more easily for some people than for others. We apparently get into habits of imaginative or unimaginative responses to various situations. Many people who may be considered "unimaginative" habitually follow a certain order of activ-

ities. Others tend to experiment consistently and introduce new elements to most aspects of their lives. Nearly everyone, however, has an imagination that can be developed and applied in many different directions.

You could begin to explore your imaginative potential through the expression of a dream; this could be a regular dream, daydream, or wish. In the next exercise, you will be asked to record the dream in both words and pictures. Don't be afraid to express your fantasies; everyone has them and only you need see your work. You may find that you have some difficulty in forming a visual image from your imagination. Some people fantasize more in words or physical sensations than in pictures. If this is the case, try to look around you, refer to books or pictures to find images that might serve to represent your dream and to give you a more concrete picture of your imaginary scene. As you continue to draw, you will grow more conscious of what you see. As a result, you may find that your visual imagination will become more vivid, and substantial images will come more easily (see Figure 9.15).

253

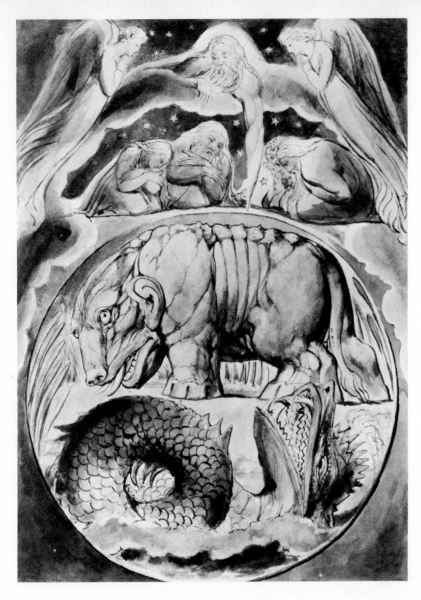

Figure 9.15
WILLIAM BLAKE (British, 1757–1827)
Behold the Behemoth which I made with thee (Illustration No. XV of the Book of Job) (watercolor), 275 x 200 mm (10 13/16 x 7 13/16")

Courtesy of the Fogg Art Museum, Harvard University. Bequest of Grenville L. Winthrop

Blake was a mystic whose images and writing are derived, to a large extent, from his visions and dreams. Many of his drawings are wonderfully mysterious interpretations of the Bible. The composition and forms are innocent in style, yet complex in their symbolism.

Exercise 11

DREAM WORK

(Time: 30 minutes to 1 hour; no medium requirements)

Write down a dream, daydream, or wish. Try to remember every detail. Develop the details if you like, but be sure to get down the major themes or images. Begin to draw from your notes, conjuring up pictures in your mind as you read, jotting them quickly onto paper. Don't be concerned with specifics now; just establish a scene. These sketches can be quite abstract since they need be legible only to you. Read through the text of your dream several times, each time making one or two sketches. Then look over the sketches and decide on the most descriptive one. Make a larger drawing from this sketch, adding details. You may still develop on your dream as new images present themselves.

The ability to unlock and apply your imagination takes practice; often barriers must be broken down and some inhibitions done away with. However, the results in terms of art (and possibly understanding) are well worth the initial effort. We are in no way implying that to be an artist you have to be an **abstract expressionist** or **surrealist.** We mean, rather, that your conscious and unconscious mind offers a vast resource, whether you use realism or pure abstraction as a means of self-expression. You should be able to contact this source of inspiration whenever you wish, as a supplement and complement to your immediate visual experience.

Unlocking the door of imagination often requires a key. As you have seen in rendering your dreams, once the initial image has been established, details come readily. Anything—a dream, an emotion, a piece of music, a pain or sensation, an object, a landscape—may stir up new images. At some time or another, you might catch yourself daydreaming or remembering something, and you will not be able to

figure out where or why you began. If you traced your thoughts and actions, you would probably find that something in the environment triggered an initial image, and the daydream or memory followed through a series of associations. By being aware of your responses to your surroundings and by developing deeper sensitivity, you can find an endless range of inner and outer sources for creative drawing.

Exercise 12

INITIAL RESPONSE
(No time limit or medium requirements)

Allow yourself time just to walk around the house or neighborhood. As you see things, be aware of any responses, ideas, or memories that come to you. Jot these down in a sketchbook with a few words and a quick drawing, or, if convenient, sit down and make a picture based on your response. If this immediate work is not possible, complete the drawing at home with your sketch and notes before you. Try to recreate the initial response. Then develop the drawing as images arise. Use objects, landscapes, people, or abstract patterns.

Allow responses to come out as they will in these beginning exercises. Later on, try to expand the resources of your imagination. The basic material for this expansion must come from experience. Read books, look at art that is different from your own, study your own art for its undeveloped possibilities.

In your studies, look for something new. If you are a realist by inclination, read and look at works of fantasy, surrealism, and **expressionism;** if you are naturally inclined toward the imaginative, study works of more traditional or realistic artists and writers. The human mind has potential in any direction. By concentrating on the familiar in our lives and art, we limit ourselves and our possibilities.

Exercise 13

USING THE WRITTEN WORD
(No time limit or medium requirements)

Read a fictional book or a short story by an unfamiliar writer. Observe how visual images arise as you read the descriptive passages. At a particularly engrossing description, make a few quick sketches of images as they occur. Return to the passage and to the original sketches and make a longer, developed drawing, as if it were to be an illustration for the book. Use your sketch as a compositional plan. Often first scribbles present strong design possibilities. Develop your drawing from this plan, structuring forms and assigning values. Introduce details as they arise either from the verbal descriptions or from your imagination. You may wish to do some research into the material elements described in the book: costumes, objects, landscapes, and so on. These studies should encourage your imaginative thinking. Do the same type of exercise creating images inspired by a poem, the lyrics of a song, or a conversation. This study can lead to the creation of a body of interpretive drawings, paintings, or stories.

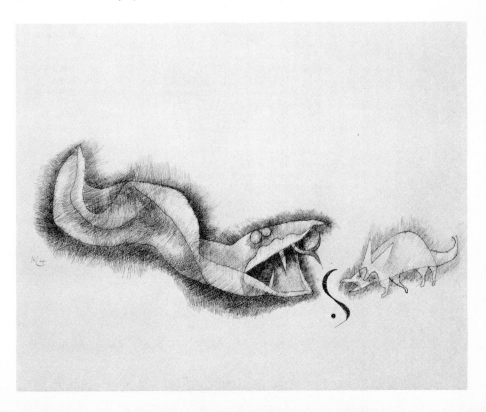

Figure 9.16
PAUL KLEE (Swiss, 1879–1940)
The Serpent's Prey (ink drawing)
Courtesy of the Museum of Fine Arts, Boston. J. H. and E. A. Payne Fund

Klee, a master of fantasy and design, has concocted an image that is both humorous and sinister. The seeming simplicity of forms belies the planning and sophistication that went into the drawing.

Exercise 14

MEMORY IMAGES
(No time limit or medium requirements)

Create a drawing from a memory. If nothing comes to mind, relax; a memory may arise as you sit waiting for inspiration. Even if it doesn't appear to be very inspiring or interesting, begin to draw from it anyway, developing the images as they flow from your mind. You may discover a very interesting subject beneath *your initial thoughts. Memories come to us from sight, and sound, but also from touch, taste, and particularly from smell. Be aware of the images that come to you as a result of any of these sensations, and create a drawing. It may start out very abstract. Later it can be developed into more recognizable forms if you wish. Record any thoughts that might occur during the course of remembering and keep them with the drawing in your sketchbook. You can refer to these as a diary.*

Figure 9.17
DAVID ARONSON (American, 20th century)
Rabbi III (brown pastel)

Courtesy of the Museum of Fine Arts, Boston. Gift of Arthur E. Vershbow, Benjamin A. Trustman, Samuel Glaser, and Dr. Earl Stone

The image of the rabbi, part of a series by the artist, presents more than just the figure of a man. The soft, deep tones, quiet light, and simplified, abstracted shapes combine to give us insight into the emotional symbolism associated with the religious teacher.

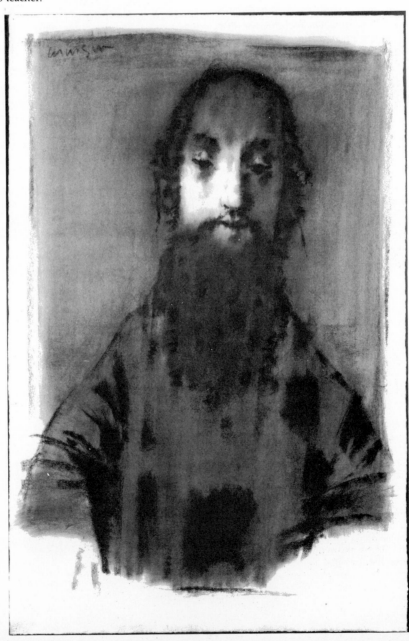

Exercise 15

USING IMAGERY

(No time limit or medium requirements)

Keep a record of dreams every night for a couple of months. See what kind of images reoccur. First, try to recall the dreams in detail, writing down and drawing whatever you remember; continue to write, letting your imagination embellish these thoughts or images.

Make an occasional extended drawing from one or more of these dreams, developing the imagery into a composition. You may wish to research settings and costumes for your dream picture as you did for your illustration in Exercise 13.

Conclusion

THE EXERCISES IN THIS BOOK have been designed to put you more in touch with your perceptions, imagination, and, to some extent, your body. They also provide a means to convert your experience into a personal image. Our purpose has been to stress the act of drawing rather than the finished product; the enrichment gained through the deepening of sight and the pleasure of graphic exploration are both exciting in themselves even if the result is not totally satisfying. At the same time, by concentrating your energy on the making, you will maintain the balance of freedom and control that will lead to good drawing.

Your drawing will continue to develop throughout your life. You will experience times of frustration as well as moments of triumph at every stage. No matter what your level, however, remember to accept and take pleasure in what you are doing. Learning anything well requires hard work, but don't allow the effort to take away your enjoyment.

Glossary

Abstract: Opposed to what is concrete or solid. In art, abstract refers to work that does not obviously represent natural forms. Abstract principles structure every form of art, whether representational or nonrepresentational.

Abstract expressionism: Style of nonobjective art developed in the 1940s and 1950s, in which the action of painting and the expression of emotions were the important elements. Among the main proponents: Franz Kline, Hans Hoffman, Jackson Pollack.

Aerial perspective: Visual phenomenon that forms appear less distinct as they recede in space because of the greater density of the air between the viewer and the object.

Bleeding: When a liquid color flows beyond its area, either because it blends into another color area or because it is spread by absorbent paper.

Bas relief: Sculpture technique; shallow sculptural forms rising from background. Though relatively flat, the images often appear to have greater depth because of the play of shadows on the modeled surface.

261

Blocking in: Use of gestural or construction lines to give basic indications of large shapes and compositional arrangements.

Calligraphic: In reference to a drawing, the use of an expressive, flowing, gestural line of varying width, value, and direction. The term is often applied to Oriental brush painting.

Calligraphy: Handwriting characterized by lines of varying widths; often ornamental or decorative handwriting.

Cartoon: Originally meant a full-size preparatory drawing. May also refer to a comic drawing or animated film.

Chiaroscuro: Italian for light-dark; in painting, chiaroscuro refers to the use of strong value contrast to structure a composition. Chiaroscuro effects became popular in the baroque period, employed by artists such as Carravagio and Rembrandt.

Chroma or chromatic: Having to do with color.

Color scheme: A combination or organization of colors in a painting or drawing. Often a color scheme develops around one predominant color—"a blue color scheme."

Complementary colors: Those colors that may be added to another color to complete the color spectrum; those colors that·are opposite one another on the color wheel; for example, blue is the complement of orange, red is the complement of green.

Composition: Organization of elements in pictorial space.

Compositional sketch: Quick prelimary drawing to determine the organization of a picture. Compositional sketches are usually done within a framework. Negative space, linear movement, and value structure all may be considered when doing a compositional sketch.

Construction lines: Lines used to organize and simplify complex forms by reducing them to basic geometric shapes.

Counterpoint: Originally a music term, counterpoint implies the playing off of one subject or element against another. For example, a few dark values may be "counterpointed" against a large light area to enliven the composition and direct the viewer's eye.

Contour or outline: Line that follows the outer edge of a form.

Crop: Literally, to cut off a part. In creating a composition, it is often necessary to crop a certain area (from the top, bottom, or sides) of the scene or object to make a more contained or unified image. The same definition applies to cropping in photography. Cropping sometimes refers to cutting off part of the drawing or photograph, or to sectioning off part of the image area with a viewfinder or imagination.

Cross contour lines: Lines that pass over the interior surface of a form, defining its three-dimensional shape through modulation.

Cubism: Style of painting and drawing developed by Pablo Picasso and Georges Braque in the early 1900s. Forms are abstracted by breaking them down into geometric shapes and facets.

Diminution: Optical illusion that objects appear smaller as they recede in space.

Directional guide: Lines or shapes that carry or direct the eye around a form or a composition.

Draftsman: Artist who concentrates on drawing; may refer to one who specializes in technical or architectural renderings.

Dry brush: Concerning ink drawing, watercolor, or painting. Refers to the broken uneven mark left on a paper or canvas from the application of a brush that had been blotted or somewhat dried out.

Earth colors: Deep reds, browns, olive greens, neutral colors such as those found in the earth (as opposed to pastel colors or saturated colors).

Editing: Process by which an artist chooses to eliminate or play down certain elements in making a picture, such as not drawing several trees that appear in a view because they would not aid the composition of the picture.

Elements: In art, those components that make up a drawing: line, form, value, space, texture, and color.

Ellipse: Regular oval shape. A circle becomes an ellipse when seen in perspective.

Empathy: Ability to identify physically or emotionally with another person, animal, or object; to project your senses or personality into something or someone else to understand the subject more completely.

Expressionism: Painting style developed in Germany at the beginning of the twentieth century. The expression of emotions dictated the distortion of forms and colors. Main proponents: Ludvig Kirchner, Edvard Munch, Franz Marc, Kathe Kollwitz, Ernst Barlach.

Eye level: Height of your eyes when looking at an object. You may be looking down, up, or directly at an object. In perspective drawing,

eye level is the same level as the horizon line.

Field vision: Broad, all-inclusive awareness of an area, as opposed to a focused view of a small detail.

Foreshortening: Optical illusion that a form is distorted as it recedes or comes forward in space. The closer aspects look large, the farther sections appear smaller, and the midsection appears to be shorter. The degree of foreshortening distortion depends on the position of viewing.

Formula: In drawing, a simplified representation device repeated over and over. (Unfortunately, a formula sometimes takes the place of careful observation.)

Fresco: Wall painting on wet plaster; an exacting medium because the painting must be done before the plaster dries.

Genre: A particular form of art having to do with everyday objects or occurrences.

Gesture: Quick scribbles or marks designed to show movement or action by flowing over and through the interior of a form or composition.

Graphic: Having to do with drawing, writing, or printmaking. Representation on a two-dimensional surface.

Illustration: Drawing for explanatory purposes; for example, illustrations for a novel, technical illustrations.

Impressionism: Painting school developed at the end of the nineteenth century, which drew its inspiration from the effect of light on forms. The style employed by impressionist artists was often more suggestive or abstract than the traditional art of the period.

Intervals: Originally from music, refers to spaces between forms in a picture. Usually suggests a pattern or rhythm to the spacings that helps structure a composition and encourage eye movement.

Key: Dominant range of value or color in a picture:
High key—bright colors or light values.
Low key—neutral colors, dark values.
Middle key—in between the two extremes.

Kinesthetic awareness or kinetic sense: Person's awareness of his or her own body and movements, or an empathetic awareness of another's movements.

Lateral: Sideways.

Linear: Having to do with line. Linear drawings would be built mostly with line, as opposed to tonal drawings, which depend on value areas for structure.

Linear perspective: Perspective system in which forms get smaller as they recede in space, receding parallel lines converge at a vanishing point, and forms in the same line of vision overlap one another; also called "vanishing point perspective."

Line quality: A variety of width, value, and activity in line that can be used for both descriptive and expressive purposes.

Lithography: Printmaking process in which an image is drawn on a stone or plate with a greasy marker, then set and printed. A very large number of impressions can be taken from a lithographic stone.

Margin or border: Line around the edge of a picture that frames the image.

Matting: Partial framing process in which a hole is cut from a piece of matboard (special cardboard) to frame the image and protect the picture.

Mediums: Material used to create an image, such as oil paints, charcoal, pencil.

Negative space (interspace or background shapes): Shape of the space around an object, between several objects, or in an opening within an object; the space between the handle and the body of a cup is a negative space.

Neolithic: New Stone Age (beginning c. 8000 B.C.), period when prehistoric humans began to polish stone implements.

Neutral: Applies to both color and value. Colors include gray, brown, and others that have been rendered less intense, or neutralized. Colors are neutralized when a small amount of their complementary color is added. In terms of value, neutral refers to an area of overall gray, in which there are no strong contrasting tones. Neutral areas do not attract attention; strong contrasts of dark and light do.

Opaque: Something that cannot be seen through.

Overlap: When one object is in front of another object in the same line of vision, the front object hides (overlaps) a part of the object behind it.

Painterly: Referring to an approach to painting or drawing in which colors and tones are laid on thickly and loosely. Pastels can be used in a "painterly" fashion.

Pastel colors: Soft, delicate shades of color, such as pink, rose, light blues and greens. This term is

somewhat misleading, since pastel colors can provide a full range of color and values.

Perspective: Means by which forms can be positioned in the implied three-dimensional space of a picture.

Planes: May refer to surfaces, faces, or facets of an object, or to the vertical planes in space that delineate foreground, middle ground, and background.

Plastic: Something that can be formed or modeled, such as clay. "Plastic arts" refers to drawing and painting as well as sculpture.

Profile: In portrait drawing, the side view of a subject.

Proportion: Size of one object in relation to another, or the size of one part of an object in relation to another part.

Rendering: Portrayal, representation, or reproduction of something. Generally refers to an accurate and detailed representation of a form rather than an abstract or expressionistic work.

Sanguine: Reddish-brown, oil-based chalk, currently referred to as conte crayon.

Saturated colors: Colors that approach being pure hues, as opposed to neutralized colors.

Scale: Size relationships between objects.

Schema: Diagram or formula used to describe something. In art it refers to an oversimplification and inaccurate representation of a form due to preconceptions and poor observation.

Scumbling: Painting techniques in which one layer of paint or pastel is applied over another in a coarse or uneven fashion, which allows the color underneath to show through to some degree.

Spatial devices or spatial indicators: Use of line or tone in a drawing to give the impression of three-dimensionality and depth.

Stipple: Pen-and-pencil technique in which textures and values are developed from a pattern of dots.

Style: Artist's unique approach to technique and imagery, the way a subject is interpreted through the use of mediums and artistic elements. Style is a product of the artist's personality, training, intention, and mood.

Surrealism: School of art developed in the 1920s and 1930s in which symbols and fantasies are presented in either a pseudo-realistic or a stylized imagery. Theories of surrealism were closely related to theories of psychoanalysis, and much of the painting was supposedly a manifestation of the artist's unconscious.

Tactile sensations: Sensations from touching something. May be implied in a drawing through textural indications.

Three-dimensional indicators: *See* Spatial devices.

Three-quarter view: In portrait drawings, a view in which the subject sits halfway between frontal and profile view.

Tonal drawing: Drawing built primarily of areas of gray as opposed to a line drawing.

Tone: Area of color or value of a particular lightness or darkness.

Tooth: Grain or texture on a piece of paper.

Translucency: Surface that can be seen through to a limited degree.

Transparency: Surface that can be seen through completely.

Undersketch: Quick gestural or construction marks put down on a drawing or canvas first, to establish basic forms or movements, then drawn or painted over.

Vanishing point: Point in a perspective drawing where receding parallel lines converge.

Value: Range of dark and light in a picture.

Visual energy: Energy apparently contained within a graphic form or combination of forms. The amount of visual energy is determined by the nature of the image, its degree of development, and its relationship to other forms or the edge of the page. Visual energy depends to a large extent on our emotional response to the image. If an image makes us excited, nervous, anxious, or uncomfortable, due to its nature or development, we would say that the image is highly charged with visual energy.

Visual weight: Optical illusion that a drawn or painted image has weight. The degree of visual weight depends upon the relative size, development, value, and importance of a form.

Wash: Tonal areas created with watered-down liquid color or ink.

Bibliography

Anatomy

Barcsay, Jeno. *Anatomy for the Artist.* Budapest: Corvina, 1955.

Bridgeman, George. *The Book of a Hundred Hands* (1920). New York: Dover Publications, Inc., 1974.

——. *Bridgeman's Life Drawing* (1924). New York: Dover Publications, Inc., 1973.

——. *Constructive Anatomy* (1920). New York: Dover Publications, Inc., 1973.

——. *The Female Form, Draped and Undraped.* New York: Sterling Publishing Company, Inc., 1963.

——. *Heads, Features and Faces* (1932). New York: Dover Publications, Inc., 1974.

——. *The Human Machine* (1939). New York: Dover Publications, Inc., 1972.

Richer, Dr. Paul. *Artistic Anatomy;* trans. Robert Beverly Hale. New York: Watson-Guptill, Inc., 1971.

Schider, Fritz. *An Atlas of Anatomy for Artists.* New York: Dover Publications, Inc., 1947, 1958.

Animal Drawing

CALDERON, FRANK. *Animal Painting and Anatomy.* London: Seeley, Service and Company, 1936. New Edition—New York: Dover Publications, Inc., 1975.

HULTGREN, KEN. *The Art of Animal Drawing.* New York: McGraw-Hill, Inc., 1950.

MUYBRIDGE, EADWEARD. *Animals in Motion.* New York: Dover Publications, Inc., 1957.

Drawing, History, and Theory

ARNHEIM, RUDOLPH. *Art and Visual Perception.* Berkeley, Calif.: University of California Press, 1967.

———. *Visual Thinking.* Berkeley, Calif.: University of California Press, 1967.

HILL, EDWARD. *The Language of Drawing.* Englewood Cliffs, N.J.: Prentice-Hall, Inc., 1966.

MENDELOWITZ, DANIEL M. *Drawing.* New York: Holt, Rinehart and Winston, Inc., 1967.

Figure Drawing

GOLDSTEIN, NATHAN. *Figure Drawing.* Englewood Cliffs, N.J.: Prentice-Hall, Inc., 1975.

HALE, ROBERT BEVERLY. *Drawing Lessons from the Great Masters.* New York: Watson-Guptill, Inc., 1964.

MUYBRIDGE, EADWEARD. *The Human Figure in Motion.* New York: Dover Publications, Inc., 1955.

NICOLAIDES, KIMON. *The Natural Way to Draw.* Boston: Houghton Mifflin Company, 1941.

General Drawing Study

CHAET, BERNARD. *The Art of Drawing.* New York: Holt, Rinehart and Winston, Inc., 1970.

COLLIER, GRAHAM. *Form, Space and Vision* (3rd ed.). Englewood Cliffs, N.J.: Prentice-Hall, Inc., 1972.

GOLDSTEIN, NATHAN. *The Art of Responsive Drawing, Second Edition.* Englewood Cliffs, N.J.: Prentice-Hall, Inc., 1977.

KLEE, PAUL. *Pedagogical Sketchbook.* New York: Praeger Publishers, Inc., 1953.

MENDELOWITZ, DANIEL M. *A Guide to Drawing.* New York: Holt, Rinehart and Winston, Inc., 1975.

ROSENBERG, J. *Great Draughtsmen.* Cambridge, Mass.: Harvard University Press, 1959.

Materials

HERBERTS, K. *The Complete Book of Artist's Techniques.* New York: Frederick A. Praeger, Inc., 1958.

KAY, REED. *The Painter's Guide to Studio Methods and Materials.* Garden City, New York: Doubleday and Company, Inc., 1972.

MAYER, RALPH W. *The Artist's Handbook of Materials and Techniques* (rev.). New York: The Viking Press, Inc., 1970.

WATROUS, JAMES. *The Craft of Old Master Drawings.* Madison, Wisc.: University of Wisconsin Press, 1957.

Perspective

BURNETT, CALVIN. *Objective Drawing Techniques.* New York: Van Nostrand Reinhold Company, 1966.

COLE, REX V. *Perspective: The Practice and Theory of Perspective as Applied to Pictures.* New York: Dover Publications, Inc., 1927.

NORLING, ERNEST R. *Perspective Made Easy.* New York: The Macmillan Company, 1939.

WATSON, ERNEST W. *How to Use Creative Perspective.* New York: Reinhold Publishing Company, 1960.

Index